CREATIVITY 36
Annual Awards

CREATIVITY 36
Annual Awards

Edited by
THE CREATIVITY AWARDS
Board of Editors

COLLINS|DESIGN
An Imprint of HarperCollins*Publishers*

CREATIVITY 36
Copyright © 2007 by COLLINS DESIGN and GEORGE DICK

HarperCollins books may be purchased for educational, business, or sales promotional use. For information, please write: Special Markets Department, HarperCollins Publishers, 10 East 53rd Street, New York, NY 10022.

First Edition

First published in 2007 by:
Collins Design
An Imprint of HarperCollins*Publishers*
10 East 53rd Street
New York, NY 10022
Tel: (212) 207-7000
Fax: (212) 207-7654
collinsdesign@harpercollins.com
www.harpercollins.com

Distributed throughout the world by:
HarperCollins*Publishers*
10 East 53rd Street
New York, NY 10022
Fax: (212) 207-7654

Special thanks to Tim Moran, for seamlessly organizing the 2006 competition and judging procedures.

Cover and page design by Joe Weber

Additional photography provided by Melissa McIntosh, www.1214.biz

Production and book design by Designs on You! • Anthony and Suzanna Stephens

Library of Congress Control Number: 2007925502

ISBN: 978-0-06-125572-4
ISBN-10: 0-06-125572-6

Produced by Crescent Hill Books, Louisville, KY.
Printed in China by Everbest Printing Company through Crescent Hill Books, Louisville, Kentucky.

First Printing, 2007

TABLE OF CONTENTS

MEDAL DESIGNATIONS

Platinum—This symbol designates a Platinum Award winning design. Our most prestigious award is reserved for the Best in Category. Only one design is awarded per category.

Gold—This symbol designates a Gold Award winning design. The top 10% of designs in each category are selected for the Gold Award.

Silver—This symbol designates a Silver Award winning design. The top 25% of designs in each category are selected for the Silver Award.

CREATIVITY ANNUAL AWARDS
Register online.

creativityawards.com

Creative Firm: **A3 DESIGN — CHARLOTTE, NC**
Creative Team: **ALAN ALTMAN, AMANDA ALTMAN**
Client: **MATTAMY HOMES**

Creative Firm: **ORIGINAL IMPRESSIONS — MIAMI, FL**
Creative Team: **LISA CUERVO**
Client: **SUNSET HEIGHTS**

Creative Firm: **30SIXTY ADVERTISING+DESIGN, INC. — LOS ANGELES, CA**
Creative Team: **HENRY VIZCARRA, DAVID FUSCELLARO, LEE BARETT, MARK PRUDEAUX**
Client: **KING'S SEAFOOD COMPANY**

Creative Firm: **HORNALL ANDERSON DESIGN WORKS — SEATTLE, WA**
Creative Team: **DAVID BATES, YURI SHVETS, JACOB CARTER**
Client: **WET PAINT**

Creative Firm: **MT&L PUBLIC RELATIONS LTD. — HALIFAX, NS, CANADA**
Creative Team: **PAUL WILLIAMS**
Client: **AIRFIRE WIRELESS CONNECTIVITY**

Creative Firm: **STEPHEN LONGO DESIGN ASSOCIATES — WEST ORANGE, NJ**
Creative Team: **STEPHEN LONGO**
Client: **THE HEARING GROUP**

Creative Firm: **SNAP CREATIVE — ST. CHARLES, MO**
Creative Team: **ANGELA NEAL, HILARY CLEMENTS**
Client: **MIDWEST INDUSTRIAL**

Creative Firm: **VERY MEMORABLE DESIGN — NEW YORK, NY**
Creative Team: **MICHAEL PINTO**
Client: **WEINER ASSOCIATES**

Creative Firm: **KAREN SKUNTA & COMPANY — CLEVELAND, OH**
Creative Team: **KAREN SKUNTA, JAMIE FINKELHOR**
Client: **THE CLEVELAND PLAY HOUSE**

BLUEGIN

VISIONQUEST

Creative Firm: **VINCE RINI DESIGN — HUNTINGTON BEACH, CA**
Creative Team: **VINCE RINI**
Client: **NEWPORT ORTHOPEDIC INSTITUTE**

Creative Firm: **GROUP T DESIGN — WASHINGTON, DC**
Creative Team: **TOM KLINEDINST**
Client: **BLUE GIN**

Creative Firm: **MAD STUDIOS — HONG KONG**
Creative Team: **BRIAN YEE HUAN LAU, LILIAN LAI YEE CHAN**
Client: **VISIONQUEST INTERNATIONAL**

iCONCLUDE

Creative Firm: **CONNIE HWANG DESIGN — GAINESVILLE, FL**
Creative Team: **CONNIE HWANG**
Client: **ICONCLUDE**

Creative Firm: **NEURON SYNDICATE INC. —SANTA MONICA, CA**
Creative Team: **SEAN ALATORRE, RYAN CRAMER, JASON BURNAM**
Client: **20TH CENTURY FOX MOBILE DIVISION**

MASHERY

SOUNDTANKER
CHARTERING

dairygood
for life

Creative Firm: **PLUMBLINE STUDIOS, INC — NAPA, CA**
Creative Team: **DOM MORECI**
Client: **MASHERY**

Creative Firm: **SILVER CREATIVE GROUP — SOUTH NORWALK, CT**
Creative Team: **BONNIE HARRIMAN, DONNA BONATO**
Client: **SOUNDTANKER CHARTERING**

Creative Firm: **ASPREY CREATIVE — FITZROY, VICTORIA, AUSTRALIA**
Creative Team: **GEORGE MARGARITIS, PETER ASPREY**
Client: **AUSTRALIAN DAIRY CORPORATION**

Creative Firm: **MCGUFFIE DESIGN — NORTH VANCOUVER, BC, CANADA**
Creative Team: **STEVE MCGUFFIE**
Client: **VANCOUVER BOARD OF PARKS AND RECREATION**

Creative Firm: **BREEDWORKS — ONEONTA, NY**
Creative Team: **SUSAN MUTHER**
Client: **SUN KING ALPACAS**

Creative Firm: **LEVERAGE MARKETING GROUP — NEWTOWN, CT**
Creative Team: **DON WHELAN, DAVID GOODWICK, TOM MARKS, BECKY KOROL, RICH BRZOZOWSKI**
Client: **SEALED AIR CORPORATION**

Creative Firm: **MAD DOG GRAPHX — ANCHORAGE, AK**
Creative Team: **KRIS RYAN-CLARKE**
Client: **SIMPLIFY**

Creative Firm: **RODGERS TOWNSEND — ST. LOUIS, MO**
Creative Team: **KRIS WRIGHT**
Client: **RODGERS TOWNSEND GOLF TOURNAMENT**

Creative Firm: **KOMP|REHENSIVE DESIGN — KING OF PRUSSIA, PA**
Creative Team: **JEANNE KOMP**
Client: **GOLD LION ASSOCIATES**

Creative Firm: **DANIEL GREEN EYE-D DESIGN — GREEN BAY, WI**
Creative Team: **DANIEL GREEN**
Client: **GREEN BAY EAST HIGH SOCCER BOOSTER CLUB**

Creative Firm: **KOR GROUP — BOSTON, MA**
Creative Team: **KAREN DENDY SMITH, KJERSTIN WESTGAARD OH**
Client: **BOSTON PROPERTIES**

Creative Firm: **JANIS BROWN & ASSOCIATES — CARLSBAD, CA**
Creative Team: **TRACY SABIN, JANIS BROWN**
Client: **GARRETT RANCH**

the brilliance of innovation

Creative Firm: **SMITH + BARTELS — BERKELEY, CA**
Creative Team: **DON BARTELS, NANCY SMITH**
Client: **AGILENT TECHNOLOGIES, INC.**

Creative Firm: **MARK OLIVER, INC.—SOLVANG, CA**
Creative Team: **MARK OLIVER, TOM HENNESSY**
Client: **SANTA RITA HILLS WINEGROWERS ALLIANCE**

Creative Firm: **STELLAR DEBRIS — HADANO-SHI, KANAGAWA-KEN, JAPAN**
Creative Team: **CHRISTOPHER JONES**
Client: **STELLAR DEBRIS**

Creative Firm: **DESIGNSKI L.L.C. — TOLEDO, OH**
Creative Team: **DENNY KREGER**
Client: **NICK PINOTTI**

Creative Firm: **FITTING GROUP — PITTSBURGH, PA**
Creative Team: **ANDREW ELLIS, TRAVIS NORRIS, ANDREA FITTING**
Client: **PRODUCT STRATEGY NETWORK**

Creative Firm: **HORNALL ANDERSON DESIGN WORKS — SEATTLE, WA**
Creative Team: **JACK ANDERSON, MARK POPICH, DAVID BATES, ANDREW WICKLUND, LEO RAYMUNDO, JACOB CARTER**
Client: **EOS AIRLINES**

Creative Firm: **INFORMATION EXPERTS — RESTON, VA**
Creative Team: **ELICIA ROBERTS, JERRY SMITH**
Client: **COMMDEV**

Creative Firm: **HITCHCOCK FLEMING & ASSOCIATES INC. — AKRON, OH**
Creative Team: **NICK BETRO, TODD MOSER**
Client: **VERITAS**

Creative Firm: **FITTING GROUP — PITTSBURGH, PA**
Creative Team: **TRAVIS NORRIS, ANDREW ELLIS, ANDREA FITTING**
Client: **I-SQUARED**

Creative Firm: **FITTING GROUP — PITTSBURGH, PA**
Creative Team: **ANDREW ELLIS, TRAVIS NORRIS**
Client: **BLACK KNIGHT SECURITY**

Creative Firm: **ATOMIC DESIGN — CROWLEY, TX**
Creative Team: **LEWIS GLASER**
Client: **STEVEN C. WOOD**

Creative Firm: **ENGINE, LLC — SAN FRANCISCO, CA**
Creative Team: **LOTUS CHILD, GEOFF SKIGEN**
Client: **MEDJOOL**

Creative Firm: **SPRINGBOARD CREATIVE — MISSION, KS**
Creative Team: **KEVIN FULLERTON**
Client: **SPRINGBOARD CREATIVE**

Creative Firm: **LORENC+YOO DESIGN — ROSWELL, GA**
Creative Team: **JAN LORENC, DAVID PARK, JISUN AN**
Client: **GENERAL GROWTH PROPERTIES**

Creative Firm: **BETH SINGER DESIGN — ARLINGTON, VA**
Creative Team: **BETH SINGER, CHRIS HOCH,**
SUCHA SNIDVONGS
Client: **CABLE IN THE CLASSROOM**

Creative Firm: **DESIGN OBJECTIVES PTE LTD — SINGAPORE**
Creative Team: **RONNIE S C TAN**
Client: **JW MARRIOTT HOTEL, BEIJING**

Creative Firm: **VENTRESS DESIGN GROUP — FRANKLIN, TN**
Creative Team: **TOM VENTRESS**
Client: **SUSAN GRAY SCHOOL**

Creative Firm: **KELLY BREWSTER**
— CHARLOTTE, NC
Creative Team: **KELLY BREWSTER**
Client: **BURTIN POLYMER LABORATORIES**

Creative Firm: **BRAND ENGINE — SAUSALITO, CA**
Creative Team: **ANDREW OTTO, MEGHAN ZODROW,**
KONRAD TSE, ISKRA JOHNSON
Client: **PLUM ORGANICS**

Creative Firm: **TD2, S.C. — MEXICO CITY, D.F., MEXICO**
Creative Team: **JOSE LUIS (PAT) PATIÑO, R. RODRIGO**
CORDOVA, RAFAEL TREVINO
Client: **COA**

Creative Firm: **ZENN GRAPHIC DESIGN — LOS ANGELES, CA**
Creative Team: **ZENGO YOSHIDA, MARK WOOD**
Client: **MARK WOOD DESIGN OFFICE**

Creative Firm: **Q — WIESBADEN, GERMANY**
Creative Team: **THILO VON DEBSCHITZ, LAURENZ NIELBOCK,**
MARCEL KUMMERER, CHRISTOPH DAHINTEN
Client: **HESSENCHEMIE**

Creative Firm: **KOLANO DESIGN — PITTSBURGH, PA**
Creative Team: **BILL KOLANO, TIM CARRERA**
Client: **NICHOLE GOLDSMITH, WORLD SHOE TRAVELERS**
ASSOCIATION

Creative Firm: **BAER DESIGN GROUP — EVANSTON, IL**
Creative Team: **DAVE SEIDLER, TODD BAER**
Client: **SOMMERS ORGANIC**

Creative Firm: **TOM FOWLER, INC. — NORWALK, CT**
Creative Team: **ELIZABETH P. BALL**
Client: **SERVICEMACS LLC**

Creative Firm: **WHET DESIGN, INC. — NEW YORK, NY**
Creative Team: **CHERYL OPPENHEIM,**
CRISTINA LAGORIO
Client: **EMPLOYEES ONLY**

Creative Firm: **VISUALLY SPEAKING — BALTIMORE, MD**
Creative Team: **CRAIG KIRBY**
Client: **RED ABBEY CAPITAL MANAGEMENT**

Creative Firm: **ELEVATOR — SPLIT, CROATIA (HRVATSKA)**
Creative Team: **TONY ADAMIC, LANA VITAS, GORANA MARSIC**
Client: **BIOLAB**

Creative Firm: **REDUCED FAT — SARATOGA SPRINGS, NY**
Creative Team: **JOHN BOLSTER**
Client: **DEBRA DOCYK**

Creative Firm: **MIKE SALISBURY EFFECTIVE CREATIVE STRATEGIES — VENICE, CA**
Creative Team: **MIKE SALISBURY, MATT BRIGHT**
Client: **DISNEY'S CALIFORNIA ADVENTURE**

Creative Firm: **OCTAVO DESIGNS — FREDERICK, MD**
Creative Team: **SUE HOUGH, MARK BURRIER**
Client: **STRATEGIC PARTNERSHIPS INTERNATIONAL**

Creative Firm: **FUTUREBRAND — NEW YORK, NY**
Creative Team: **DIEGO KOLSKY, MIKE WILLIAMS, CHERYL HILLS, STEPHANIE CARROLL, WILLIAM SHINTANI, RAYMOND CHAN**
Client: **ARCAPITA**

Creative Firm: **DEVER DESIGNS — LAUREL, MD**
Creative Team: **JEFFREY DEVER**
Client: **TAKOMA ACADEMY JAMAICA TOUR**

Creative Firm: **DESIGN OBJECTIVES PTE LTD — SINGAPORE**
Creative Team: **RONNIE S C TAN**
Client: **BEAUFORT SENTOSA DEVELOPMENT PTE LTD**

Creative Firm: **OJO DESIGN LIMITED — KOWLOON BAY, HONG KONG**
Creative Team: **ONG JOEL NG, ONG CHAN CHUNG CHUN, ONG JESSIKA OLIVE**
Client: **CARITAS YOUTH & COMMUNITY SERVICE**

Creative Firm: **MAD DOG GRAPHX — ANCHORAGE, AK**
Creative Team: **MICHAEL ARDAIZ**
Client: **GREAT CIRCLE FLIGHT SERVICES**

Creative Firm: MORNINGSTAR DESIGN, INC. — FREDERICK, MD
Creative Team: MISTI MORNINGSTAR
Client: FUSION NIGHTCLUB

Creative Firm: ZERO GRAVITY DESIGN GROUP
— SMITHTOWN, NY
Creative Team: ZERO GRAVITY DESIGN
GROUP
Client: DIRECT ACCESS PARTNERS

Creative Firm: BETH SINGER DESIGN — ARLINGTON, VA
Creative Team: BETH SINGER, SUCHA SNIDVONGS
Client: TCI

Creative Firm: AF&A BRANDTELLIGENCE — PITTSBURGH, PA
Creative Team: ROBERT ADAM, BLAIR GOOD, RALPH RUSSINI
Client: PIETRAGALLO, BOSICK & GORDON, LLP

Creative Firm: CONNIE HWANG DESIGN
— GAINESVILLE, FL
Creative Team: CONNIE HWANG
Client: JITTERBIT

Creative Firm: SILVER COMMUNICATIONS INC — NEW YORK, NY
Creative Team: GREGG SIBERT, CHRISTINA WEISSMAN
Client: EAST MIDTOWN ASSOCIATION

Creative Firm: SABINGRAFIK, INC. — CARLSBAD, CA
Creative Team: TRACY SABIN
Client: SABINGRAFIK, INC.

Creative Firm: SPEEDY MOTORCYCLE STUDIO, LTD.
— PHILADELPHIA, PA
Creative Team: E. JUNE ROBERTS-LUNN
Client: SPEEDY MOTORCYCLE STUDIO, LTD.

Creative Firm: DESIGN NUT — KENSINGTON, MD
Creative Team: WENDY BOGART, BRENT ALMOND
Client: COUNCIL FOR ADVANCEMENT AND SUPPORT
OF EDUCATION

Creative Firm: **MARK DEITCH & ASSOCIATES, INC. — BURBANK, CA**
Creative Team: **DVORJAC RIEMERSMA**
Client: **AEG**

Creative Firm: **BRAND ENGINE — SAUSALITO, CA**
Creative Team: **ERIC READ, AILEEN KENDLE-SMITH, CORALIE RUSSO**
Client: **SUGAR BOWL BAKERY**

Creative Firm: **CONRY DESIGN — TOPANGA, CA**
Creative Team: **RHONDA CONRY**
Client: **THE JOB COACH**

Creative Firm: **GROUP T DESIGN — WASHINGTON, DC**
Creative Team: **TOM KLINEDINST**
Client: **MANA WAERE**

Creative Firm: **MEGAN BOYER — ENCINITAS, CA**
Creative Team: **MEGAN BOYER, HEATHER HOOGENDAM**
Client: **SOUTHERN CALIFORNIA VACATION RENTALS**

 Creative Firm: **BERRY DESIGN INC — ALPHARETTA, GA**
Creative Team: **BOB BERRY, CHIP WALLER**
Client: **CRABAPPLE TAVERN**

Creative Firm: **FAINE-OLLER PRODUCTIONS — SEATTLE, WA**
Creative Team: **CATHERINE OLLER, BRUCE HALE, NANCY STENTZ**
Client: **COLESON FOODS, INC.**

Creative Firm: **MAD STUDIOS — HONG KONG**
Creative Team: **BRIAN YEE HUAN LAU, LILIAN LAI YEE CHAN**
Client: **BABYFIRST**

Creative Firm: **CROXSON DESIGN — HOUSTON, TX**
Creative Team: **STEPHEN CROXSON, RICHARD BYRD**
Client: **HOUSTON AREA WOMEN'S CENTER**

Creative Firm: **VINCE RINI DESIGN — HUNTINGTON BEACH, CA**
Creative Team: **VINCE RINI**
Client: **BLUE COW**

Creative Firm: **AIJALON — LINCOLN, NE**
Creative Team: **LANCE FORD**
Client: **DYNAMIC HOLDINGS**

Creative Firm: **KIKU OBATA & COMPANY — ST. LOUIS, MO**
Creative Team: **ELEANOR SAFE**
Client: **SMARTCARE**

Creative Firm: **GRAFIK MARKETING COMMUNICATIONS**
— ALEXANDRIA, VA
Creative Team: **KRISTIN MOORE, MELISSA WILETS,**
HAL SWETNAM, HEATH DWIGGINS
Client: **WASHINGTON COURT HOTEL**

Creative Firm: **ORIGINAL IMPRESSIONS — MIAMI, FL**
Creative Team: **LISA CUERVO**
Client: **THE ALEDAN GROUP**

Creative Firm: **GRAPHICAT LTD. — WANCHAI, HONG KONG**
Creative Team: **COLIN TILLYER**
Client: **JC HOLDINGS LTD.**

Creative Firm: **GREENFIELD/BELSER LTD. — WASHINGTON, DC**
Creative Team: **BURKEY BELSER, CAROLYN SEWELL**
Client: **CHOATE HALL & STEWART LLP**

Creative Firm: **A3 DESIGN — CHARLOTTE, NC**
Creative Team: **ALAN ALTMAN, AMANDA ALTMAN**
Client: **GOODY'S PAINT INC.**

Creative Firm: **ACME COMMUNICATIONS, INC. — NEW YORK, NY**
Creative Team: **KIKI BOUCHER**
Client: **BEACH HOUSE SUPPLY CO.**

LOGOS & TRADEMARKS

Creative Firm: DESIGNSKI L.L.C. — TOLEDO, OH
Creative Team: DENNY KREGER
Client: COMMERCIAL INTERIORS

Creative Firm: KINESIS — ASHLAND, OR
Creative Team: SHAWN BUSSE, MICHELLE CHENEY
Client: SWEETGRASS NATURAL FIBERS

Creative Firm: VENTRESS DESIGN GROUP
— FRANKLIN, TN
Creative Team: TOM VENTRESS
Client: ZIA MUSIC PRODUCTION

Creative Firm: ACOSTA DESIGN INC — NEW YORK, NY
Creative Team: MAURICIO ACOSTA
Client: ACOSTA DESIGN INC

Creative Firm: FIVESTONE — BUFORD, GA
Creative Team: JASON LOCY, PATRICIO JUAREZ
Client: RETHINK GROUP

Creative Firm: TOM FOWLER, INC. — NORWALK, CT
Creative Team: THOMAS G. FOWLER, ELIZABETH P. BALL,
STEPHANIE JOHNSON
Client: THE CONNECTICUT GRAND OPERA & ORCHESTRA

Creative Firm: A3 DESIGN — CHARLOTTE, NC
Creative Team: ALAN ALTMAN, AMANDA ALTMAN,
SCOTT ELLIOTT
Client: MATTAMY HOMES

Creative Firm: BBK STUDIO — GRAND RAPIDS, MI
Creative Team: SHARON OLENICZAK,
KEVIN BUDELMANN, BRIAN HAUCH, TIM CALKINS
Client: XBY2

Creative Firm: INFORMATION EXPERTS — RESTON, VA
Creative Team: ELICIA ROBERTS, JERRY SMITH
Client: CRISIS PARTNERS INTERNATIONAL

19

Creative Firm: **VANPELT CREATIVE — GARLAND, TX**
Creative Team: **CHIP VANPELT**
Client: **FIRST UNITED METHODIST CHURCH OF GARLAND**

Creative Firm: **GRAFIK MARKETING COMMUNICATIONS — ALEXANDRIA, VA**
Creative Team: **KRISTIN MOORE, MELISSA WILETS, HAL SWETNAM, HEATH DWIGGINS**
Client: **WASHINGTON COURT HOTEL**

Creative Firm: **TANGRAM STRATEGIC DESIGN — NOVARA, ITALY**
Creative Team: **ENRICO SEMPI, ANDREA SEMPI**
Client: **CARLO FILIPPO FOLLIS**

Creative Firm: **DEVER DESIGNS — LAUREL, MD**
Creative Team: **JEFFREY DEVER**
Client: **NATIONAL ASSOCIATION OF COUNTIES**

Creative Firm: **DESIGN GROUP WEST — CARLSBAD, CA**
Creative Team: **TRACY SABIN, JIM NAEGELI**
Client: **UNIVERSITY OF SAN DIEGO**

Creative Firm: **TOM FOWLER, INC. — NORWALK, CT**
Creative Team: **MARY ELLEN BUTKUS, ELIZABETH P. BALL**
Client: **ACME UNITED CORPORATION**

Creative Firm: **MAD STUDIOS — HONG KONG**
Creative Team: **BRIAN YEE HUAN LAU, LILIAN LAI YEE CHAN**
Client: **ECCHINESE**

Creative Firm: **ACART COMMUNICATIONS — OTTAWA, ON, CANADA**
Creative Team: **KERRY CAVLOVIC, VERNON LAI, TOM MEGGINSON, JOHN STARESINIC, CRAIG CEBRYK**
Client: **WORLD JUNIOR CHAMPIONSHIP**

Creative Firm: **TD2, S.C. — MEXICO CITY, D.F., MEXICO**
Creative Team: **GABRIELA ZAMORA, R. RODRIGO CORDOVA, RAFAEL TREVINO**
Client: **CIE**

Brand Engine ™

Creative Firm: **BRIGHT RAIN CREATIVE — ST. LOUIS, MO**
Creative Team: **KEVIN HOUGH, MATT MARINO**
Client: **BRIGHT RAIN CREATIVE**

Creative Firm: **MAD DOG GRAPHX — ANCHORAGE, AK**
Creative Team: **MICHAEL ARDAIZ**
Client: **HARBOR DINNER CLUB**

Creative Firm: **BRAND ENGINE — SAUSALITO, CA**
Creative Team: **ERIC READ, ROBERT BURNS, YUSUKE ASAKA**
Client: **BRAND ENGINE**

Creative Firm: **HBO OFF-AIR CREATIVE SERVICES — NEW YORK, NY**
Creative Team: **VENUS DENNISON, ANA RACELIS, CARLOS TEJEDA**
Client: **HBO PRODUCT DEVELOPMENT**

Creative Firm: **KOR GROUP —BOSTON, MA**
Creative Team: **JIM GIBSON**
Client: **KERWIN**

Creative Firm: **TYPE G DESIGN — CARLSBAD, CA**
Creative Team: **TRACY SABIN, MIKE NELSON**
Client: **PASTA PASTA RESTAURANT**

Creative Firm: **BRIGHT RAIN CREATIVE — ST. LOUIS, MO**
Creative Team: **MATT MARINO, KEVIN HOUGH**
Client: **SMOKIN' DICK'S BBQ**

Creative Firm: **HORNALL ANDERSON DESIGN WORKS — SEATTLE, WA**
Creative Team: **JACK ANDERSON, LARRY ANDERSON, JAY HILBURN, BRUCE STIGLER, ELMER DELA CRUZ, DAYMON BRUCK, HAYDEN SCHOEN**
Client: **WIDMER BROTHERS BREWERY**

Creative Firm: **CBX — NEW YORK, NY**
Client: **NEIGHBOURS**

21

Creative Firm: **BRAND ENGINE — SAUSALITO, CA**
Creative Team: **ERIC READ, MEGHAN ZODROW, ROBERT BURNS, AILEEN KENDLE-SMITH**
Client: **PACKAGE DESIGN MAGAZINE: DESIGN CHALLENGE 2005**

Creative Firm: **A3 DESIGN — CHARLOTTE, NC**
Creative Team: **ALAN ALTMAN, AMANDA ALTMAN**
Client: **HOT SAKE CREATIVE**

Creative Firm: **TD2, S.C. — MEXICO CITY, D.F., MEXICO**
Creative Team: **R. RODRIGO CORDOVA, MAURICIO MUÑOZ**
Client: **CHIN-AI BAR**

Creative Firm: **DON SCHAAF & FRIENDS, INC. — WASHINGTON, DC**
Creative Team: **DON SCHAAF**
Client: **HONESTY ONLINE**

Creative Firm: **DEVER DESIGNS — LAUREL, MD**
Creative Team: **JEFFREY DEVER**
Client: **NATIONAL ASSOCIATION OF COUNTIES**

Creative Firm: **VENTRESS DESIGN GROUP — FRANKLIN, TN**
Creative Team: **TOM VENTRESS**
Client: **COMMUNITY INITIATIVE**

Creative Firm: **AF&A BRANDTELLIGENCE — PITTSBURGH, PA**
Creative Team: **ROBERT ADAM, RALPH RUSSINI, BLAIR GOOD**
Client: **ONE OCEAN**

Creative Firm: **FITTING GROUP — PITTSBURGH, PA**
Creative Team: **TRAVIS NORRIS, ANDREW ELLIS, ANDREA FITTING**
Client: **THE FRENCH TART**

Creative Firm: **PATRICIA LOPEZ-HURTADO — SAN MATEO, CA**
Client: **COLLEGE OF SAN MATEO**

WESTCHESTER
SPORTS & WELLNESS

asfaltna cesta

Creative Firm: **TOM FOWLER, INC. — NORWALK, CT**
Creative Team: **BRIEN O'REILLY, THOMAS G. FOWLER**
Client: **WESTCHESTER SPORTS AND WELLNESS**

Creative Firm: **ELLEN BRUSS DESIGN — DENVER, CO**
Creative Team: **ELLEN BRUSS**
Client: **UNIVERSITY OF DAYTON**

Creative Firm: **ELEVATOR — SPLIT, CROATIA (HRVATSKA)**
Creative Team: **TONY ADAMIC, LANA VITAS**
Client: **ASFALTNA CESTA**

NORTHLANDS

Creative Firm: **KARACTERS DESIGN GROUP/DDB CANADA — VANCOUVER, BC, CANADA**
Creative Team: **JAMES BATEMAN, MARSHA LARKIN, HELEN WYNNE, PHIL COLLINS, MARK FINN, RUSS HORII**
Client: **NORTHLANDS**

Creative Firm: **BRIGHT RAIN CREATIVE — ST. LOUIS, MO**
Creative Team: **MATT MARINO**
Client: **PLAY 54, LLC**

Creative Firm: **PHOENIX CREATIVE GROUP, LLC — POTOMAC FALLS, VA**
Creative Team: **SEAN MULLINS, NICK LUTKINS, CHRISTIAN MUSSELMAN**
Client: **URBAN LAND INSTITUTE**

Creative Firm: **HOTSAUCE — NEW YORK, NY**
Creative Team: **WYNDY SLOAN**
Client: **VIRGIN COMICS**

Creative Firm: **DESIGN SYSTEMAT, INC. — MAKATI, MANILA, PHILIPPINES**
Creative Team: **STEFANO PAOLO BUNAG, GERONIMO SANTOS**
Client: **OOGLE AND BEYOND**

Creative Firm: **SINGULARITY DESIGN, INC. — PHILADELPHIA, PA**
Creative Team: **OWEN LINTON, JOSHUA COHEN**
Client: **PENN IMAGE COMPUTING & SCIENCE LAB**

Creative Firm: **SERAN DESIGN — KEEZLETOWN, VA**
Creative Team: **SANG YOON**
Client: **COLLEGE OF VISUAL & PERFORMING ARTS, JAMES MADISON UNIVERSITY**

Creative Firm: **A3 DESIGN — CHARLOTTE, NC**
Creative Team: **ALAN ALTMAN, AMANDA ALTMAN**
Client: **MATTAMY HOMES**

Creative Firm: **G2 — NEW YORK, NY**
Creative Team: **LOU ANTONUCCI, ANDRE KALLAUR**
Client: **AEROBED**

Creative Firm: **LISKA + ASSOCIATES — CHICAGO, IL**
Creative Team: **TANYA QUICK, FERNANDO MUNOZ**
Client: **AROMAFLORIA**

Creative Firm: **BBK STUDIO — GRAND RAPIDS, MI**
Creative Team: **KEVIN BUDELMANN, BRIAN HAUCH, TIM CALKINS**
Client: **1TO3.ORG**

Creative Firm: **ORIGINAL IMPRESSIONS — MIAMI, FL**
Creative Team: **FRANK IRIAS**
Client: **VILLAS AT JASMINE PARK**

Creative Firm: **HELENA SEO DESIGN — SUNNYVALE, CA**
Client: **VIVENDI DEVELOPMENT**

Creative Firm: **BETH SINGER DESIGN — ARLINGTON, VA**
Creative Team: **BETH SINGER, SUCHA SNIDVONGS**
Client: **PARTNERSHIP FOR JEWISH LIFE AND LEARNING (PJLL)**

Creative Firm: **RULE29 — GENEVA, IL**
Creative Team: **JUSTIN AHERNS, KERRI LIU**
Client: **AGROPURE**

Creative Firm: **GREEN CAT DZINE — ISSAQUAH, WA**
Creative Team: **ELISABETH RUMPELSBERGER**
Client: **HJORTEN GROUP**

Creative Firm: **A3 DESIGN — CHARLOTTE, NC**
Creative Team: **ALAN ALTMAN, AMANDA ALTMAN**
Client: **CROWN COMMUNICATIONS**

Creative Firm: **ORIGINAL IMPRESSIONS — MIAMI, FL**
Creative Team: **FRANK IRIAS**
Client: **YACHTSMAN'S COVE**

Creative Firm: **LIBBY PERSZYK KATHMAN — CINCINNATI, OH**
Creative Team: **PETER BOROWSKI, ANNELLE STOTZ**
Client: **CINCINNATI ART MUSEUM**

Creative Firm: **LISKA + ASSOCIATES — CHICAGO, IL**
Creative Team: **STEVE LISKA**
Client: **JOHN MICHAEL KOHLER ARTS CENTER**

Creative Firm: **CRABTREE & COMPANY — FALLS CHURCH, VA**
Creative Team: **SUSAN ANGRISANI, JOE VELASQUEZ**
Client: **EVENTOLOGY, LLC**

Creative Firm: **ORIGINAL IMPRESSIONS — MIAMI, FL**
Creative Team: **FRANK IRIAS**
Client: **UNION CHARTER**

Creative Firm: **DESIGN OBJECTIVES PTE LTD — SINGAPORE**
Creative Team: **RONNIE S C TAN**
Client: **SHERATON TAIPEI HOTEL**

Creative Firm: **CONNIE HWANG DESIGN — GAINESVILLE, FL**
Creative Team: **CONNIE HWANG**
Client: **YOUSENDIT**

Creative Firm: **MCMILLIAN DESIGN — BROOKLYN, NY**
Creative Team: **WILLIAM MCMILLIAN**
Client: **JASON RICHELSON**

Creative Firm: **HORNALL ANDERSON DESIGN WORKS — SEATTLE, WA**
Creative Team: **JACK ANDERSON, LARRY ANDERSON, HOLLY CRAVEN, JAY HILBURN, CHRIS FREED**
Client: **COLD STANDARD**

Creative Firm: **DESIGN OBJECTIVES PTE LTD — SINGAPORE**
Creative Team: **RONNIE S C TAN**
Client: **BEAUFORT SENTOSA DEVELOPMENT PTE LTD**

Creative Firm: **FUTUREBRAND — NEW YORK, NY**
Creative Team: **DIEGO KOLSKY, MIKE WILLIAMS, CHERYL HILLS, BRENDAN O'NEILL, SAMAR SAMUEL, RITA PINTO**
Client: **DUBAI AEROSPACE ENTERPRISE**

Creative Firm: **PLUMBLINE STUDIOS, INC — NAPA, CA**
Creative Team: **DOM MORECI**
Client: **ON THE HOOK RECORDINGS**

Creative Firm: **HORNALL ANDERSON DESIGN WORKS — SEATTLE, WA**
Creative Team: **JACK ANDERSON, JAMES TEE, ANDREW WICKLUND, ELMER DELA CRUZ, HOLLY CRAVEN, JAY HILBURN**
Client: **WEYERHAEUSER CORP.**

Creative Firm: **GREENFIELD/BELSER LTD. — WASHINGTON, DC**
Creative Team: **BURKEY BELSER, JONATHAN BRUNS, ALYSON FIELDMAN**
Client: **CAMELLIA HOME HEALTH & HOSPICE**

Creative Firm: **VSA PARTNERS, INC. — CHICAGO, IL**
Creative Team: **CURT SCHREIBER, STEVE RYAN, ASHLEY LIPPARD, SILAS MUNRO, WENDY BELT,**
Client: **IBM CORPORATION**

BELLA TUNNO

Creative Firm: **KELLY BREWSTER,**
— **CHARLOTTE, NC**
Creative Team: **KELLY BREWSTER**
Client: **BELLA TUNNO LLC**

Creative Firm: **SUBSTANCE — CHICAGO, IL**
Creative Team: **MATTHEW BRETT**
Client: **LAKEWOOD REHABILITATION CENTER**

Creative Firm: **HORNALL ANDERSON DESIGN WORKS**
— **SEATTLE, WA**
Creative Team: **JACK ANDERSON, ANDREW WICKLUND,**
LEO RAYMUNDO, JOHN ANICKER, HOLLY CRAVEN
Client: **SCHNITZER NORTHWEST**

Creative Firm: **WHET DESIGN, INC. — NEW YORK, NY**
Creative Team: **CHERYL OPPENHEIM**
Client: **LORELEI ENTERPRISES & EVENTS**

Creative Firm: **ADVANTAGE LTD**
— **HAMILTON, BERMUDA**
Creative Team: **SUSAN TANG-PETERSEN**
Client: **THE PROPERTY GROUP LTD.**

Creative Firm: **CROXSON DESIGN — HOUSTON, TX**
Creative Team: **STEPHEN CROXSON, RICHARD BYRD**
Client: **M.D. ANDERSON CANCER CENTER**

Creative Firm: **DESIGN OBJECTIVES PTE LTD**
— **SINGAPORE**
Creative Team: **RONNIE S C TAN**
Client: **PEARL ENERGY LIMITED**

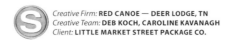

Creative Firm: **RED CANOE — DEER LODGE, TN**
Creative Team: **DEB KOCH, CAROLINE KAVANAGH**
Client: **LITTLE MARKET STREET PACKAGE CO.**

Creative Firm: **DESIGN OBJECTIVES PTE LTD — SINGAPORE**
Creative Team: **RONNIE S C TAN**
Client: **SHERATON TAIPEI HOTEL**

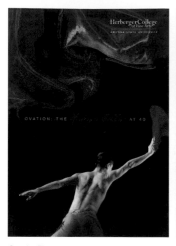

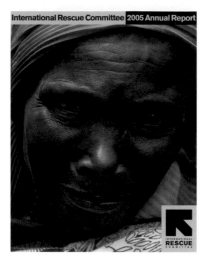

Creative Firm: **HERBERGER COLLEGE OF FINE ARTS — TEMPE, AZ**
Creative Team: **AMY NG, LAURA TOUSSAINT, TRACEY BENSON, STACEY SHAW**
Client: **HERBERGER COLLEGE OF FINE ARTS**

Creative Firm: **EMERSON, WAJDOWICZ STUDIOS — NEW YORK, NY**
Creative Team: **JUREK WAJDOWICZ , LISA LAROCHELLE, MANNY MENDEZ, STEVEN MANNING, PETER BIRO, SCOTT ANGER AND OTHERS**
Client: **INTERNATIONAL RESCUE COMMITTEE**

Creative Firm: **TAYLOR DESIGN — STAMFORD, CT**
Creative Team: **MARLE BARRETT, LARRY KAUFMAN, ROB WALLACE, DAN TAYLOR**
Client: **KEEP AMERICA BEAUTIFUL**

Creative Firm: **ADDISON — NEW YORK, NY**
Creative Team: **DAVID KOHLER, MIHO NISHIMANIWA**
Client: **GATX**

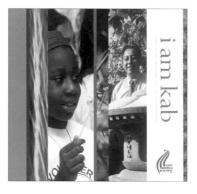

Creative Firm: **HULL CREATIVE GROUP — BROOKLINE, MA**
Creative Team: **CARYL H. HULL, AMY BRADDOCK, RUSS SHLEIPMAN**
Client: **DYAX**

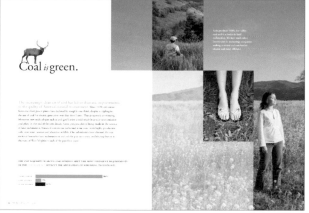

Creative Firm: **KOLBRENER INC. — PITTSBURGH, PA**
Creative Team: **MICHAEL KOLBRENER, DECK SLONE, KIM LINK, KIRK LITTELL**
Client: **ARCH COAL INC.**

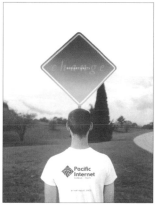

Creative Firm: DEVON ENERGY - IN HOUSE
— OKLAHOMA CITY, OK
Creative Team: **TIM LANGENBERG, ZACK HAGAR,
SHEA SNYDER, CHIP MINTY, SCOTT RAFFE**
Client: **DEVON ENERGY CORPORATION**

Creative Firm: **Q-PLUS DESIGN PTE LTD. — SINGAPORE**
Creative Team: **DILLON J., MARK SIDWELL**
Client: **PACIFIC INTERNET LIMITED**

Creative Firm: **RWI — NEW YORK, NY**
Creative Team: **MICHAEL DEVOURSNEY, ROBERT WEBSTER**
Client: **VNU**

Creative Firm: **DESIGN OBJECTIVES PTE LTD — SINGAPORE**
Creative Team: **RONNIE S C TAN**
Client: **SP CHEMICALS LTD**

Creative Firm: **CREDENCE PARTNERSHIP PTE LTD**
— SINGAPORE
Creative Team: **FRANCIS SKG, RESHMA, STEPHEN**
Client: **MULTIVISION INTELLIGENT SURVEILLANCE**
LIMITED

Creative Firm: **GRAPHICAT LTD. — WANCHAI, HONG KONG**
Creative Team: **COLIN TILLYER**
Client: **NOBLE GROUP LTD.**

Creative Firm: **Q-PLUS DESIGN PTE LTD. — SINGAPORE**
Creative Team: **DILLON J., LI SAR SNG**
Client: **LOW KENG HUAT LTD.**

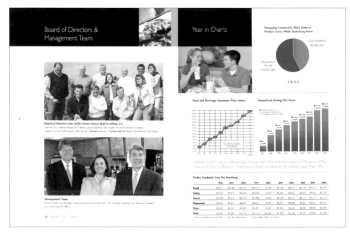

Creative Team: **ORIGINAL IMPRESSIONS — MIAMI, FL**
Art directors: **LISA CUERVO**
Client: **IPC**

Creative Firm: **GODBE COMMUNICATIONS**
— HALF MOON BAY, CA
Client: **LUCILE PACKARD CHILDREN'S HOSPITAL**

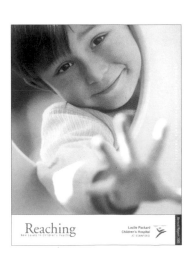

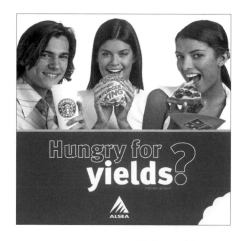

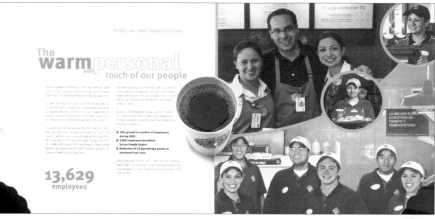

Creative Team: **SIGNI — MEXICO CITY, D.F., MEXICO**
Art directors: **RENE GALINDO, PABLO GARCIA**
Client: **ALSEA**

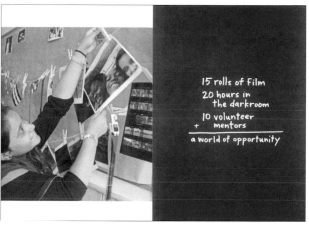

Creative Firm: **SUKA DESIGN — NEW YORK, NY**
Creative Team: **MARIA BELFIORE**
Client: **THE FRESH AIR FUND**

Creative Firm: **Q-PLUS DESIGN PTE LTD. — SINGAPORE**
Creative Team: **DILLON J., MARK SIDWELL**
Client: **SINGAPORE AIRPORT TERMINAL SERVICE LTD.**

 Creative Firm: **VSA PARTNERS, INC. — CHICAGO, IL**
Creative Team: **CURT SCHREIBER, STEVE RYAN, JEN ORTH,**
MICHAEL FREIMUTH, AZURE DAVIS, RICHARD RENNO
Client: **IBM CORPORATION**

Creative Team: **BCN COMMUNICATIONS**
— CHICAGO, IL
Art directors: **CARA CARPENTER, JAMES PITROSKI,**
MICHAEL NEU, JAMES SCHNEPF, TED STOIK
Client: **HNI CORPORATION**

Creative Firm: **MEDIACONCEPTS CORPORATION — ASSONET, MA**
Creative Team: **MEDIACONCEPTS CORPORATION, GREG DOBOS**
Client: **OCEAN SPRAY**

Creative Firm: **PARAGRAPHS DESIGN — CHICAGO, IL**
Creative Team: **JIM CHILCUTT, ROBIN ZVONEK**
Client: **HOSPIRA**

Creative Firm: **SIGNI — MEXICO CITY, D.F., MEXICO**
Creative Team: **DANIEL CASTELAO, ODETTE EDWARDS**
Client: **WAL-MART MEXICO**

Creative Firm: **TAYLOR & IVES INCORPORATED — NEW YORK, NY**
Creative Team: **ALISA ZAMIR, PAMELA BROOKS**
Client: **THE READER'S DIGEST ASSOCIATION, INC.**

Creative Firm: **ADDISON — NEW YORK, NY**
Creative Team: **DAVID KOHLER, JASON MILLER**
Client: **SL GREEN REALTY CORP.**

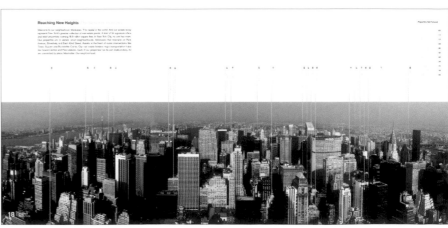

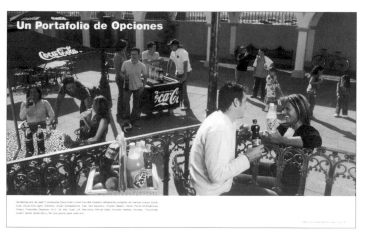

Creative Firm: **PARAGRAPHS DESIGN — CHICAGO, IL**
Creative Team: **DORA RODRIGUEZ, RACHEL RAPTKE, ROBIN ZVONEK**
Client: **COCA-COLA FEMSA**

Creative Firm: **DEVER DESIGNS — LAUREL, MD**
Creative Team: **JEFFREY DEVER, KIM POLLOCK**
Client: **SOCIETY FOR NEUROSCIENCE**

Creative Firm: **PARSONS BRINCKERHOFF
— NEW YORK, NY**
Creative Team: **ANA TIBURCIO-RIVERA,
SUSAN WALSH**
Client: **PARSONS BRINCKERHOFF**

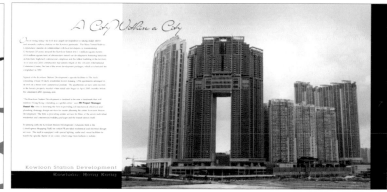

Creative Firm: **MEDIACONCEPTS CORPORATION
— ASSONET, MA**
Creative Team: **MEDIACONCEPTS CORPORATION,
GREG DOBOS**
Client: **SEPRACOR**

Creative Firm: **ALL MEDIA PROJECTS LIMITED
— PORT OF SPAIN, TRINIDAD AND TOBAGO**
Creative Team: **SHELLEY HOSEIN, ANTHONY MOORE,
DEBBIE GARRAWAY, JULIEN GREENIDGE,
CARIBBEAN PAPER AND PRINTED PRODUCTS (1993) LTD ,**
Client: **CLICO**

Creative Firm: **COATES AND COATES** — **NAPERVILLE, IL**
Creative Team: **CAROLIN COATES, RON COATES, JAMES SCHNEPF, STEVEN MCDONALD, ANDY GOODWIN**
Client: **SARA LEE CORPORATION**

Creative Firm: **MAD DOG GRAPHX** — **ANCHORAGE, AK**
Creative Team: **KRIS RYAN CLARKE**
Client: **ALASKA COMMUNITY FOUNDATION**

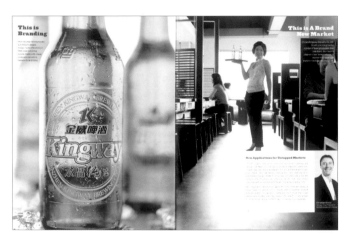

Creative Firm: **ADDISON** — **NEW YORK, NY**
Creative Team: **RICHARD COLBOURNE, JASON MILLER**
Client: **AVERY DENNISON**

Creative Firm: **MEDIACONCEPTS CORPORATION** — **ASSONET, MA**
Creative Team: **MEDIACONCEPTS CORPORATION, GREG DOBOS**
Client: **CRITICAL THERAPEUTICS, INC.**

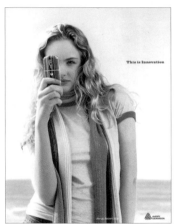

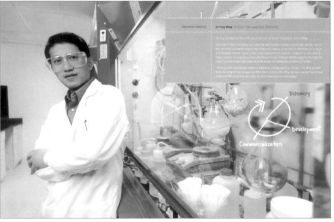

Creative Firm: **DESIGN OBJECTIVES PTE LTD** — **SINGAPORE**
Creative Team: **RONNIE S C TAN**
Client: **BEAUTY CHINA HOLDINGS LIMITED**

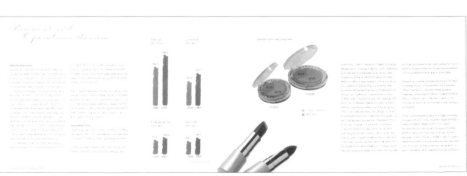

UNDERSTANDING OUR COMPANY
AN IBM PROSPECTUS

IBM ANNUAL REPORT
2008

Creative Firm: **VSA PARTNERS, INC. — CHICAGO, IL**
Creative Team: **CURT SCHREIBER, STEVE RYAN, ASHLEY LIPPARD, WENDY BELT, SILAS MUNRO, RICHARD RENNO**
Client: **IBM CORPORATION**

ON 8 AUGUST 2008,
THE WORLD WILL......

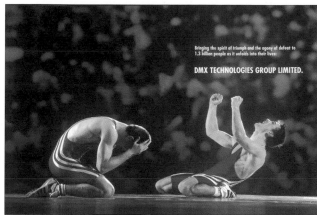

Bringing the spirit of triumph and the agony of defeat to 1.3 billion people as it unfolds into their lives:

DMX TECHNOLOGIES GROUP LIMITED.

Creative Firm: **Q-PLUS DESIGN PTE LTD. — SINGAPORE**
Creative Team: **DILLON J., MARK SIDWELL**
Client: **DMX TECHNOLOGIES GROUP LIMITED**

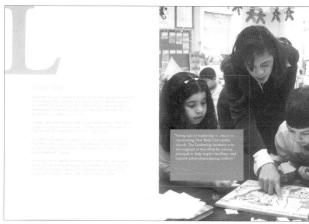

Creative Firm: **SUKA DESIGN — NEW YORK, NY**
Creative Team: **LOLA BERNABE**
Client: **THE FUND FOR PUBLIC SCHOOL**

Creative Firm: **ADDISON — NEW YORK, NY**
Creative Team: **DAVID KOHLER, CHRISTINA ANTONOPOULOS**
Client: **GENWORTH FINANCIAL**

Creative Firm: **SIGNI — MEXICO CITY, D.F., MEXICO**
Creative Team: **RENE GALINDO**
Client: **CEMEX**

growing
ON

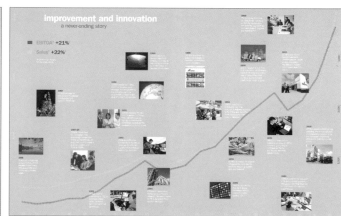

improvement and innovation
a never-ending story

EBITDA⁺ +21%
Sales⁺ +22%

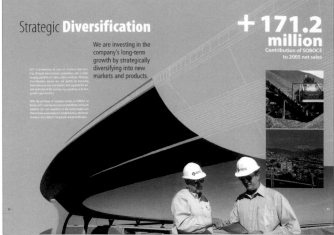

Creative Firm: **EMERSON, WAJDOWICZ STUDIOS**
— NEW YORK, NY
Creative Team: **LISA LAROCHELLE, JUREK WAJDOWICZ,**
YOKO YOSHIDA, TRICKLE UP PROGRAM
Client: **TRICKLE UP PROGRAM**

Creative Firm: **SIGNI — MEXICO CITY, D.F., MEXICO**
Creative Team: **DANIEL CASTELAO, PABLO GARCIA**
Client: **GRUPO CEMENTOS DE CHIHUAHUA**

Creative Firm: **PARAGRAPHS DESIGN — CHICAGO, IL**
Creative Team: **DORA RODRIGUEZ, RACHEL RADKE,**
ROBIN ZVONEX
Client: **ALLSCRIPTS**

Creative Firm: **KAN & LAU DESIGN CONSULTANTS**
— KOWLOON TONG, HONG KONG
Creative Team: **FREEMAN LAU SIU HONG,**
KO SI HONG, JAN HAU
Client: **ROADSHOW HOLDINGS LTD.**

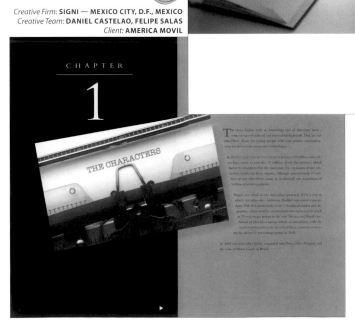

Creative Firm: **SIGNI — MEXICO CITY, D.F., MEXICO**
Creative Team: **DANIEL CASTELAO, FELIPE SALAS**
Client: **AMERICA MOVIL**

Creative Firm: **EMERSON, WAJDOWICZ STUDIOS— NEW YORK, NY**
Creative Team: **L. LAROCHELLE,
J. WAJDOWICZ,
Y. YOSHIDA,
M. MENDEZ ,
P. PETTERSSON,
R. HAVIV,
B. STEVENS,
P. BONET,
S. BOELSCH
AND OTHERS**
Client: **MÉDECINS SANS FRONTIÈRES /
DOCTORS WITHOUT BORDERS**

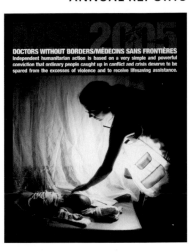

Creative Firm: **PARAGRAPHS DESIGN — CHICAGO, IL**
Creative Team: **MEOW VATANATUMRAK,
RACHEL RADTKE, CARY MARTIN**
Client: **SUNTRUST BANKS, INC.**

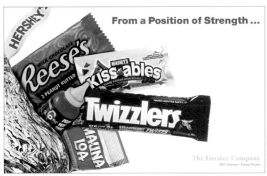

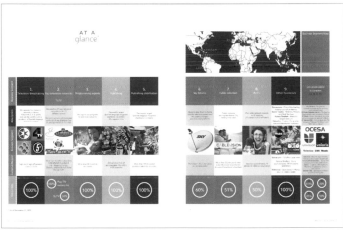

Creative Firm: **SIGNI — MEXICO CITY, D.F., MEXICO**
Creative Team: **RENE GALINDO, ODETTE EDWARDS**
Client: **TELEVISA**

Creative Firm: **TAYLOR & IVES INCORPORATED — NEW YORK, NY**
Creative Team: **ALISA ZAMIR, TREVOR PACCIONE**
Client: **THE HERSHEY COMPANY**

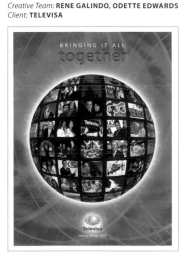

Creative Firm: **BCN COMMUNICATIONS — CHICAGO, IL**
Creative Team: **MICHAEL O'BRIEN,
HARRI BOLLER, MICHAEL NEU,
ROTH & RAMBERG PHOTOGRAPHY ,
TED STOIK**
Client: **CN**

Creative Firm: **SUKA DESIGN — NEW YORK, NY**
Creative Team: **BRIAN WONG**
Client: **GAY, LESBIAN, AND STRAIGHT EDUCATION NETWORK**

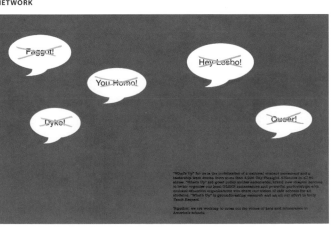

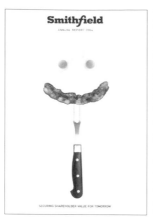
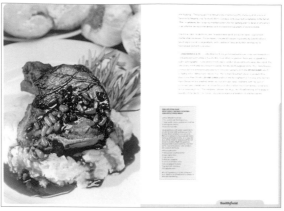

 Creative Firm: **TAYLOR & IVES INCORPORATED — NEW YORK, NY**
Creative Team: **ALISA ZAMIR, DANIEL CASPESCHA**
Client: **SMITHFIELD FOODS, INC.**

Creative Firm: **VOICEBOX CREATIVE — SAN FRANCISCO, CA**
Creative Team: **JACQUES ROSSOUW, MARK TUSCHMAN, SUSAN SHARPE**
Client: **PALO ALTO MEDICAL FOUNDATION**

Creative Firm: **PHOENIX CREATIVE GROUP, LLC — POTOMAC FALLS, VA**
Creative Team: **NICOLE KASSOLIS, SEAN MULLINS, C&R PRINTING, JUPITER IMAGES, AGE FOTOSTOCK, MASTERFILE, PICTUREQUEST**
Client: **ICI MUTUAL**

Creative Firm: **SILVER COMMUNICATIONS INC — NEW YORK, NY**
Creative Team: **GREGG SIBERT, CHRISTINA WEISSMAN**
Client: **EAST MIDTOWN ASSOCIATION**

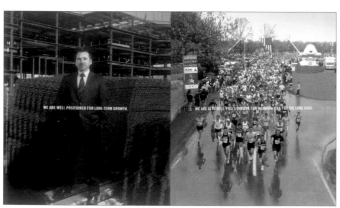

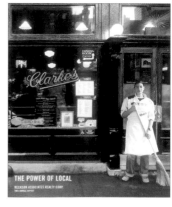

Creative Firm: **ADDISON — NEW YORK, NY**
Creative Team: **RICHARD COLBOURNE, BRYONY GOMEZ-PALACIO**
Client: **RECKSON ASSOCIATES REALTY CORP.**

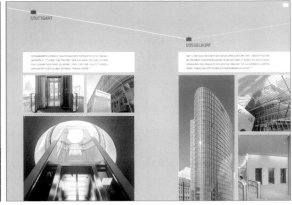

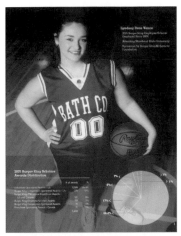

 Creative Firm: **RTS RIEGER TEAM WERBEAGENTUR GMBH — DÜSSELDORF, GERMANY**
Creative Team: **MICHAELA MÜLLER, VEREUA TRURNIT, ULRICH GIELISCH, FRANCISCO NAVARRO Y GOMES**
Client: **THYSSENKRUPP ELEVATOR AG**

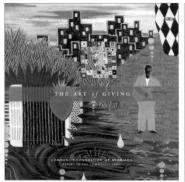

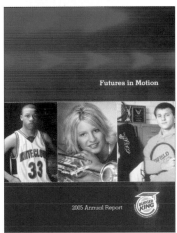

Creative Team: **KATE FERRY, RAYMOND HEBERT**
Client: **COMMUNITY FOUNDATION OF ACADIANA**

Creative Firm: **ORIGINAL IMPRESSIONS
— MIAMI, FL**
Creative Team: **LISA CUERVO**
Client: **BURGER KING/MCLAMORE FOUNDATION**

Creative Firm: **THE DESIGN STUDIO
AT KEAN UNIVERSITY— UNION, NJ**
Creative Team: **ANIA MURRAY, ERIN SMITH**
Client: **KEAN UNIVERSITY FOUNDATION**

Creative Firm: **ADDISON — NEW YORK, NY**
Creative Team: **DAVID KOHLER, RICK SLUSHER**
Client: **ENGELHARD**

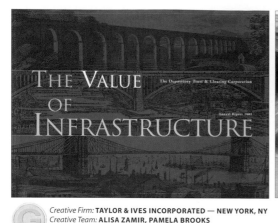

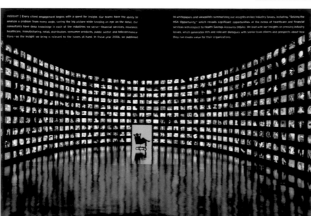

Creative Firm: **TAYLOR & IVES INCORPORATED — NEW YORK, NY**
Creative Team: **ALISA ZAMIR, PAMELA BROOKS**
Client: **THE DEPOSITORY TRUST & CLEARING CORPORATION**

Creative Firm: **PARAGRAPHS DESIGN — CHICAGO, IL**
Creative Team: **MEOW VATANATUMRAK, RACHEL RADTKE**
Client: **DIAMOND**

Creative Firm: **EMERSON, WAJDOWICZ STUDIOS — NEW YORK, NY**
Creative Team: **JUREK WAJDOWICZ, LISA LAROCHELLE, MANNY MENDEZ, JONAS BENDIKSEN**
Client: **THE ROCKEFELLER FOUNDATION**

Creative Firm: ADDISON — NEW YORK, NY
Creative Team: **DAVID KOHLER, BRYONY GOMEZ-PALACIO**
Client: AES CORPORATION

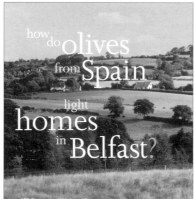

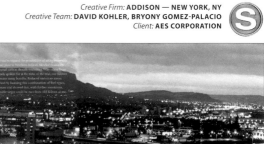

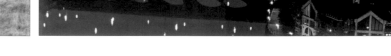

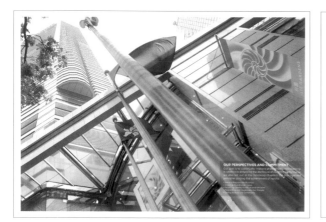

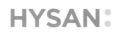

Creative Firm: **KAN & LAU DESIGN CONSULTANTS — KOWLOON TONG, HONG KONG**
Creative Team: **KAN TAI-KEUNG, CARMEN KWOK, JUSTIN YU**
Client: **HYSAN DEVELOPMENT CO. LTD.**

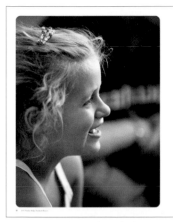

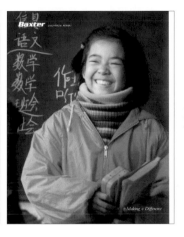

2005 Highlights

Creative Firm: **KOLBRENER INC. — PITTSBURGH, PA**
Creative Team: **MICHAEL KOLBRENER, YVONNE ROEBUCK**
Client: **PRESSLEY RIDGE**

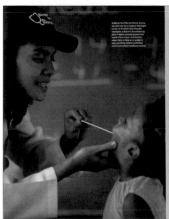

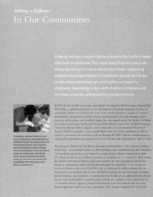

Creative Firm: **PARAGRAPHS DESIGN — CHICAGO, IL**
Creative Team: **MEOW VATANATUMRAK, ROBIN ZVONEK**
Client: **BAXTER INTERNATIONAL INC.**

Creative Firm: **TAYLOR & IVES INCORPORATED — NEW YORK, NY**
Creative Team: **ALISA ZAMIR, DANIEL CASPESCHA**
Client: **BLACKROCK**

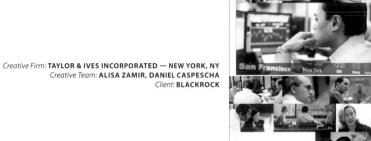

Creative Firm: **HENRYGILL ADVERTISING — DENVER, CO**
Creative Team: **BRYANT FERNANDEZ**
Client: **BLACK HILLS CORPORATION**

Creative Firm: **GRAPHICAT LTD. — WANCHAI, HONG KONG**
Creative Team: **COLIN TILLYER**
Client: **ASIA SATELLITE TELECOMMUNICATIONS HOLDINGS LTD.**

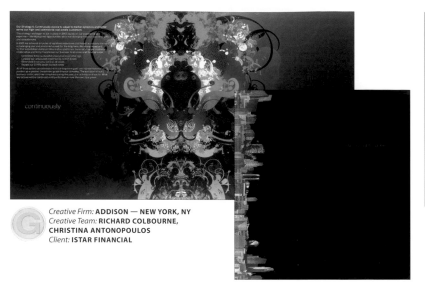

sustainability
Our planet, our communities

Creative Firm: **ADDISON — NEW YORK, NY**
Creative Team: **RICHARD COLBOURNE,**
CHRISTINA ANTONOPOULOS
Client: **ISTAR FINANCIAL**

Creative Firm: **COATES AND COATES — NAPERVILLE, IL**
Creative Team: **CAROLIN COATES, RON COATES**
Client: **PROLOGIS**

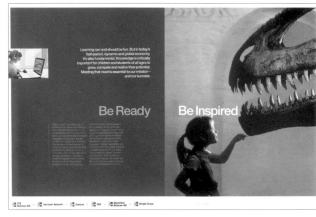

Creative Firm: **ADDISON — NEW YORK, NY**
Creative Team: **DAVID KOHLER, RICK SLUSHER**
Client: **THE MCGRAW-HILL COMPANIES, INC.**

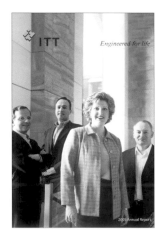

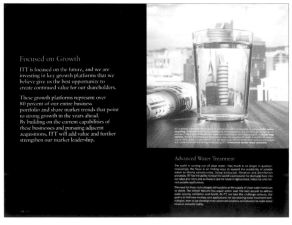

Creative Firm: **ADDISON — NEW YORK, NY**
Creative Team: **RICHARD COLBOURNE, JASON MILLER**
Client: **ITT**

Creative Firm: **HERMAN MILLER, INC. — ZEELAND, MI**
Creative Team: **STEVE FRYKHOLM, ANDREW DULL,**
CLARK MALCOLM, MARLENE CAPOTOSTO
Client: **HERMAN MILLER, INC.**

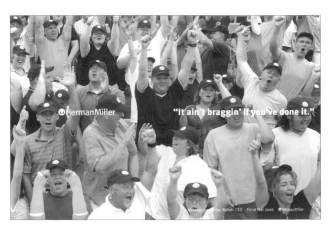

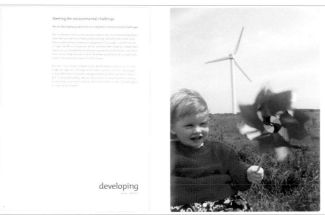

Creative Firm: **PARAGRAPHS DESIGN — CHICAGO, IL**
Creative Team: **JIM CHILCUTT, ROBIN ZVONEK**
Client: **EXELON CORPORATION**

Creative Firm: **COATES AND COATES
— NAPERVILLE, IL**
Creative Team: **CAROLIN COATES, RON COATES,
TED STOIK**
Client: **MOLSON COORS BREWING COMPANY**

Creative Firm: **ORIGINAL IMPRESSIONS — MIAMI, FL**
Creative Team: **LISA CUERVO**
Client: **BURGER KING/MCLAMORE FOUNDATION**

Creative Firm: **ERWIN ZINGER GRAPHIC DESIGN — GRONINGEN, NETHERLANDS**
Creative Team: **ERWIN ZINGER, DESIRÉE DIJKSTRA, TEACKELE SOEPBOER**
Client: **N.V. NEDERLANDSE GASUNIE**

Creative Firm: **SIGNI — MEXICO CITY, D.F., MEXICO**
Creative Team: **RENE GALINDO, FELIPE SALAS**
Client: **CASAS GEO**

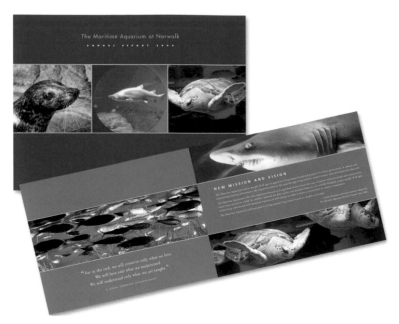

Creative Firm: **COASTLINES CREATIVE GROUP — VANCOUVER, BC, CANADA**
Creative Team: **BYRON DOWLER, MICHAEL SINANAN, ERIK PROSSER, KAREN SPEIRS**
Client: **CHROMOS MOLECULAR SYSTEMS**

Creative Firm: **TOM FOWLER, INC. — NORWALK, CT**
Creative Team: **ELIZABETH P. BALL, BRIEN O'REILLY, THOMAS G. FOWLER**
Client: **THE MARITIME AQUARIUM AT NORWALK**

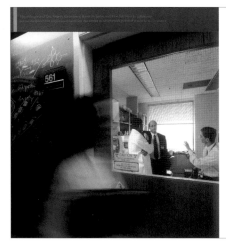

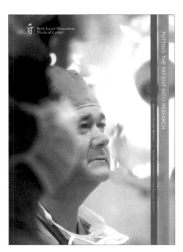

Creative Firm: **KOR GROUP — BOSTON, MA**
Creative Team: **ANNE CALL, JIM GIBSON, LEN RUBENSTEIN, BETSY CULLEN**
Client: **BETH ISRAEL DEACONESS MEDICAL CENTER**

Creative Firm: **PHOENIX CREATIVE GROUP, LLC — POTOMAC FALLS, VA**
Creative Team: **SEAN MULLINS, NICOLE KASSOLIS, THERESA WALLACE, S&S GRAPHICS**
Client: **AMERICAN WOODWORK CORPORATION**

Creative Firm: **BCN COMMUNICATIONS — CHICAGO, IL**
Creative Team: **JAMES PITROSKI, MICHAEL O'BRIEN, MICHAEL NEU, JAMES SCHNEPF**
Client: **GENERAL MOTORS CORPORATION**

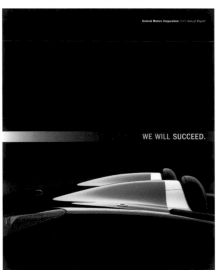

People Unlocking Potential

The BANK of NEW YORK

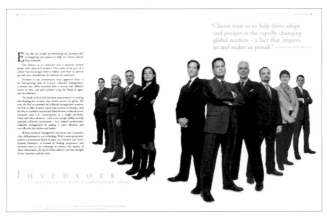

"Clients trust us to help them adapt and prosper in the rapidly changing global markets – a fact that inspires us and makes us proud."

Inventors

Creative Firm: **TAYLOR & IVES INCORPORATED — NEW YORK, NY**
Creative Team: **ALISA ZAMIR, DANIEL CASPESCHA**
Client: **THE BANK OF NEW YORK, INC.**

Creative Firm: **STAN GELLMAN GRAPHIC DESIGN INC. — ST. LOUIS, MO**
Creative Team: **MEGAN MILLER, BARRY TILSON, GREG KIGER, COLLEEN CLEMENTS**
Client: **LABARGE INC.**

FOCUSED ON GROWTH

LaBarge inc

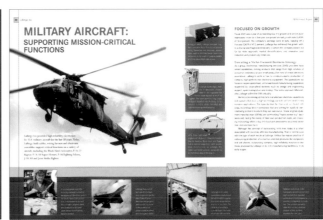

MILITARY AIRCRAFT:
SUPPORTING MISSION-CRITICAL FUNCTIONS

FOCUSED ON GROWTH

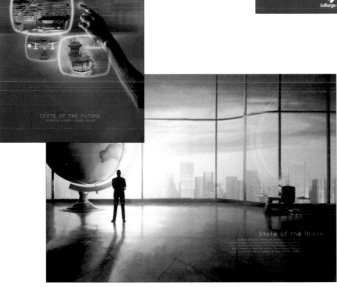

STATE OF THE FUTURE

State of the Union

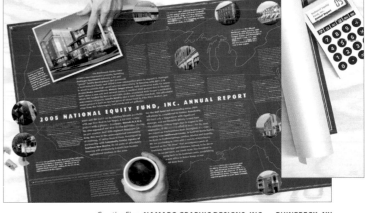

2005 NATIONAL EQUITY FUND, INC. ANNUAL REPORT

Creative Firm: **SPLASH PRODUCTIONS PTE LTD — SINGAPORE**
Creative Team: **TERRY LEE, STANLEY TAP, NORMAN LAI**
Client: **STRATECH SYSTEMS LIMITED**

Creative Firm: **NAMARO GRAPHIC DESIGNS, INC. — RHINEBECK, NY**
Creative Team: **NADINE ROBBINS, WENDY MACOMBER**
Client: **NATIONAL EQUITY FUND INC.**

I'M MORE THAN A PATIENT.

Creative Firm: **SUKA DESIGN — NEW YORK, NY**
Creative Team: **BRIAN WONG, LOLA BERNABE**
Client: **VISITING NURSE SERVICE OF NEW YORK**

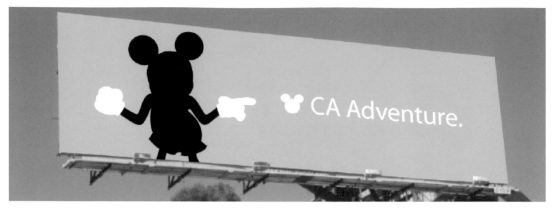

Creative Firm: **MIKE SALISBURY EFFECTIVE CREATIVE STRATEGIES — VENICE, CA**
Creative Team: **MIKE SALISBURY, MATT BRIGHT, GUSTAVO MORAIS**
Client: **DISNEY'S CALIFORNIA ADVENTURE**

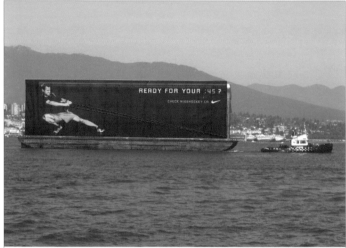

The average hockey shift is :45 seconds. During the NHL lockout, a Nike outdoor campaign showed NHL stars using the city to train and prepare for their shift. Markus Naslund trains for strength by being pulled around Vancouver Harbour by a real resistance band connected to a tugboat.

Creative Firm: **TAXI CANADA INC. — TORONTO, ON, CANADA**
Creative Team: **ZAK MROUEH, LANCE MARTIN, JAIMES ZENTIL, CRAIG MCINTOSH, BRUCE ELLIS, MARK ZIBERT**
Client: **NIKE CANADA**

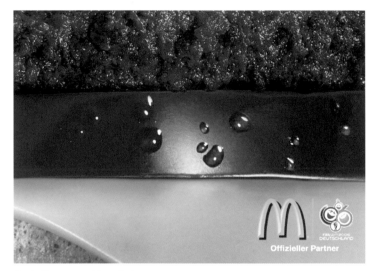

Creative Firm: **HEYE&PARTNER GMBH — UNTERHACHING, BAVARIA, GERMANY**
Creative Team: **JAN WOELFEL, LUKAS BECKER, MARKUS LANGE, MICHAEL STEMPROCK**
Client: **MCDONALD'S GERMANY**

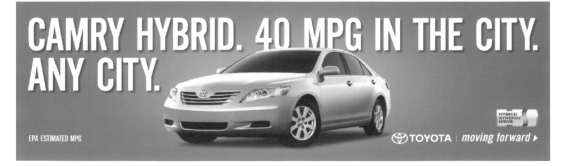

Creative Firm: **HOFFMAN/LEWIS — SAN FRANCISCO, CA**
Creative Team: **SHARON KRINSKY, JAMES CABRAL**
Client: **TOYOTA**

Creative Firm: **HOFFMAN/LEWIS — SAN FRANCISCO, CA**
Creative Team: **SHARON KRINSKY, JAMES CABRAL, RONDA DUNN, JASON HEADLEY**
Client: **HENRY'S**

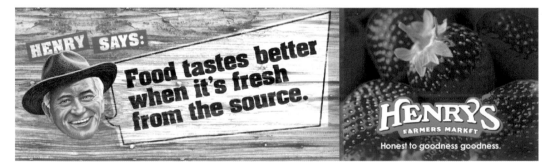

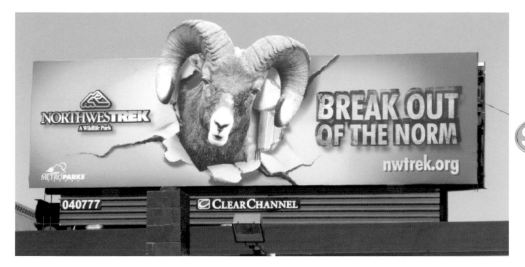

Creative Firm: **RUSTY GEORGE DESIGN — TACOMA, WA**
Creative Team: **RYAN MELINE, RUSTY GEORGE DESIGN**
Client: **NORTHWEST TREK**

Creative Firm: **HOFFMAN/LEWIS — SAN FRANCISCO, CA**
Creative Team: **SHARON KRINSKY, JAMES CABRAL,
RONDA DUNN, JASON HEADLEY**
Client: **HENRY'S**

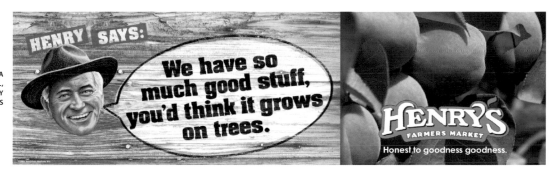

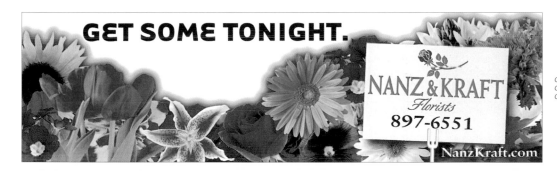

Creative Firm: **CREATIVE ALLIANCE — LOUISVILLE, KY**
Creative Team: **JOE ADAMS, ERIC HAHN, CHRISTINA KNOPF**
Client: **NANZ & KRAFT FLORISTS**

Creative Firm: **YOUNG & RUBICAM GMBH & CO. KG — FRANKFURT AM MAIN,
HESSEN, GERMANY**
Creative Team: **CHRISTIAN DAUL, ULRIKE JOST, ROBIN EBENER**
Client: **COLGATE PALMOLIVE**

Creative Firm: **HEYE&PARTNER GMBH — UNTERHACHING, BAVARIA, GERMANY**
Creative Team: **THOMAS ALEXY, MATTHIAS REMMLING**
Client: **STEPPENWOLF GMBH MOUNTAINBIKES**

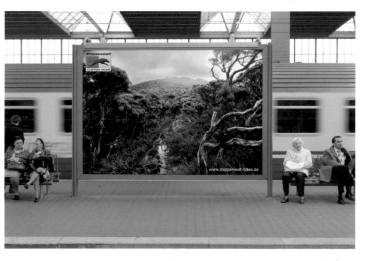

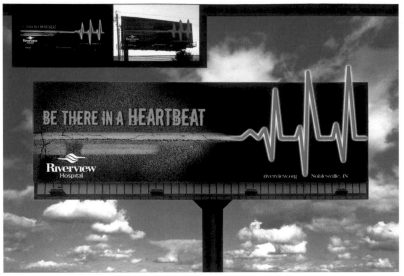

Creative Firm: **KELLER CRESCENT — EVANSVILLE, IN**
Creative Team: **RANDALL ROHN, LEE BRYANT**
Client: **RIVERVIEW HOSPITAL**

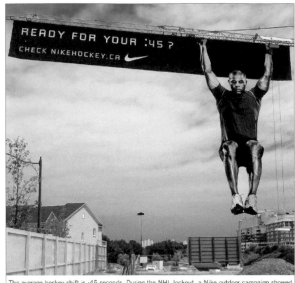

The average hockey shift is :45 seconds. During the NHL lockout, a Nike outdoor campaign showed NHL stars using the city to train and prepare for their shift. A crane erected alongside a major motorway shows a larger than life Jarome Iginla training for strength by doing leg lifts.

Creative Firm: **TAXI CANADA INC. — TORONTO, ON, CANADA**
Creative Team: **ZAK MROUEH, LANCE MARTIN, JAIMES ZENTIL, CRAIG MCINTOSH, BRUCE ELLIS, MARK ZIBERT**
Client: **NIKE CANADA**

Creative Firm: **HEYE&PARTNER GMBH — UNTERHACHING, BAVARIA, GERMANY**
Creative Team: **HANNES CIATTI, GUNNAR IMMISCH, JAN OKUSLUK, OLIVER DIEHR**
Client: **HENKEL/PATTEX POWERTAPE**

Creative Firm: **YELLOW SHOES CREATIVE WEST, DISNEYLAND RESORT — ANAHEIM, CA**
Creative Team: **SCOTT STARKEY, MARTY MULLER, JACQUELYN MOE, WES CLARK JIM ST. AMANT**
Client: **DISNEYLAND RESORT**

Creative Firm: **DISNEYLAND RESORT — ANAHEIM, CA**
Creative Team: **SCOTT STARKEY, MARTY MULLER, JACQUELYN MOE, WES CLARK**
Client: **DISNEYLAND RESORT**

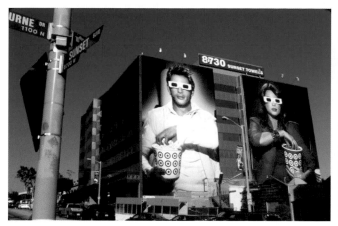

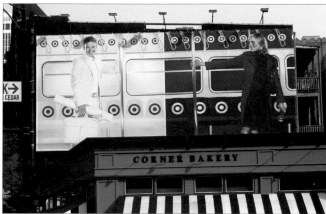

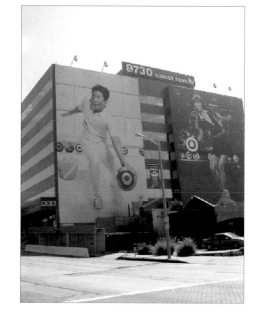

Creative Firm: **PETERSON MILLA HOOKS — MINNEAPOLIS, MN**
Creative Team: **DAVE PETERSON, SUE KAASE, ELLEN FREGO, CATHERINE IRMITER, KENNETH WILLARDT**
Client: **TARGET**

Creative Firm: **DISNEYLAND RESORT — ANAHEIM, CA**
Creative Team: **SCOTT STARKEY, WES CLARK, JANE ROHAN, MARTY MULLER, JACQUELYN MOE**
Client: **DISNEYLAND RESORT**

Creative Firm: **TAXI CANADA — MONTRÉAL, QC, CANADA**
Creative Team: **STÉPHANE CHARIER, PATRICK CHAUBET, BRIAN GILL, ELYSE NOËL DE TILLY, GUILLAUME BLANCHET, BARRY HARRIS**
Client: **REITMANS/CASSIS**

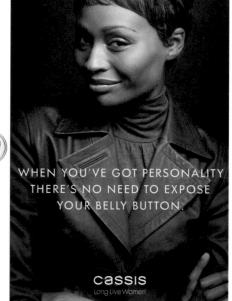

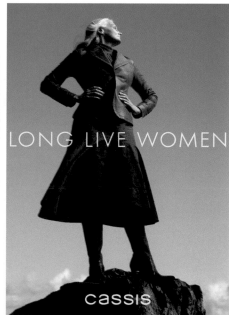

Creative Firm: **YOUNG & RUBICAM GMBH & CO. KG — FRANKFURT AM MAIN, HESSEN, GERMANY**
Creative Team: **CHRISTIAN DAUL, BRUNO PETZ, THOMAS BALZER, MARC WUCHNER**
Client: **CAMPBELL'S GERMANY GMBH**

Creative Firm: **TV LAND — NEW YORK, NY**
Creative Team: **KIM ROSENBLUM, DOMINIQUE VITALI, KEVIN HARTMAN, CHELSEA MOST, MONIQUE SANKEY, TONY D'ORIO**
Client: **TV LAND**

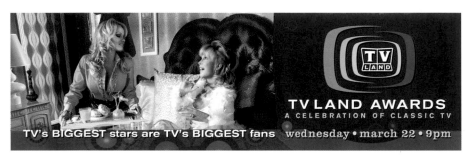

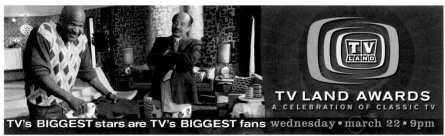

Creative Firm: **YELLOW SHOES CREATIVE WEST, DISNEYLAND RESORT — ANAHEIM, CA**
Creative Team: **SCOTT STARKEY, MARTY MULLER, JACQUELYN MOE, WES CLARK, JIM ST. AMANT, JANE ROHAN**
Client: **DISNEYLAND RESORT**

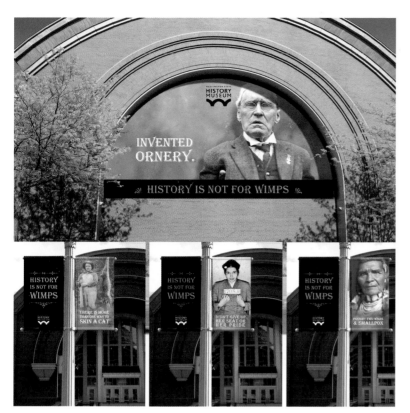

INVENTED ORNERY.

HISTORY IS NOT FOR WIMPS

Creative Firm: **RUSTY GEORGE DESIGN — TACOMA, WA**
Creative Team: **RYAN MELINE**
Client: **WASHINGTON STATE HISTORY MUSEUM**

Sews for the homeless. Mends more than clothes.

VOLUNTEERING

Pass It On.

THE FOUNDATION F.O.R A BETTER LIFE
www.forbetterlife.org

As a student, he was no Einstein.

CONFIDENCE

Pass It On.

THE FOUNDATION F.O.R A BETTER LIFE
www.forbetterlife.org

Oh, when the saints came marchin' in.

CARING

Pass It On.

THE FOUNDATION F.O.R A BETTER LIFE
www.forbetterlife.org

Lost leg, not heart.

OVERCOMING

Pass It On.

THE FOUNDATION F.O.R A BETTER LIFE
www.forbetterlife.org

Creative Firm: **THE FOUNDATION FOR A BETTER LIFE — DENVER, CO**
Creative Team: **BERNIE HOGYA, RON WACHINO, RUSSELL DIXON**
Client: **THE FOUNDATION FOR A BETTER LIFE**

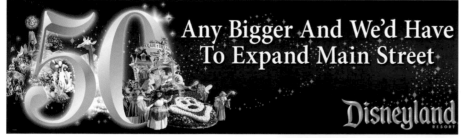

Any Bigger And We'd Have To Expand Main Street

Disneyland RESORT

Creative Firm: **DISNEYLAND RESORT — ANAHEIM, CA**
Creative Team: **SCOTT STARKEY, WES CLARK, JACQUELYN MOE, MARTY MULLER, JIM ST. AMANT**
Client: **DISNEYLAND RESORT**

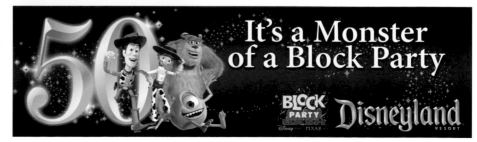

It's a Monster of a Block Party

BLOCK PARTY BASH Disney PIXAR
Disneyland RESORT

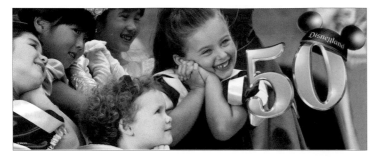

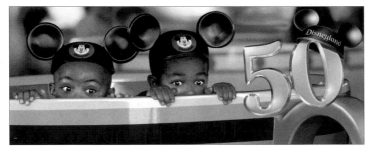

Creative Firm: **LEO BURNETT/YELLOW SHOES CREATIVE WEST, DISNEYLAND RESORT — ANAHEIM, CA**
Creative Team: **SCOTT STARKEY, MARTY MULLER, JACQUELYN MOE, WES CLARK, JIM ST. AMANT**
Client: **DISNEYLAND RESORT**

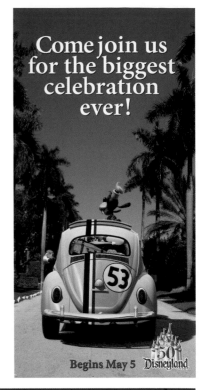

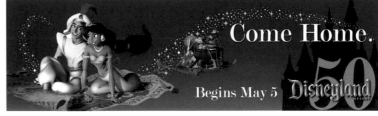

Creative Firm: **YELLOW SHOES CREATIVE WEST, DISNEYLAND RESORT — ANAHEIM, CA**
Creative Team: **DATHAN SHORE, WES CLARK, MARTY MULLER, JACQUELYN MOE, JIM ST. AMANT**
Client: **DISNEYLAND**

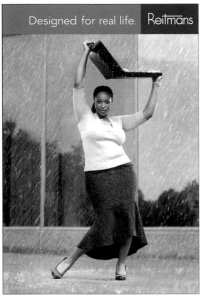

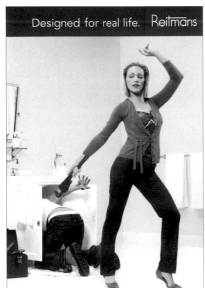

Creative Firm: **TAXI CANADA — MONTRÉAL, QC, CANADA**
Creative Team: **STÉPHANE CHARIER, PATRICK CHAUBET, BRIAN GILL**
Client: **REITMANS**

Creative Firm: **IM-AJ COMMUNICATIONS & DESIGN, INC. — WEST KINGSTON, RI**
Creative Team: **JAMI OUELLETTE, LESLIE EMERT**
Client: **RHODE ISLAND HOUSING**

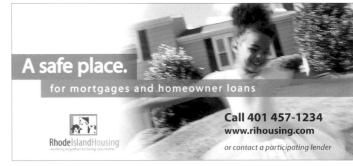

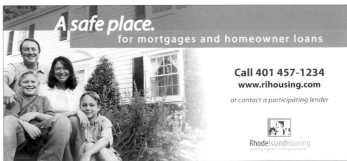

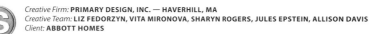

Creative Firm: **PRIMARY DESIGN, INC. — HAVERHILL, MA**
Creative Team: **LIZ FEDORZYN, VITA MIRONOVA, SHARYN ROGERS, JULES EPSTEIN, ALLISON DAVIS**
Client: **ABBOTT HOMES**

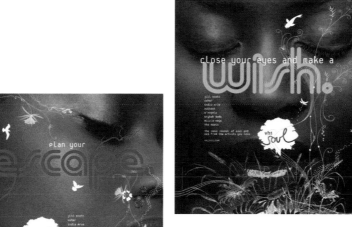

Creative Firm: **VH1 — NEW YORK, NY**
Client: **VH1**

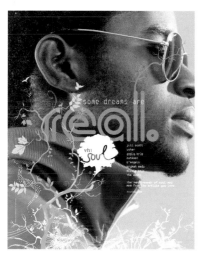

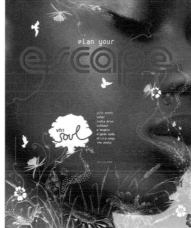

Creative Firm: **RUDER FINN DESIGN — NEW YORK, NY**
Creative Team: **LISA GABBAY, SAL CATANIA, KAVEN LAM, JOHN GRUEN**
Client: **TRANSPLACE**

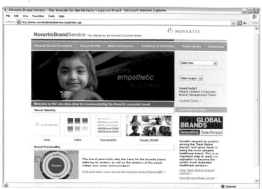

Core Principles & Elements Style Guide

𝌀 NOVARTIS

Caring and curing
At Novartis, we are committed to answering the unmet needs of patients around the world.

Breakthrough medicines are our highest priority — they open up healthcare's frontier and answer unmet needs. But no two patients are exactly alike. That's why at Novartis we go beyond breakthrough medicines to offer disease prevention, generic alternatives and access to medicines.

𝌀 NOVARTIS
Caring and curing

Creative Firm: **RUDER FINN DESIGN — NEW YORK, NY**
Creative Team: **MICHAEL SCHUBERT, LISA GABBAY, SAL CATANIA, DIANA YEO, KEI CHAN, JEEYOON RHEE**
Client: **NOVARTIS**

RiverWalk
at BEDFORD

Ⓢ *Creative Firm:* **PRIMARY DESIGN, INC. — HAVERHILL, MA**
Creative Team: **DAVID VADALA, JULES EPSTEIN**
Client: **ARBORS INDEPENDENT LIVING**

Creative Firm: **PRIMARY DESIGN, INC. — HAVERHILL, MA**
Creative Team: **ALLISON DAVIS, JULES EPSTEIN, KRISTEN LOSSMAN, SHARYN ROGERS, VITA MIRONOVA**
Client: **GILLIS HOMES** Ⓖ

Sept. 8, 2005 -
I can't imagine a more perfect place.

67 acres of rolling hillside on the Ayer/Groton line.
Incredible vistas. Open-concept floorplans
with first floor master suites. Walking trails, storybook pond,
Community Center, amenities galore.
If this isn't the perfect community for Active Adults,
I don't know what is...

Call today! 888-772-0544
Phase II now available starting in the low $300,000's.

AUTUMN·RIDGE
FARM

www.AutumnRidgeFarm.com
Sales Office: *Thurs. — Mon. 12 to 4 or by appt.*

A GILLIS HOMES COMMUNITY

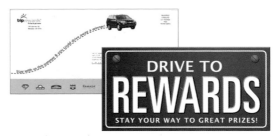

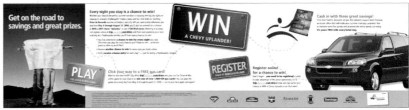

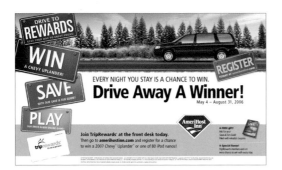

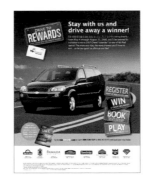

Creative Firm: **CAMPBELL-EWALD** — WARREN, MI
Creative Team: **BILL LUDWIG, SUSAN LOGAR BRODY, RAYMOND ALLSTON, CINNAMON PRITCHARD, BECKY CELESTINI, DANI GUDOWSKI**
Client: **CENDANT TRIPREWARDS**

Creative Firm: **ENGINE, LLC** — SAN FRANCISCO, CA
Creative Team: **LOTUS CHILD, GEOFF SKIGEN**
Client: **MEDJOOL**

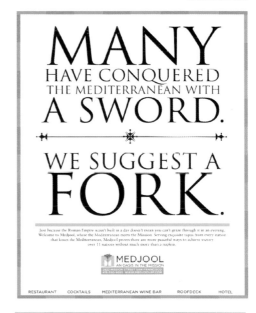

Creative Firm: **STRATEGY ONE** — WOODBUY, MN
Creative Team: **JASON THOMPSON, BRIAN DANAHER, TODD BAXTER, JOHN PHOTOS, SUSAN JENKS**
Client: **HIWIN**

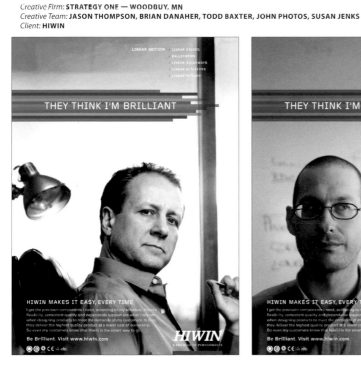

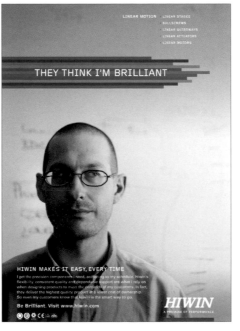

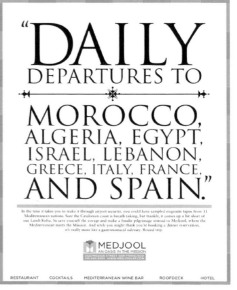

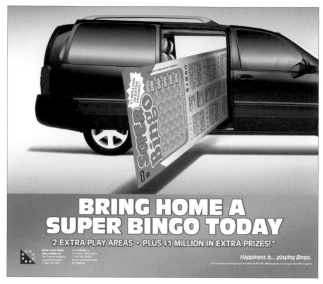

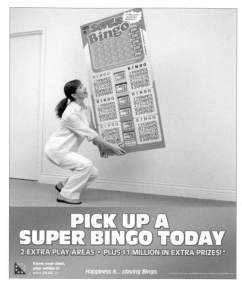

Creative Firm: **BMR (BROOKS MARKETING RESOURCES) — SAULT STE. MARIE, ON, CANADA**
Creative Team: **MARK FALKINS**
Client: **OLG**

Creative Firm: **ALEXANDER MARKETING SERVICES INC. — BUFFALO GROVE, IL**
Creative Team: **TRISH RADAJ, LYNN WIER**
Client: **INITIAL TROPICAL PLANTS**

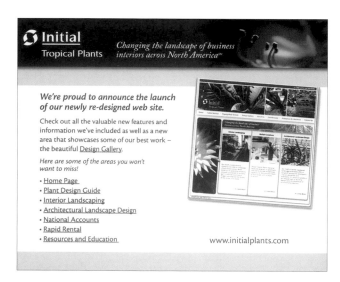

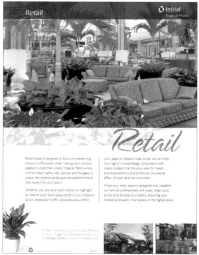

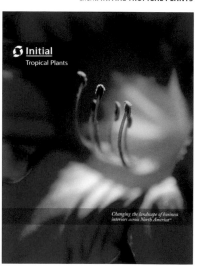

Creative Firm: **INCA TANVIR ADVERTISING — SHARJAH, UNITED ARAB EMIRATES**
Creative Team: **ERNEST DESAI, MAX D'LIMA**
Client: **JASHANMAL NATIONAL COMPANY LLC**

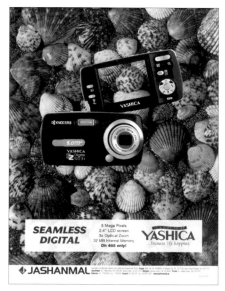

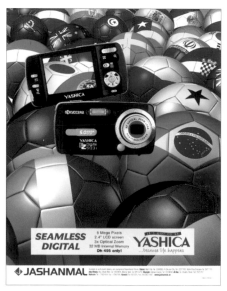

Creative Firm: **PRIMARY DESIGN, INC. — HAVERHILL, MA**
Creative Team: **ALLISON DAVIS, JULES EPSTEIN, DAVID VADALA**
Client: **GLOBAL PROPERTY DEVELOPMENT**

631 East Street, Mansfield, MA 02048 · TEL: 888-261-6685 · www.HeronCrest55.com

Creative Firm: **RUDER FINN DESIGN — NEW YORK, NY**
Creative Team: **LISA GABBAY, SAL CATANIA, DIANA YEO,**
KEI CHAN, EMILY KORSMO, DAVID NICOLAOU
Client: **INTERNATIONAL CENTER OF PHOTOGRAPHY**

Creative Firm: **RUDER FINN DESIGN — NEW YORK, NY**
Creative Team: **LISA GABBAY, SAL CATANIA, JEEYOON RHEE, KEI CHAN**
Client: **CHIRON - A NOVARTIS COMPANY**

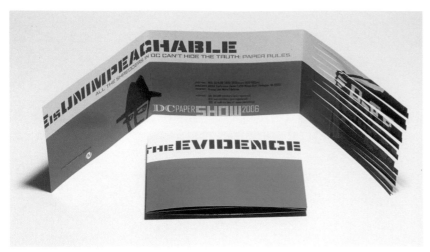

Creative Firm: **DESIGN NUT — KENSINGTON, MD**
Creative Team: **BRENT ALMOND, STEVE SMITH**
Client: **ART DIRECTORS CLUB OF METROPOLITAN WASHINGTON**

Creative Firm: **BUITENKANT ADVERTISING & DESIGN — FLUSHING, NY**
Creative Team: **VAVA BUITENKANT, DEBBIE MCCARTHY, DAN PALLOTTA, JOYCE ANDERSON , RALPH L. CWERMAN, DEENA PLOTKA**
Client: **CONNIE'S BAKERY & GENERAL STORE**

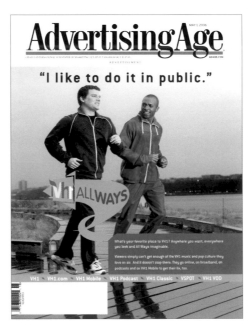

Creative Firm: **VH1 — NEW YORK, NY**
Client: **VH1**

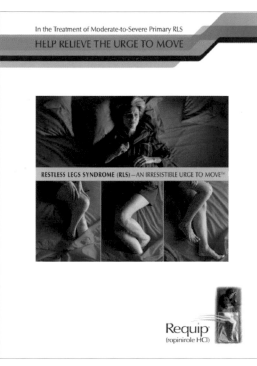

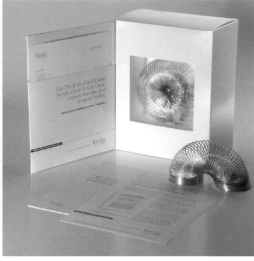

Creative Firm: **BRC MARKETING,INC — DAYTON, OH**
Creative Team: **DOM CIMEI, MARK MARTEL, TERRY NEUBERG, AMBER MOORE, BLAIR BOONE, JIM STONE**
Client: **TERADATA**

Creative Firm: **TORRE LAZUR MCCANN — PARSIPPANY, NJ**
Creative Team: **KRISTY HUSZAR, MARK OPPICI, JAIME SOBOLEWSKI, JENNIFER ALAMPI, MARCIA GODDARD**
Client: **GLAXOSMITHKLINE**

Creative Firm: **KARAKTER LTD — LONDON, UNITED KINGDOM**
Creative Team: **CLIVE ROHALD, MEI WING CHAN, KAM DEVSI, SHAHAR SILBERSHATZ, PIERRE VINSOT**
Client: **CSA CZECH AIRLINES**

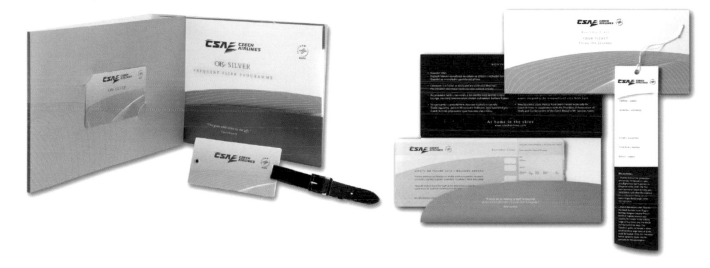

Creative Firm: **TORRE LAZUR MCCANN — PARSIPPANY, NJ**
Creative Team: **ANNEMARIE ANESES, MEGAN DILLEY, DEBRA FEATH, TATIANA LYONS, STACEY DUSKIN, JENNIFER / MARCIA ALAMPI / GODDARD**
Client: **EISAI / PRICARA**

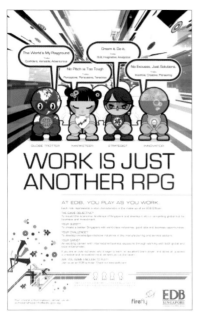

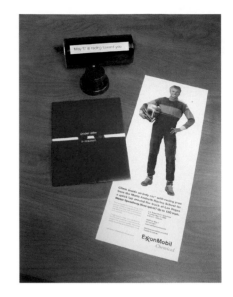

Creative Firm: **ATOMZ I! PTE LTD — SINGAPORE**
Creative Team: **PATRICK LEE, ALBERT LEE, KESTREL LEE**
Client: **ECONOMIC DEVELOPMENT BOARD**

Creative Firm: **HOTSAUCE — NEW YORK, NY**
Creative Team: **WYNDY SLOAN, ALICIA DOTTER**
Client: **LENOX HILL VETERINARIANS**

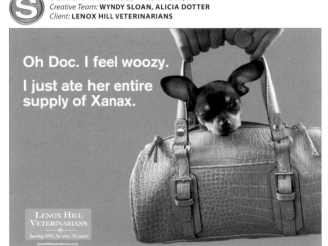

Creative Firm: **CROXSON DESIGN — HOUSTON, TX**
Creative Team: **STEPHEN CROXSON, MICHAEL RATCLIFF, RICHARD BYRD**
Client: **EXXONMOBIL CHEMICAL COMPANY**

Creative Firm: **TORRE LAZUR MCCANN — PARSIPPANY, NJ**
Creative Team: **KRISTY HUSZAR, MARK OPPICI, JENNIFER ALAMPI, MARCIA GODDARD**
Client: **GLAXOSMITHKLINE**

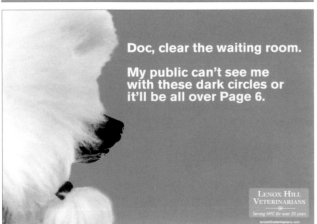

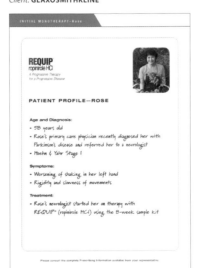

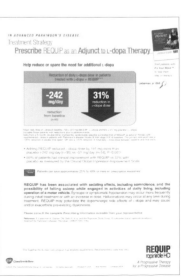

Creative Firm: **PRIMARY DESIGN, INC. — HAVERHILL, MA**
Creative Team: **DAVID VADALA, JULES EPSTEIN, LIZ FEDORZYN, SHARYN ROGERS, VITA MIRONOVA**
Client: **OXBOW DEVELOPMENT**

Creative Firm: **ALEXANDER MARKETING SERVICES INC. — BUFFALO GROVE, IL**
Creative Team: **DOUG WAYNER, LAURIE BRAMMER, DIANE PRAIS**
Client: **JUNO LIGHTING GROUP**

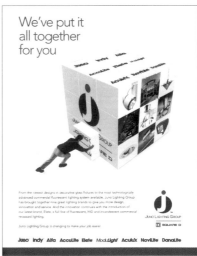

Creative Firm: **JPL PRODUCTIONS — HARRISBURG, PA**
Creative Team: **JIM MITCHELL, DAVE ROBERTSON, MATT DALY, CHELSIE MARKEL**
Client: **HARRISBURG UNIVERSITY OF SCIENCE AND TECHNOLOGY**

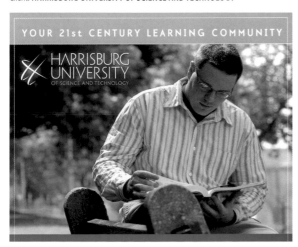

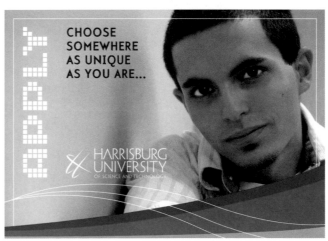

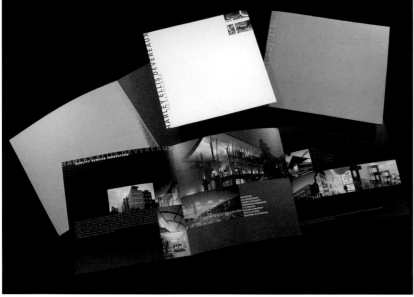

Creative Firm: **SKIDMORE, INC. — ROYAL OAK, MI**
Creative Team: **PETE NOTHSTEIN**
Client: **HARLEY ELLIS DEVEREAUX**

Creative Firm: **STELLAR DEBRIS — HADANO-SHI, KANAGAWA-KEN, JAPAN**
Creative Team: **CHRISTOPHER JONES**
Client: **STELLAR DEBRIS**

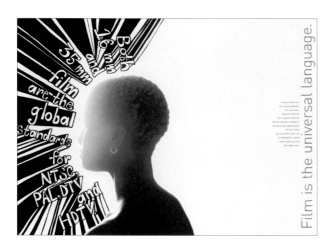

Creative Firm: **BUCK & PULLEYN — PITTSFORD, NY**
Creative Team: **BRENDA BRODSKY, DAN MULCAHY, PJ GALGAY, WAYNE CALABRESE**
Client: **EASTMAN KODAK COMPANY**

Creative Firm: **MENDES PUBLICIDADE — BELÉM, PARÁ, BRAZIL**
Creative Team: **OSWALDO MENDES, MARIA ALICE PENNA, LUIZ BRAGA, OCTAVIO CARDOSO, JOÃO RAMID**
Client: **BENEDITO MUTRAN**

Creative Firm: **HULL CREATIVE GROUP — BROOKLINE, MA**
Creative Team: **CARYL H. HULL, AMY BRADDOCK, SHELBY HYPES**
Client: **ICOSYSTEM**

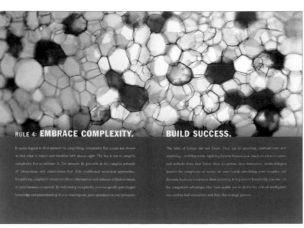

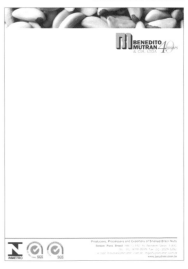

BRANDNEW PLACE

Creative Firm: **GREENFIELD/BELSER LTD.**
— WASHINGTON, DC
Creative Team: **BURKEY BELSER, CAROLYN SEWELL, GEORGE KELL, JAIME CHIRINOS**
Client: **MARGER JOHNSON & MCCOLLOM PC**

Creative Firm: **HORNALL ANDERSON DESIGN WORKS**
— SEATTLE, WA
Creative Team: **J. ANDERSON, J. TEE, A. WICKLUND, E. DELA CRUZ, H. CRAVEN, J. HILBURN, H. SCHOEN, B. BOWLING, Y. SHVETS, M. CONNORS**
Client: **WEYERHAEUSER CORP.**

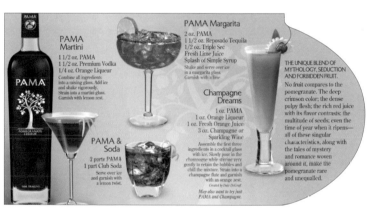

Creative Firm: **KELLER CRESCENT**
— EVANSVILLE, IN
Creative Team: **GERRY ULRICH, MARY REILLY, LYNNE MLADY, RANDY ROHN**
Client: **HEAVEN HILL**

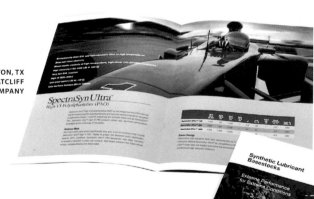

Creative Firm: **CROXSON DESIGN — HOUSTON, TX**
Creative Team: **STEPHEN CROXSON, MICHAEL RATCLIFF**
Client: **EXXONMOBIL CHEMICAL COMPANY**

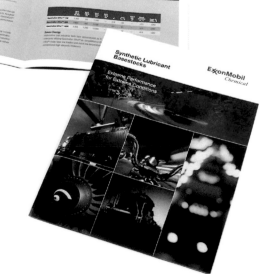

Creative Firm: **MYTTON WILLIAMS — BATH, BANES, UNITED KINGDOM**
Creative Team: **BOB MYTTON, TRACEY BOWES, TOM CHESHIRE, SIMON JONES**
Client: **INK COPYWRITERS**

Creative Firm: **Q — WIESBADEN, GERMANY**
Creative Team: **MATTHIAS FREY, LAURENZ NIELBOCK, CHRISTOPH DAHINTEN, UTE DERSCH, FRANK C. LAMBERRY**
Client: **HESSENCHEMIE**

Creative Firm: **BRIGHT RAIN CREATIVE — ST. LOUIS, MO**
Creative Team: **KEVIN HOUGH, MATT MARINO**
Client: **ST. LOUIS YPO**

Creative Firm: **ALEXANDER MARKETING SERVICES INC.
— BUFFALO GROVE, IL**
Creative Team: **TRISH RADAJ, LYNN WIER**
Client: **INITIAL TROPICAL PLANTS**

Creative Firm: **HERMAN MILLER, INC. — ZEELAND, MI**
Creative Team: **ANDREW DULL, JUSTIN MACOHOCHIE,
MARLENE CAPOTOSTO**
Client: **HERMAN MILLER, INC.**

Creative Firm: **KELLER CRESCENT
— EVANSVILLE, IN**
Creative Team: **RANDALL ROHN,
LYNNE MLADY, MARY REILLY,
GERRY ULRICH, RANDY ROHN,
PAT FAGAN**
Client: **HEAVEN HILL**

Creative Firm: **CSC'S P2 COMMUNICATIONS SERVICES — FALLS CHURCH, VA**
Creative Team: **AARON KOBILIS, TERRY WILSON, JOHN FARQUHAR, MAURICE COTTINGHAM**
Client: **CSC TMG**

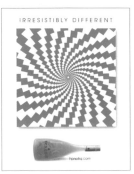

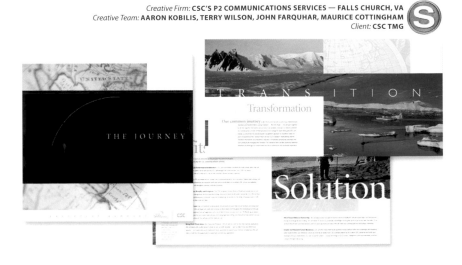

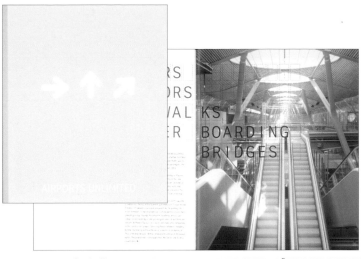

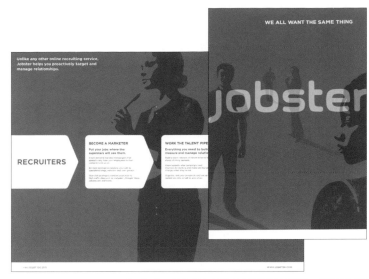

Creative Firm: **RTS RIEGER TEAM WERBEAGENTUR GMBH — DÜSSELDORF, GERMANY**
Creative Team: **MICHAELA MÜLLER, DANIELA SCHÄFER, ULRICH GIELISCH, FRANCISCO NAVARRO Y GOMES**
Client: **THYSSENKRUPP ELEVATOR AG**

Creative Firm: **HORNALL ANDERSON DESIGN WORKS — SEATTLE, WA**
Creative Team: **JACK ANDERSON, MICHAEL CONNORS, LEO RAYMUNDO, ENSI MOFASSER**
Client: **JOBSTER**

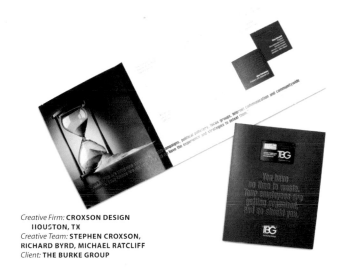

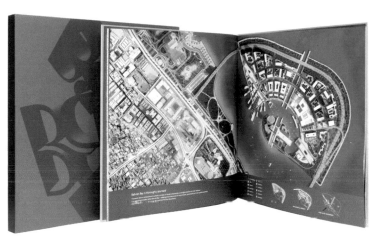

Creative Firm: **CROXSON DESIGN HOUSTON, TX**
Creative Team: **STEPHEN CROXSON, RICHARD BYRD, MICHAEL RATCLIFF**
Client: **THE BURKE GROUP**

Creative Firm: **FUTUREBRAND BRAND EXPERIENCE — NEW YORK, NY**
Creative Team: **DIEGO KOLSKY, CHERYL HILLS, ANTONIO BAGLIONE, STEPHANIE CARROLL, WILLIAM SHINTANI, RAYMOND CHAN**
Client: **ARCAPITA**

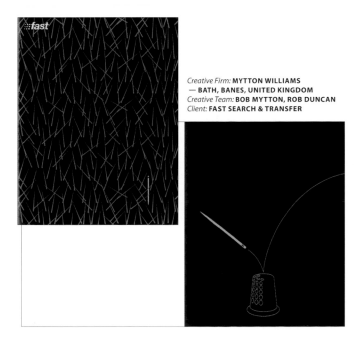

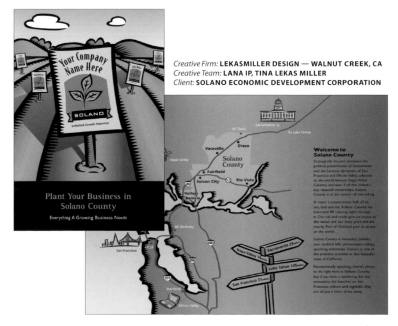

Creative Firm: **MYTTON WILLIAMS — BATH, BANES, UNITED KINGDOM**
Creative Team: **BOB MYTTON, ROB DUNCAN**
Client: **FAST SEARCH & TRANSFER**

Creative Firm: **LEKASMILLER DESIGN — WALNUT CREEK, CA**
Creative Team: **LANA IP, TINA LEKAS MILLER**
Client: **SOLANO ECONOMIC DEVELOPMENT CORPORATION**

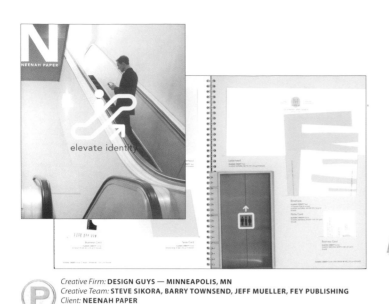

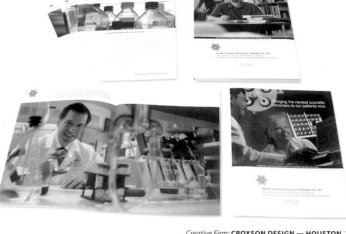

Creative Firm: **DESIGN GUYS — MINNEAPOLIS, MN**
Creative Team: **STEVE SIKORA, BARRY TOWNSEND, JEFF MUELLER, FEY PUBLISHING**
Client: **NEENAH PAPER**

Creative Firm: **CROXSON DESIGN — HOUSTON, TX**
Creative Team: **STEPHEN CROXSON, RICHARD BYRD, JOHN SMALLWOOD**
Client: **M.D. ANDERSON CANCER CENTER**

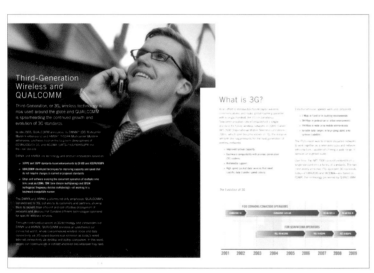

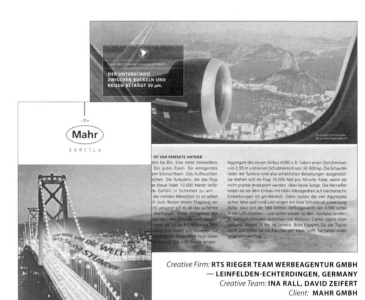

Creative Firm: **QUALCOMM — SAN DIEGO, CA**
Creative Team: **FRANK BERNAS, CHRIS LEE**

Creative Firm: **RTS RIEGER TEAM WERBEAGENTUR GMBH
— LEINFELDEN-ECHTERDINGEN, GERMANY**
Creative Team: **INA RALL, DAVID ZEIFERT**
Client: **MAHR GMBH**

Creative Firm: **GODBE COMMUNICATIONS — HALF MOON BAY, CA**
Client: **CALIFORNIA CPA PROTECTPLUS**

Creative Firm: **PARAGRAPHS DESIGN — CHICAGO, IL**
Creative Team: **JIM CHILCUTT**
Client: **KAUFMANHALL**

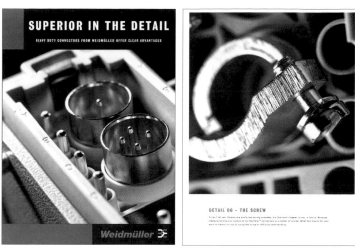

SUPERIOR IN THE DETAIL

HEAVY DUTY CONNECTORS FROM WEIDMÜLLER OFFER CLEAR ADVANTAGES

Weidmüller

DETAIL 06 – THE SCREW

Creative Firm: **RTS RIEGER TEAM WERBEAGENTUR GMBH — DÜSSELDORF, GERMANY**
Creative Team: **MICHAELA MÜLLER, KERSTIN OYDA, HEINZ ZANDER**
Client: **WEIDMÜLLER INTERFACE GMBH & CO.**

Creative Firm: **TOYOTA FINANCIAL SERVICES MEDIA DESIGN — TORRANCE, CA**
Creative Team: **DANIEL KO**
Client: **TOYOTA FINANCIAL SERVICES**

Creative Firm: **LISKA + ASSOCIATES — CHICAGO, IL**
Creative Team: **STEVE LISKA, VANESSA OLTMANNS, ANN MARIE GRAY**
Client: **CRANE & CO. PAPER**

Creative Firm: **HORNALL ANDERSON DESIGN WORKS — SEATTLE, WA**
Creative Team: **J. ANDERSON, J. TEE, A. WICKLUND, E. DELA CRUZ, H. CRAVEN, J. HILBURN, H. SCHOEN, B. BOWLING, Y. SHVETS, M. CONNORS**
Client: **WEYERHAEUSER CORP.**

Creative Firm: **GREENFIELD/BELSER LTD. — WASHINGTON, DC**
Creative Team: **BURKEY BELSER, SIOBHAN DAVIS, JOE WALSH**
Client: **ERS GROUP**

Creative Firm: **DON SCHAAF & FRIENDS, INC. — WASHINGTON, DC**
Creative Team: **DON SCHAAF**
Client: **FLOWSERVE**

Creative Firm: **HITCHCOCK FLEMING & ASSOCIATES INC. — AKRON, OH**
Creative Team: **NICK BETRO, KIM BRUNS, TODD MOSER**
Client: **VERITAS**

Creative Firm: **EFFECTIVENESS THROUGH COMMUNICATION — EL CAJON, CA**
Creative Team: **MARIE HORN**
Client: **ELEMENTARY INSTITUTE OF SCIENCE**

ciena (in other words) : a network of opportunity

Creative Firm: **HORNALL ANDERSON DESIGN WORKS — SEATTLE, WA**
Creative Team: **JACK ANDERSON, ANDY DAVIDHAZY, HOLLY CRAVEN, SONJA MAX, YURI SHVETS, ANDREW WICKLUND, KRIS DELANEY**
Client: **CIENA**

Creative Firm: **TAYLOR DESIGN — STAMFORD, CT**
Creative Team: **SUZANNE REUSCH, DAN TAYLOR, CRAIG FRAZIER**
Client: **MASTERCARD**

Creative Firm: **QUALCOMM — SAN DIEGO, CA**
Creative Team: **LUISA LOPEZ, CHRIS LEE**

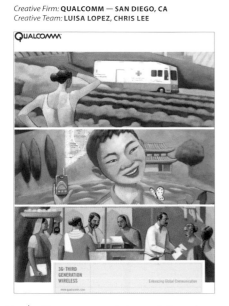

Creative Firm: **GODBE COMMUNICATIONS — HALF MOON BAY, CA**
Client: **PACIFIC CAPITAL INVESTMENTS**

Creative Firm: **DOUBLE TAKE CREATIVE — LAWRENCEVILLE, GA**
Creative Team: **VINCENT MARASCHIELLO, AMY POWERS**
Client: **DESIGN TYPE PRINTING SERVICES**

Creative Firm: **HORNALL ANDERSON DESIGN WORKS — SEATTLE, WA**
Creative Team: **J. ANDERSON, M. CONNORS, L. A. JOHNSON, L. RAYMUNDO, Y. SHVETS, E. LEE, K. SAITO, B. STIGLER, D. BATES**
Client: **JOBSTER**

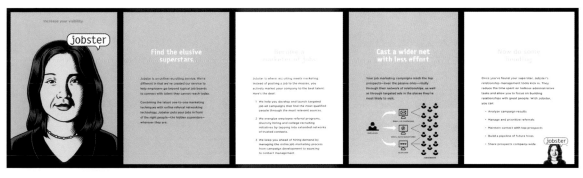

Creative Firm: **PLUMBLINE STUDIOS, INC — NAPA, CA**
Creative Team: **DOM MORECI, MARK JORDAN, CRAIG SHEROD**
Client: **WYSE**

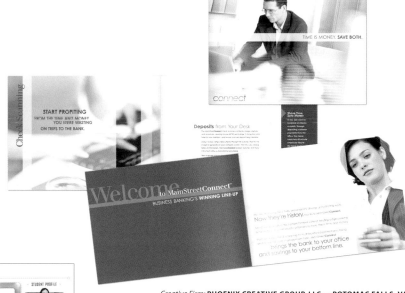

Creative Firm: **PHOENIX CREATIVE GROUP, LLC — POTOMAC FALLS, VA**
Creative Team: **NICOLE KASSOLIS, SEAN MULLINS, GARFUNKLE & ASSOCIATES, STOCK BYTE**
Client: **MAINSTREET BANK, HERNDON, VA**

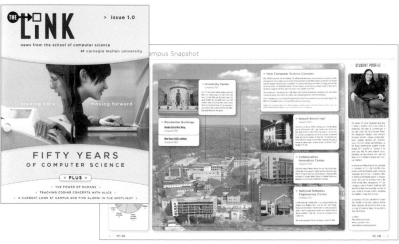

Creative Firm: **FITTING GROUP — PITTSBURGH, PA**
Creative Team: **TRAVIS NORRIS**
Client: **SCHOOL OF COMPUTER SCIENCE AT CARNEGIE MELLON UNIVERSITY**

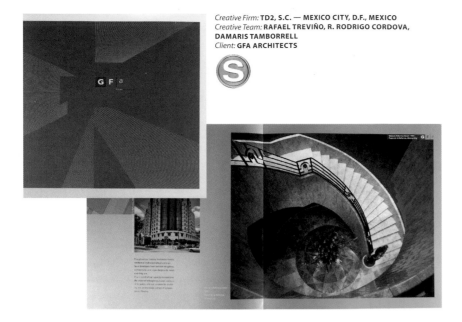

Creative Firm: **TD2, S.C. — MEXICO CITY, D.F., MEXICO**
Creative Team: **RAFAEL TREVIÑO, R. RODRIGO CORDOVA, DAMARIS TAMBORRELL**
Client: **GFA ARCHITECTS**

Creative Firm: **Q — WIESBADEN, GERMANY**
Creative Team: **KATIA WITTROWSKI, THILO VON DEBSCHITZ, UTE DERSCH**
Client: **ICR, WESTPORT/CT**

Creative Firm: **PLUMBLINE STUDIOS, INC — NAPA, CA**
Creative Team: **DOM MORECI, TERRY LORANT**
Client: **COBLENTZ, PATCH, DUFFY & BASS, LLP**

Creative Firm: **HORNALL ANDERSON DESIGN WORKS — SEATTLE, WA**
Creative Team: **J. ANDERSON, J. TEE, A. WICKLUND, E. DELA CRUZ, H. CRAVEN, J. HILBURN, H. SCHOEN, B. BOWLING, Y. SHVETS, M. CONNORS**
Client: **WEYERHAEUSER CORP.**

Creative Firm: **TOYOTA FINANCIAL SERVICES MEDIA DESIGN — TORRANCE, CA**
Creative Team: **DANIEL KO**
Client: **TOYOTA FINANCIAL SERVICES**

Creative Firm: **MUELLER & WISTER, INC. — BLUE BELL, PA**
Creative Team: **WOLFGANG MUELLER, CLARK MILLS, ANNE TELLEFSEN**
Client: **COLORCON**

Creative Firm: **HERMAN MILLER, INC. — ZEELAND, MI**
Creative Team: **BARBARA LOVELAND, AMBER FRITCHER, LINDA HELSON, MARLENE CAPOTOSTO, ROY BAKER, PETER KIAR**
Client: **HERMAN MILLER, INC.**

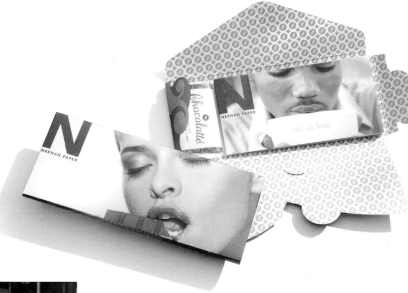

Creative Firm: **DESIGN GUYS — MINNEAPOLIS, MN**
Creative Team: **STEVE SIKORA, BARRY TOWNSEND, JAY THEIGE, KAREN LOKENSGARD, POMCO GRAPHIC ARTS**
Client: **NEENAH PAPER**

Creative Firm: **HORNALL ANDERSON DESIGN WORKS — SEATTLE, WA**
Creative Team: **JOHN ANICKER, JACK ANDERSON, ANDREW WICKLUND, LEO RAYMUNDO, CHRIS FREED, KATHLEEN GIBSON**
Client: **SCHNITZER NORTHWEST**

Creative Firm: **GREENFIELD/BELSER LTD. — WASHINGTON, DC**
Creative Team: **BURKEY BELSER, GEORGE KELL, JOHN MITRIONE, MOSAIC**
Client: **WOMBLE CARLYLE SANDRIDGE & RICE, PLLC**

Creative Firm: **LITTLE BIRD COMMUNICATIONS — MOBILE, AL**
Creative Team: **DIANE GIBBS, SONJA FOSHEE**
Client: **SONJA FOSHEE PHOTOGRAPHER**

Creative Firm: **CREATIVE MINDWORKS**
— MIAMI LAKES, FL
Creative Team: **ANGELICA MARTINEZ, RAISA SIRES,**
LIZETTE FERNANDEZ
Client: **PRESTIGE BUILDERS PARTNERS**

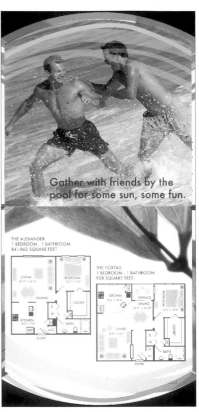

Creative Firm: **DEVER DESIGNS — LAUREL, MD**
Creative Team: **JEFFREY DEVER, KIM POLLOCK**
Client: **LEADERSHIP TO KEEP CHILDREN ALCOHOL FREE**

Creative Firm: **HULL CREATIVE GROUP**
— BROOKLINE, MA
Creative Team: **CARYL H. HULL,**
CAROLYN COLONNA, STUART DANFORTH
Client: **DANFORTH ASSOCIATES**

Creative Firm: **SHERIFF DESIGN — ELKINS PARK, PA**
Creative Team: **PAUL SHERIFF, DR. AMY SCHLEVEL, JUDY FOX, HEIDI WIRTH**
Client: **TUFTS UNIVERSITY**

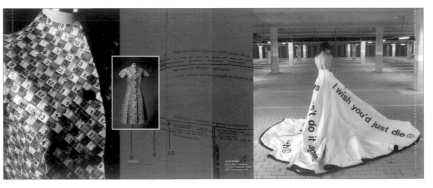

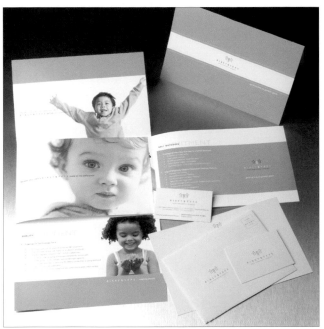

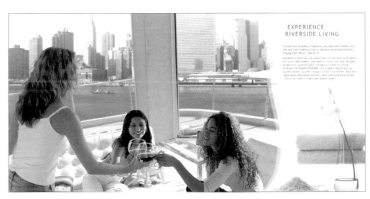

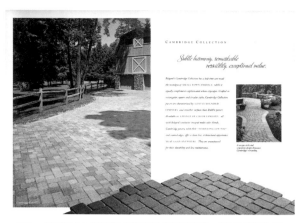

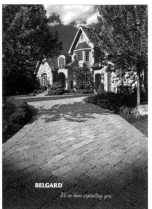

Creative Firm: **BRIAN J. GANTON & ASSOCIATES — CEDAR GROVE, NJ**
Creative Team: **MARK GANTON, BRIAN J. GANTON JR., PAT PALMIERI, BRIAN J. GANTON SR., CHRISTOPHER GANTON, JOHN HOVELL**
Client: **BELGARD**

Creative Firm: **BURROWS — BRENTWOOD, ESSEX, UNITED KINGDOM**
Creative Team: **DEREK PRICE, ROYDON HEARNE, MARK ELLIS, ZOE FOWLER, NIGEL HALL**
Client: **FORD MOTOR COMPANY (EUROPE)**

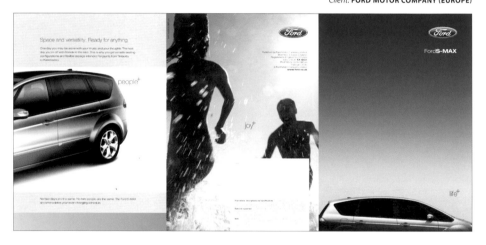

Creative Firm: **ALL MEDIA PROJECTS LIMITED — PORT OF SPAIN, TRINIDAD AND TOBAGO**
Creative Team: **CATHLEEN JONES, MARISA CAMEJO, JULIEN GREENIDGE, JOSIANE KHAN**
Client: **BP TRINIDAD AND TOBAGO (BPTT)**

Creative Firm: **RODGERS TOWNSEND — ST. LOUIS, MO**
Creative Team: **ERIK MATHRE, LIZ FORSYTHE, BILL ECKLOFF, CHERYL SPARKS**
Client: **THE BLACK REP**

Creative Firm: **HERBERGER COLLEGE OF FINE ARTS — TEMPE, AZ**
Creative Team: **AMY NG, MARTHA KNIGHT, STACEY SHAW, TIM TRUMBLE**
Client: **HERBERGER COLLEGE FOR KIDS/AT LARGE**

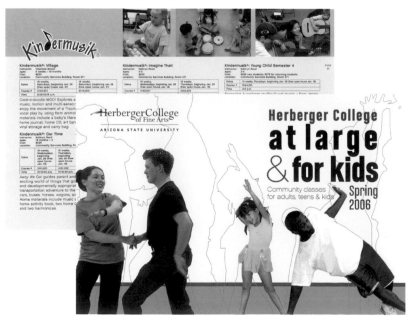

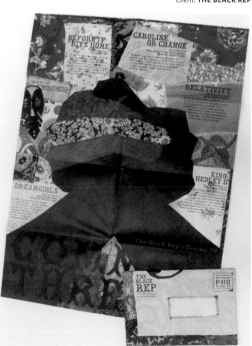

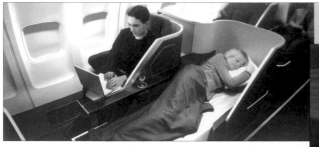

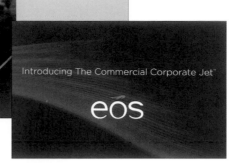

Introducing The Commercial Corporate Jet™

eos

PROGRESS REPORT ON
ALZHEIMER'S DISEASE
2004–2005

New
Discoveries,
New Insights

Creative Firm: **HORNALL ANDERSON DESIGN WORKS — SEATTLE**
Creative Team: **JACK ANDERSON, JULIE LOCK, LAURA JAKOBSEN BECKON WYLD**
Client: **EOS AIRLINES**

Creative Firm: **DEVER DESIGNS — LAUREL, MD**
Creative Team: **JEFFREY DEVER,
KRISTIN DEUEL DUFFY, FATIMA AMEEN**
Client: **NAT'L INSTITUTES OF HEALTH/
NAT'L INSTITUTE OF AGING**

WORLD CLASS MANAGERS
*The Alliance Program's portfolio managers offer more than
30 diverse portfolios and investment styles to meet your
financial planning needs.*

PERSONALIZED
WEALTH MANAGEMENT

ALLIANCE

Creative Firm: **MCGUFFIE DESIGN
NORTH VANCOUVER, BC, CANADA**
Creative Team: **STEVE MCGUFFIE**
Client: **CANACCORD CAPITAL**

**THE CALLING TO
LEAVE A LEGACY**

LEADER *of* LEADERS

**THE WILL
TO POWER
DESTINIES**

SAF OVERSEAS SCHOLARSHIP

Creative Firm: **HELENA SEO DESIGN — SUNNYVALE, CA**
Creative Team: **HELENA SEO, BILL O'SUCH**
Client: **INEKE, LLC**

INEKE

abcd
hijklmn
opqrs
vw

Creative Firm: **SPLASH PRODUCTIONS PTE LTD — SINGAPORE**
Creative Team: **TERRY LEE, LOW JAT LENG, BRICE LI, STANLEY TAP**
Client: **MINDEF SCHOLARSHIP CENTRE**

Creative Firm: **WESTGROUP CREATIVE — NEW YORK, NY**
Creative Team: **CHIP TOLANEY, MARVIN BERK, PETER SAKAS, MAX SHUPPERT**
Client: **IPSILON MUSIC SERVICES**

AFTER MY OWN HEART
THE SCENT OF *fresh lilacs* FLOATING ON
THE EARLY EVENING BREEZE

Juliana Sings...

Juliana Sings...
Yiddish Folksongs

At the center of it all stands the condominiums at North Bank Park.

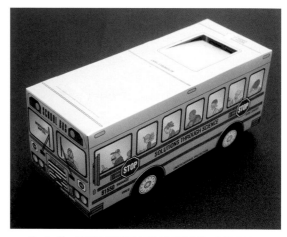

 Creative Firm: **SCOTT ADAMS DESIGN ASSOCIATES — COLUMBUS, OH**
Creative Team: **SCOTT ADAMS, MANDY MILLER, COLIN MCGUIRE, TOM GRIFFIN, NATHAN KRAFT**
Client: **NATIONWIDE REALTY INVESTORS**

Creative Firm: **ORIGINAL IMPRESSIONS — MIAMI, FL**
Creative Team: **FRANK IRIAS**
Client: **OCEAN REEF CLUB**

Creative Firm: **TTA ADVERTISING — PHOENIX, AZ**
Creative Team: **RUSTY PILE, SWAPNA SALGAR**
Client: **DIAMOND SHOWCASE**

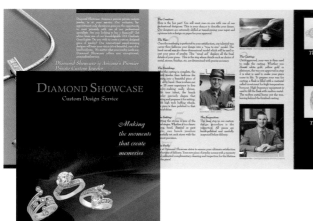

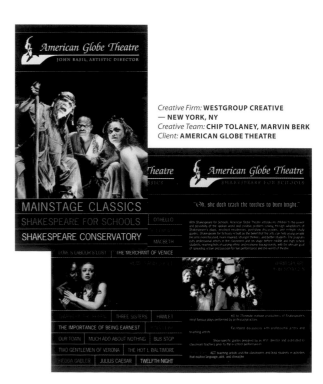

Creative Firm: **HARRIS, DEVILLE & ASSOCIATES, INC. — BATON ROUGE, LA**
Creative Team: **ELIZABETH PERRY, STAN TAYLOR, BEVERLY SMILEY**
Client: **SOLUTIONS THROUGH SCIENCE**

Creative Firm: **VANPELT CREATIVE — GARLAND, TX**
Creative Team: **CHIP VANPELT, TODD BRASHEAR, J.W. BURKEY**
Client: **AM APPLIANCE GROUP**

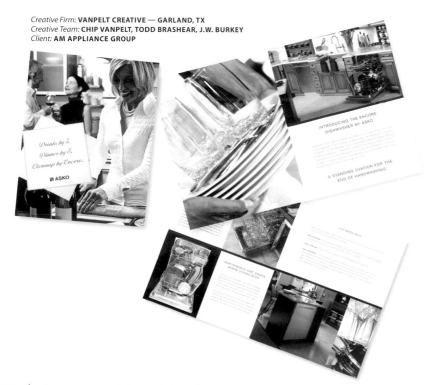

Creative Firm: **WESTGROUP CREATIVE — NEW YORK, NY**
Creative Team: **CHIP TOLANEY, MARVIN BERK**
Client: **AMERICAN GLOBE THEATRE**

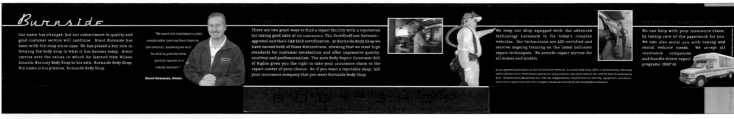

Creative Firm: **NEVER BORING DESIGN ASSOCIATES — MODESTO, CA**
Creative Team: **KATRINA FURTON**
Client: **BURNSIDE BODY SHOP**

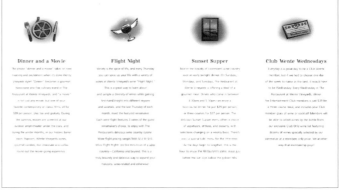

Creative Firm: **LEKASMILLER DESIGN — WALNUT CREEK, CA**
Creative Team: **LANA IP**
Client: **THE RESTAURANT AT WENTE VINEYARDS**

Creative Firm: **A3 DESIGN — CHARLOTTE, NC**
Creative Team: **ALAN ALTMAN, AMANDA ALTMAN**
Client: **CARMAL COUNTRY CLUB**

Creative Firm: **GRAFIK MARKETING COMMUNICATIONS — ALEXANDRIA, VA**
Creative Team: **MICHELLE MAR COLLINS, JOHNNY VITOROVICH, HAL SWETNAM, IVAN HOOKER, CINDY COLE, DEAN ALEXANDER**
Client: **EYA**

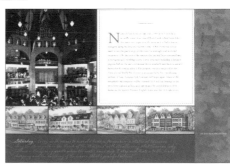

Creative Firm: **KOR GROUP — BOSTON, MA**
Creative Team: **MB JAROSIK, JAMES GRADY**
Client: **THE CONGRESS GROUP**

Creative Firm: **HUGHES HUNTER, INC. — THOUSAND OAKS, CA**
Creative Team: **JIM HUGHES, BRUCE POLKES, KIRSTEN MCGUIRE**
Client: **AVEX AVIATION**

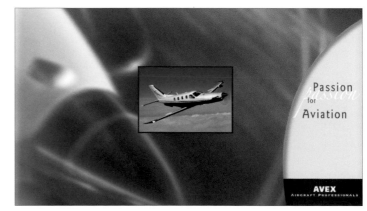

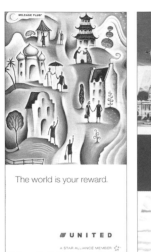
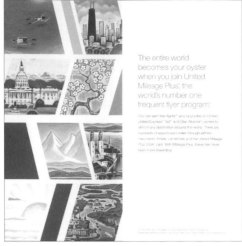

The entire world becomes your oyster when you join United Mileage Plus, the world's number one frequent flyer program.

The world is your reward.

UNITED
A STAR ALLIANCE MEMBER

Creative Firm: **SGDP — CHICAGO, IL**
Creative Team: **KIM TERZIS, ALBENA IVANOVA, KEVIN KLEBER**
Client: **UNITED AIRLINES**

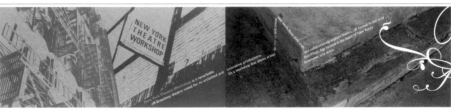

Creative Firm: **HOWARD HANNA SMYTHE CRAMER — CLEVELAND , OH**
Creative Team: **AIMEE CAMPBELL**
Client: **GARDENS OF CHARLESTON**

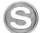
Creative Firm: **RUDER FINN DESIGN — NEW YORK, NY**
Creative Team: **LISA GABBAY, SAL CATANIA, AARON WILSON**
Client: **NEW YORK THEATRE WORKSHOP**

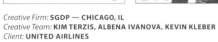

Creative Firm: **HORNALL ANDERSON DESIGN WORKS — SEATTLE, WA**
Creative Team: **MARK POPICH, PETER ANDERSON, YURI SHVETS, MICHAEL BRUGMAN**
Client: **ONREQUEST**

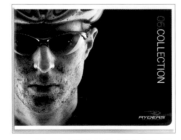

Creative Firm: **SUBPLOT DESIGN INC. — VANCOUVER, BC, CANADA**
Creative Team: **MATTHEW CLARK, ROY WHITE, STEPH GIBSON**
Client: **RYDERS EYEWEAR**

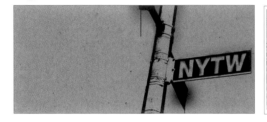

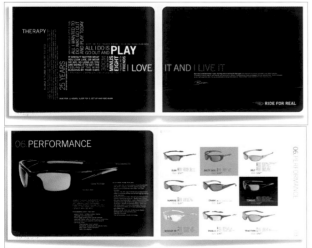

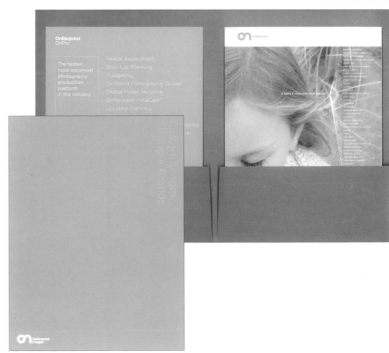

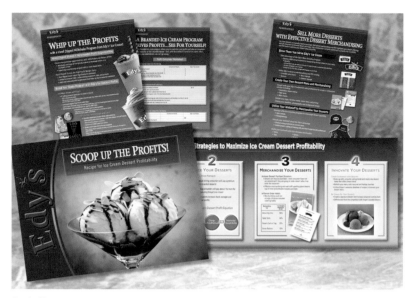

Creative Firm: **GAMMON RAGONESI ASSOCIATES — NEW YORK, NY**
Creative Team: **MARY RAGONESI, YARITSA ARENAS**
Client: **NESTLE**

Creative Firm: **SILVER COMMUNICATIONS INC — NEW YORK, NY**
Creative Team: **GREGG SIBERT, CHRISTINA WEISSMAN**
Client: **EAST MIDTOWN ASSOCIATION**

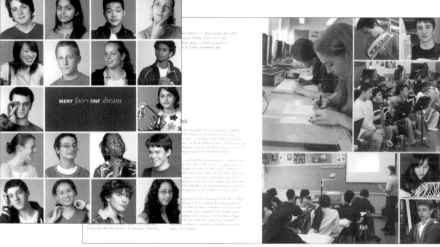

Creative Firm: **SUKA DESIGN — NEW YORK, NY**
Creative Team: **BRIAN WONG**
Client: **THE BRONX HIGH SCHOOL OF SCIENCE**

Creative Firm: **RUDER FINN DESIGN — NEW YORK, NY**
Creative Team: **LISA GABBAY, SAL CATANIA, DIANA YEO**
Client: **NOVARTIS**

Creative Firm: **TRIPLE 888 STUDIOS — PARRAMATTA, NSW, AUSTRALIA**
Creative Team: **TRIPLE 888 CREATIVE TEAM**
Client: **SIRTEX MEDICAL**

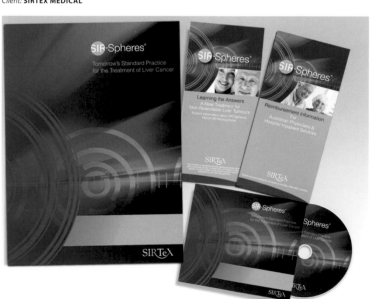

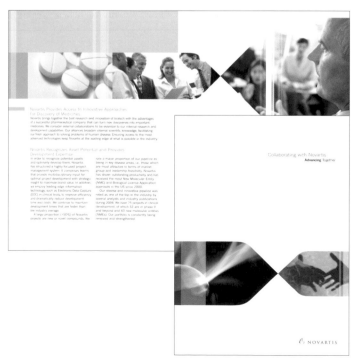

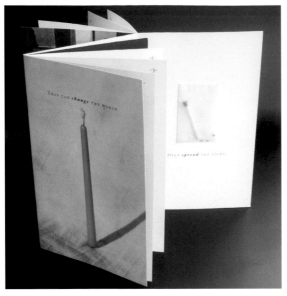

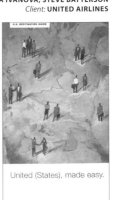

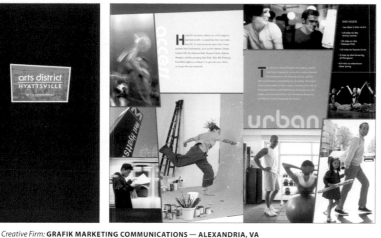

Creative Firm: **GRAFIK MARKETING COMMUNICATIONS — ALEXANDRIA, VA**
Creative Team: **MICHELLE MAR COLLINS, LYNN MURPHY, JOHNNY VITOROVICH, HAL SWETNAM, REGINA ESPOSITO, IVAN HOOKER**
Client: **EYA**

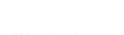

Creative Firm: **THE COLLEGE OF SAINT ROSE — ALBANY, NY**
Creative Team: **MARK HAMILTON, CHRIS PARODY, MEREDITH ROSE**
Client: **THE COLLEGE OF SAINT ROSE**

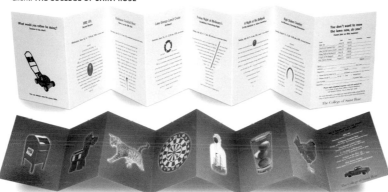

Creative Firm: **QUALCOMM — SAN DIEGO, CA**
Creative Team: **FRANK BERNAS, CHRIS LEE**
Client: **RANCHO SANTA FE GOLF CLUB**

Creative Firm: **THE COLLEGE OF SAINT ROSE — ALBANY, NY**
Creative Team: **MARK HAMILTON, CHRIS PARODY, JOHN HUNTER**
Client: **THE COLLEGE OF SAINT ROSE**

Creative Firm: **HARRIS, DEVILLE & ASSOCIATES, INC. — BATON ROUGE, LA**
Creative Team: **ELIZABETH PERRY, STAN TAYLOR, BEVERLY SMILEY**
Client: **SOLUTIONS THROUGH SCIENCE**

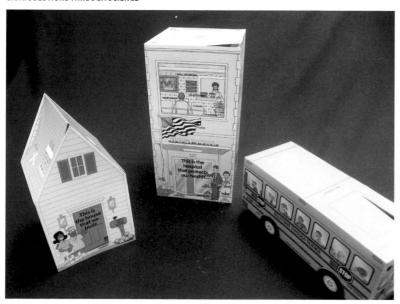

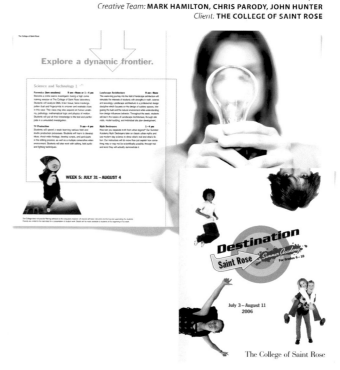

81

Creative Firm: **SPLASH PRODUCTIONS PTE LTD — SINGAPORE**
Creative Team: **TERRY LEE, NORMAN LAI**
Client: **SURBANA INTERNATIONAL CONSULTANTS PTE. LTD.**

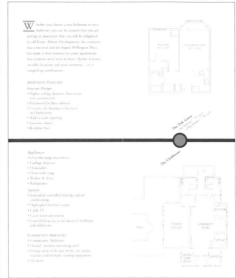

Creative Firm: **PRIMARY DESIGN, INC. — HAVERHILL, MA**
Creative Team: **JULES EPSTEIN, DAVID VADALA, SHARYN ROGERS, ALLISON DAVIS**
Client: **ABBOTT DEVELOPMENT**

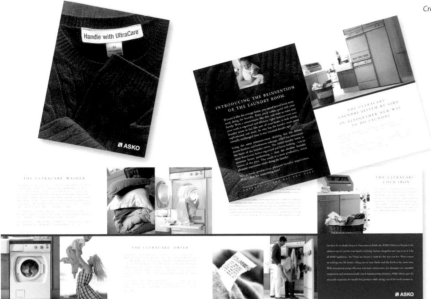

Creative Firm: **VANPELT CREATIVE — GARLAND, TX**
Creative Team: **CHIP VANPELT, TODD BRASHEAR, J.W. BURKEY**
Client: **AM APPLIANCE GROUP**

Creative Firm: **SUKA DESIGN — NEW YORK, NY**
Creative Team: **LAURA PLOSZAJ**
Client: **APOLLO THEATRE FOUNDATION**

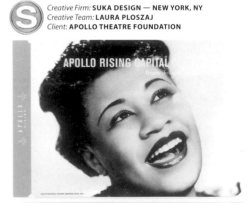

Creative Firm: **SPLASH PRODUCTIONS PTE LTD — SINGAPORE**
Creative Team: **TERRY LEE, LOW JAT LENG, STANLEY TAP, BRICE LI**
Client: **MINDEF SCHOLARSHIP CENTRE**

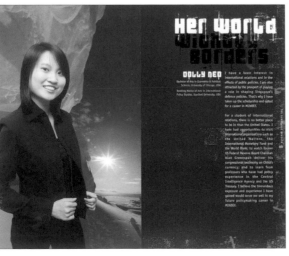
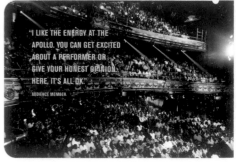

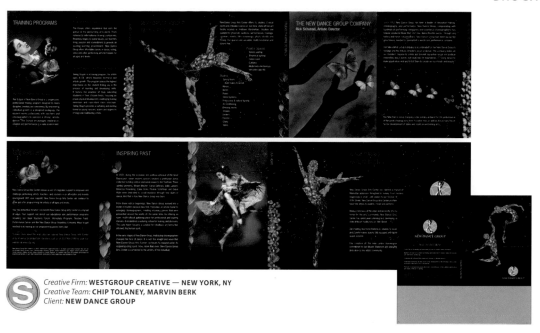

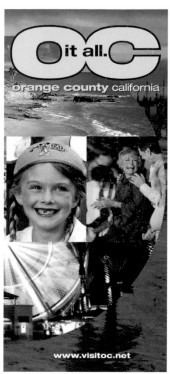

Creative Firm: **WESTGROUP CREATIVE — NEW YORK, NY**
Creative Team: **CHIP TOLANEY, MARVIN BERK**
Client: **NEW DANCE GROUP**

Creative Firm: **YELLOW SHOES CREATIVE WEST, DISNEYLAND RESORT — ANAHEIM, CA**
Creative Team: **STEVEN GERRY, WES CLARK, JACQUELYN MOE, ANIKO BOTA, CLAIRE BILBY**
Client: **ORANGE COUNTY VISITORS & CONVENTION BUREAU**

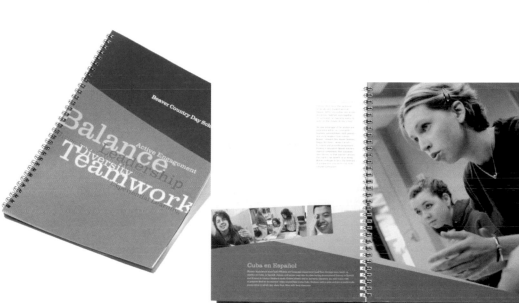

Creative Firm: **KOR GROUP — BOSTON, MA**
Creative Team: **JIM GIBSON, TONY RINALIDO**
Client: **BEAVER COUNTRY DAY SCHOOL**

Creative Firm: **BELYEA — SEATTLE, WA**
Creative Team: **RON HANSEN, ANNE BRYANT, SHERI-LOU STANNARD**
Client: **HOLY NAMES ACADEMY**

Creative Firm: **VENTRESS DESIGN GROUP — FRANKLIN, TN**
Creative Team: **TOM VENTRESS, ERIC VENTRESS, BILL COVERT, DAN LOFTIN, SANDY CAMPBELL**
Client: **VANDERBILT UNIVERSITY LAW SCHOOL**

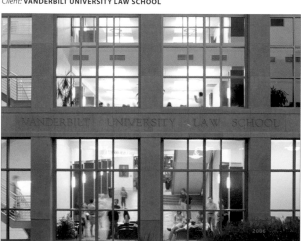

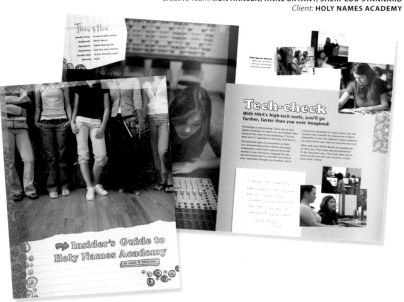

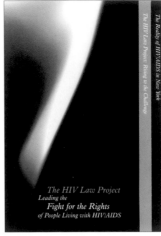
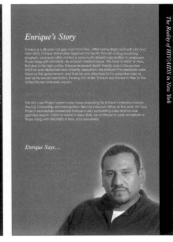

Creative Firm: **KOR GROUP — BOSTON, MA**
Creative Team: **KAREN DENDY SMITH, JAMES GRADY, JIM GIBSON, LEN RUBENSTEIN, MARTHA EDISON**
Client: **MIT**

Creative Firm: **TAPROOT FOUNDATION — BROOKLYN, NY**
Creative Team: **CHIP TOLANEY, LINDSAY MERGENS, PETER DOLCHIN, BERNARD LEIBOV, ANNE OLDEROG, ANDREW GRYN**
Client: **THE HIV LAW PROJECT**

Creative Firm: **GRAFIK MARKETING COMMUNICATIONS — ALEXANDRIA, VA**
Creative Team: **GREGG GLAVIANO, LYNN MURPHY, HEATH DWIGGINS**
Client: **FM STRATEGIC COMMUNICATIONS**

Creative Firm: **SUKA DESIGN — NEW YORK, NY**
Creative Team: **LOLA BERNABE**
Client: **THE EAST HARLEM SCHOOL**

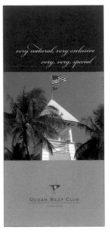
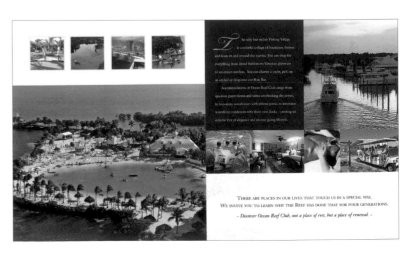
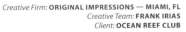

Creative Firm: **ORIGINAL IMPRESSIONS — MIAMI, FL**
Creative Team: **FRANK IRIAS**
Client: **OCEAN REEF CLUB**

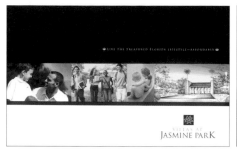

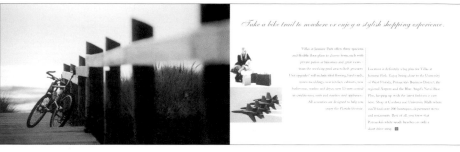

Creative Firm: **ORIGINAL IMPRESSIONS — MIAMI, FL**
Creative Team: **FRANK IRIAS**
Client: **VILLAS AT JASMINE PARK**

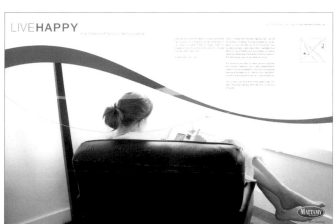

Creative Firm: **A3 DESIGN — CHARLOTTE, NC**
Creative Team: **ALAN ALTMAN, AMANDA ALTMAN**
Client: **MATTAMY HOMES**

Creative Firm: **FUTURA DDB — LJUBLANA, SLOVENIA**
Creative Team: **ZARE KERIN, MARKO VICIC, MATEJA PODMENIK**

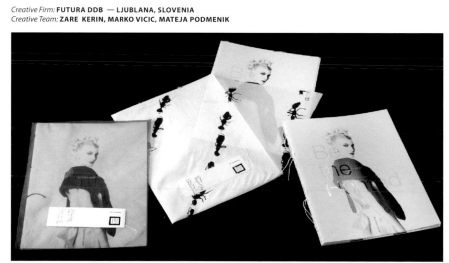

Creative Firm: **KOR GROUP — BOSTON, MA**
Creative Team: **ANNE CALLAHAN, JIM GIBSON, LEN RUBENSTEIN**
Client: **RAMAPO COLLEGE**

Creative Firm: **WESTGROUP CREATIVE
— NEW YORK, NY**
Creative Team: **CHIP TOLANEY, MARVIN BERK,
NOEL HAYASHI, CAROL ROSEGG**
Client: **PAUL RAJECKAS**

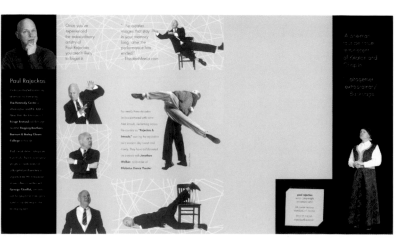

BUSINESS CARDS

Creative Firm: **STUDIO FIVE — NEW YORK, NY**
Creative Team: **TATIANA AROCHA,**
MELISSA GORMAN
Client: **EXPANSION TEAM**

Creative Firm: **ACME COMMUNICATIONS, INC.**
— NEW YORK, NY
Creative Team: **KIKI BOUCHER,**
ANDREA ROSS BOYLE
Client: **PHILIP SHIPPER**

Creative Firm: **RUDER FINN DESIGN**
— NEW YORK, NY
Creative Team: **LISA GABBAY, SAL CATANIA,**
DIANA YEO, KAVEN LAM, RUBEN MERCADO,
JEFF GILLAM
Client: **RUDER FINN DESIGN**

Creative Firm: **PERCEPT CREATIVE GROUP**
— CRONULLA, NSW, AUSTRALIA
Creative Team: **LEWIS JENKINS**
Client: **CARMENS NIGHT CLUB / MIRANDA HOTEL**

Creative Firm: **RULE29 — GENEVA, IL**
Creative Team: **JUSTIN AHERNS, O'NEIL PRINTING**
Client: **BLUE SQUARE STUDIOS**

Creative Firm: **HERE! NETWORKS — NEW YORK, NY**
Creative Team: **ERIC FELDMAN, CRAIG OELRICH**
Client: **HERE! NETWORKS.**

Creative Firm: **MODERN MARKETING CONCEPTS — LOUISVILLE, KY**
Creative Team: **MARK A. GROVES**
Client: **MODERN MARKETING CONCEPTS**

Creative Firm: **MARK DEITCH & ASSOCIATES, INC.**
— BURBANK, CA
Creative Team: **LISA CLARK**
Client: **MARK DEITCH & ASSOCIATES, INC.**

Creative Firm: **MT&L PUBLIC RELATIONS LTD.**
— HALIFAX, NS, CANADA
Creative Team: **DANNY GODFREY, PAUL WILLIAMS**
Client: **AIRFIRE WIRELESS CONNECTIVITY**

Creative Firm: **KAREN SKUNTA & COMPANY — CLEVELAND, OH**
Creative Team: **KAREN SKUNTA, JAMIE FINKELHOR**
Client: **THE CLEVELAND PLAY HOUSE**

Creative Firm: **LAJEUNESSE COMMUNICATION MARKETING — MONTREAL, QC, CANADA**
Creative Team: **YVES DUQUETTE, NATHALIE DAIGLE**

Creative Firm: **BRIGHT RAIN CREATIVE — ST. LOUIS, MO**
Creative Team: **MATT MARINO, KEVIN HOUGH**
Client: **REDLINE PRODUCTION & POST**

Creative Firm: **MTV OFF AIR CREATIVE — NEW YORK, NY**
Creative Team: **JEFFREY KEYTON, JIM DEBARROS, KAREN WEISS, STACY DRUMMOND**
Client: **MTV NETWORKS**

 Creative Firm: **INTERROBANG DESIGN COLLABORATIVE, INC. — RICHMOND, VT**
Creative Team: **MARK D. SYLVESTER**
Client: **JENNA ADAMS / STYLIST**

Creative Firm: **& WOJDYLA ADVERTISING — CHICAGO, IL**
Creative Team: **DAVID WOJDYLA**
Client: **& WOJDYLA ADVERTISING**

Creative Firm: **KARACTERS DESIGN GROUP/DDB CANADA — VANCOUVER, BC, CANADA**
Creative Team: **MARIA KENNEDY, MARSHA LARKIN, HELEN WYNNE, MARK FINN, RUSS HORII**
Client: **KARACTERS DESIGN GROUP**

Creative Firm: **THE GRAFIOSI — NEW DELHI, INDIA**
Creative Team: **PUSHKAR THAKUR**
Client: **THE GRAFIOSI**

Creative Firm: **MC CREATIONS DESIGN STUDIO, INC. — JERICHO, NY**
Creative Team: **MICHAEL CALI, CYNTHIA MORILLO**

 Creative Firm: **VOICEBOX CREATIVE — SAN FRANCISCO, CA**
Creative Team: **JACQUES ROSSOUW, VOICEBOX TEAM, GREG CLARKE, JAN DENTON**
Client: **VINTAGE POINT**

Creative Firm: **STELLAR DEBRIS — HADANO-SHI, KANAGAWA-KEN, JAPAN**
Creative Team: **CHRISTOPHER JONES**
Client: **STELLAR DEBRIS**

Creative Firm: **CJ DESIGN — SANTA CRUZ, CA**
Creative Team: **CHRIS MARK, CHRIS MARK, DAN JENKINS, NIKKI BROOKS, ART DURAND**
Client: **AIKANE**

Creative Firm: **NINA DAVID KOMMUNIKATIONSDESIGN — DUESSELDORF, NRW, GERMANY**
Creative Team: **NINA DAVID, NINA DAVID**
Client: **FONT-O-RAMA**

Creative Firm: **RTS RIEGER TEAM WERBEAGENTUR GMBH — LEINFELDEN-ECHTERDINGEN, GERMANY**
Creative Team: **ANNETTE PIENTKA, CHRISTINE GRAF**
Client: **H. STOLL GMBH & CO. KG**

Creative Firm: **PHOENIX CREATIVE GROUP, LLC — POTOMAC FALLS, VA**
Creative Team: **NICOLE KASSOLIS, SEAN MULLINS, HICKORY PRINTING, ALDERMAN STUDIOS**
Client: **TIMBERLAKE / AMERICAN WOODWORK**

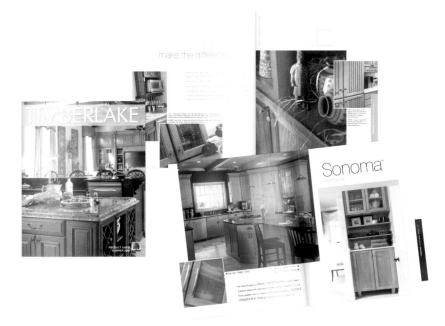

Creative Firm: **STAN GELLMAN GRAPHIC DESIGN INC. — ST. LOUIS, MO**
Creative Team: **JILL FRANTTI, DIANA DOERR, BARRY TILSON**
Client: **HINDA INCENTIVES**

Creative Firm: **UNITED STATES POSTAL SERVICE — ARLINGTON, VA**

Creative Firm: **BOOMM! MARKETING & COMMUNICATIONS — WESTCHESTER, IL**
Client: **MCCAIN FOODS USA**

Creative Firm: **LTD CREATIVE — FREDERICK, MD**
Creative Team: **LOUANNE WELGOSS, TIMOTHY FINNEN, BRIDGIT KEARNS**
Client: **HANLEY WOOD, LLC**

Creative Firm: **LTD CREATIVE — FREDERICK, MD**
Creative Team: **LOUANNE WELGOSS, TIMOTHY FINNEN, KIMBERLY DOW, SARA TOBIN**
Client: **HANLEY WOOD, LLC**

Creative Firm: **UIUC SCHOOL OF ART AND DESIGN — CHAMPAIGN, IL**
Creative Team: **JENNIFER GUNJI, ANNETTE ROTZ-GLEASON, KRISTINE DECHAVEZ, TIRZAH ROSE**
Client: **SCHOOL OF ART AND DESIGN**

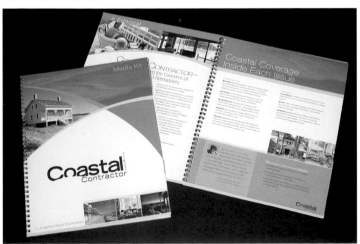

Creative Firm: **UNITED STATES POSTAL SERVICE — ARLINGTON, VA**

Creative Firm: **UNITED STATES POSTAL SERVICE — ARLINGTON, VA**

Creative Firm: **UNITED STATES POSTAL SERVICE — ARLINGTON, VA**

Creative Firm: **UNITED STATES POSTAL SERVICE — ARLINGTON, VA**

Creative Firm: **CJ DESIGN — SANTA CRUZ, CA**
Creative Team: **CHRIS MARK, ART DURAND**
Client: **AIKANE**

Creative Firm: **CROSLEY RADIO — LOUISVILLE, KY**
Creative Team: **MARK A. GROVES**
Client: **CROSLEY RADIO**

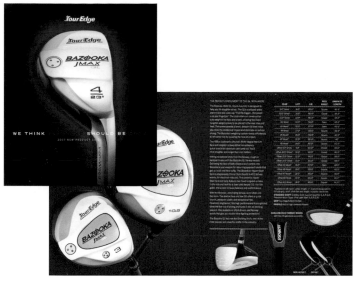

Creative Firm: **RULE29 — GENEVA, IL**
Creative Team: **JUSTIN AHERNS, JOSH JENSEN**
Client: **TOUR EDGE**

Creative Firm: **THE DESIGN STUDIO AT KEAN UNIVERSITY — UNION, NJ**
Creative Team: **STEVEN BROWER, TRICIA DECKER, STEPHANIE HELLER**
Client: **CAS GALLERY, KEAN UNIVERSITY**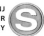

Creative Firm: **BRIAN J. GANTON & ASSOCIATES — CEDAR GROVE, NJ**
Creative Team: **CHRISTOPHER GANTON, BRIAN GANTON JR., MARK GANTON**
Client: **BELGARD**

Creative Firm: **MENDES PUBLICIDADE — BELÉM, PARÁ, BRAZIL**
Creative Team: **OSWALDO MENDES, DALMIRO FREITAS, MARCEL CHAVES**
Client: **SEBRAE/PA**

Creative Firm: **FIVESTONE — BUFORD, GA**
Creative Team: **JASON LOCY, PATRICIO JUAREZ**
Client: **PASSION**

Creative Firm: **DAVIS DESIGN PARTNERS — HOLLAND, OH**
Creative Team: **MATT DAVIS, PEGGY FELIX, KAREN DAVIS**
Client: **PURDUE THEATRE (PURDUE UNIVERSITY)**

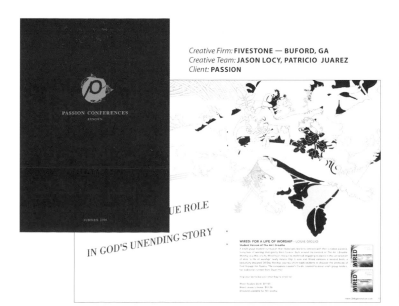

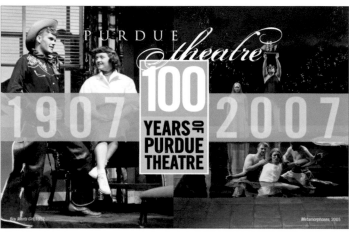

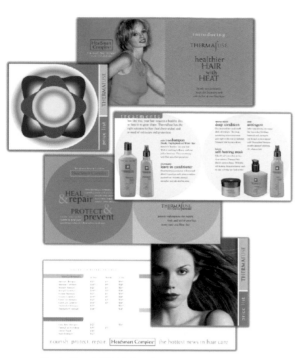

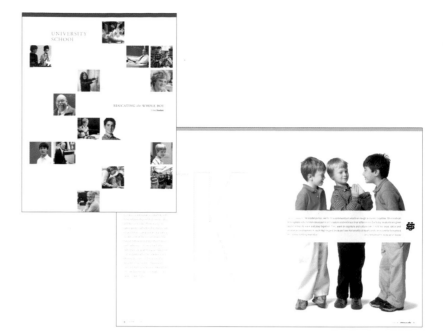

Creative Firm: **JONI RAE AND ASSOCIATES — ENCINO, CA**
Creative Team: **JONI RAE RUSSELL, BEVERLY TRENGOVE**
Client: **THERMAFUSE**

Creative Firm: **DAVIS DESIGN PARTNERS — HOLLAND, OH**
Creative Team: **MATT DAVIS, KAREN MEYERS, GABRIEL AMADEAUS COONEY,**
KAREN DAVIS, FIONA REILLY
Client: **UNIVERSITY SCHOOL**

Creative Firm: **DESIGN GUYS — MINNEAPOLIS, MN**
Creative Team: **STEVE SIKORA, KELLY MUNSON,**
GEORGE HEINRICH, JEFF MUELLER,
POMCO GRAPHIC ARTS
Client: **LAZOR OFFICE**

Creative Firm: **RUDER FINN DESIGN — NEW YORK, NY**
Creative Team: **LISA GABBAY, SAL CATANIA, EMILY KORSMO**
Client: **RUDER FINN PRESS**

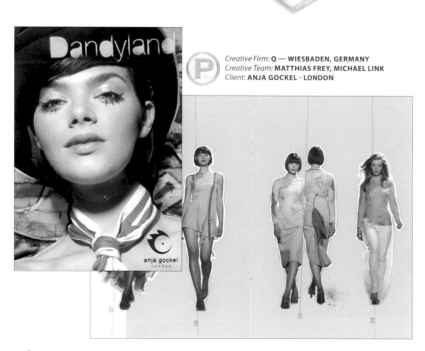

Creative Firm: **Q — WIESBADEN, GERMANY**
Creative Team: **MATTHIAS FREY, MICHAEL LINK**
Client: **ANJA GOCKEL - LONDON**

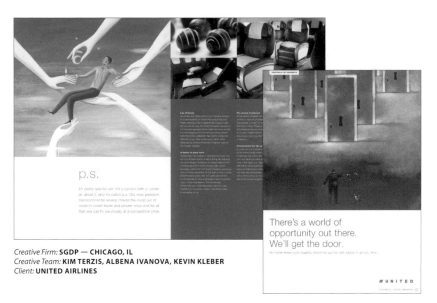

Creative Firm: **SGDP — CHICAGO, IL**
Creative Team: **KIM TERZIS, ALBENA IVANOVA, KEVIN KLEBER**
Client: **UNITED AIRLINES**

Creative Firm: **HUGHES HUNTER, INC. — THOUSAND OAKS, CA**
Creative Team: **JIM HUGHES, BRUCE POLKES, RENEE AIRINGTON, LIZ FIELDS, JODY LEVITAN, CAROL GRAVELLE**
Client: **FLEETWOOD RV**

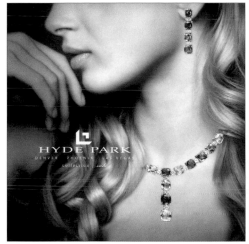

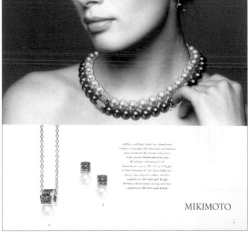

Creative Firm: **ELLEN BRUSS DESIGN — DENVER, CO**
Creative Team: **ELLEN BRUSS, CHARLES CARPENTER, STEVE RURA**
Client: **HYDE PARK JEWLERS**

Creative Firm: **ORANGESEED DESIGN — MINNEAPOLIS, MN**
Creative Team: **DAMIEN WOLF, DALE MUSTFUL, ROB REBISCHKE**
Client: **MONTANA LEGEND**

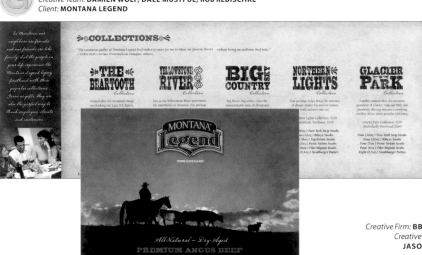

Creative Firm: **BBK STUDIO — GRAND RAPIDS, MI**
Creative Team: **YANG KIM, BRIAN HAUCH, JASON MURRAY, JEREMY FRECHETTE, DAVID KNORR**
Client: **STEELCASE**

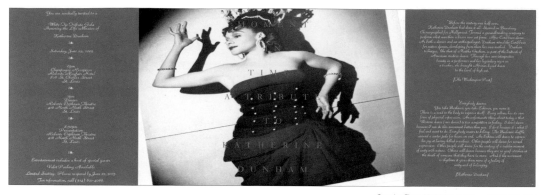

Creative Firm: **GRIZZELL & CO. — ST. LOUIS, MO**
Creative Team: **JOHN H. GRIZZELL**
Client: **FRIENDS OF KATHERINE DUNHAM**

Creative Firm: **CMT — NEW YORK, NY**
Creative Team: **JAMES HITCHCOCK, AMIE NGUYEN, NORA GAFFNEY**
Client: **CMT**

Creative Firm: **HULL CREATIVE GROUP — BROOKLINE, MA**
Creative Team: **CARYL H. HULL, SUSAN ZANEY**
Client: **DANFORTH MUSEUM OF ART**

Creative Firm: **COMEDY CENTRAL — NEW YORK, NY**
Creative Team: **ROLYN BARTHELMAN**

 Creative Firm: **TORRE LAZUR MCCANN — PARSIPPANY, NJ**
Creative Team: **DAVID PROUDFOOT, KATHRYN LIEBERTHAL, JULIET ALVAREZ, JENNIFER ALAMPI, MARCIA GODDARD**
Client: **BMS / SANOFI**

Creative Firm: **TLC DESIGN — CHURCHVILLE, VA**
Creative Team: **TRUDY L. COLE**
Client: **TLC DESIGN**

Creative Firm: **PATRICK HENRY CREATIVE PROMOTIONS, INC. — STAFFORD, TX**
Creative Team: **CATHY DONALDSON**
Client: **PATRICK HENRY CREATIVE PROMOTIONS, INC.**

Creative Firm: **FIVE VISUAL COMMUNICATION & DESIGN
— WEST CHESTER, OH**
Creative Team: **RONDI TSCHOPP**
Client: **FAIRFIELD COMMUNITY ARTS CENTER**

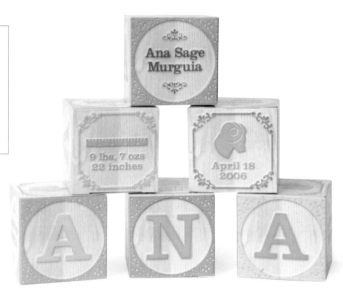

Creative Firm: **KOR GROUP — BOSTON, MA**
Creative Team: **KAREN DENDY SMITH, BRIGITTE TING**
Client: **ZOO NEW ENGLAND**

Creative Firm: **DISCO DOG DESIGN — SAUSALITO, CA**
Creative Team: **BETHANIE MURGUIA**

Creative Firm: **WALLACE CHURCH, INC. — NEW YORK, NY**
Creative Team: **STAN CHURCH, MARITESS MANALUZ**
Client: **WALLACE CHURCH, INC.**

Creative Firm: **BRC MARKETING,INC — DAYTON, OH**
Creative Team: **DOM CIMEI, JASON KANTER, MARY FRANCES RODRIGUEZ, AMBER MOORE**
Client: **BRC**

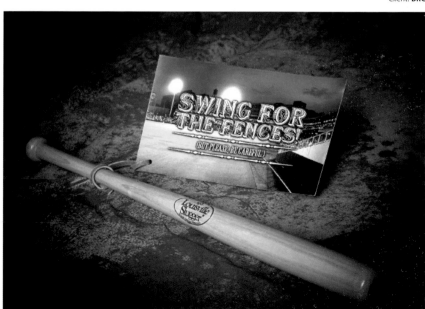

APR-MAY

getch'er hot dog!

JUN - JUL

popcorn here!

AUG-SEP

getch'er soda!

Creative Firm: WALLACE CHURCH, INC. — NEW YORK, NY
Creative Team: STAN CHURCH, JHOMY IRRAZABA, RICH RICKABY, SHERRI SEBASTIAN
Client: WALLACE CHURCH, INC.

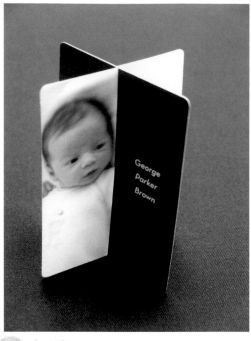

Creative Firm: ELLEN BRUSS DESIGN — DENVER, CO
Creative Team: ELLEN BRUSS, CHARLES CARPENTER
Client: MARK AND RACHEL BROWN

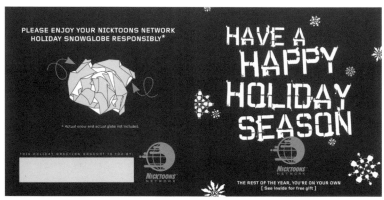

PLEASE ENJOY YOUR NICKTOONS NETWORK
HOLIDAY SNOWGLOBE RESPONSIBLY*

HAVE A HAPPY HOLIDAY SEASON

* Actual snow and actual globe not included.

THIS HOLIDAY GREETING BROUGHT TO YOU BY:

THE REST OF THE YEAR, YOU'RE ON YOUR OWN
[See inside for free gift]

Creative Firm: NICKTOONS — NEW YORK, NY
Creative Team: TERRY MCCORMICK, SUE KIM
Client: NICKTOONS NETWORK

Creative Firm: ORIGINAL IMPRESSIONS — MIAMI, FL
Creative Team: FRANK IRIAS
Client: ST. THOMAS UNIVERSITY

Caribbean Carnivale

Friday, May 13, 2005

Parrot Jungle Island

Creative Firm: PARSONS BRINCKERHOFF — NEW YORK, NY
Creative Team: ANA TIBURCIO-RIVERA
Client: PARSONS BRINCKERHOFF

Creative Firm: GRAFIK MARKETING COMMUNICATIONS — ALEXANDRIA, VA
Creative Team: MICHELLE MAR COLLINS, MICHAEL MATEOS, LYNN UMEMOTO
Client: MCKEE NELSON, LLP

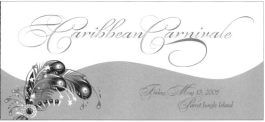

YOU'LL FIND US IN OUR NEW OFFICES AT

McKee Nelson LLP

celebrate!

please join us for a celebration of the season!

Parsons Brinckerhoff invites you

when:
November 9, 2005

6:00-9:30pm
reception/open house
for our clients,
colleagues & friends

where:
Pyramid
1029 "K" Street,
Downtown Sacramento

RSVP by November 1, 2005

Creative Firm: **GRAFIK MARKETING COMMUNICATIONS — ALEXANDRIA, VA**
Creative Team: **GREGG GLAVIANO, MILA ARRISUENO, LYNN MURPHY, REGINA ESPOSITO**
Client: **SMITHSONIAN LATINO CENTER**

WISHING YOU

Creative Firm: **PHP COMMUNICATIONS — BIRMINGHAM, AL**
Creative Team: **BRYAN CHACE, LYNN SMITH**
Client: **PHP COMMUNICATIONS**

Creative Firm: **HERBERGER COLLEGE OF FINE ARTS — TEMPE, AZ**
Creative Team: **AMY NG, MARTHA KNIGHT, STACEY SHAW, TIM TRUMBLE**
Client: **HERBERGER COLLEGE OF FINE ARTS**

Creative Firm: **HBO OFF-AIR CREATIVE SERVICES — NEW YORK, NY**
Creative Team: **VENUS DENNISON, IVY CALAHORRANO, JOSE MENDEZ, IMELDA MOCARSKI**
Client: **HBO MEDIA RELATIONS**

Creative Firm: **THE HUMANE SOCIETY OF THE UNITED STATES — WASHINGTON, DC**
Creative Team: **PAULA JAWORSKI, ANNE LEUCK FELDHAUS**
Client: **THE HUMANE SOCIETY OF THE UNITED STATES**

Creative Firm: **CSC'S P2 COMMUNICATIONS SERVICES — FALLS CHURCH, VA**
Creative Team: **NANCY NAUGHTON, TERRY WILSON, AARON KOBILIS, LYNN JEUNETTE, ADAM DONOVAN**
Client: **CSC CORPORATE**

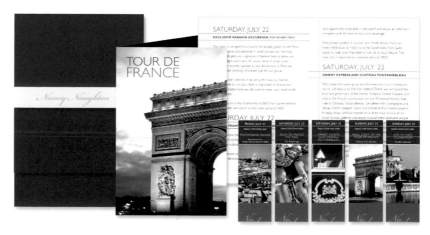

 Creative Firm: **ELLEN BRUSS DESIGN — DENVER, CO**
Creative Team: **ELLEN BRUSS, CHARLES CARPENTER**
Client: **ELLEN BRUSS DESIGN**

Creative Firm: **CRABTREE & COMPANY
— FALLS CHURCH, VA**
Creative Team: **SUSAN ANGRISANI, TAMERA FINN**
Client: **DISCOVERY CREEK**

Creative Firm: **CREATIVE ALLIANCE — LOUISVILLE, KY**
Creative Team: **JOE ADAMS, ERIC HA**
Client: **CREATIVE ALLIANCE**

Creative Firm: **BELYEA — SEATTLE, WA**
Creative Team: **RON HANSEN, NAOMI COX, SHERI-LOU STANNARD**
Client: **COLORGRAPHICS**

Creative Firm: **GEE + CHUNG DESIGN — SAN FRANCISCO, CA**
Creative Team: **EARL GEE, EARL GEE, FANI CHUNG, EARL GEE, KEVIN NG**
Client: **DCM**

Creative Firm: **A3 DESIGN — CHARLOTTE, NC**
Creative Team. **ALAN ALTMAN, AMANDA ALTMAN, MARIE LORIMER**
Client: **MATTAMY HOMES**

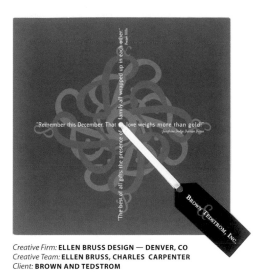

Creative Firm: **ELLEN BRUSS DESIGN — DENVER, CO**
Creative Team: **ELLEN BRUSS, CHARLES CARPENTER**
Client: **BROWN AND TEDSTROM**

Creative Firm: **PHOENIX CREATIVE GROUP, LLC — POTOMAC FALLS, VA**
Creative Team: **SEAN MULLINS**
Client: **BATES-WHITE**

Creative Firm: **THE HUMANE SOCIETY OF THE UNITED STATES — WASHINGTON, DC**
Creative Team: **PAULA JAWORSKI, PATTI GAY**
Client: **THE HUMANE SOCIETY OF THE UNITED STATES**

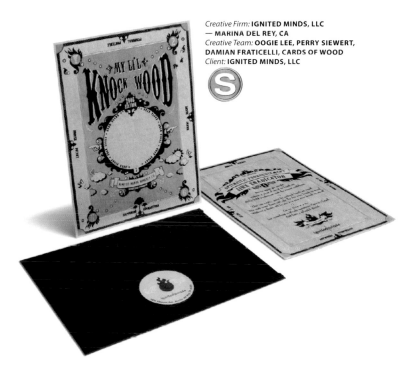

Creative Firm: **IGNITED MINDS, LLC — MARINA DEL REY, CA**
Creative Team: **OOGIE LEE, PERRY SIEWERT, DAMIAN FRATICELLI, CARDS OF WOOD**
Client: **IGNITED MINDS, LLC**

Creative Firm: **SPIKE TV — NEW YORK, NY**
Creative Team: **ANDRE RAZO, BOB SALAZAR, MILINDA ZUMPANO**
Client: **SPIKE**

Creative Firm: **LYNN CYR DESIGN — ST-JEAN-DE-LA-LANDE, QC, CANADA**
Creative Team: **LYNN CYR**
Client: **LYNN CYR DESIGN**

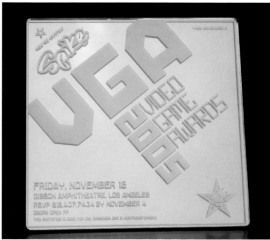

Creative Firm: **MTV NETWORKS CREATIVE SERVICES — NEW YORK, NY**

Creative Firm: **GREENFIELD/BELSER LTD. — WASHINGTON, DC**
Creative Team: **MARK LEDGERWOOD, SHIKHA SAVDAS, CAROLYN SEWELL, GENE SHAFFER**
Client: **INTERNATIONAL CENTER FOR RESEARCH ON WOMEN**

Creative Firm: **PEGGY LAURITSEN DESIGN GROUP — MINNEAPOLIS, MN**
Creative Team: **BRIAN DANAHER**

Creative Firm: **DESIGN GUYS — MINNEAPOLIS, MN**
Creative Team: **STEVE SIKORA, BARRY TOWNSEND, JAY THEIGE, JAY THEIGE, KAREN LOKENSGARD, SHAPCO PRINTING**
Client: **MINNESOTA PUBLIC RADIO**

Creative Firm: **GEE + CHUNG DESIGN — SAN FRANCISCO, CA**
Creative Team: **EARL GEE, EARL GEE, FANI CHUNG, EARL GEE**
Client: **DCM**

Creative Firm: **19NOVANTA COMMUNICATION PARTNERS — ROME, ITALY**
Creative Team: **CONSUELO UGHI, ANDREA PROVVIDENZA, LUCA BALDI, VALERIA CIARDULLI, ROCCO VIGGIANO, MARIO BIZZARRI**

Creative Firm: **DAWN DESIGN — CHICAGO, IL**
Creative Team: **DAWN PECCATIELLO**
Client: **UIC- COLLEGE OF PHARMACY**

Creative Firm: **BRC MARKETING INC — DAYTON, OH**
Creative Team: **DOM CIMEI, MARK MARTEL, AMBER MOORE**

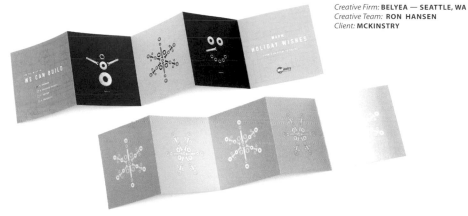

Creative Firm: **BELYEA — SEATTLE, WA**
Creative Team: **RON HANSEN**
Client: **MCKINSTRY**

Creative Firm: **AD HARVEST — SIMPSONVILLE, KY**
Creative Team: **MARK GROVES**
Client: **MELINDA & BEN HARDIN**

Creative Firm: **TOM FOWLER, INC. — NORWALK, CT**
Creative Team: **ELIZABETH P. BALL**
Client: **NORWALK EMERGENCY SHELTER**

Creative Firm: **ELLEN BRUSS DESIGN — DENVER, CO**
Creative Team: **ELLEN BRUSS, STEVE RURA**
Client: **THE LAB AT BELMAR**

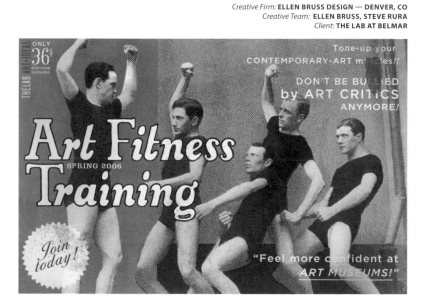

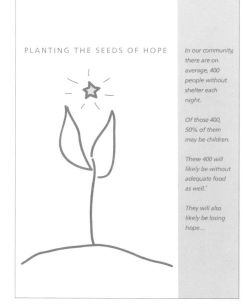

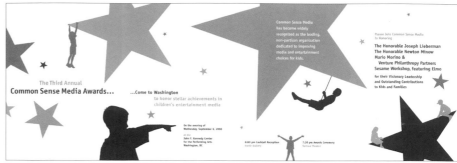

Creative Firm: **CRABTREE & COMPANY — FALLS CHURCH, VA**
Creative Team: **SUSAN ANGRISANI, ROD VERA**
Client: **COMMON SENSE MEDIA**

Creative Firm: **LAJEUNESSE COMMUNICATION MARKETING — MONTREAL, QC, CANADA**
Creative Team: **YVES DUQUETTE, NATHALIE DAIGLE**

Creative Firm: **AD HARVEST — SIMPSONVILLE, KY**
Creative Team: **MARK GROVES**
Client: **SHELBY COUNTY REUNION**

Creative Firm: **PRIMARY DESIGN, INC. — HAVERHILL, MA**
Creative Team: **LIZ FEDORZYN, JULES EPSTEIN, SHARYN ROGERS**
Client: **PRIMARY DESIGN, INC.**

Creative Firm: **MTV NETWORKS CREATIVE SERVICES — NEW YORK, NY**

Creative Firm: **ELEVATOR — SPLIT, CROATIA (HRVATSKA)**
Creative Team: **TONY ADAMIC, GORANA MARSIC**
Client: **PORTUS ADRIA**

PASSPORT

₤ Open House & Wine Tasting ₤

McKee Nelson LLP

FRANCE

WHEN winemakers in the New World decided that they had the climate and geology to make world class wines, they invariably looked to the wine regions of France for inspiration. The Chateaux of Bordeaux were the benchmarks for top quality Cabernet and Merlot based reds. The incredible vineyards of Burgundy's famed Cote D'Or were world renowned for producing the finest Pinot Noir and Chardonnay in the world, and the great wine regions of the northern Rhone earned Syrah a reputation as one of the finest red wine grapes in the world.

France's centuries-old wine trade was organized based on the firm belief that the *terroir* of a vineyard site is the single most important determinant of a wine's style and quality. The resulting wines are the classics of the wine world, and the importance of place is evident in the fact that the name of the vineyard, town or region is almost always the most dominant identifying feature on each label. It is dangerous to generalize in the wine business, but Old World wines tend to be elegant, more subtle, more *terroir* driven than their New World counterparts, while New World wines tend to offer

more ripeness, power, and solid rich opulence. This is in some cases reflective of the fact that many New World regions are warmer than those in the Old World, and this warmth results in grapes with more natural ripeness and wines that are fuller and more fruit driven. But these differences also stem from the Old World philosophy that places emphasis on the *terroir* and all of the tradition that surrounds this belief.

[BIENVENUE · 33RD FLOOR]

06

07

Creative Firm: **GRAFIK MARKETING COMMUNICATIONS — ALEXANDRIA, VA**
Creative Team: **MICHELLE MAR COLLINS, MILA ARRISUENO, LYNN UMEMOTO, HEATH DWIGGINS, REGINA ESPOSITO**
Client: **MCKEE NELSON, LLP**

Creative Firm: **THE HUMANE SOCIETY OF THE UNITED STATES — WASHINGTON, DC**
Creative Team: **PAULA JAWORSKI**
Client: **THE HUMANE SOCIETY OF THE UNITED STATES**

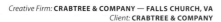

Creative Firm: **JACK NADEL INTERNATIONAL — LOS ANGELES, CA**
Creative Team: **SCOTT BROWN, SAM MINSTER**
Client: **JACK NADEL INTERNATIONAL**

Creative Firm: **SILVER COMMUNICATIONS INC — NEW YORK, NY**
Creative Team: **GREGG SIBERT , CHRISTINA WEISSMAN**
Client: **EAST MIDTOWN ASSOCIATION**

Creative Firm: **CRABTREE & COMPANY — FALLS CHURCH, VA**
Client: **CRABTREE & COMPANY**

Creative Firm: **ELLEN BRUSS DESIGN — DENVER, CO**
Creative Team: **ELLEN BRUSS, STEVE RURA**
Client: **THE LAB AT BELMAR**

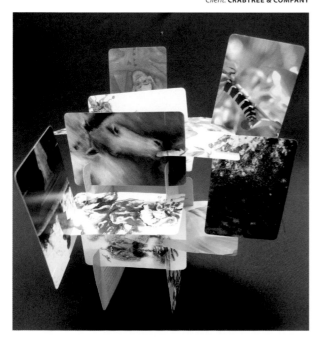

COLLATERAL MATERIAL

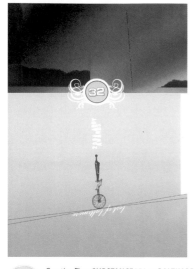

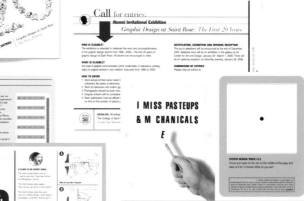

 Creative Firm: **SUBSTANCE151 — BALTIMORE, MD**
Creative Team: **IDA CHEINMAN, RICK SALZMAN**
Client: **ADVERTISING ASSOCIATION OF BALTIMORE**

Creative Firm: VINCE RINI DESIGN — HUNTINGTON BEACH, CA
Creative Team: VINCE RINI
Client: NEWPORT ORTHOPEDIC INSTITUTE

Creative Firm: **THE COLLEGE OF SAINT ROSE — ALBANY, NY**
Creative Team: **MARK HAMILTON, CHRIS PARODY,**
LUIGI BENINCASA, KRISTINE HERRICK
Client: **THE COLLEGE OF SAINT ROSE**

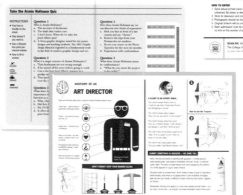

Creative Firm: **LOGO — NEW YORK, NY**
Creative Team: **NANCY BENNETT, TOM BAYER,**
VALENTINA AKERMAN, WAGNER WAGNER, VINNY LOPEZ
Client: **LOGO MARKETING**

Creative Firm: **ALOFT GROUP, INC. — NEWBURYPORT, MA**
Creative Team: **DON CRANE, KIM CILLEY**
Client: **DICTAPHONE HEALTHCARE**

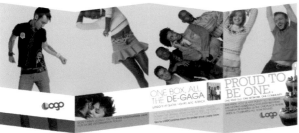

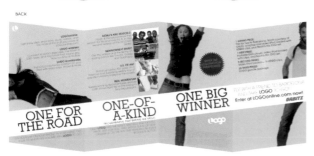

Hands-on training
Career-oriented skills
Industry connections

Creative Firm: **BRC MARKETING,INC — DAYTON, OH**
Creative Team: **MARY FRANCES RODRIGUEZ, DOM CIMEI, JASON KANTNER, JEFFREY DUSKO, VIRVE TREMBLAY, AMBER MOORE**
Client: **NCR**

Creative Firm: **HENRYGILL ADVERTISING — DENVER, CO**
Creative Team: **BRYANT FERNANDEZ**
Client: **REDSTONE COLLEGE**

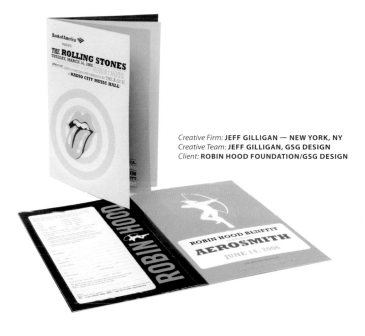

Creative Firm: **JEFF GILLIGAN — NEW YORK, NY**
Creative Team: **JEFF GILLIGAN, GSG DESIGN**
Client: **ROBIN HOOD FOUNDATION/GSG DESIGN**

Creative Firm: **YOUNG & RUBICAM GMBH & CO. KG
— FRANKFURT AM MAIN, HESSEN, GERMANY**
Creative Team: **CHRISTIAN DAUL, UWE MARQUARDT, MONIKA SPIRKL**
Client: **FRAUENNOTRUF FRANKFURT (WOMEN'S EMERGENCY CALL)**

Women's Emergency Call Frankfurt, "Bag"

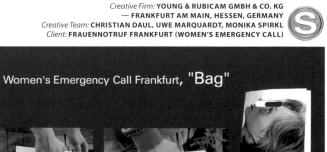

Briefing was to raise attention for Women's
Emergency Call Frankfurt hot line. The bags in
combination with the hand of the carrier transport
the common widely ignored problem of abuse
and violence against women to the public.

Creative Firm: **YELLOW SHOES CREATIVE WEST,
DISNEYLAND RESORT — ANAHEIM, CA**
Creative Team: **DATHAN SHORE, WES CLARK,
MARTY MULLER, JACQUELYN MOE,
KEVIN YONEDA**
Client: **DISNEYLAND RESORT**

Creative Firm: **MNA CREATIVE — DANBURY, CT**
Creative Team: **MNA CREATIVE - THE ENTIRE AGENCY**
Client: **TSINGTAO**

Creative Firm: **PALIO COMMUNICATIONS**
— SARATOGA SPRINGS, NY
Creative Team: **TOM ROTHERMEL, LEAH DWORNIK,**
ANALIA DEL GIORGIO, NICK PARSLOW,
ALEN MERCIER, MIREK JANCHOR
Client: **SARATOGA SHAKESPEARE COMPANY**

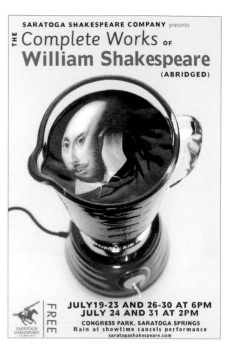

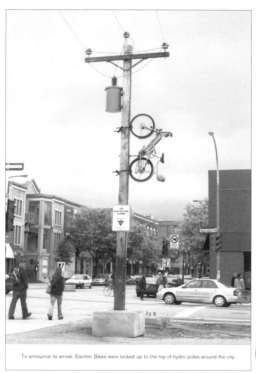

To announce its arrival, Electric Bikes were locked up to the top of hydro poles around the city.

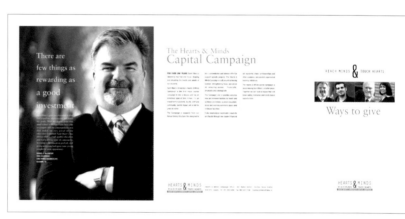

Creative Firm: **TAXI CANADA INC.**
— TORONTO, ON, CANADA
Creative Team: **ZAK MROUEH, LANCE MARTIN,**
SAM CERULLO, JOSEPH BONNICI,
KIRA THOMSON, CHERYL MCKENZIE
Client: **CANADIAN TIRE**

Creative Firm: **MT&L PUBLIC RELATIONS LTD. — HALIFAX, NS, CANADA**
Creative Team: **PAUL WILLIAMS, KELLY CLARK, ANNMARIE GREENE**
Client: **SAINT MARY'S UNIVERSITY**

Creative Firm: **BETH SINGER DESIGN — ARLINGTON, VA**
Creative Team: **BETH SINGER, SUCHA SNIDVONGS**
Client: **AMERICAN ISRAEL PUBLIC AFFAIRS COMMITTEE**

Creative Firm: **KOCH CREATIVE GROUP — WICHITA, KS**
Creative Team: **KAY DAVIS, DUSTIN COMMER**
Client: **YOUTH ENTREPRENEURS OF KANSAS**

Creative Firm: **RULE29 — GENEVA, IL**
Creative Team: **JUSTIN AHERNS, JOSH JENSEN, KERRI LIU, DAN HASSENPLUG, BRIAN MACDONALD, TERRY MARKS**
Client: **O'NEIL PRINTING**

Creative Firm: **REVOLUZION ADVERTISING & DESIGN — NEUHAUSEN OB ECK, GERMANY**
Creative Team: **BERND LUZ, CHRISTOS SCHWEEN**
Client: **ALLEZ-Y SÉJOURS LINGUISTIQUES**

Creative Firm: **TROUTMAN/DEWERTH DESIGN — AKRON, OH**
Creative Team: **JANICE TROUTMAN, BRITTYN DEWERTH, KEVIN OLDS, DUNCAN PRESS**
Client: **EMILY DAVIS GALLERY/THE UNIVERSITY OF AKRON**

Creative Firm: **FITTING GROUP — PITTSBURGH, PA**
Creative Team: **ANDREW ELLIS, TRAVIS NORRIS**
Client: **BLACK KNIGHT SECURITY**

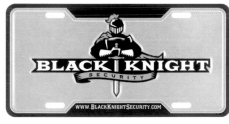

Creative Firm: **MAD DOG GRAPHX — ANCHORAGE, AK**
Creative Team: **KRIS RYAN-CLARKE**
Client: **NANA MANAGEMENT SERVICES**

Creative Firm: **COMCAST SPOTLIGHT — MALVERN, PA**
Creative Team: **CARA NGO, ANN LETIZI**
Client: **COMCAST SPOTLIGHT**

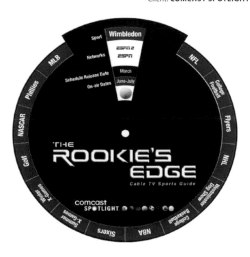

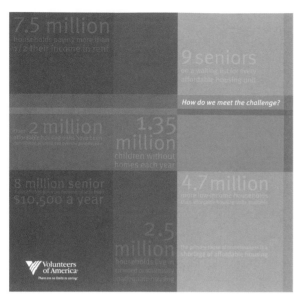

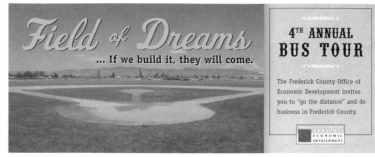

Creative Firm: **OCTAVO DESIGNS — FREDERICK, MD**
Creative Team: **SUE HOUGH, MARK BURRIER**
Client: **FREDERICK COUNTY OFFICE OF ECONOMIC DEVELOPMENT**

Creative Firm: **GRAFIK MARKETING COMMUNICATIONS — ALEXANDRIA, VA**
Creative Team: **KRISTIN MOORE, MILA ARRISUENO, MELBA BLACK, IVAN HOOKER**
Client: **VOLUNTEERS OF AMERICA**

Creative Firm: **ACOSTA DESIGN INC — NEW YORK, NY**
Creative Team: **MAURICIO ACOSTA**
Client: **NCG**

Creative Firm: **KOLANO DESIGN — PITTSBURGH, PA**
Creative Team: **BILL KOLANO, TIMOTHY CARRERA**
Client: **DONNA HOLDORF — NATIONAL ROAD HERTIAGE CORRIDOR**

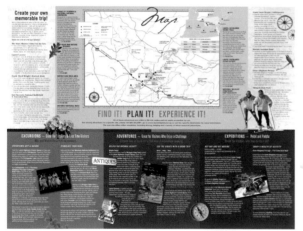

Creative Firm: **DESIGN OBJECTIVES PTE LTD — SINGAPORE**
Creative Team: **RONNIE S C TAN**
Client: **MERITUS SUITES STATE TOWER. BANGKOK**

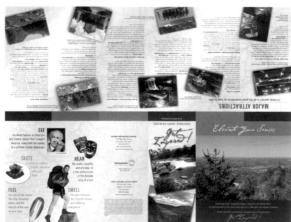

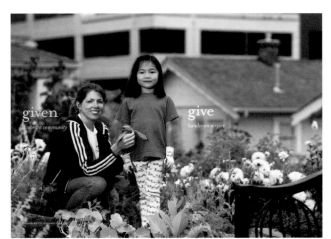

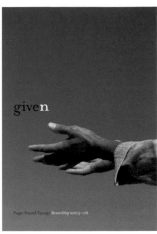

Creative Firm: **THINKHOUSE CREATIVE — ATLANTA, GA**
Client: **PUGET SOUND ENERGY**

Creative Firm: **BBK STUDIO — GRAND RAPIDS, MI**
Creative Team: **MICHELE CHARTIER, TIM CALKINS**
Client: **DYER-IVES FOUNDATION**

Creative Firm: **DESIGN GUYS — MINNEAPOLIS, MN**
Creative Team: **STEVE SIKORA, KELLY MUNSON,
JEFF MUELLER, GEORGE HEINRICH**
Client: **NEENAH PAPER**

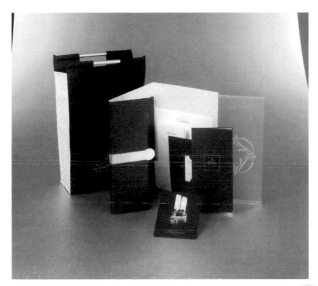

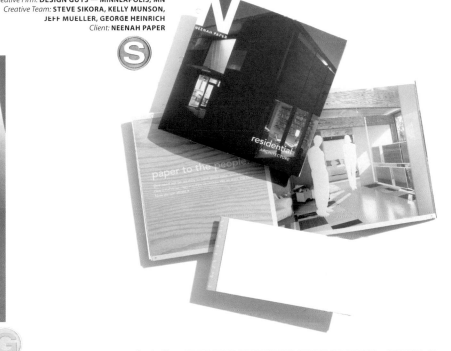

Creative Firm: **G2 — NEW YORK, NY**
Creative Team: **BEN GOLD, RAY MARRERO, DANIELA MASIELLO, JIHEE KIM,
MEGAN TRINIDAD**
Client: **RUSHMORE**

Creative Firm: **YELLOW SHOES CREATIVE WEST, DISNEYLAND RESORT — ANAHEIM, CA**
Creative Team: **DATHAN SHORE, WES CLARK, MARTY MULLER, JACQUELYN MOE,
JIM ST. AMANT, SHAG**
Client: **DISNEYLAND RESORT**

Creative Firm: **DAVIS DESIGN PARTNERS
— HOLLAND, OH**
Creative Team: **MATT DAVIS, KAREN DAVIS,
GABRIEL AMADEAUS COONEY,
JOSEPH W. DARWAL,
UNIVERSITY SCHOOL ARCHIVES**
Client: **UNIVERSITY SCHOOL**

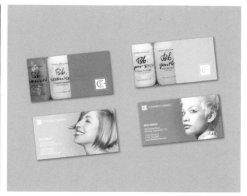

Creative Firm: **VELOCITY DESIGN WORKS — WINNIPEG, MB, CANADA**
Creative Team: **LASHA ORZECHOWSKI**
Client: **EDWARD CARRIERE**

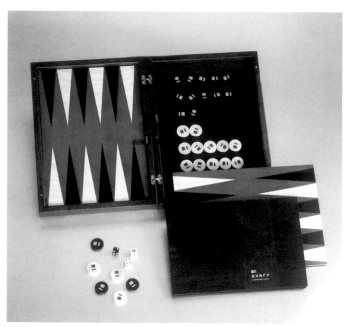

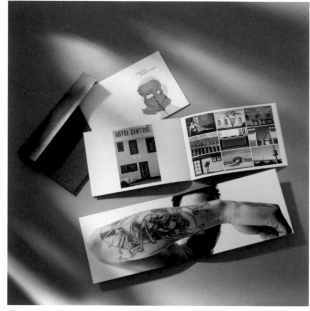

Creative Firm: **INTERROBANG DESIGN COLLABORATIVE, INC. — RICHMOND, VT**
Creative Team: **MARK D. SYLVESTER, BOB PACKERT, SHARON WHITE**
Client: **WHITE / PACKERT PHOTOGRAPHY**

Creative Firm: **G2 — NEW YORK, NY**
Creative Team: **BEN GOLD, RAY MARRERO, DANIELA MASIELLO**
Client: **AVERY**

Creative Firm: **NBC UNIVERSAL GLOBAL NETWORKS ITALIA SRL — ROME, ITALY**
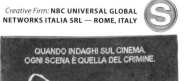

Creative Firm: **CRABTREE & COMPANY — FALLS CHURCH, VA**
Creative Team: **SUSAN ANGRISANI, TAMERA FINN**
Client: **NATIONAL ASSOCIATION OF REALTORS®**

Creative Firm: **AD HARVEST — SIMPSONVILLE, KY**
Creative Team: **MARK GROVES**
Client: **SHELBY COUNTY COMMUNITY THEATRE**

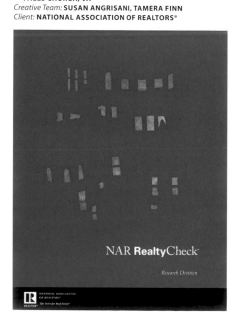

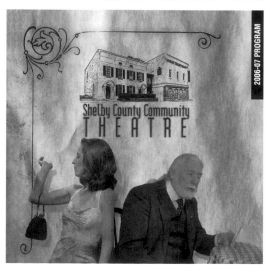

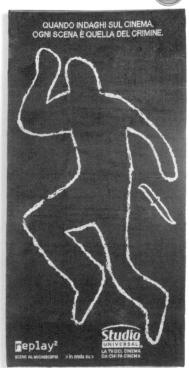

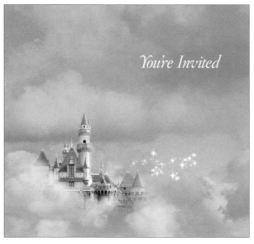

Creative Firm: **YELLOW SHOES CREATIVE WEST, DISNEYLAND RESORT — ANAHEIM, CA**
Creative Team: **STEVEN GERRY, WES CLARK, MARTY MULLER, JACQUELYN MOE, ANIKO BOTA**
Client: **DISNEYLAND RESORT**

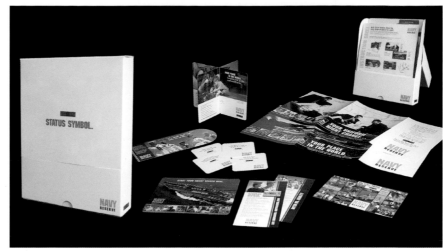

Creative Firm: **CAMPBELL-EWALD — WARREN, MI**
Creative Team: **BILL LUDWIG, SUSAN LOGAR BRODY, RAYMOND ALLSTON, ILYA HARDEY, DAVID BARLOW, CHAD WOOLUMS**
Client: **THE UNITED STATES NAVY**

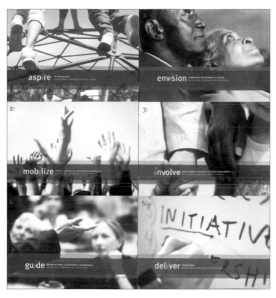

Creative Firm: **GRAFIK MARKETING COMMUNICATIONS — ALEXANDRIA, VA**
Creative Team: **GREGG GLAVIANO, MILA ARRISUENO, REGINA ESPOSITO, IVAN HOOKER**
Client: **UNITED WAY**

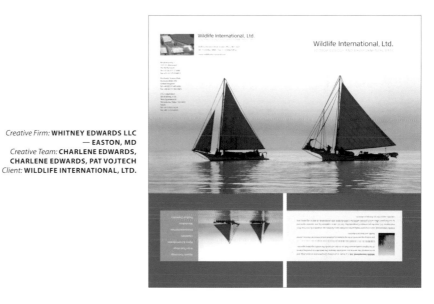

Creative Firm: **WHITNEY EDWARDS LLC — EASTON, MD**
Creative Team: **CHARLENE EDWARDS, CHARLENE EDWARDS, PAT VOJTECH**
Client: **WILDLIFE INTERNATIONAL, LTD.**

Creative Firm: **DESIGN HOCH DREI — STUTTGART, BADEN-WÜRTTEMBERG, GERMANY**
Creative Team: **SUSANNE WACKER, TOBIAS KOLLMANN, IOANNIS KARANASIOS**
Client: **DAIMLER CHRYSLER AG**

Creative Firm: **YELLOW SHOES CREATIVE WEST, DISNEYLAND RESORT — ANAHEIM, CA** *Creative Team:* **DATHAN SHORE, WES CLARK, JACQUELYN MOE, JIM ST. AMANT, MICHAEL FIRMAN**
Client: **DISNEYLAND RESORT**

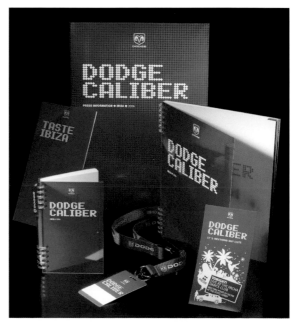

Creative Firm: **HELENA SEO DESIGN & SCHULTE DESIGN — SUNNYVALE, CA**
Client: **MPM CAPITAL**

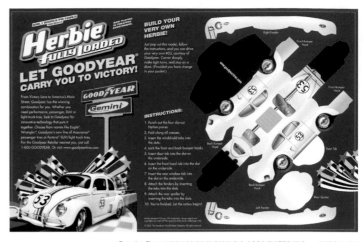

Creative Firm: **HITCHCOCK FLEMING & ASSOCIATES INC. — AKRON, OH**
Creative Team: **NICK BETRO, CHUCK REPEDE, LENNY SPENGLER, MATT MCCALLUM**
Client: **GOODYEAR TIRE & RUBBER COMPANY**

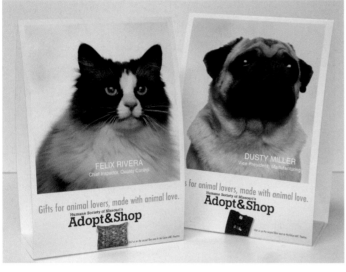

Creative Firm: **RODGERS TOWNSEND — ST. LOUIS, MO**
Creative Team: **ERIK MATHRE, MARK ARNOLD, TODD MITCHELL, CHERYL SPARKS**
Client: **HUMANE SOCIETY OF MISSOURI**

Creative Firm: **SUKA DESIGN — NEW YORK, NY**
Creative Team: **MARIA BELFIORE**
Client: **THE POLLOCK-KRASNER REPORT**

Creative Firm: **ORIGINAL IMPRESSIONS — MIAMI, FL**
Creative Team: **LISA CUERVO**
Client: **YACHTSMAN'S COVE**

Creative Firm: **ALCONE MARKETING — IRVINE, CA**
Creative Team: **CARLOS MUSQUEZ, JULIE KIMURA, SHIVONNE MILLER, LUIS CAMANO**
Client: **EBAY**

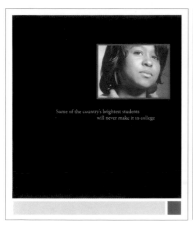

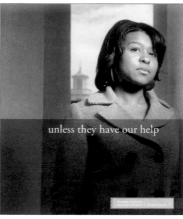

Creative Firm: **GRAFIK MARKETING COMMUNICATIONS — ALEXANDRIA, VA**
Creative Team: **MICHAEL MATEOS, HAL SWETNAM, IVAN HOOKER, MAX HIRSHFELD**
Client: **WASHINGTON METROPOLITAN SCHOLARS**

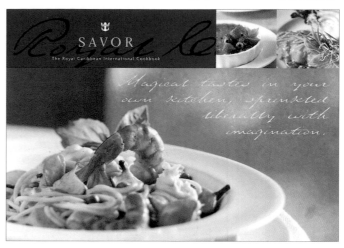

Creative Firm: **ORIGINAL IMPRESSIONS — MIAMI, FL**
Creative Team: **FRANK IRIAS**
Client: **ROYAL CARIBBEAN INTERNATIONAL**

Creative Firm: **CSC'S P2 COMMUNICATIONS SERVICES — FALLS CHURCH, VA**
Creative Team: **NANCY NAUGHTON, JENNIFER VOLTAGGIO, AARON KOBILIS, TERRY WILSON, JOHN LANCASTER, LALITHA SUNDARAM**
Client: **CSC GLOBAL LEARNING DEVELOPMENT MANAGEMENT (GLDM)**

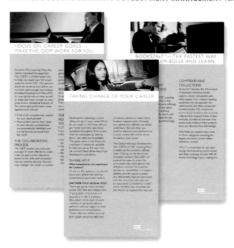

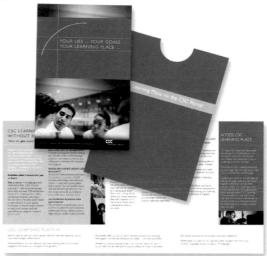

Creative Firm: **BETH SINGER DESIGN — ARLINGTON, VA**
Creative Team: **BETH SINGER, HOWARD SMITH, DON WHELAN, ELLEN KARDELL, LISA CORDES, TRACI SLATER-RIGAUD**
Client: **PRESIDENT'S COMMITTEE ON THE ARTS AND HUMANITIES**

Creative Firm: **MCGRAW-HILL CORPORATE CREATIVE SERVICES — NEW YORK, NY**
Creative Team: **MARIANNE JOHNSTON, PAUL BIEDERMANN**
Client: **MCGRAW-HILL CORPORATE ROYALTY OPERATIONS**

Creative Firm: **ORANGESEED DESIGN — MINNEAPOLIS, MN**
Creative Team: **DAMIEN WOLF, JOHN WIELAND, REBECCA AVIÑA**
Client: **TWIN CITIES MARATHON**

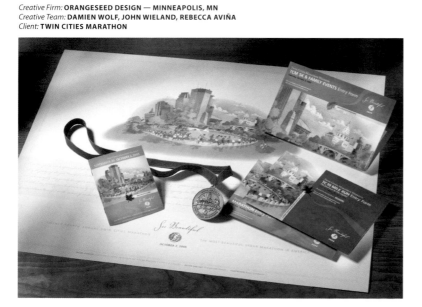

COLLATERAL MATERIAL

Creative Firm: **Q — WIESBADEN, GERMANY**
Creative Team: **THILO VON DEBSCHITZ, MATTHIAS FREY, UTE DERSCH**
Client: **ARJOWIGGINS**

Creative Firm: **BBK STUDIO — GRAND RAPIDS, MI**
Creative Team: **SHARON OLENICZAK, BRIAN HAUCH, TIM CALKINS, YANG KIM**
Client: **HERMAN MILLER**

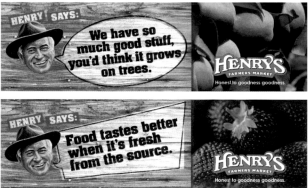

Creative Firm: **HOFFMAN/LEWIS — SAN FRANCISCO, CA**
Creative Team: **SHARON KRINSKY, JAMES CABRAL, RONDA DUNN, JASON HEADLEY**
Client: **HENRY'S**

Creative Firm: **A3 DESIGN — CHARLOTTE, NC**
Creative Team: **ALAN ALTMAN, AMANDA ALTMAN**
Client: **LIMERICK STUDIOS**

Creative Firm: **MCGRAW-HILL CORPORATE CREATIVE SERVICES — NEW YORK, NY**
Creative Team: **MARIANNE JOHNSTON, PAUL BIEDERMANN**
Client: **MCGRAW-HILL CORPORATE HUMAN RESOURCES**

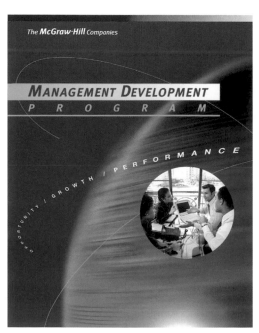

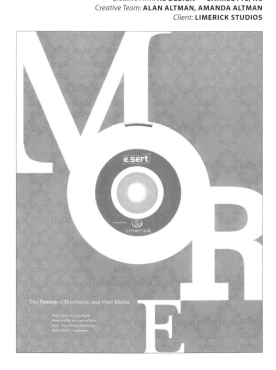

Creative Firm: **ISLAND OASIS — WALPOLE, MA**
Creative Team: **JENNY KEECH**
Client: **ISLAND OASIS**

Creative Firm: **JACK NADEL INTERNATIONAL — LOS ANGELES, CA**
Creative Team: **SHELLEY SLUBOWSKI, AMYLIN PHARMECEUTICALS ART DIRECTION**
Client: **AMYLIN PHARMACEUTICALS / ELI LILLY**

PRODUCT / SELL SHEETS

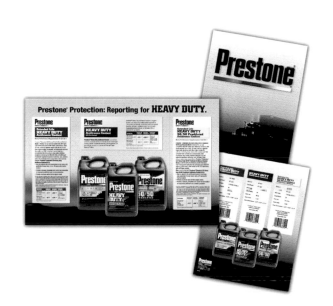

Creative Firm. **TOM FOWLER, INC. — NORWALK, CT**
Creative Team: **MARY ELLEN BUTKUS, BRIEN O'REILLY, THOMAS G. FOWLER**
Client: **HONEYWELL CONSUMER PRODUCTS**

CORPORATE ID MANUALS, *SINGLE*

Creative Firm: **YELLOW SHOES CREATIVE WEST,
DISNEYLAND RESORT — ANAHEIM, CA**
Creative Team: **STEVEN GERRY, WES CLARK,
MARTY MULLER, JACQUELYN MOE,
ANIKO BOTA, CLAIRE BILBY**
Client: **DISNEYLAND RESORT**

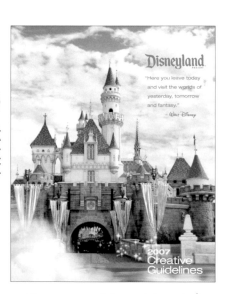

Creative Firm: **SUBPLOT DESIGN INC. — VANCOUVER, BC, CANADA**
Creative Team: **ROY WHITE, MATTHEW CLARK, STEPH GIBSON**
Client: **VANCOUVER AQUARIUM**

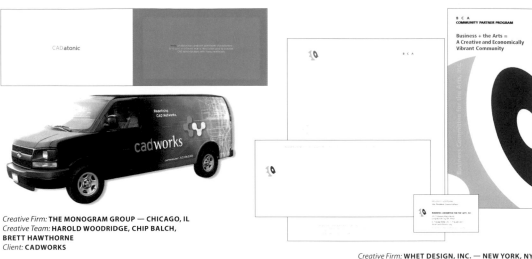

Creative Firm: **THE MONOGRAM GROUP — CHICAGO, IL**
Creative Team: **HAROLD WOODRIDGE, CHIP BALCH,
BRETT HAWTHORNE**
Client: **CADWORKS**

Creative Firm: **WHET DESIGN, INC. — NEW YORK, NY**
Creative Team: **CHERYL OPPENHEIM, JOHN WATERS, YOHEI TAKESHITA**
Client: **BUSINESS COMMITTEE FOR THE ARTS, INC.**

Creative Firm: **REDUCED FAT — SARATOGA SPRINGS, NY**
Creative Team: **JOHN BOLSTER, JOHN MISSALE**
Client: **DEBRA DOCYK**

Creative Firm: **30SIXTY ADVERTISING+DESIGN, INC. — LOS ANGELES, CA**
Creative Team: **HENRY VIZCARRA, DAVID FUSCELLARO, LEE BARETT,
SUZANA LAKATOS, YUJIN ONO, BRUCE VENTANILLA**
Client: **DISNEY CONSUMER PRODUCTS**

Creative Firm: **KARACTERS DESIGN GROUP/DDB CANADA — VANCOUVER, BC, CANADA**
Creative Team: **MARIA KENNEDY, JAMES BATEMAN, MONICA MARTINEZ, TIM HOFFPAUIR,
ANNE FARRER, HELEN WYNNE**
Client: **VANCOUVER 2010 OLYMPIC COMMITTEE**

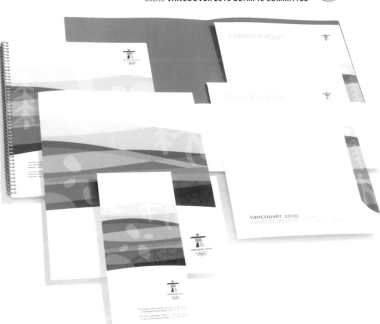

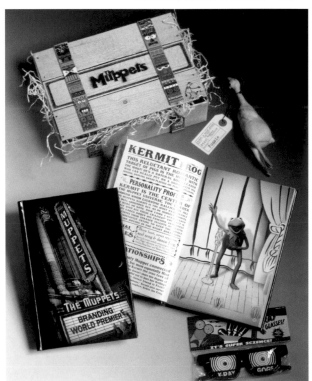

Creative Firm: **STEPHEN LONGO DESIGN ASSOCIATES — WEST ORANGE, NJ**
Creative Team: **STEPHEN LONGO**
Client: **EKKO RESTAURANT**

Creative Firm: **TM&N DESIGN AND BRAND CONSULTANTS LTD. — HONG KONG**
Creative Team: **LEILA NACHTIGALL, JILLIAN LEE, LIEM CHEUNG**
Client: **ZENIKA HOLDINGS LIMITED**

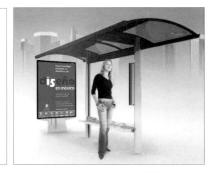

AÑOS
di5eño
en méxico

Creative Firm: **SIGNI
— MEXICO CITY, D.F., MEXICO**
Creative Team: **RENE GALINDO**
Client: **QUORUM**

RETROSPECTIVA DEL PREMIO QUORUM

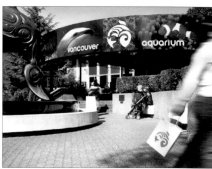

Creative Firm: **SUBPLOT DESIGN INC. — VANCOUVER, BC, CANADA**
Creative Team: **ROY WHITE, MATTHEW CLARK, STEPH GIBSON**
Client: **VANCOUVER AQUARIUM**

Creative Firm: **RUDER FINN DESIGN — NEW YORK, NY**
Creative Team: **MICHAEL SCHUBERT, LISA GABBAY, SAL CATANIA, DIANA YEO, EMILY KORSMO, LAURA VINCHESI**
Client: **NOVARTIS**

Creative Firm: **DON SCHAAF & FRIENDS, INC. — WASHINGTON, DC**
Creative Team: **DON SCHAAF, BRUCE MACINDOE**
Client: **OFFIT KURMAN**

Creative Firm: **KARACTERS DESIGN GROUP/DDB CANADA — VANCOUVER, BC, CANADA**
Creative Team: **JAMES BATEMAN, KARA BOHL, ANNE FARRER, HELEN WYNNE, SCOTT RUSSELL, MARK FINN**
Client: **MOUNTAIN EQUIPMENT CO-OP**

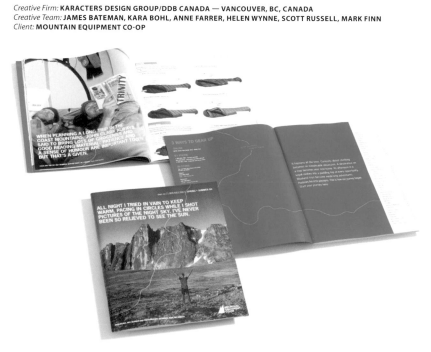

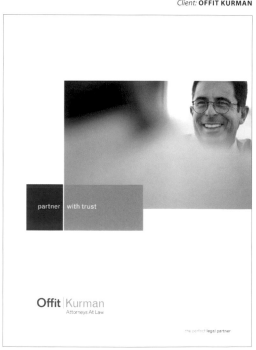

Creative Firm: **SIGNI — MEXICO CITY, D.F., MEXICO**
Creative Team: **RENE GALINDO**
Client: **CICOM**

Creative Firm: **NAMARO GRAPHIC DESIGNS, INC. — RHINEBECK, NY**
Creative Team: **NADINE ROBBINS, MOLLY AHEARN, WENDY MACOMBER**
Client: **CANON USA**

Creative Firm: **NAMARO GRAPHIC DESIGNS, INC. — RHINEBECK, NY**
Creative Team: **NADINE ROBBINS, MOLLY AHEARN**
Client: **NATIONAL EQUITY FUND INC.**

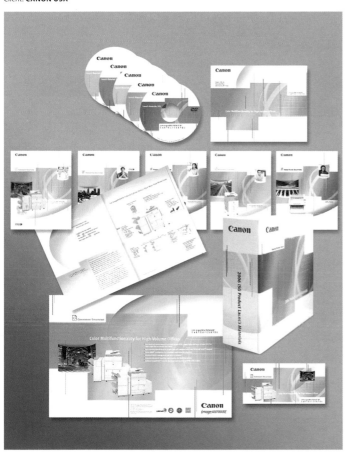
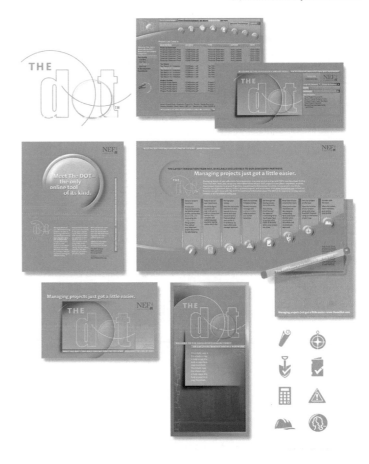

Creative Firm: **KARACTERS DESIGN GROUP/DDB CANADA — VANCOUVER, BC, CANADA**
Creative Team: **JAMES BATEMAN, MARSHA LARKIN, NIKI MATSUMOTO, HELEN WYNNE, MARK FINN, PHIL COLLINS, RUSS HORII**
Client: **NORTHLANDS**

Creative Firm: **LEVINE & ASSOCIATES** — **WASHINGTON, DC**
Creative Team: **GREG SITZMANN, JENNIE JARIEL, MEGAN RIORDAN, MONICA SNELLINGS, LENA MARKLEY**
Client: **LEVINE & ASSOCIATES**

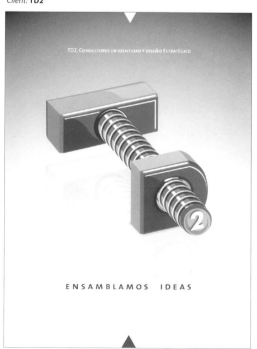

Creative Firm: **SUNSPOTS CREATIVE** — **FRANKLIN LAKES, NJ**
Creative Team: **RICK BONELLI, DEENA HARTLEY, DAVE VIOREANU**
Client: **SUNSPOTS CREATIVE**

Creative Firm: **KARACTERS DESIGN GROUP/DDB CANADA**
— **VANCOUVER, BC, CANADA**
Creative Team: **MARIA KENNEDY, ALAN RUSSELL, KARA BOHL,
JAMES LEE, HELEN WYNNE, LISA GOOD, MARK FINN**
Client: **DDB CANADA**

Creative Firm: **TD2, S.C.** — **MEXICO CITY, D.F., MEXICO**
Creative Team: **VANESSA GARCIA**
Client: **TD2**

Creative Firm: **DESIGN 446** — **MANASQUAN, NJ**
Creative Team: **BRIAN STERN**
Client: **DESIGN 446**

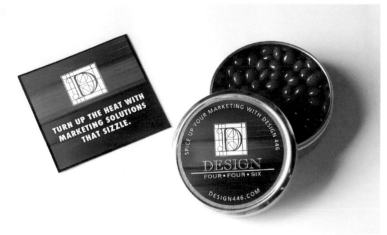

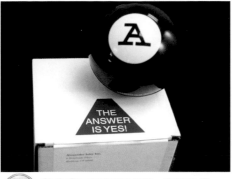

 Creative Firm: **ALEXANDER ISLEY — REDDING, CT**
Creative Team: **ALEXANDER ISLEY, GEORGE KOKKINIDIS, CHERITH VICTORINO**
Client: **ALEXANDER ISLEY INC.**

Creative Firm: **ROTTMAN CREATIVE GROUP — LA PLATA, MD**
Creative Team: **GARY ROTTMAN**
Client: **ROTTMAN CREATIVE GROUP, INC.**

Announcing the arrival of designer
David Hough to Bright Rain Creative,
now wishing you 50% Happier Holidays.

Creative Firm: **BRIGHT RAIN CREATIVE — ST. LOUIS, MO**
Creative Team: **KEVIN HOUGH, DAVID HOUGH**
Client: **BRIGHT RAIN CREATIVE**

Creative Firm: **THE DAVE AND ALEX SHOW — REDDING, CT**
Creative Team: **AMY UNIKEWICZ, DAVE GOLDENBERG**
Client: **THE DAVE AND ALEX SHOW**

Creative Firm: **PHP COMMUNICATIONS — BIRMINGHAM, AL**
Creative Team: **LYNN SMITH**
Client: **PHP COMMUNICATIONS**

MEET BRYAN CHACE

CREATIVE DIRECTOR, PHP COMMUNICATIONS, INC.

Creative Firm: **PHP COMMUNICATIONS — BIRMINGHAM, AL**
Creative Team: **BRYAN CHACE, LYNN SMITH**
Client: **PHP COMMUNICATIONS**

Creative Firm: **TD2, S.C. — MEXICO CITY, D.F., MEXICO**
Creative Team: **R. RODRIGO CORDOVA**
Client: **TD2**

Creative Firm: **CMT — NEW YORK, NY**
Creative Team: **JAMES HITCHCOCK, AMIE NGUYEN, NORA GAFFNEY**
Client: **CMT**

Creative Firm: **OCTAVO DESIGNS — FREDERICK, MD**
Creative Team: **SUE HOUGH, MARK BURRIER**
Client: **OCTAVO DESIGNS**

Creative Firm: **LISKA + ASSOCIATES — CHICAGO, IL**
Creative Team: **STEVE LISKA, SABINE KRAUSS, ANN MARIE GRAY**
Client: **BRININSTOOL + LYNCH**

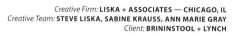

Time for an update?

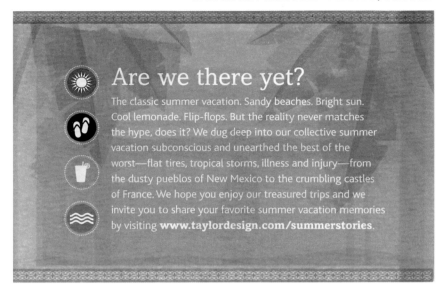

Are we there yet?

The classic summer vacation. Sandy beaches. Bright sun. Cool lemonade. Flip-flops. But the reality never matches the hype, does it? We dug deep into our collective summer vacation subconscious and unearthed the best of the worst—flat tires, tropical storms, illness and injury—from the dusty pueblos of New Mexico to the crumbling castles of France. We hope you enjoy our treasured trips and we invite you to share your favorite summer vacation memories by visiting **www.taylordesign.com/summerstories**.

Creative Firm: **TAYLOR DESIGN — STAMFORD, CT**
Creative Team: **SUZANNE REUSCH, HANNAH FICHANDLER, MARLE BARRETTI, KEN HOCKER, STEVE HABERSANG, MIKE KRAUZ, MICHELLE DOVE**
Client: **TAYLOR DESIGN**

Creative Firm: **BCN COMMUNICATIONS — CHICAGO, IL**
Creative Team: **JAMES PITROSKI, MICHAEL NEU**
Client: **BCN COMMUNICATIONS**

Creative Firm: **DOUBLE TAKE CREATIVE — LAWRENCEVILLE, GA**
Creative Team: **AMY POWERS, VINCENT MARASCHIELLO**
Client: **DOUBLE TAKE CREATIVE**

Creative Firm: **BCN COMMUNICATIONS — CHICAGO, IL**
Creative Team: **MICHAEL O'BRIEN, MICHAEL NEU**
Client: **BCN COMMUNICATIONS**

collaborate *innovate*

Creative Firm: **PHP COMMUNICATIONS — BIRMINGHAM, AL**
Creative Team: **BRYAN CHACE, LYNN SMITH**
Client: **PHP COMMUNICATIONS**

Won more time

PHP Communications is proud to have won hundreds of national and international awards for its clients. Now we've won a big one of our own. Neenah Paper has selected PHP's letterhead package as the "Design of the Year" in the PAPERWORKS Competition. Designed by PHP Art Director Lynn Smith, it's the first such award to a Birmingham agency in years. So for winning communications of all kinds, PHP is the won and only.

Creative Firm: **MARKET STREET MARKETING — REDDING, CA**
Creative Team: **KATHLEEN DOWNS**
Client: **MARKET STREET MARKETING**

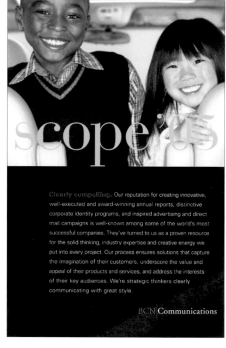

Creative Firm: **BCN COMMUNICATIONS — CHICAGO, IL**
Creative Team: **JAMES PITROSKI, MICHAEL NEU**
Client: **BCN COMMUNICATIONS**

Creative Firm: **PERCEPT CREATIVE GROUP — CRONULLA, NSW, AUSTRALIA**
Creative Team: **LEWIS JENKINS**
Client: **PERCEPT CREATIVE GROUP**

Creative Firm: **JACK NADEL INTERNATIONAL — LOS ANGELES, CA**
Creative Team: **SCOTT BROWN, ROBERT BUCKINGHAM, STEVE WIDDECOMBE**
Client: **JACK NADEL INTERNATIONAL**

Creative Firm: **MYTTON WILLIAMS — BATH, BANES, UNITED KINGDOM**
Creative Team: **BOB MYTTON, GARY MARTYNIAK**

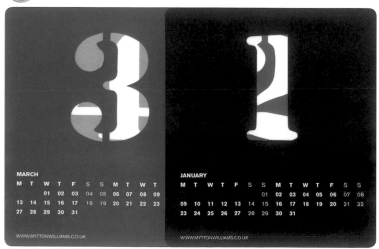

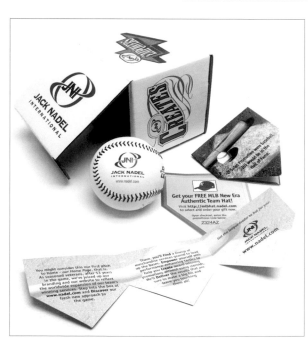

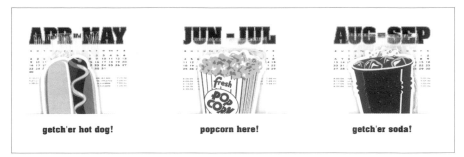

getch'er hot dog!

popcorn here!

getch'er soda!

Creative Firm: **WALLACE CHURCH, INC. — NEW YORK, NY**
Creative Team: **STAN CHURCH, JHOMY IRRAZABA, RICH RICKABY, SHERRI SEBASTIAN**
Client: **WALLACE CHURCH, INC.**

Creative Firm: **UNIVERSITY OF AKRON/DESIGN X NINE — AKRON, OH**
Creative Team: **JANICE TROUTMAN, JOHN MORRISON, DESIGN X NINE TEAM**
Client: **DESIGN X NINE**

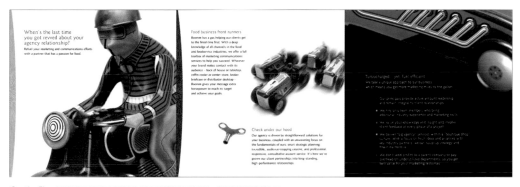

Creative Firm: **BOOMM! MARKETING & COMMUNICATIONS — WESTCHESTER, IL**
Client: **BOOMM! MARKETING & COMMUNICATIONS**

Creative Firm: **GRIFFO — BELÉM, PARÁ, BRAZIL**
Creative Team: **EDGAR CARDOSO, SERGIO BASTOS, ANTÔNIO NATSUO**
Client: **GRIFFO**

Creative Firm: **KAA DESIGN GROUP, INC. - GRAPHICS STUDIO — LOS ANGELES, CA**
Creative Team: **MELANIE ROBINSON, LOUIS-PHILIPPE CARRETTA, WELDON BREWSTER PHOTOGRAPHY, PHILIP CLAYTON THOMPSON PHOTOGRAPHY, BRANDIE HANDELMANN**
Client: **KAA DESIGN GROUP, INC.**

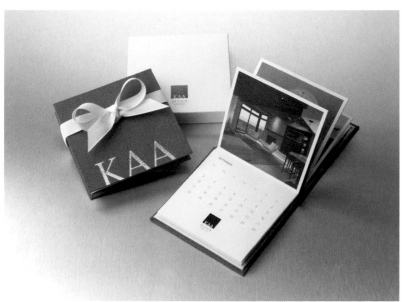

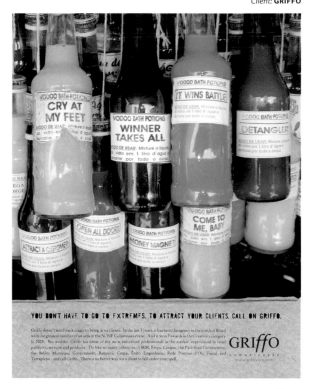

LA PLATA **brew**
Ho**U**se
COFFEES

LA PLATA BREWHOUSE COFFEES
CORPORATE IDENTITY

Creative Firm: **RULE29 — GENEVA, IL**
Creative Team: **JUSTIN AHERNS, JOSH JENSEN, BILLY CARLSON, BRIAN MACDONALD, O'NEIL PRINTING**
Client: **RULE29**

Creative Firm: **ROTTMAN CREATIVE GROUP — LA PLATA, MD**
Creative Team: **GARY ROTTMAN**
Client: **ROTTMAN CREATIVE GROUP, INC.**

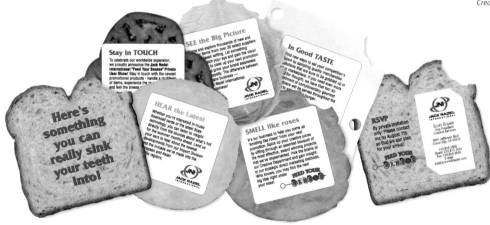

Creative Firm: **JACK NADEL INTERNATIONAL — LOS ANGELES, CA**
Creative Team: **SCOTT BROWN, SAM MINSTER**
Client: **JACK NADEL INTERNATIONAL**

Creative Firm: **UNIVERSITY OF AKRON/DESIGN X NINE — AKRON, OH**
Creative Team: **JANICE TROUTMAN, JOHN MORRISON, NATHAN MUELLER**
Client: **SHERRY SIMMS**

Creative Firm: **PHP COMMUNICATIONS — BIRMINGHAM, AL**
Creative Team: **BRYAN CHACE, LYNN SMITH**
Client: **PHP COMMUNICATIONS**

SPEAK SOFTLY AND CARRY A BIG STICK.

SHERRYSIMMS.com
jewelry · sculpture

The work of Sherry Simms is seductive, feminine and colorful. Inspiration for her work is derived from fashion magazines, make-up counter displays, contemporary patterning and historic ornamentation. To create her jewelry and sculpture, Simms draws upon the same materials and methods employed in the marketing strategies used to seduce customers. She is intrigued by the ways in which individuals, particularly women, seek to create their identities and personas through their choices of clothing, accessories and the application of make-up. By making objects with obsessive, luscious and enticing surfaces, Simms creates a desire and attraction for her work similar to those designed and created by the very industries that serve to inspire her.

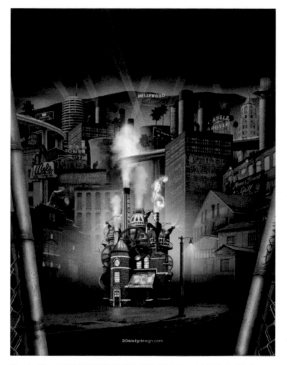

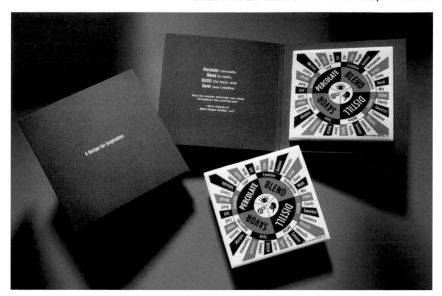

Creative Firm: **BETH SINGER DESIGN — ARLINGTON, VA**
Creative Team: **BETH SINGER, CHRIS HOCH**
Client: **BETH SINGER DESIGN**

Creative Firm: **30SIXTY ADVERTISING+DESIGN, INC. — LOS ANGELES, CA**
Creative Team: **HENRY VIZCARRA, DAVID FUSCELLARO, MARISA GHIGLIERI,**
OLEG ZATLER, SCOTT HENSEL
Client: **30SIXTY ADVERTISING+DESIGN, INC.**

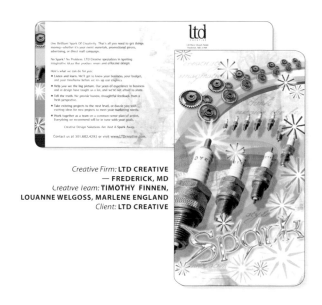

Creative Firm: **LTD CREATIVE**
— FREDERICK, MD
Creative Team: **TIMOTHY FINNEN,**
LOUANNE WELGOSS, MARLENE ENGLAND
Client: **LTD CREATIVE**

Creative Firm: **KIMBO DESIGN — VANCOUVER, BC, CANADA**
Creative Team: **KIM PICKETT, BUDIANTO NASRUN**
Client: **KIMBO DESIGN**

Creative Firm: **LTD CREATIVE — FREDERICK, MD**
Creative Team: **TIMOTHY FINNEN, LOUANNE WELGOSS, KIMBERLY DOW,**
EVAN WIEGAND, MARLENE ENGLAND
Client: **LTD CREATIVE**

Creative Firm: **30SIXTY ADVERTISING+DESIGN, INC. — LOS ANGELES, CA**
Creative Team: **HENRY VIZCARRA, DAVID FUSCELLARO, MARISA GHIGLIERI**
Client: **30SIXTY ADVERTISING+DESIGN, INC.**

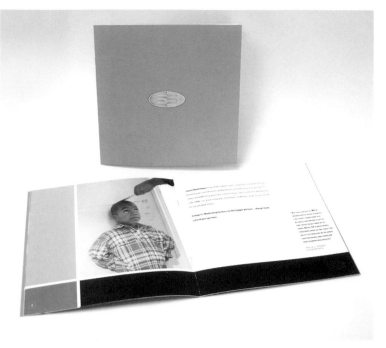

 Creative Firm: **ORANGESEED DESIGN — MINNEAPOLIS, MN**
Creative Team: **DAMIEN WOLF, REBECCA AVIÑA, ROGER LUNDQUIST**
Client: **ORANGESEED DESIGN**

Creative Firm: **GROUP 55 MARKETING — DETROIT, MI**
Creative Team: **JEANNETTE GUTIERREZ, HEATHER SOWINSKI, JENNIFER REWITZ, DAVE WARNER**
Client: **GROUP FIFTY-FIVE MARKETING**

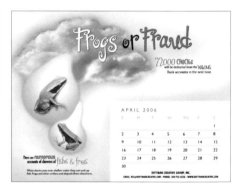

Creative Firm: **ROTTMAN CREATIVE GROUP — LA PLATA, MD**
Creative Team: **GARY ROTTMAN, MARY ROTTMAN, TANIA BAUMLER, NIKKI PLASCHKO, ROBERT WHETZEL**
Client: **ROTTMAN CREATIVE GROUP, INC.**

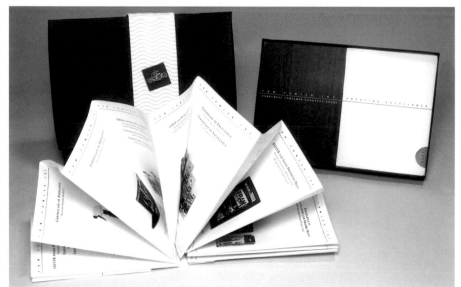

Creative Firm: **TOM FOWLER, INC. — NORWALK, CT**
Creative Team: **MARY ELLEN BUTKUS, ELIZABETH P. BALL, THOMAS G. FOWLER, STEPHANIE JOHNSON**
Client: **TOM FOWLER, INC.**

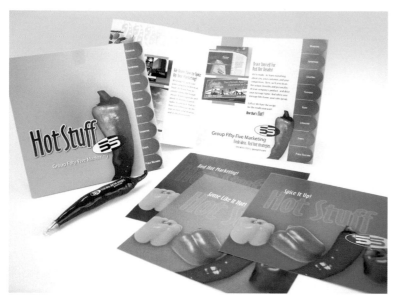

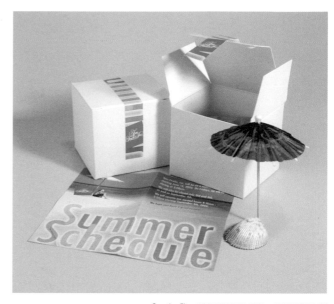

Creative Firm: **GROUP 55 MARKETING — DETROIT, MI**
Creative Team: **JEANNETTE GUTIERREZ**
Client: **GROUP FIFTY-FIVE MARKETING**

Creative Firm: **TOM FOWLER, INC. — NORWALK, CT**
Creative Team: **ELIZABETH P. BALL**
Client: **TOM FOWLER, INC.**

Creative Firm: **YOUI — SURREY, BC, CANADA**
Creative Team: **SIONG CHAN**

 Creative Firm: **G2 — NEW YORK, NY**
Creative Team: **JASON BORZOUYEH, STEVE BROCKWAY, KURT HAIMAN**
Client: **G2**

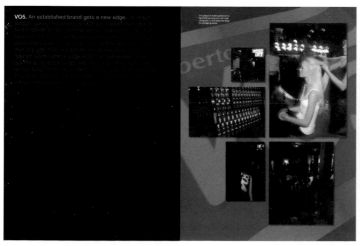

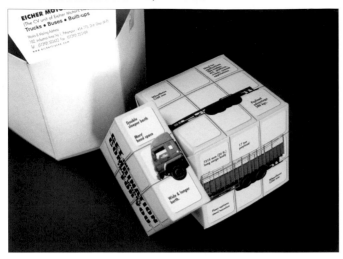

Creative Firm: **DESIGN GUYS — MINNEAPOLIS, MN**
Creative Team: **STEVE SIKORA, JAY THEIGE**
Client: **TARGET**

Creative Firm: **PURPLE FOCUS PVT. LTD. — INDORE, MADHYA PRADESH, INDIA**
Creative Team: **SAMEER DIXIT, ANURAG YADAV, PRAVEEN KARPE**
Client: **EICHER MOTORS LTD.**

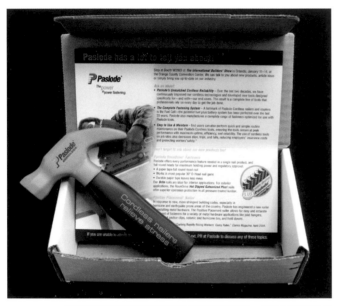

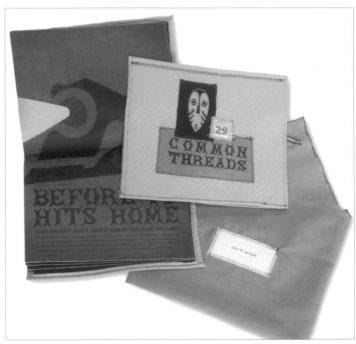

Creative Firm: **ALEXANDER MARKETING SERVICES INC. — BUFFALO GROVE, IL**
Creative Team: **LAURIE BRAMMER, LYNN WIER**
Client: **ITW PASLODE**

Creative Firm: **RODGERS TOWNSEND — ST. LOUIS, MO**
Creative Team: **ERIK MATHRE, LIZ FORSYTHE, BILL ECKLOF**
Client: **THE BLACK REP**

Creative Firm: **CAMPBELL-EWALD — WARREN, MI**
Creative Team: **SUSAN LOGAR BRODY, JOEL BENAY, MICHELLE KRYSZAK, BOB HUFFMAN, BRANDI GEUY, TOM FORDE**
Client: **GM**

Creative Firm: **MEDIA CONSULTANTS — LYNDHURST, NJ**
Creative Team: **HARVEY HIRSCH, BARRY GOULD, ROBERT NAGY, EDYTA TOCZYNSKI**
Client: **DIGITAL DIMENSIONS 3**

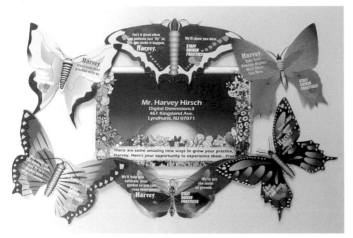

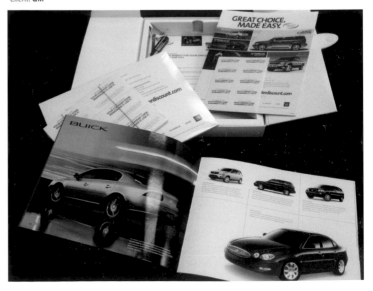

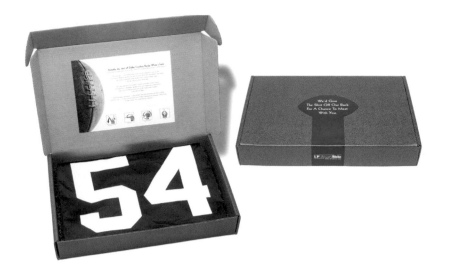

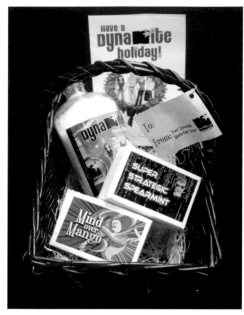

Creative Firm: HITCHCOCK FLEMING & ASSOCIATES INC. — AKRON, OH
Creative Team: NICK BETRO, TONY CARTER, TONY FANIZZI, MATT WEISS, KEVIN KINSLEY
Client: LP BUILDING PRODUCTS

Creative Firm: MORNINGSTAR DESIGN, INC. — FREDERICK, MD
Creative Team: MISTI MORNINGSTAR, MELISSA NEAL,
EMILY POTTHAST, RACHEL RABAT

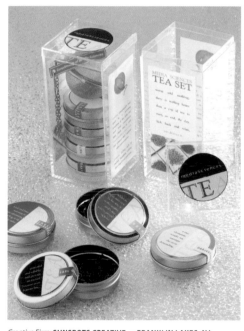

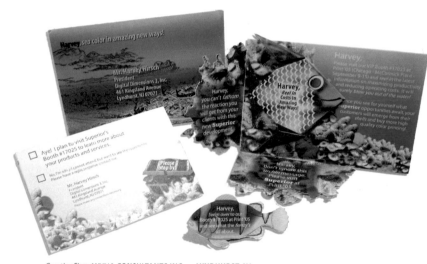

Creative Firm: MEDIA CONSULTANTS INC. — LYNDHURST, NJ
Creative Team: HARVEY HIRSCH, BARRY GOULD, ROBERT NAGY, EDYTA TOCZYNSKI
Client: DIGITAL DIMENSIONS 3

Creative Firm: SUNSPOTS CREATIVE — FRANKLIN LAKES, NJ
Creative Team: RICK BONELLI, DAVE VIOREANU, DEENA HARTLEY
Client: MEDIA SCIENCES

Creative Firm: FIRST MARKETING — POMPANO BEACH, FL
Creative Team: KEITH JOHNSON, SUSIE REKECHENSKY, MELISSA KIESEY
Client: NEXTEL PARTNERS

Creative Firm: RODGERS TOWNSEND — ST. LOUIS, MO
Creative Team: ERIK MATHRE, MICHELLE VESTH
Client: SBC COMMUNICATIONS, INC

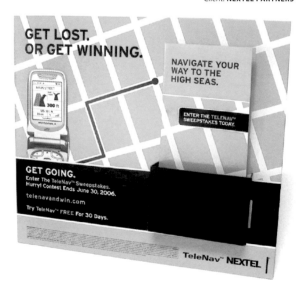

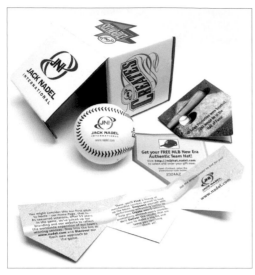

Creative Firm: **AOL | 360 CREATIVE — NEW YORK, NY**
Creative Team: **ANTHONY FARIA, ERIC LANE, TOM POLLEY, ERIKA ALONSO**
Client: **AOL MEDIA NETWORKS**

Creative Firm: **JACK NADEL INTERNATIONAL — LOS ANGELES, CA**
Creative Team: **SCOTT BROWN, ROBERT BUCKINGHAM, STEVE WIDDECOMBE**
Client: **JACK NADEL INTERNATIONAL**

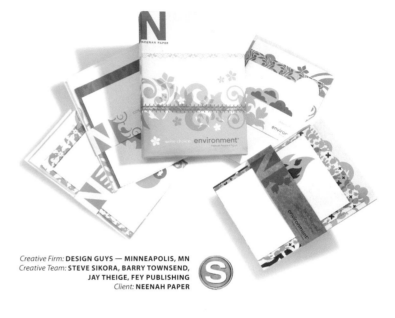

Creative Firm: **DESIGN GUYS — MINNEAPOLIS, MN**
Creative Team: **STEVE SIKORA, BARRY TOWNSEND, JAY THEIGE, FEY PUBLISHING**
Client: **NEENAH PAPER**

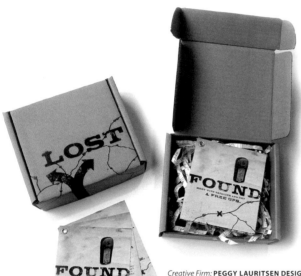

Creative Firm: **PEGGY LAURITSEN DESIGN GROUP — MINNEAPOLIS, MN**
Creative Team: **BRIAN DANAHER**
Client: **DATALINK**

Creative Firm: **RODGERS TOWNSEND — ST. LOUIS, MO**
Creative Team: **MICHELLE VESTH, ERIK MATHRE**
Client: **SBC COMMUNICATIONS, INC**

Creative Firm: **OLSON/KOTOWSKI, INC. — TORRANCE, CA**
Creative Team: **JANICE OLSON, KEVIN KOTOWSKI, STEVE MURPHY, JEFF GUIDO**
Client: **INTUIT**

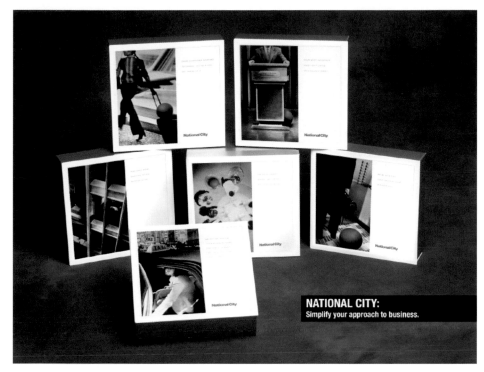

Creative Firm: **CAMPBELL-EWALD — WARREN, MI**
Creative Team: **BILL LUDWIG, ANNE MOORE, JOE PAS, SUSAN BERRY, JENNIFER BEAUDOIN, JOHN WOODWARD**
Client: **NATIONAL CITY CORPORATION**

Creative Firm: **EPOS, INC. — SANTA MONICA, CA**
Creative Team: **BRANDON FALL, GABRIELLE RAUMBERGER**
Client: **LOS ANGELES PUBLIC LIBRARY**

Creative Firm: **KOR GROUP — BOSTON, MA**
Creative Team: **ANNE CALLAHAN, KAREN DENDY SMITH, MB JAROSIK, JIM GIBSON, JAMES GRADY, RACHEL JOHNSON**
Client: **KOR GROUP**

Creative Firm: **HOWARD HANNA SMYTHE CRAMER — CLEVELAND , OH**
Creative Team: **AIMEE CAMPBELL**
Client: **K&D GROUP**

Creative Firm: **YELLOW SHOES CREATIVE WEST, DISNEYLAND RESORT — ANAHEIM, CA**
Creative Team: **JANE ROHAN, WES CLARK, JACQUELYN MOE, JIM ST. AMANT**
Client: **DISNEYLAND RESORT**

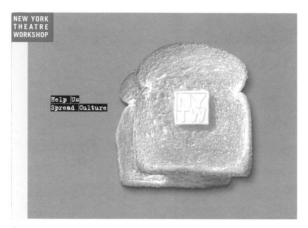

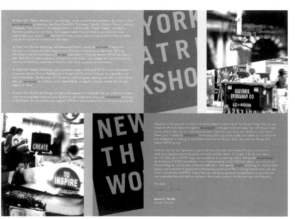

Creative Firm: **RUDER FINN DESIGN — NEW YORK, NY**
Creative Team: **LISA GABBAY, SAL CATANIA, AARON WILSON**
Client: **NEW YORK THEATRE WORKSHOP**

Creative Firm: **FITTING GROUP — PITTSBURGH, PA**
Creative Team: **TRAVIS NORRIS, AMY CHIAVERINI**
Client: **WOMEN & GIRLS FOUNDATION**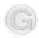

Creative Firm: **PUBLICIS DIALOG — SAN FRANCISCO, CA**
Creative Team: **LYLE LIM, MICHAEL AYHAN, KRISTY WARNER, BRIAN TYLER, CATHY KUZIA, CHRISTOPHER NELSON**
Client: **HP**

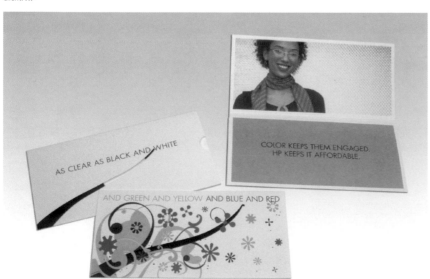

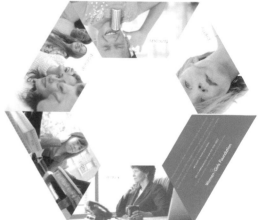

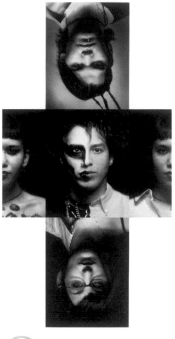

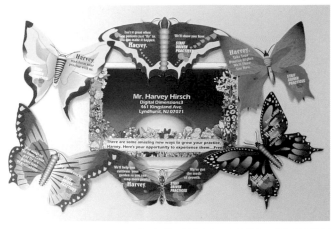

Creative Firm: **MEDIA CONSULTANTS — LYNDHURST, NJ**
Creative Team: **HARVEY HIRSCH, BARRY GOULD, ROBERT NAGY, EDYTA TOCZYNSKI**
Client: **DIGITAL DIMENSIONS 3**

Creative Firm: **THE BUDDY PROJECT/SQUAREHAND — ASTORIA, NY**
Creative Team: **DAVID SACKS, MÓNICA TORREJÓN KELLY**
Client: **DAVID SACKS PHOTOGRAPHY**

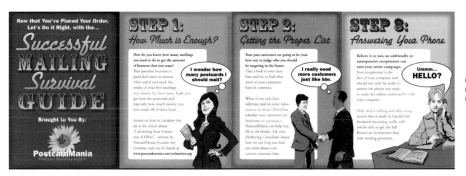

Creative Firm: **POSTCARD MANIA — CLEARWATER, FL**
Creative Team: **JOE NIEWIERSICI, JUDAA DOBIN**
Client: **POSTCARD MANIA**

Creative Firm: **PUBLICIS DIALOG — SAN FRANCISCO, CA**
Creative Team: **JONATHAN BUTTS, ALEX GROSSMAN, CHRISTOPHER ST. JOHN, BLAIR CERNY, BRIAN TYLER, MARTIN KOJNOK**
Client: **SPRINT**

Creative Firm: **YELLOW SHOES CREATIVE WEST, DISNEYLAND RESORT — ANAHEIM, CA**
Creative Team: **DATHAN SHORE, WES CLARK, MARTY MULLER, JACQUELYN MOE, KEVIN YONEDA**
Client: **DISNEYLAND RESORT**

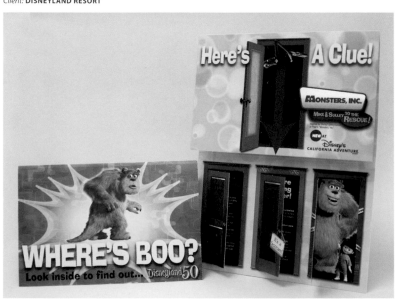

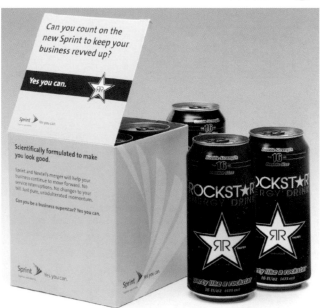

Creative Firm: **PUBLICIS DIALOG — SAN FRANCISCO, CA**
Creative Team: **LYLE LIM, KRISTY WARNER, JASON LAKIS, CATHY KUZIA, CHRISTOPHER NELSON**
Client: **HP**

Creative Firm: **PHP COMMUNICATIONS — BIRMINGHAM, AL**
Creative Team: **BRYAN CHACE, LYNN SMITH**
Client: **LEGAL SERVICES ALABAMA**

Creative Firm: **POSTCARD MANIA — CLEARWATER, FL**
Creative Team: **JOE NIEWIERSICI**
Client: **POSTCARD MANIA**

Creative Firm: **RUSTY GEORGE DESIGN — TACOMA, WA**
Creative Team: **LANCE KAGEY, RUSTY GEORGE DESIGN**
Client: **SEATTLE DIRECT MARKETING ASSOCIATION**

Creative Firm: **PUBLICIS DIALOG — SAN FRANCISCO, CA**
Creative Team: **JONATHAN BUTTS, ALEX GROSSMAN, KRISTY ANDRELIUNAS, LANE JORDAN, BRIAN TYLER, MARTIN KOJNOK**
Client: **SPRINT**

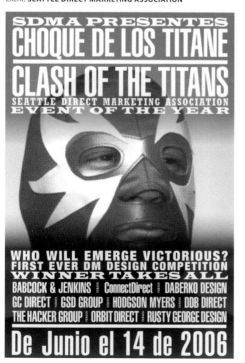

Creative Firm: **PUBLICIS DIALOG — SAN FRANCISCO, CA**
Creative Team: **JONATHAN BUTTS, KATIE HOPKINS, SHAWN POE, SIOW WEI KAY, MARTIN KOJNOK**
Client: **SPRINT**

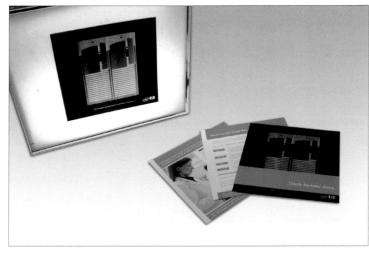

Creative Firm: **PUBLICIS DIALOG — SAN FRANCISCO, CA**
Creative Team: **LYLE LIM, THERESA LEE, LEANNE MILWAY, ANTHONY BORDERS, CHRISTOPHER NELSON**
Client: **HP**

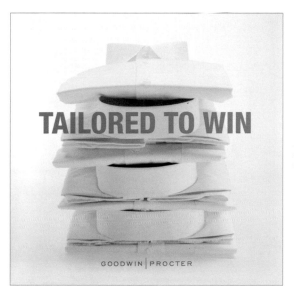

TAILORED TO WIN

GOODWIN | PROCTER

Creative Firm: **GREENFIELD/BELSER LTD. — WASHINGTON, DC**
Creative Team: **CAROLYN SEWELL, JOE WALSH, GENE SHAFFER**
Client: **GOODWIN PROCTER LLP**

Creative Firm: **A3 DESIGN — CHARLOTTE, NC**
Creative Team: **ALAN ALTMAN, AMANDA ALTMAN, SUSAN WALKER**
Client: **THE LIGHT FACTORY**

Creative Firm: **PUBLICIS DIALOG — SAN FRANCISCO, CA**
Creative Team: **JONATHAN BUTTS, ALEX GROSSMAN, JASON LAKIS, JASON BLACK, MARTIN KOJNOK, CHRISTOPHER NELSON**
Client: **SPRINT**

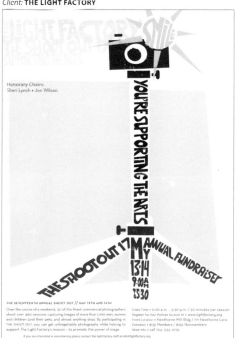

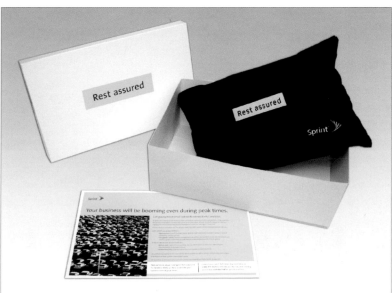

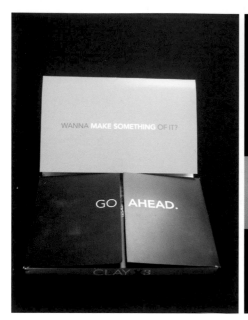

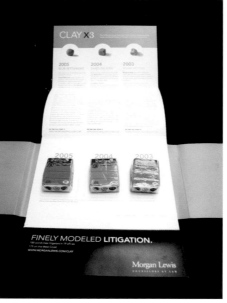

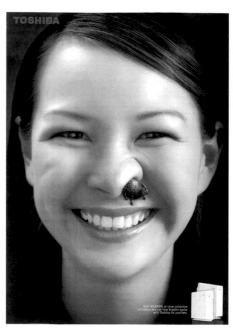

Creative Firm: **GREENFIELD/BELSER LTD. — WASHINGTON, DC**
Creative Team: **BURKEY BELSER, JOE WALSH, SIOBHAN DAVIS, GEORGE KELL, CHRIS ATKIN, CAVANAUGH PRESS**
Client: **MORGAN, LEWIS & BOCKIUS LLP**

Creative Firm: **DEZAINWERKZ — SINGAPORE**
Creative Team: **XAVIER SANJIMAN, FLUX FOTOGRAPHY, JEANETTE LAU, CHUA CHYE TECK**
Client: **TOSHIBA SINGAPORE**

Creative Firm: **STAN GELLMAN GRAPHIC DESIGN INC. — ST. LOUIS, MO**
Creative Team: **JILL FRANTTI, BARRY TILSON, KAREN ROGERS**
Client: **HENNEMAN ENGINEERING INC.**

Creative Firm: **PUBLICIS DIALOG — SAN FRANCISCO, CA**
Creative Team: **JONATHAN BUTTS, ALEX GROSSMAN, LEANNE MILWAY, TEIJA KUOSKU, SUSAN SYMMONS, ERIC CHOI**
Client: **BERMUDA TOURISM**

Creative Firm: **PURPLE FOCUS PVT. LTD. — INDORE, MADHYA PRADESH, INDIA**
Creative Team: **AARISH NANDEDKAR, ANURAG YADAV, VINOD BHARGAV**
Client: **NAIDUNIYA**

Creative Firm: **PUBLICIS DIALOG — SAN FRANCISCO, CA**
Creative Team: **LYLE LIM, LANE JORDAN, JASON BLACK, CATHY KUZIA**
Client: **HP**

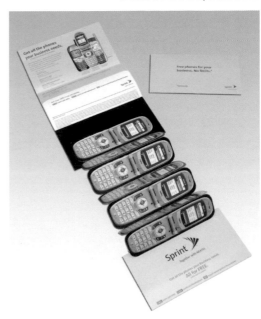

Creative Firm: **PUBLICIS DIALOG — SAN FRANCISCO, CA**
Creative Team: **KATIE HOPKINS, ANTHONY BORDERS, IAN GOLDER**
Client: **SPRINT**

Creative Firm: **GREENFIELD/BELSER LTD. — WASHINGTON, DC**
Creative Team: **DONNA GREENFIELD, AARON HANSEN**
Client: **BURKE SCHOOL**

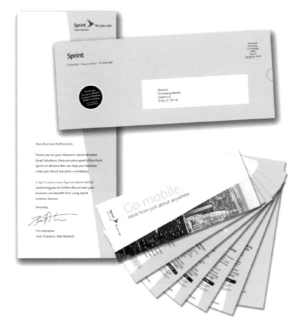

Creative Firm: **PUBLICIS DIALOG — SAN FRANCISCO, CA**
Creative Team: **JONATHAN BUTTS,**
CHRISTOPHER ST. JOHN, THERESA LEE,
IAN GOLDER, MARTIN KOJNOK
Client: **SPRINT**

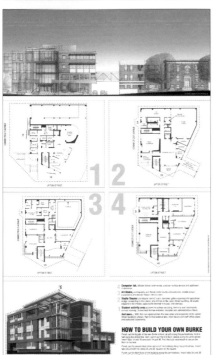

Creative Firm: **TAPAGE COMMUNICATION — BLAINVILLE, QC, CANADA**
Creative Team: **CHRISTINE EMOND, ISABELLE GAGNÉ**
Client: **GROUPE DOMCO**

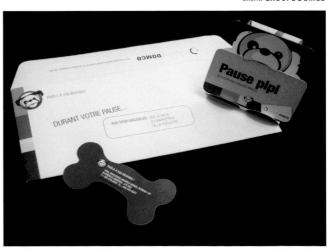

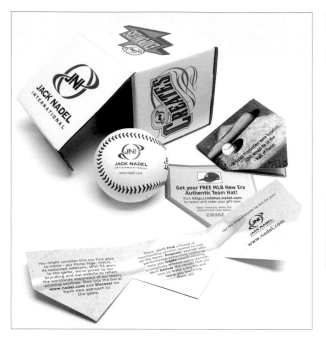

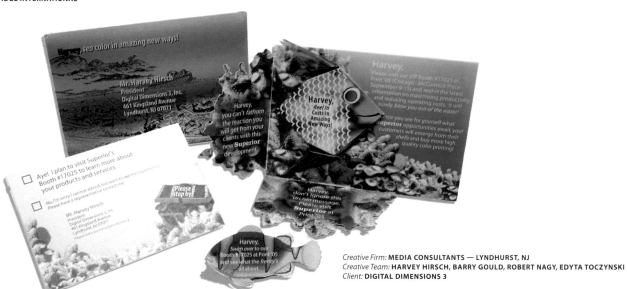

Creative Firm: YELLOW SHOES CREATIVE WEST, DISNEYLAND RESORT — ANAHEIM, CA
Creative Team: JANE ROHAN, WES CLARK, JACQUELYN MOE, JIM ST. AMANT
Client: DISNEYLAND RESORT

Creative Firm: JACK NADEL INTERNATIONAL — LOS ANGELES, CA
Creative Team: SCOTT BROWN, ROBERT BUCKINGHAM, STEVE WIDDECOMBE
Client: JACK NADEL INTERNATIONAL

Creative Firm: MEDIA CONSULTANTS — LYNDHURST, NJ
Creative Team: HARVEY HIRSCH, BARRY GOULD, ROBERT NAGY, EDYTA TOCZYNSKI
Client: DIGITAL DIMENSIONS 3

Creative Firm: REDUCED FAT — SARATOGA SPRINGS, NY
Creative Team: JOHN BOLSTER
Client: DEBRA DOCYK

Creative Firm: PUBLICIS DIALOG — SAN FRANCISCO, CA
Creative Team: ALEX GROSSMAN, BLAIR CERNY, JASON BLACK, MARTIN KOJNOK,
TOM HOWARD, MADELYN HAPPEL
Client: SPRINT

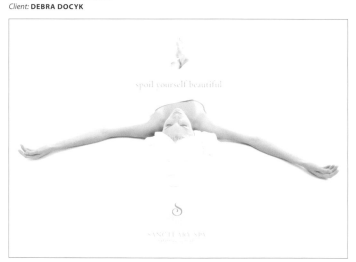

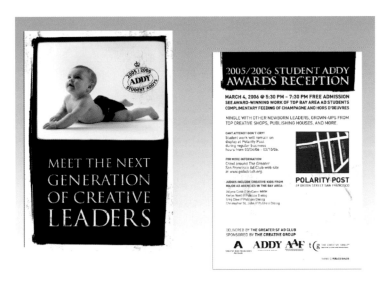

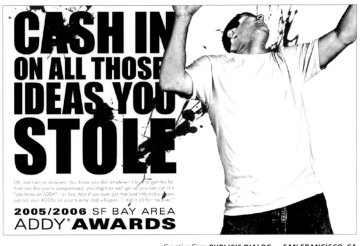

Creative Firm: **PUBLICIS DIALOG — SAN FRANCISCO, CA**
Creative Team: **CHRISTOPHER ST. JOHN, TEIJA KUOSKU**
Client: **GREATER SAN FRANCISCO AD CLUB**

Creative Firm: **PUBLICIS DIALOG — SAN FRANCISCO, CA**
Creative Team: **CHRISTOPHER ST. JOHN, KARLYN NEEL, JILL WHYSEL**
Client: **GREATER SAN FRANCISCO AD CLUB**

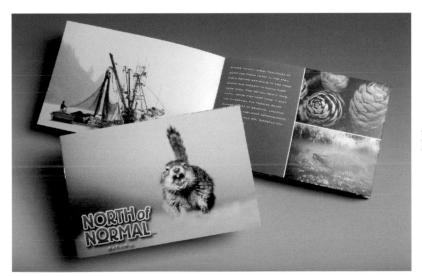

Creative Firm: **MAD DOG GRAPHX — ANCHORAGE, AK**
Creative Team: **MICHAEL ARDAIZ**
Client: **ALASKA STOCK**

Creative Firm: **STRATEGY ONE — WOODBUY, MN**
Creative Team: **JASON THOMPSON, BRIAN DANAHER**
Client: **GRAND THEATER CORPORATION**

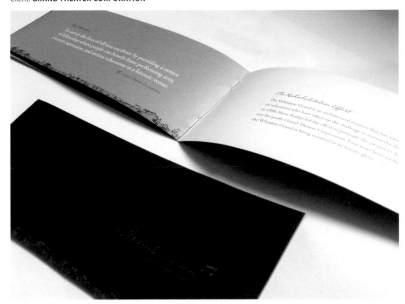

Creative Firm: **PUBLICIS DIALOG
— SAN FRANCISCO, CA**
Creative Team: **KATIE HOPKINS,
THERESA LEE, JASON BLACK,
TOM HOWARD,
NICOLE HOGARTY**
Client: **SPRINT**

GO PAPERLESS. NW Natural®

PAPERLESS BILLING IS HERE.
LOSE THE PAPER, WIN $100 IN CASH.

As a NW Natural Auto Pay customer,
you appreciate simple billing options, so
we've created Paperless Billing: the
convenient new way to get your bill
online which saves time, reduces bill
clutter and helps decrease the amount
of paper that goes into landfills. Sign up
at nwnatural.com/pb by March 31, 2006
and as a "thanks" for using less paper,
we'll enter you in a drawing for a chance
to win one of ten $100 cash prizes.

NW Natural®

Creative Firm: **PUBLICIS DIALOG — SAN FRANCISCO, CA**
Creative Team: **CHRISTOPHER ST. JOHN, KARLYN NEEL, JILL WHYSEL**
Client: **GREATER SAN FRANCISCO AD CLUB**

Creative Firm: **MAGNETO BRAND ADVERTISING
— PORTLAND, OR**
Creative Team: **R. CRAIG OPFER, JAY FAWCETT, MIKE TERRY**
Client: **NW NATURAL**

UNIVERSITY ART GALLERY · TCU

2005-2006 Season Calendar

Creative Firm: **PAT SLOAN DESIGN — FORT WORTH, TX**
Creative Team: **PAT SLOAN**
Client: **UNIVERSITY ART GALLERY-TCU**

Creative Firm: **BRIGHT ORANGE ADVERTISING — RICHMOND, VA**
Creative Team: **BRUCE GOLDMAN, DANIEL GOLDMAN**
Client: **JEWISH FEDERATION OF GREATER HARTFORD**

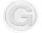 Creative Firm: **PUBLICIS DIALOG — SAN FRANCISCO, CA**
Creative Team: **JONATHAN BUTTS, ALEX GROSSMAN, LANE JORDAN, JASON BLACK, ANDY ROSS, CATHY KUZIA**
Client: **SPRINT**

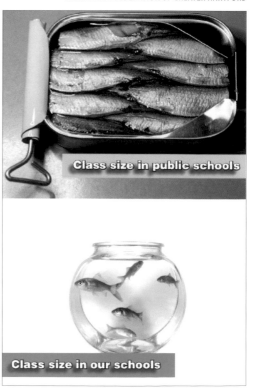

Class size in public schools

Class size in our schools

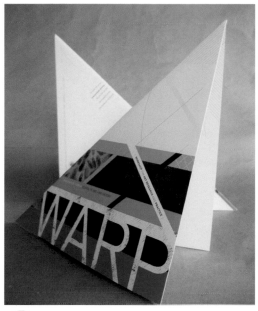

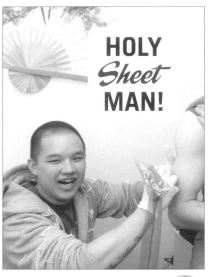

WE TOLD 10 PEOPLE THAT *Buntin Reid* IS HAVING ANOTHER PAPER SHOW AT THE HARD ROCK CAFÉ AND THIS IS WHAT THEY HAD TO SAY:

HOLY *Sheet* MAN!

Creative Firm: **KOLEGRAM — GATNINEAU, QC, CANADA**
Creative Team: **GONTRAN BLAIS, YANNICE BEAUVALET**
Client: **BUNTIN REID**

Creative Firm: **CONNIE HWANG DESIGN — GAINESVILLE, FL**
Creative Team: **CONNIE HWANG, BETHANY TAYLER, SEAN MILLER**
Client: **WARP PROGRAM AT SA+AH**

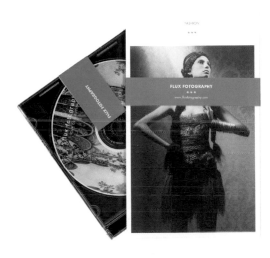

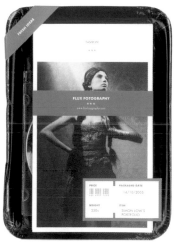

Creative Firm: **DEZAINWERKZ — SINGAPORE**
Creative Team: **XAVIER SANJIMAN, SIMON LOW,**
JEANETTE LAU
Client: **FLUX FOTOGRAPHY**

Creative Firm: **PUBLICIS DIALOG — SAN FRANCISCO, CA**
Creative Team: **JONATHAN BUTTS, ALEX GROSSMAN,**
LEANNE MILWAY, LANE JORDAN, MARTIN KOJNOK
Client: **SPRINT**

Creative Firm: **ACME COMMUNICATIONS, INC. — NEW YORK, NY**
Creative Team: **KIKI BOUCHER, ANDREA ROSS BOYLE**
Client: **DIRTWORKS, PC**

DIRTWORKS, PC
LANDSCAPE ARCHITECTURE
200 PARK AVENUE SOUTH
NEW YORK, NEW YORK 10003

NEW Projects

NEW Photos

NEW Information

Company News

Dirtworks invites you to look
at their updated web site.

www.dirtworks.us
TEL 212·529·2263 FAX 212·505·0904
EMAIL INFO@DIRTWORKS.US

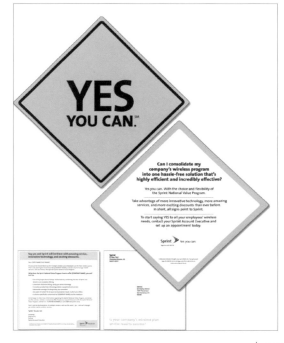

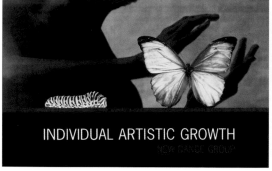

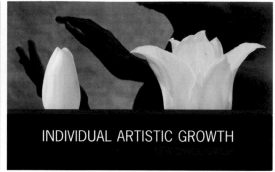

Creative Firm: **WESTGROUP CREATIVE — NEW YORK, NY**
Creative Team: **CHIP TOLANEY, MARVIN BERK**
Client: **NEW DANCE GROUP**

Creative Firm: **ALOFT GROUP, INC. — NEWBURYPORT, MA**
Creative Team: **DON CRANE, KIM CILLEY,**
MICHAEL INDRESANO
Client: **DICTAPHONE HEALTHCARE**

Creative Firm: **BRC MARKETING — DAYTON, OH**
Creative Team: **DOM CIMEI, JASON KANTER, MICHAEL BOYD, AMBER MOORE**
Client: **CINTAS**

Creative Firm: **SNAP CREATIVE — ST. CHARLES, MO**
Creative Team: **ANGELA NEAL, HILARY CLEMENTS**
Client: **JACQUIN STUDIOS**

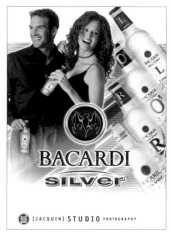

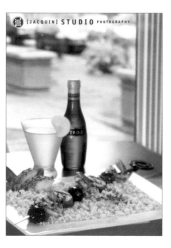

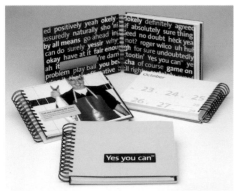

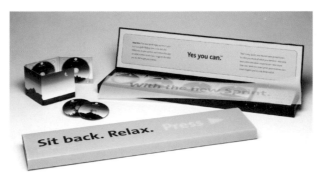

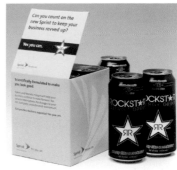

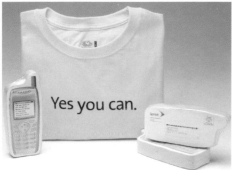

Creative Firm: **PUBLICIS DIALOG — SAN FRANCISCO, CA**
Creative Team: **JONATHAN BUTTS, ALEX GROSSMAN, LANE JORDAN, JASON BLACK, CATHY KUZIA, MARTIN KOJNOK**
Client: **SPRINT**

Creative Firm: **RUDER FINN DESIGN — NEW YORK, NY**
Creative Team: **LISA GABBAY, SAL CATANIA, KEI CHAN**
Client: **HUNTER MOUNTAIN**

Creative Firm: **MAD DOG GRAPHX — ANCHORAGE, AK**
Creative Team: **MICHAEL ARDAIZ**
Client: **ALASKA STOCK**

 Creative Firm: **OLSON/KOTOWSKI, INC. — TORRANCE, CA**
Creative Team: **JANICE OLSON, KEVIN KOTOWSKI, MOIRA DYER, JEFF GUIDO, DONNA JOHNSON, THAD WAWRO**
Client: **EPSON**

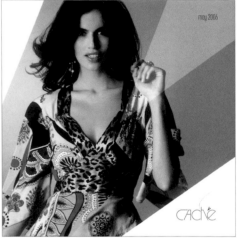

Creative Firm: **ORANGESEED DESIGN — MINNEAPOLIS, MN**
Creative Team: **DAMIEN WOLF, REBECCA AVIÑA, STAFFORD PHOTOGRAPHY**
Client: **STAFFORD PHOTOGRAPHY**

Creative Firm: **G2 — NEW YORK, NY**
Creative Team: **VICTOR MAZZEO, ELEANOR ZACH, PHIL KONTRIS, MEGAN TRINIDAD**
Client: **CACHE**

Creative Firm: **CRABTREE & COMPANY — FALLS CHURCH, VA**
Creative Team: **SUSAN ANGRISANI, TAMERA FINN**
Client: **INTERNATIONAL SPY MUSEUM**

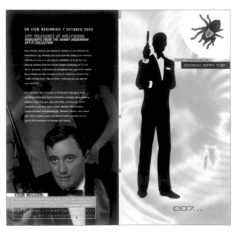

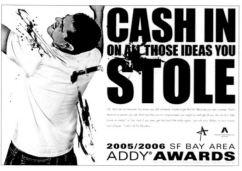

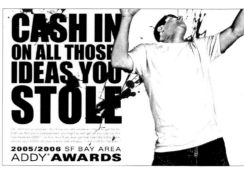

Creative Firm: **PUBLICIS DIALOG — SAN FRANCISCO, CA**
Creative Team: **JONATHAN BUTTS, CHRISTOPHER ST. JOHN, TEIJA KUOSKU, MARTIN KOJNOK**
Client: **GREATER SAN FRANCISCO AD CLUB**

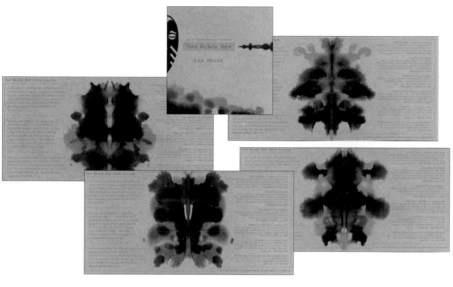

Creative Firm: **RODGERS TOWNSEND — ST. LOUIS, MO**
Creative Team: **ERIK MATHRE, RON COPELAND, RYAN MCMICHAEL**
Client: **THE BLACK REP**

Creative Firm: **PEGGY LAURITSEN DESIGN GROUP — MINNEAPOLIS, MN**
Creative Team: **BRIAN DANAHER, HIGH POINT CREATIVE**
Client: **AMERICAN MEDICAL SYSTEMS**

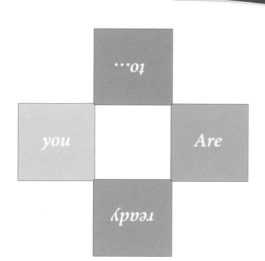

Creative Firm: **TORRE LAZUR MCCANN — PARSIPPANY, NJ**
Creative Team: **DANIELLE TERMINI, JILL LESIAK, ALBERT MAURIELLO,**
LINDA CICCARELLI, JENNIFER ALAMPI, MARCIA GODDARD
Client: **EISAI / PFIZER**

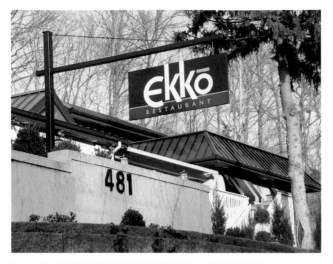

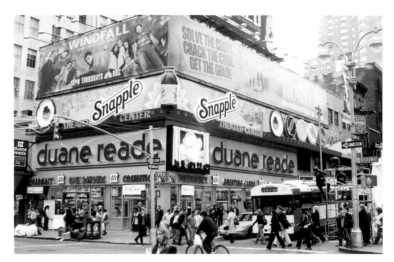

Creative Firm: **STEPHEN LONGO DESIGN ASSOCIATES — WEST ORANGE, NJ**
Creative Team: **STEPHEN LONGO**
Client: **EKKO RESTAURANT**

Creative Firm: **ALTERNATIVES — NEW YORK, NY**
Creative Team: **JULIE KOCH-BEINKE, MARK KOCH**
Client: **CADBURY SCHWEPPES**

Creative Firm: **ADSYSTEMS INTERNATIONAL — MAKATI, MANILA, PHILIPPINES**
Creative Team: **MA. PILAR BUNAG, STEFANO PAOLO BUNAG**
Client: **BAKER FRESH FOODS PHILIPPINES, INC. (DELIFRANCE)**

Creative Firm: **JGA — SOUTHFIELD, MI**
Creative Team: **KEN NISCH, KATHI MCWILLIAMS**
Client: **GODIVA CHOCOLATIER**

Creative Firm: **BETH SINGER DESIGN — ARLINGTON, VA**
Creative Team: **BETH SINGER, HOWARD SMITH, LOLAN O'ROURKE**
Client: **NATIONAL ASSOCIATION OF REALTORS**

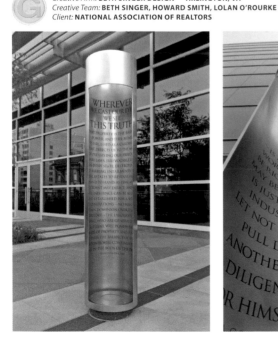

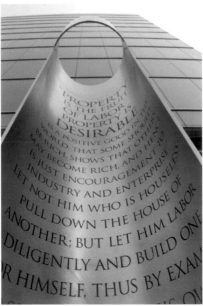

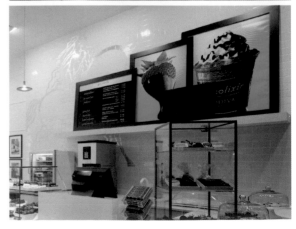

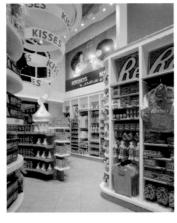

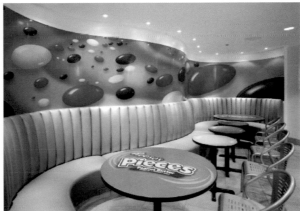

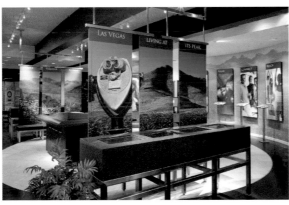

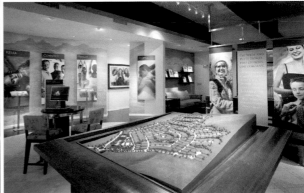

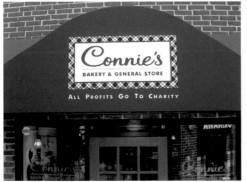

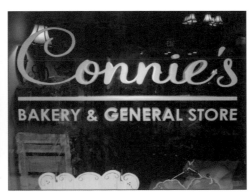

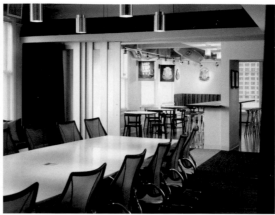

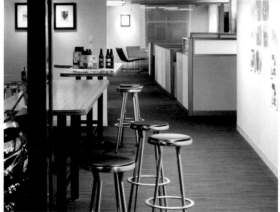

Creative Firm: **HORNALL ANDERSON DESIGN WORKS — SEATTLE, WA**
Creative Team: **JACK ANDERSON, SKB ARCHITECTS**
Client: **HORNALL ANDERSON DESIGN WORKS**

Creative Firm: **LORENC+YOO DESIGN — ROSWELL, GA**
Creative Team: **JAN LORENC, CHUNG YOUL YOO, STEVE MCCALL, DAVID PARK, JISUN AN, KEN BOYD**
Client: **MAYO CLINIC**

Creative Firm: **KARACTERS DESIGN GROUP/DDB CANADA — VANCOUVER, BC, CANADA**
Creative Team: **JAMES BATEMAN, KARA BOHL, DAN O'LEARY, HELEN WYNNE, SCOTT RUSSELL, MARK FINN**
Client: **MOUNTAIN EQUIPMENT CO-OP**

 Creative Firm: **FUTUREBRAND** — NEW YORK, NY
Creative Team: TOM LI, MIKE WILLIAMS, BRENDAN O'NEILL, ANTHONY DECOSTA, JAE HWANG, TESS ABRAHAM
Client: **NAKHEEL**

Creative Firm: **RALPH APPELBAUM ASSOCIATES** — NEW YORK, NY
Creative Team: RALPH APPELBAUM, DENNIS COHEN, KAI CHIU,
VIVI HSIN-YI HSU, MADELINE CHINNICI, IDA BACHTIAR
Client: **S'PORE DISCOVERY CENTRE**

Creative Firm: **CBX** — NEW YORK, NY
Client: **NEIGHBOURS**

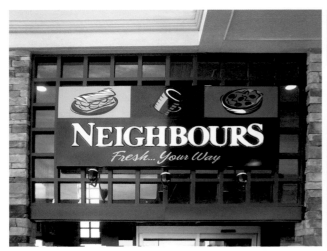

Creative Firm: **DESIGN OBJECTIVES PTE LTD — SINGAPORE**
Creative Team: **RONNIE S C TAN**
Client: **RAFFLES INTERNATIONAL**

Creative Firm: **KAREN SKUNTA & COMPANY — CLEVELAND, OH**
Creative Team: **KAREN SKUNTA, BECKY RALICH-SPAK,**
JAMIE FINKELHOR, JENNY PAN, TRG STUDIOS
Client: **THE CLEVELAND PLAY HOUSE**

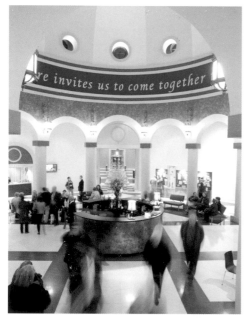

Creative Firm: **RALPH APPELBAUM ASSOCIATES — NEW YORK, NY**
Creative Team: **RALPH APPELBAUM, RICK SOBEL, MIA BUERSKENS,**
SYLVIA JURAN, KYLE CHEPULIS, AUDIO VIDEO AND CONTROLS
Client: **EDISON PRESERVATION FOUNDATION**

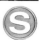

Creative Firm: **DON SCHAAF & FRIENDS, INC. — WASHINGTON, DC**
Creative Team: **DON SCHAAF, BRUCE MACINDOE**
Client: **HEART RHYTHM SOCIETY**

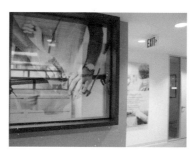

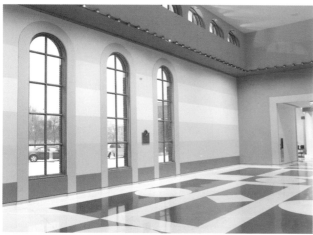

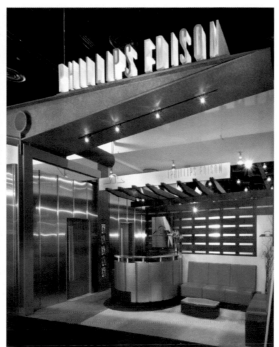

Creative Firm: **LORENC+YOO DESIGN — ROSWELL, GA**
Creative Team: **JAN LORENC, STEVE MCCALL, DAVID PARK**
Client: **PHILLIPS EDISON & COMPANY**

Creative Firm: **DESIGN OBJECTIVES PTE LTD — SINGAPORE**
Creative Team: **RONNIE S C TAN**
Client: **SHERATON TAIPEI HOTEL**

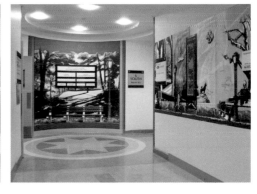

Creative Firm: **KIMAK DESIGN — ORANGEBURG, NY**
Creative Team: **JAMES KIMAK, CHILDRENS' ART COURTESY OF TRI-STATE AREA SCHOOLS**
Client: **NEW YORK PRESBYTERIAN HOSTPITAL**

Creative Firm: **FUTUREBRAND — NEW YORK, NY**
Creative Team: **ALEX SUGAI, TOM LI, CHERYL HILLS, ANTHONY DECOSTA, SAGAYARAJ PRASANNA, JAE HWANG**
Client: **DUBAI AEROSPACE ENTERPRISE**

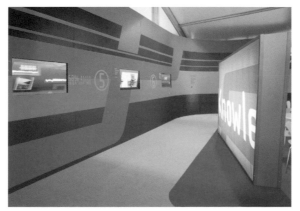

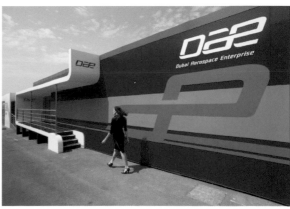

153

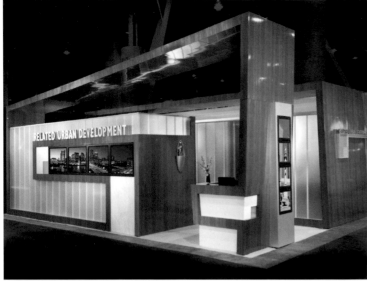

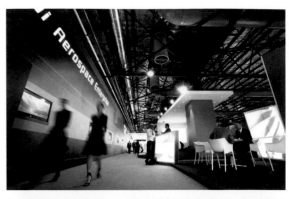

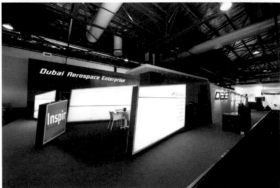

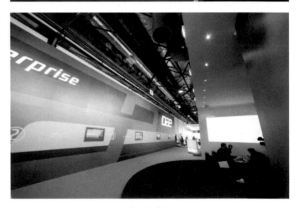

Creative Firm: **LORENC+YOO DESIGN — ROSWELL, GA**
Creative Team: **JAN LORENC, STEVE MCCALL, KEN BOYD**
Client: **THE RELATED COMPANIES**

Creative Firm: **KIKU OBATA & COMPANY — ST. LOUIS, MO**
Creative Team: **LAURA MCCANNA, RICH NELSON, RUSSELL BUCHANAN, JR., DAVID LEAVEY, TODD MAYBERRY, CAROLE JEROME**
Client: **THE ST. LOUIS CARDINALS/BUSCH STADIUM**

Creative Firm: **FUTUREBRAND — NEW YORK, NY**
Creative Team: **DIEGO KOLSKY, CHERYL HILLS, BRENDAN O'NEILL, ANTONIO BAGLIONE, SAGAYARAJ PRASANNA, JAE HWANG**
Client: **DUBAI AEROSPACE ENTERPRISE**

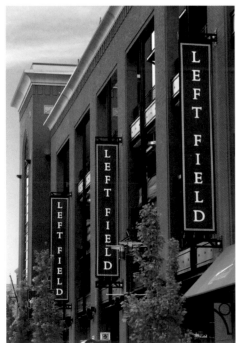

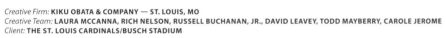

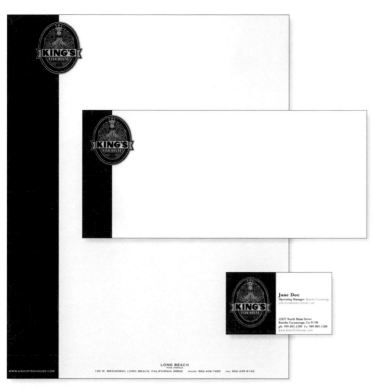

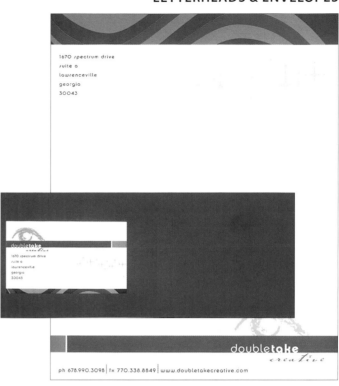

Creative Firm: **30SIXTY ADVERTISING+DESIGN, INC. — LOS ANGELES, CA**
Creative Team: **HENRY VIZCARRA, DAVID FUSCELLARO, YUJIN ONO**
Client: **KING'S SEAFOOD COMPANY**

Creative Firm: **DOUBLE TAKE CREATIVE — LAWRENCEVILLE, GA**
Creative Team: **AMY POWERS, VINCENT MARASCHIELLO**
Client: **DOUBLE TAKE CREATIVE**

Creative Firm: **VINCE RINI DESIGN — HUNTINGTON BEACH, CA**
Creative Team: **VINCE RINI**
Client: **BLUE COW**

Creative Firm: **MAYHEM STUDIOS — LOS ANGELES, CA**
Creative Team: **CALVIN LEE**
Client: **EMTEK PRODUCTS, INC.**

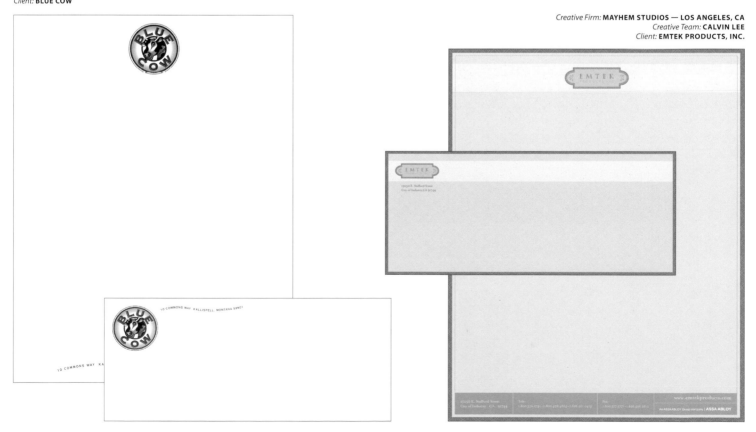

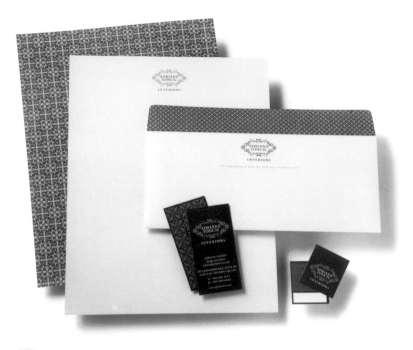

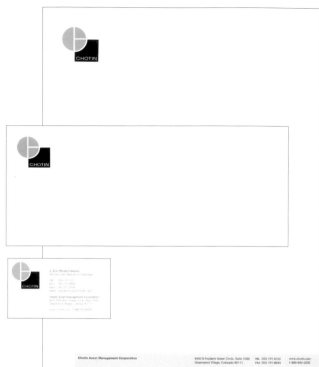

 Creative Firm: **RIORDON DESIGN — OAKVILLE, ON, CANADA**
Creative Team: **ALAN KRPAN, RIC RIORDON**
Client: **ADRIANA TONCIC INTERIORS**

Creative Firm: **ELLEN BRUSS DESIGN — DENVER, CO**
Creative Team: **ELLEN BRUSS, RYAN NEE**
Client: **THE CHOTIN GROUP**

Creative Firm: **HORNALL ANDERSON DESIGN WORKS — SEATTLE, WA**
Creative Team: **DAYMON BRUCK, YURI SHVETS, HILLARY RADBILL**
Client: **BLRB ARCHITECTS**

Creative Firm: **STELLAR DEBRIS — HADANO-SHI, KANAGAWA-KEN, JAPAN**
Creative Team: **CHRISTOPHER JONES**
Client: **STELLAR DEBRIS**

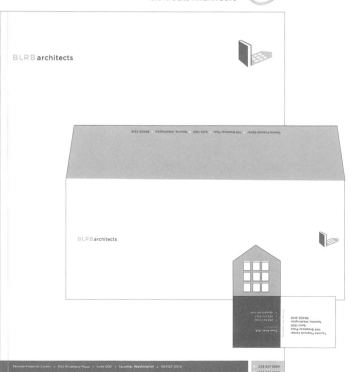

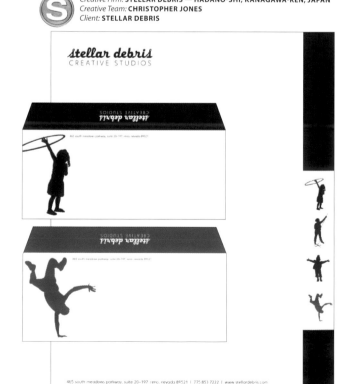

Creative Firm: **KARACTERS DESIGN GROUP/DDB CANADA — VANCOUVER, BC, CANADA**
Creative Team: **MARIA KENNEDY, MARSHA LARKIN, HELEN WYNNE, RUSS HORII, MARK FINN**
Client: **KARACTERS DESIGN GROUP**

Creative Firm: **ZERO GRAVITY DESIGN GROUP — SMITHTOWN, NY**
Creative Team: **ZERO GRAVITY DESIGN GROUP**
Client: **ATTWOOD EQUESTRIAN SURFACES**

Creative Firm: **RIORDON DESIGN — OAKVILLE, ON, CANADA**
Creative Team: **DAWN CHARNEY, SHIRLEY RIORDON**
Client: **CHELSTER HALL**

Creative Firm: **HITCHCOCK FLEMING & ASSOCIATES INC. — AKRON, OH**
Creative Team: **NICK BETRO, TODD MOSER, RENE MCCANN**
Client: **VERITAS**

Creative Firm: **ZERO GRAVITY DESIGN GROUP — SMITHTOWN, NY**
Creative Team: **ZERO GRAVITY DESIGN GROUP**
Client: **U.S. COFFEE**

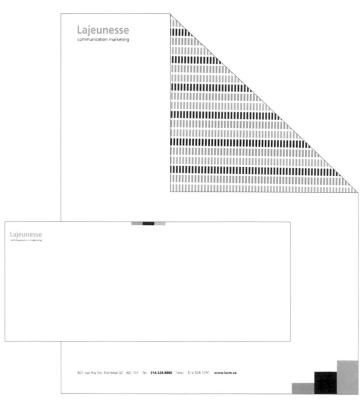

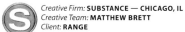
Creative Firm: **SUBSTANCE — CHICAGO, IL**
Creative Team: **MATTHEW BRETT**
Client: **RANGE**

Creative Firm: **LAJEUNESSE COMMUNICATION MARKETING — MONTREAL, QC, CANADA**
Creative Team: **YVES DUQUETTE, NATHALIE DAIGLE**

Creative Firm: **SCOTT ADAMS DESIGN ASSOCIATES — COLUMBUS, OH**
Creative Team: **SCOTT ADAMS**
Client: **ASSET STRATEGIES GROUP**

Creative Firm: **STRATEGY ONE — WOODBUY, MN**
Creative Team: **JASON THOMPSON**
Client: **COLLEGE CHURCH**

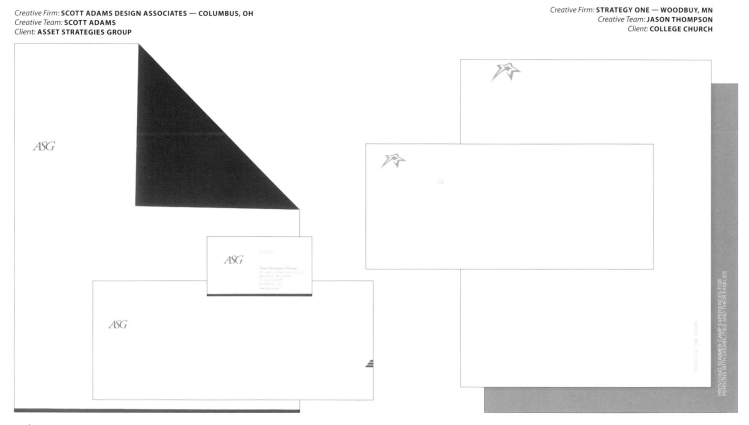

Creative Firm: **SUBSTANCE — CHICAGO, IL**
Creative Team: **MATTHEW BRETT**
Client: **SCOTT HARMS ROSE, PSYCHOTHERAPIST**

Creative Firm: **VOICEBOX CREATIVE — SAN FRANCISCO, CA**
Creative Team: **JACQUES ROSSOUW, KRISTIE WISE**
Client: **SBRAGIA FAMILY VINEYARDS**

Creative Firm: **HELENA SEO DESIGN — SUNNYVALE, CA**
Client: **ANGARA, INC.**

Creative Firm: **VOICEBOX CREATIVE — SAN FRANCISCO, CA**
Creative Team: **JACQUES ROSSOUW, VOICEBOX TEAM, GREG CLARKE, JAN DENTON**
Client: **VINTAGE POINT**

Creative Firm: **ZERO GRAVITY DESIGN GROUP — SMITHTOWN, NY**
Creative Team: **ZERO GRAVITY DESIGN GROUP**
Client: **DIRECT ACCESS PARTNERS**

Creative Firm: **HERE! NETWORKS — NEW YORK, NY**
Creative Team: **ERIC FELDMAN, CRAIG OELRICH**

Creative Firm: **MODERN MARKETING CONCEPTS — LOUISVILLE,KY**
Creative Team: **MARK GROVES**
Client: **MODERN MARKETING CONCEPTS**

Creative Firm: **SIMPATICO DESIGN STUDIO — ALEXANDRIA, VA**
Creative Team: **AMY SIMPSON**
Client: **SIMPATICO DESIGN STUDIO**

Creative Firm: **KIKU OBATA & COMPANY — ST. LOUIS, MO**
Creative Team: **JOE FLORESCA, ELEANOR SAFE**
Client: **PATRICK DAVIS PARTNERS**

Creative Firm: **ALTERNATIVES — NEW YORK, NY**
Creative Team: **LISA PAWSON**
Client: **AMY TUCKER**

Creative Firm: **SPRINGBOARD CREATIVE — MISSION, KS**
Creative Team: **KEVIN FULLERTON**
Client: **SPRINGBOARD CREATIVE**

Creative Firm: **ELLEN BRUSS DESIGN —
DENVER, CO**
Creative Team: **ELLEN BRUSS, JORGE LAMORA**
Client: **THE LAB AT BELMAR**

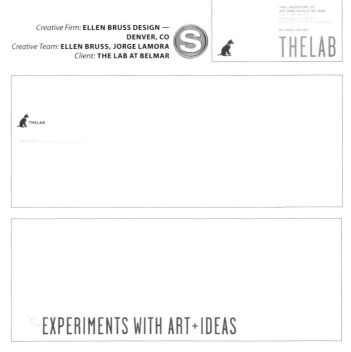

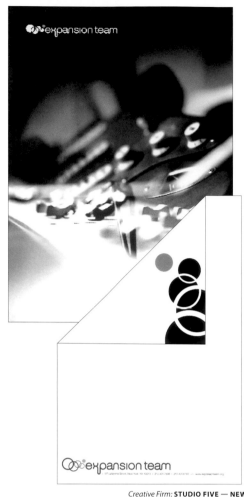

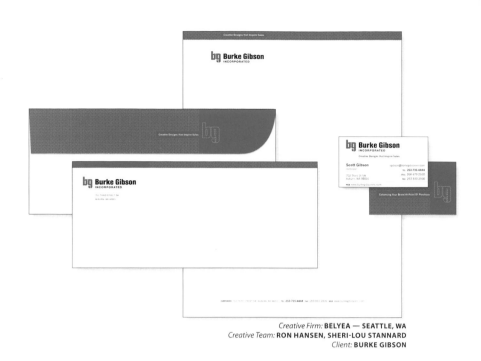

Creative Firm: **BELYEA — SEATTLE, WA**
Creative Team: **RON HANSEN, SHERI-LOU STANNARD**
Client: **BURKE GIBSON**

Creative Firm: **STUDIO FIVE — NEW YORK, NY**
Creative Team: **TATIANA AROCHA, MELISSA GORMAN**
Client: **EXPANSION TEAM**

Creative Firm: **JONI RAE AND ASSOCIATES — ENCINO, CA**
Creative Team: **JONI RAE RUSSELL, BEVERLY TRENGOVE**
Client: **JONI RAE AND ASSOCIATES**

Creative Firm: **BELYEA — SEATTLE, WA**
Creative Team: **RON HANSEN, SHERI-LOU STANNARD**
Client: **LAIRD NORTON TYEE**

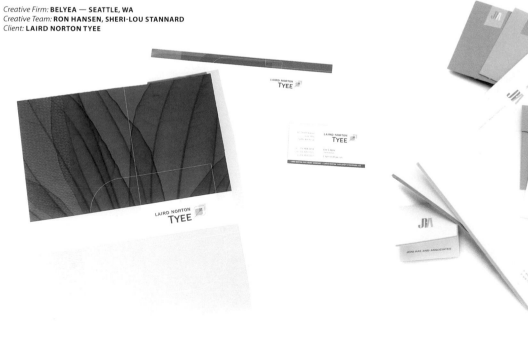

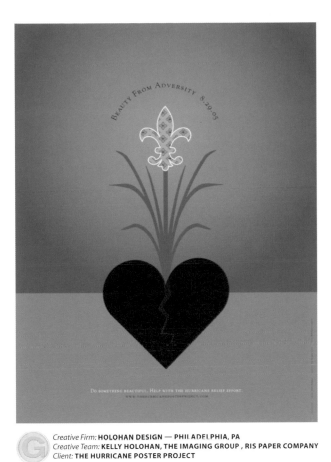

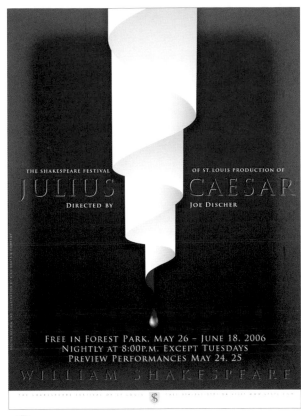

Creative Firm: **HOLOHAN DESIGN — PHILADELPHIA, PA**
Creative Team: **KELLY HOLOHAN, THE IMAGING GROUP , RIS PAPER COMPANY**
Client: **THE HURRICANE POSTER PROJECT**

Creative Firm: **KIKU OBATA & COMPANY — ST. LOUIS, MO**
Creative Team: **RICH NELSON**
Client: **THE SHAKESPEARE FESTIVAL OF ST. LOUIS**

Creative Firm: **HERMAN MILLER, INC. — ZEELAND, MI**
Creative Team: **ANDREW DULL, MARLENE CAPOTOSTO**
Client: **HERMAN MILLER, INC.**

Creative Firm: **WESTGROUP CREATIVE — NEW YORK, NY**
Creative Team: **CHIP TOLANEY, MARVIN BERK**
Client: **NEW DANCE GROUP**

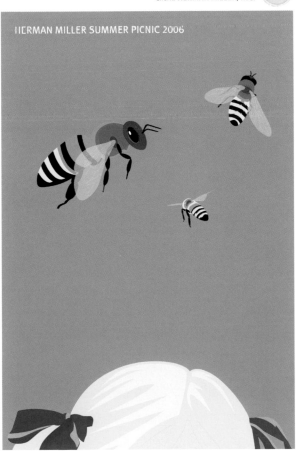

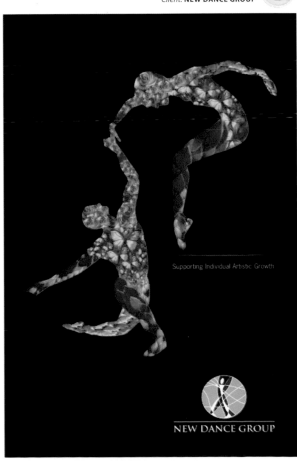

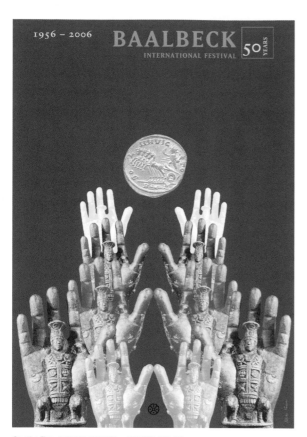

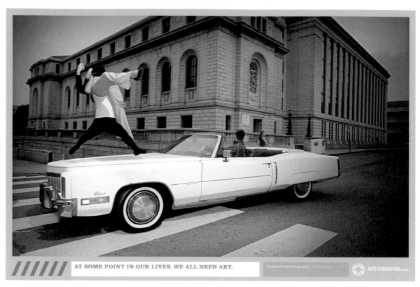

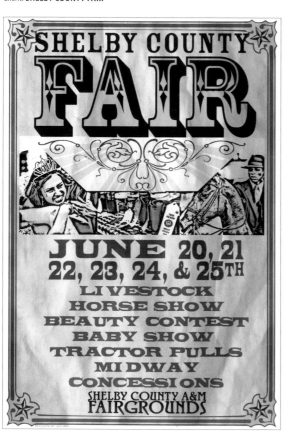

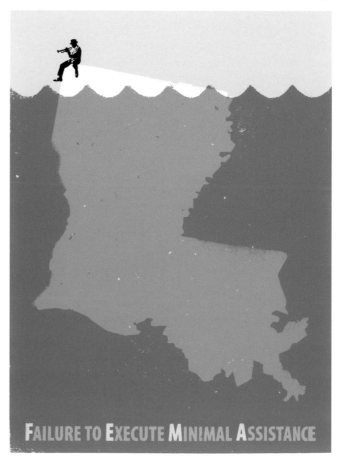

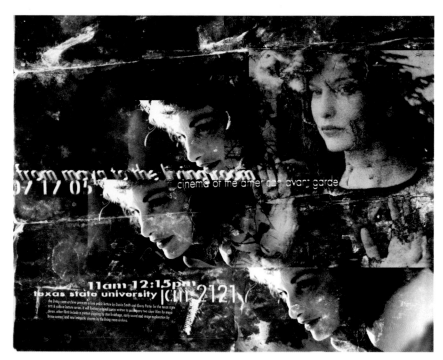

Creative Firm: **ZERO GRAVITY — SAN MARCOS, TX**
Creative Team: **IVANETE BLANCO**
Client: **JAMES HOUSEFIELD**

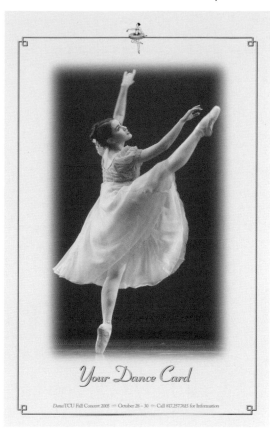

Your Dance Card

Creative Firm: **ATOMIC DESIGN — CROWLEY, TX**
Creative Team: **LEWIS GLASER**
Client: **ELLEN SHELTON/TCU BALLET & MODERN DANCE**

Creative Firm: **RODGERS TOWNSEND — ST. LOUIS, MO**
Creative Team: **TOM HUDDER, MARK ARNOLD, TODD MITCHELL, CHERYL SPARKS**
Client: **CIRCUS FLORA**

Creative Firm: **MCCANN ERICKSON, NEW YORK — NEW YORK, NY**
Creative Team: **BILL OBERLANDER, TOM SULLIVAN, LARRY PLATT, WENDY LEAHY, JOYCE KING THOMAS**
Client: **NIKON**

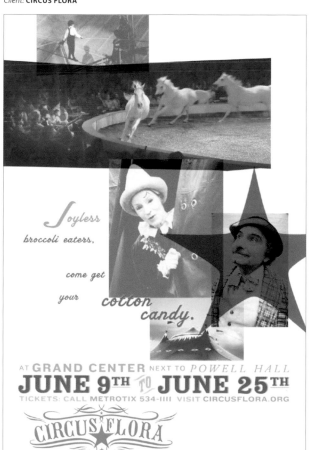

165

Creative Firm: **RODGERS TOWNSEND — ST. LOUIS, MO**
Creative Team: **ERIK MATHRE, LIZ FORSYTHE, BILL ECKLOFF,
CHERYL SPARKS**
Client: **THE BLACK REP**

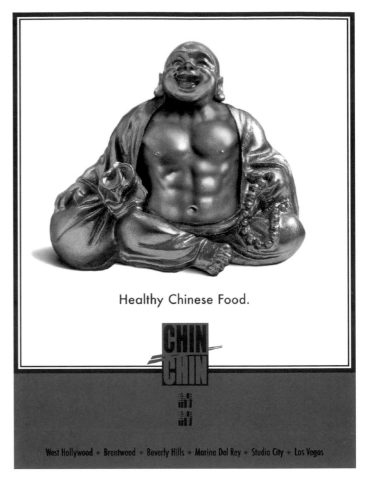

Creative Firm: **THE MILLER GROUP — LOS ANGELES, CA**
Creative Team: **RENEE MILLER, SHIN KAWASE, CHRIS ROBB, JOHN HAGE, ERNEST VON ROSEN**
Client: **CHIN CHIN**

Creative Firm: **ALCONE MARKETING — IRVINE, CA**
Creative Team: **CARLOS MUSQUEZ, JULIE KIMURA, SHIVONNE MILLER,
LUIS CAMANO, ROBERT WAGT**
Client: **EBAY**

Creative Firm: **RODGERS TOWNSEND — ST. LOUIS, MO**
Creative Team: **TOM HUDDER, JENNY STORINO, JAKE EDINGER, CHERYL SPARKS**
Client: **THE DUBLINER**

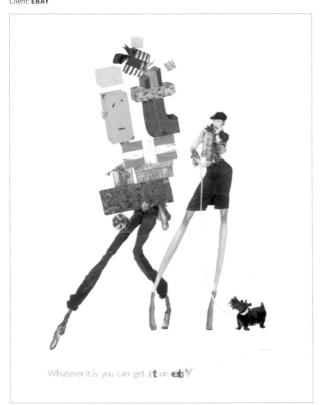

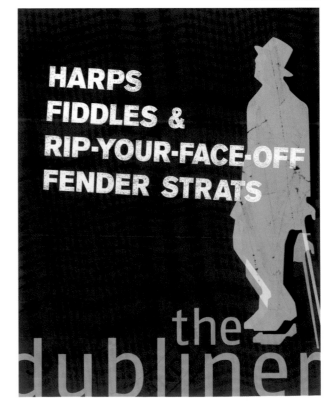

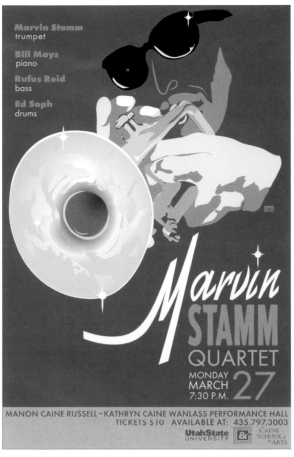

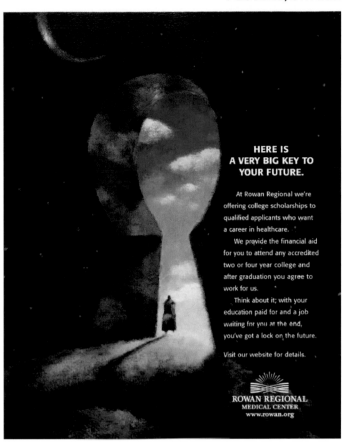

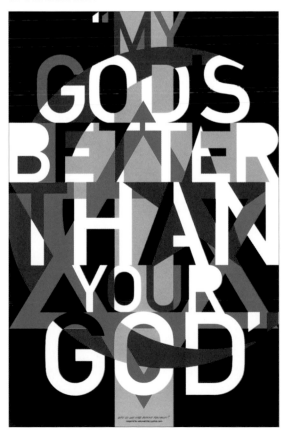

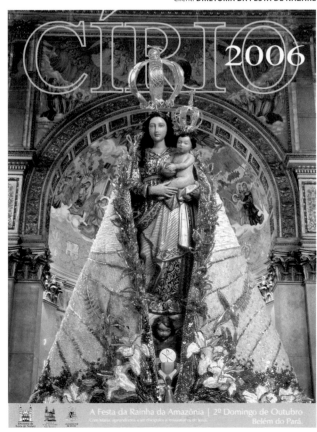

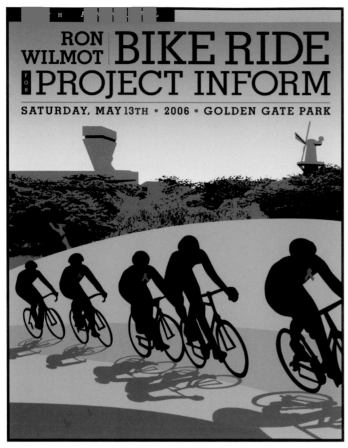

Creative Firm: **BIGWIG DESIGN — SAN FRANCISCO, CA**
Creative Team: **RICHARD LEEDS**
Client: **PROJECT INFORM**

Creative Firm: **HBO OFF-AIR CREATIVE SERVICES — NEW YORK, NY**
Creative Team: **VENUS DENNISON, MARY TCHORBAJIAN, CARLOS TEJEDA, LARRY BURNETT**
Client: **HBO DOCUMENTARY FILMS**

Creative Firm: **RODGERS TOWNSEND — ST. LOUIS, MO**
Creative Team: **TOM HUDDER, LUKE PARTRIDGE, MICHAEL MCCORMICK, BRIAN KUHLMAN, CHERYL SPARKS**
Client: **CARNIVALE D' ART**

Creative Firm: **CSC'S P2 COMMUNICATIONS SERVICES — FALLS CHURCH, VA**
Creative Team: **AARON KOBILIS, TERRY WILSON, TIM DEWAELE, LYNN JEUNETTE, ADAM DONOVAN**
Client: **CSC CORPORATE**

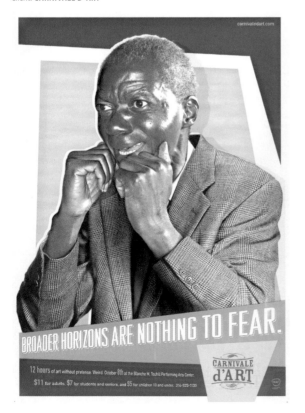

Creative Firm: **RODGERS TOWNSEND — ST. LOUIS, MO**
Creative Team: **TOM HUDDER, MARK ARNOLD, TODD MITCHELL, CHERYL SPARKS**
Client: **CIRCUS FLORA**

Creative Firm: **GREENLIGHT DESIGNS — N. HOLLYWOOD, CA**
Creative Team: **TAMI MAHNKEN, DARRYL SHELLY, MELISSA IRWIN, SHAUN WOOD**
Client: **MILLENIUM FILMS**

Creative Firm: **DIESTE HARMEL & PARTNERS — DALLAS, TX**
Creative Team: **ALDO QUEVEDO, JAIME ANDRADE, GABRIEL PUERTO, JOSE SUASTE, ALEX TOEDTLI**
Client: **WEDNESDAY'S CHILD BENEFIT CORP.**

Creative Firm: **RODGERS TOWNSEND — ST. LOUIS, MO**
Creative Team: **TOM HUDDER, LUKE PARTRIDGE, MICHAEL MCCORMICK, BRIAN KUHLMAN, CHERYL SPARKS**
Client: **CARNIVALE D' ART**

NOT NECESSARILY
A BOUNCER
MORE LIKE CUSTOMS

the dubliner

Creative Firm: **RODGERS TOWNSEND — ST. LOUIS, MO**
Creative Team: **TOM HUDDER, JENNY STORINO, JAKE EDINGER, CHERYL SPARKS**
Client: **THE DUBLINER**

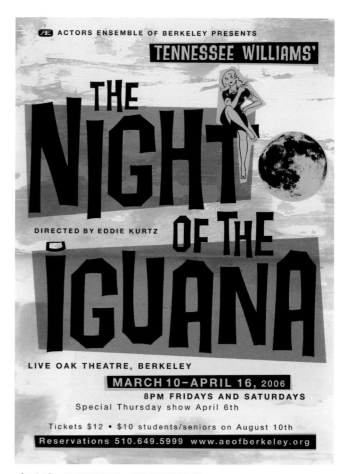

ACTORS ENSEMBLE OF BERKELEY PRESENTS

TENNESSEE WILLIAMS'

THE NIGHT OF THE IGUANA

DIRECTED BY EDDIE KURTZ

LIVE OAK THEATRE, BERKELEY
MARCH 10–APRIL 16, 2006
8PM FRIDAYS AND SATURDAYS
Special Thursday show April 6th

Tickets $12 • $10 students/seniors on August 10th
Reservations 510.649.5999 www.aeofberkeley.org

Creative Firm: **BIGWIG DESIGN — SAN FRANCISCO, CA**
Creative Team: **RICHARD LEEDS**
Client: **ACTORS ENSEMBLE OF BERKELEY**

Creative Firm: **RODGERS TOWNSEND — ST. LOUIS, MO**
Creative Team: **ERIK MATHRE, LIZ FORSYTHE, BILL ECKLOFF, CHERYL SPARKS**
Client: **THE BLACK REP**

Creative Firm: **INTELLIGENT FISH STUDIO — WOODBUY, MN**
Creative Team: **BRIAN DANAHER, JOHN PHOTOS**
Client: **ACE HARDWARE CORP**

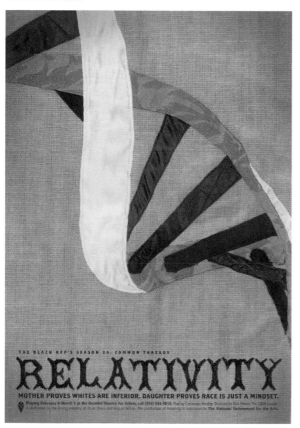

THE BLACK REP'S SEASON 29: COMMON THREADS
RELATIVITY
MOTHER PROVES WHITES ARE INFERIOR. DAUGHTER PROVES RACE IS JUST A MINDSET.

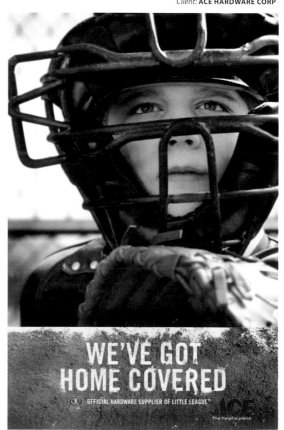

WE'VE GOT
HOME COVERED

OFFICIAL HARDWARE SUPPLIER OF LITTLE LEAGUE™

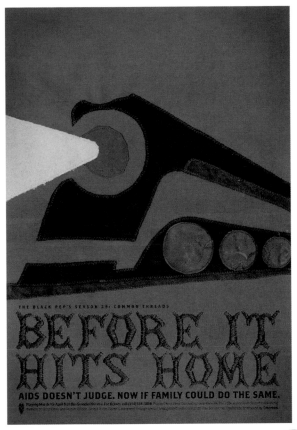

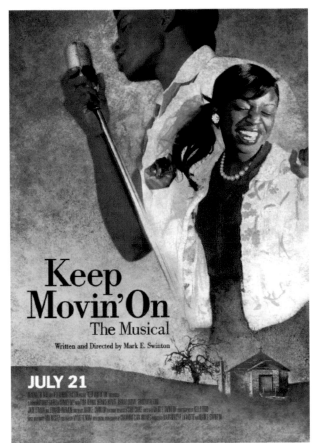

Creative Firm: **RODGERS TOWNSEND — ST. LOUIS, MO**
Creative Team: **ERIK MATHRE, LIZ FORSYTHE, BILL ECKLOFF, CHERYL SPARKS**
Client: **THE BLACK REP**

Creative Firm: **30SIXTY ADVERTISING+DESIGN, INC. — LOS ANGELES, CA**
Creative Team: **HENRY VIZCARRA, PÄR LARSSON, DAVID FUSCELLARO, BRUCE VENTANILLA, TUYET VONG**
Client: **BEYOND THE BELL**

Creative Firm: **THE MONOGRAM GROUP — CHICAGO, IL**
Creative Team: **HAROLD WOODRIDGE, BRETT HAWTHORNE, CHRISTA VELBEL**
Client: **VICTORY GARDENS THEATER**

Creative Firm: **HOTSAUCE — NEW YORK, NY**
Creative Team: **WYNDY SLOAN, ANASTASIA VASILAKIS**
Client: **NYC AFFILIATE OF THE SUSAN G. KOMEN FOUNDATION**

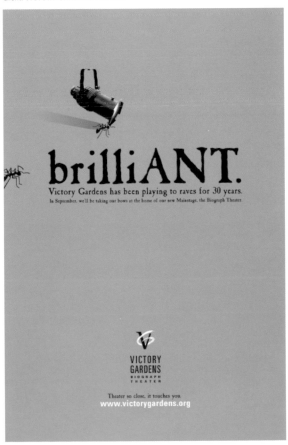

This is how babies see the world. Keep it clean.

CLOROX

Creative Firm: **DIESTE HARMEL & PARTNERS — DALLAS, TX**
Creative Team: **ALDO QUEVEDO, CARLOS TOURNE, PATRICIA MARTINEZ, RAYMUNDO VALDEZ, DIEGO DUPRAT**
Client: **CLOROX**

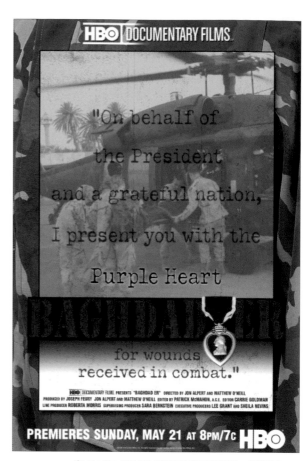

HBO DOCUMENTARY FILMS

"On behalf of the President and a grateful nation, I present you with the Purple Heart for wounds received in combat."

BAGHDAD ER

PREMIERES SUNDAY, MAY 21 AT 8PM/7C HBO

Creative Firm: **HBO OFF-AIR CREATIVE SERVICES — NEW YORK, NY**
Creative Team: **MARY TCHORBAJIAN, TONY VIOLA, VENUS DENNISON**
Client: **HBO DOCUMENTARY FILMS**

Creative Firm: **AD HARVEST — SIMPSONVILLE, KY**
Creative Team: **MARK GROVES**
Client: **SHELBYVILLE HORSE SHOW**

Creative Firm: **RODGERS TOWNSEND — ST. LOUIS, MO**
Creative Team: **ERIK MATHRE, LIZ FORSYTHE, BILL ECKLOFF, CHERYL SPARKS**
Client: **THE BLACK REP**

Shelbyville Horse Show

AUGUST 2ND-5TH 2006 Nightly At 7pm

SHELBY COUNTY FAIRGROUNDS

THE BLACK REP'S SEASON 29: COMMON THREADS
KING HEDLEY II
A RAZOR, A PISTOL AND A MACHETE. YET TRUTH BECOMES THE WEAPON OF CHOICE.

Creative Firm: **HOLOHAN DESIGN — PHILADELPHIA, PA**
Creative Team: **KELLY HOLOHAN**
Client: **TYLER SCHOOL OF ART**

Creative Firm: **GREENLIGHT DESIGNS — N. HOLLYWOOD, CA**
Creative Team: **TAMI MAHNKEN, DARRYL SHELLY, MELISSA IRWIN, SHAUN WOOD**
Client: **COLUMBIA PICTURES**

Creative Firm: **RODGERS TOWNSEND — ST. LOUIS, MO**
Creative Team: **TOM HUDDER, MARK ARNOLD, TODD MITCHELL, CHERYL SPARKS**
Client: **CIRCUS FLORA**

Creative Firm: **HBO OFF-AIR CREATIVE SERVICES — NEW YORK, NY**
Creative Team: **JOSE MENDEZ, IVY CALAHORRANO, VENUS DENNISON**
Client: **HBO LATINO**

Creative Firm: **HBO OFF-AIR CREATIVE SERVICES — NEW YORK, NY**
Creative Team: **JOSE MENDEZ, IVY CALAHORRANO,
VENUS DENNISON**
Client: **HBO SEGMENT MARKETING**

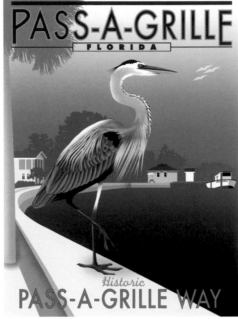

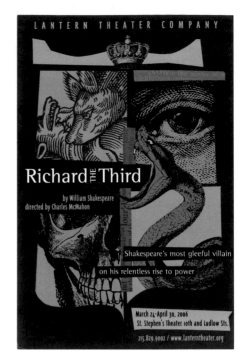

Creative Firm: **SHERIFF DESIGN — ELKINS PARK, PA**
Creative Team: **PAUL SHERIFF**
Client: **LANTERN THEATER COMPANY**

Creative Firm: **CHASE CREATIVE — ST. PETE BEACH, FL**
Creative Team: **GEORGE CHASE**
Client: **BAMBOOZLE**

Creative Firm: **RODGERS TOWNSEND — ST. LOUIS, MO**
Creative Team: **TOM HUDDER, JENNY STORINO, JAKE EDINGER,
CHERYL SPARKS**
Client: **THE DUBLINER**

Creative Firm: **RODGERS TOWNSEND — ST. LOUIS, MO**
Creative Team: **TOM HUDDER, LUKE PARTRIDGE, MICHAEL MCCORMICK,
BRIAN KUHLMAN, CHERYL SPARKS**
Client: **CARNIVALE D' ART**

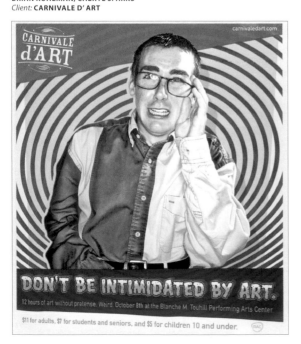

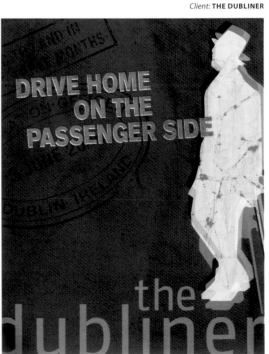

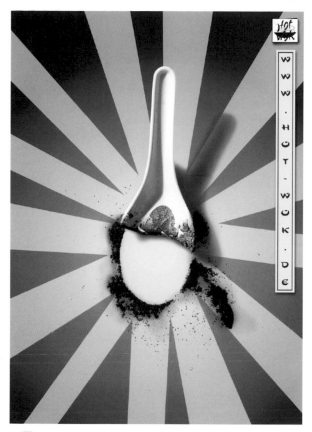

 Creative Firm: YOUNG & RUBICAM GMBH & CO. KG — FRANKFURT AM MAIN, HESSEN, GERMANY
Creative Team: UWE MARQUARDT, XENIA KLEIN
Client: ASITA GMBH

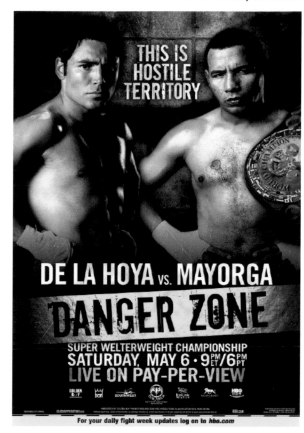

Creative Firm: HBO OFF-AIR CREATIVE SERVICES — NEW YORK, NY
Creative Team: ANA RACELIS, JOSE MENDEZ, VENUS DENNISON, LARRY BURNETT
Client: HBO PPV SPORT

Creative Firm: DIESTE HARMEL & PARTNERS — DALLAS, TX
Creative Team: ALDO QUEVEDO, JAIME ANDRADE, GABRIEL PUERTO, JOSE SUASTE, ALEX TOEDTLI
Client: WEDNESDAY'S CHILD BENEFIT CORP.

Creative Firm: GRAFISK DESIGN — ASTORIA, NY
Creative Team: JOHN FISK
Client: LIP THEATRE COMPANY

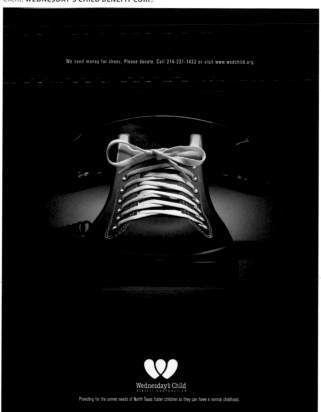

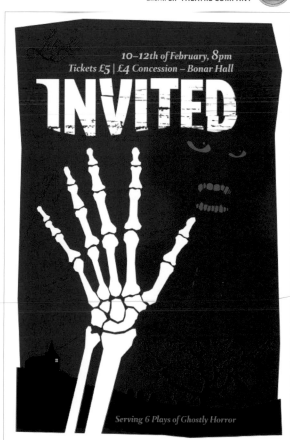

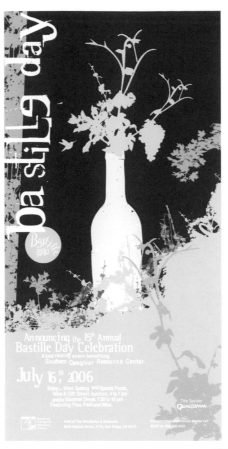

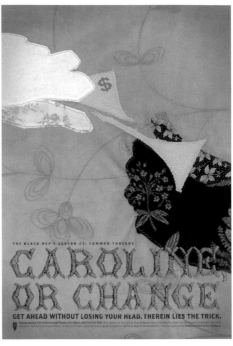

Creative Firm: **RODGERS TOWNSEND — ST. LOUIS, MO**
Creative Team: **TOM HUDDER, JENNY STORINO,
JAKE EDINGER, CHERYL SPARKS**
Client: **THE DUBLINER**

Creative Firm: **RODGERS TOWNSEND — ST. LOUIS, MO**
Creative Team: **ERIK MATHRE, LIZ FORSYTHE,
BILL ECKLOFF, CHERYL SPARKS**
Client: **THE BLACK REP**

Creative Firm: **QUALCOMM — SAN DIEGO, CA**
Creative Team: **TYLER MOLHOOK, CHRIS LEE**
Client: **SOUTHERN CAREGIVER RESOURCE CENTER**

Creative Firm: **AGENCY X ADS — SAN FRANCISCO, CA**
Creative Team: **LOTUS CHILD, DENISE ST. LOUIS**
Client: **ALICE RADIO**

Creative Firm: **ERIC CAI DESIGN CO. — BEIJING, CHINA**
Creative Team: **ERIC CAI SHI WEI, ESTHER TAN YAN**
Client: **ERIC CAI DESIGN CO.**

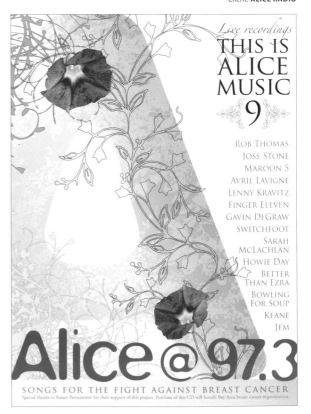

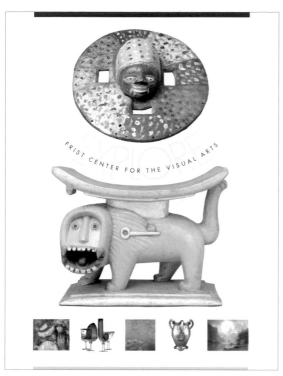

Creative Firm: **VENTRESS DESIGN GROUP — FRANKLIN, TN**
Creative Team: **TOM VENTRESS, ERIC VENTRESS**
Client: **FRIST CENTER FOR THE VISUAL ARTS**

Creative Firm: **ALCONE MARKETING — IRVINE, CA**
Creative Team: **LUIS CAMANO, SHIVONNE MILLER, JULIE KIMURA**
Client: **CALIFORNIA LOTTERY**

Creative Firm: **RAVENHOUSE DESIGN PRACTICE — TACOMA, WA**
Creative Team: **JAY HEMBER, LANCE KAGEY, TOM LLEWELLYN**
Client: **WINTERGRASS**

Creative Firm: **GRAFISK DESIGN — ASTORIA, NY**
Creative Team: **JOHN FISK**
Client: **LIP THEATRE COMPANY**

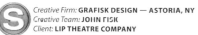

Creative Firm: **PURPLE FOCUS PVT. LTD. — INDORE, MADHYA PRADESH, INDIA**
Creative Team: **VINOD BHARGAV**
Client: **CANCER SOCIETY OF MADHYA PRADESH**

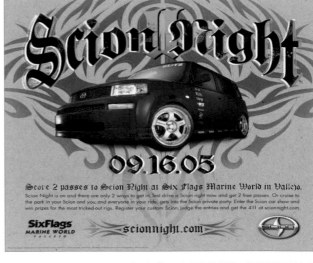

Creative Firm: **ALCONE MARKETING — IRVINE, CA**
Creative Team: **LUIS CAMANO, SHIVONNE MILLER**
Client: **CALIFORNIA LOTTERY**

Creative Firm: **AD PLANET GROUP / ACE: DAYTONS ADVERTISING — SINGAPORE**
Creative Team: **LEO TECK CHONG, ALFRED TEO, KIM TAN, JENNIFER OU, BEN LIM, JAMES TAN**
Client: **PEEP ONE EROTIC DRINK**

Creative Firm: **PATRICK HENRY CREATIVE PROMOTIONS, INC.
— STAFFORD, TX**
Creative Team: **PHCP PRESTIGE ART TEAM, DAVE PAPAZIAN**
Client: **RED LION HOTELS CORPORATION**

Creative Firm: **HBO OFF-AIR CREATIVE SERVICES — NEW YORK, NY**
Creative Team: **SETH LUTSKY, ANA RACELIS, VENUS DENNISON**
Client: **HBO SEGMENT MARKETING**

Creative Firm: **PURPLE FOCUS PVT. LTD.
— INDORE, MADHYA PRADESH, INDIA**
Creative Team: **SATYAJIT RAI, VINOD BHARGAV**
Client: **CHANNEL SITI**

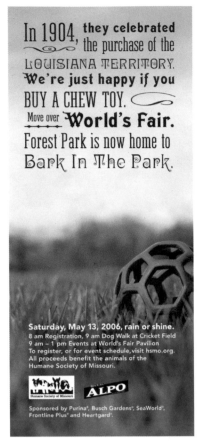

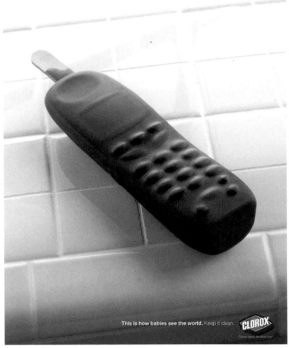

This is how babies see the world. Keep it clean.

QueerZagreb
www.queerzagreb.org

...homophobes are humans too

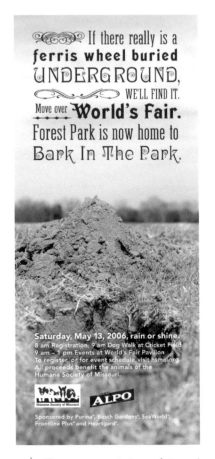

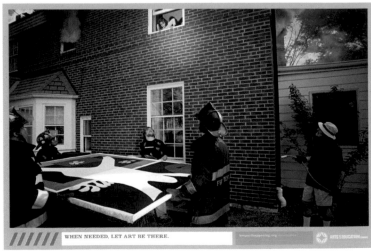

WHEN NEEDED, LET ART BE THERE.

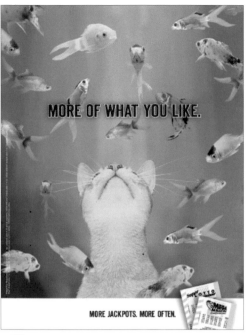

Creative Firm: **ALCONE MARKETING — IRVINE, CA**
Creative Team: **LUIS CAMANO, JULIE KIMURA**
Client: **CALIFORNIA LOTTERY**

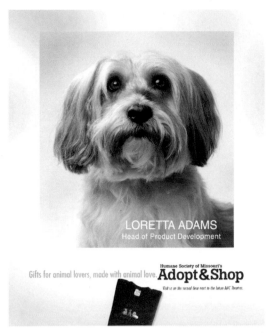

Creative Firm: **RODGERS TOWNSEND — ST. LOUIS, MO**
Creative Team: **ERIK MATHRE, MARK ARNOLD, TODD MITCHELL,
CHERYL SPARKS**
Client: **HUMANE SOCIETY OF MISSOURI**

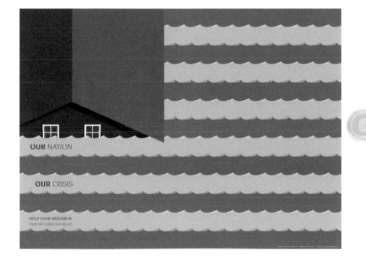

Creative Firm: **MARIBETH KRADEL-WEITZEL DESIGN — POTTSTOWN, PA**
Creative Team: **MARIBETH KRADEL-WEITZEL**
Client: **THE HURRICANE POSTER PROJECT**

Creative Firm: **SOMMESE DESIGN — PORT MATILDA, PA**
Creative Team: **LANNY SOMMESE**
Client: **CENTRAL PENNSYLVANIA FESTIVAL OF THE ARTS**

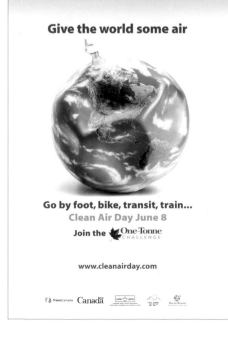

Creative Firm: **ACART COMMUNICATIONS
— OTTAWA, ON, CANADA**
Creative Team: **VERNON LAI, TOM MEGGINSON,
JOHN STARESINIC, DONNA STOTT**
Client: **CUTA**

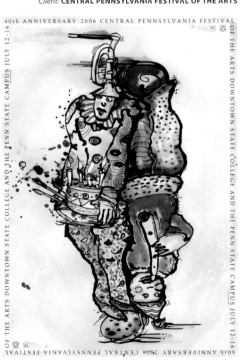

Creative Firm: **RODGERS TOWNSEND — ST. LOUIS, MO**
Creative Team: **TOM HUDDER, JENNY STORINO,**
JAKE EDINGER, CHERYL SPARKS
Client: **THE DUBLINER**

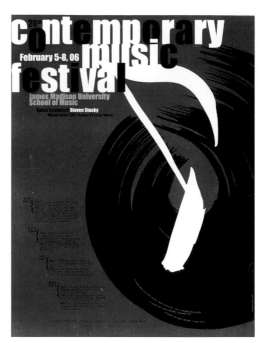

Creative Firm: **SERAN DESIGN — KEEZLETOWN, VA**
Creative Team: **SANG YOON**
Client: **SCHOOL OF MUSIC, JAMES MADISON UNIVERSITY**

Creative Firm: **DEVER DESIGNS — LAUREL, MD**
Creative Team: **JEFFREY DEVER**
Client: **DEVER DESIGNS**

Creative Firm: **TORRE LAZUR MCCANN — PARSIPPANY, NJ**
Creative Team: **DAVID PROUDFOOT, JULIET ALVAREZ,**
JENNIFER ALAMPI, MARCIA GODDARD
Client: **INTERNATIONAL OSTEOPOROSIS FOUNDATION**

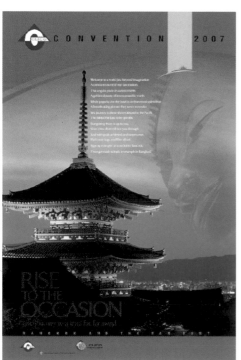

Creative Firm: **ALL MEDIA PROJECTS LIMITED**
— PORT OF SPAIN, TRINIDAD AND TOBAGO
Creative Team: **RICHARD RYAN,**
BRENT MATTHEW, DEBBIE GARRAWAY,
JULIEN GREENIDGE
Client: **CLICO**

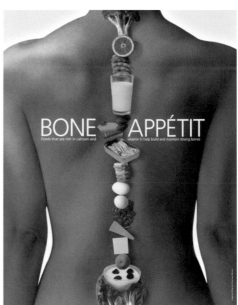

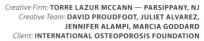

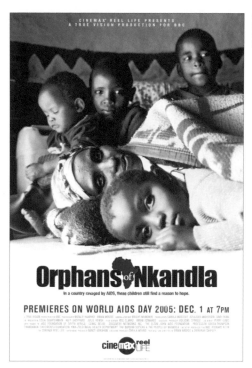

Creative Firm: **HBO — NEW YORK, NY**
Creative Team: **VENUS DENNISON, MARY TCHORBAJIAN, CARLOS TEJEDA**
Client: **HBO DOCUMENTARY FILMS**

Creative Firm: **MARIBETH KRADEL-WEITZEL DESIGN — POTTSTOWN, PA**
Creative Team: **MARIBETH KRADEL-WEITZEL**
Client: **PHILADELPHIA UNIVERSITY**

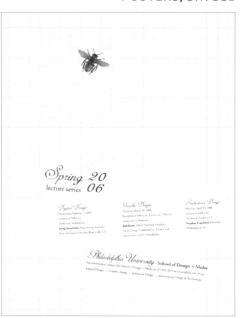

Creative Firm: **RODGERS TOWNSEND — ST. LOUIS, MO**
Creative Team: **TOM HUDDER, LUKE PARTRIDGE, JAKE EDINGER, JAMES SCHWARTZ, CHERYL SPARKS**
Client: **ARTS & EDUCATION COUNCIL OF GREATER ST. LOUIS**

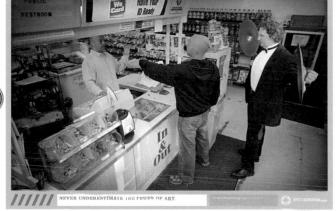

Creative Firm: **VANPELT CREATIVE — GARLAND, TX**
Creative Team: **CHIP VANPELT, J.W. BURKEY, MICHAEL EGAN**
Client: **CHAMBER MUSIC INTERNATIONAL**

Creative Firm: **ONE HUNDRED CHURCH STREET — LOGAN, UT**
Creative Team: **R.P. BISLAND**
Client: **CACHE VALLEY GARDENERS MARKET**

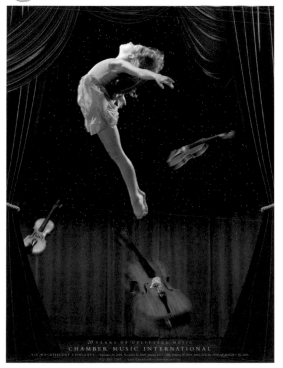

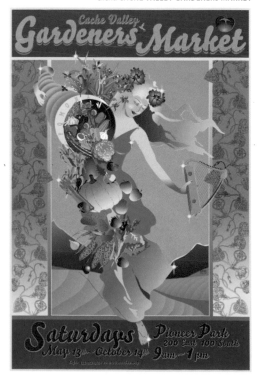

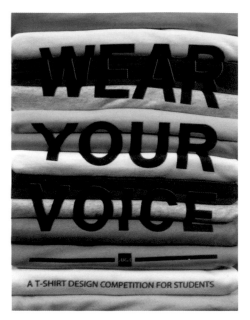

Creative Firm: **MARIBETH KRADEL-WEITZEL DESIGN**
— POTTSTOWN, PA
Creative Team: **MARIBETH KRADEL-WEITZEL**
Client: **AIGA PHILADELPHIA**

Creative Firm: **YELLOW SHOES CREATIVE WEST, DISNEYLAND**
RESORT — ANAHEIM, CA
Creative Team: **SCOTT STARKEY, JANE ROHAN, WES CLARK,**
MARTY MULLER, JACQUELYN MOE
Client: **DISNEYLAND RESORT**

Creative Firm: **RUSTY GEORGE DESIGN — TACOMA, WA**
Creative Team: **RYAN MELINE**
Client: **POINT DEFIANCE ZOO & AQUARIUM**

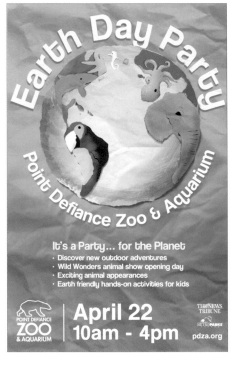

Creative Firm: **BBK STUDIO — GRAND RAPIDS, MI**
Creative Team: **YANG KIM, JASON MURRAY,**
MICHELE CHARTIER, INTEGRA
Client: **CMP**

Creative Firm: **RODGERS TOWNSEND — ST. LOUIS, MO**
Creative Team: **TOM HUDDER, LUKE PARTRIDGE, JAKE EDINGER, JAMES SCHWARTZ,**
CHERYL SPARKS
Client: **ARTS & EDUCATION COUNCIL OF GREATER ST. LOUIS**

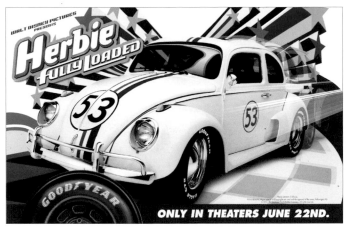

Creative Firm: **HITCHCOCK FLEMING & ASSOCIATES INC. — AKRON, OH**
Creative Team: **NICK BETRO, CHUCK REPEDE, LENNY SPENGLER, MATT MCCALLUM**
Client: **GOODYEAR TIRE & RUBBER COMPANY**

LOVE GREEN

Creative Firm: **WESTERN MICHIGAN UNIVERSITY — KALAMAZOO, MI**
Creative Team: **PRAVIN SEVAK, ARVIND SEVAK,**
KALPESH PATEL
Client: **PRAVIN C SEVAK**

Creative Firm: **RODGERS TOWNSEND — ST. LOUIS, MO**
Creative Team: **TOM HUDDER, MARK ARNOLD,**
TODD MITCHELL, CHERYL SPARKS
Client: **CIRCUS FLORA**

Creative Firm: **YOUNG & RUBICAM GMBH & CO. KG — FRANKFURT AM MAIN, HESSEN, GERMANY**
Creative Team: **CHRISTIAN DAUL, UWE MARQUARDT, HELGE KNIESS, KARSTEN RUTZ, THOMAS BALZER**
Client: **DIALOGMUSEUM**

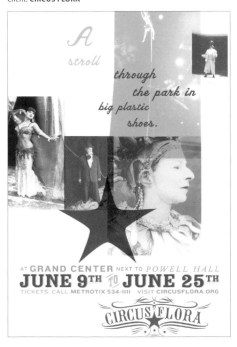

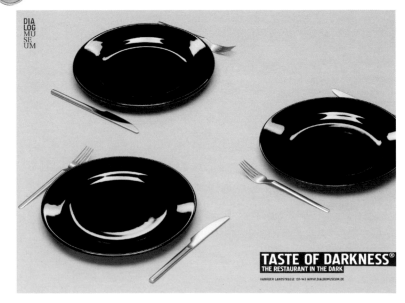

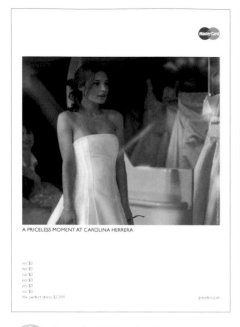

A PRICELESS MOMENT AT CAROLINA HERRERA

no: $0
no: $0
no: $0
no: $0
no: $0
no: $0
the perfect dress: $5,990

priceless.com

A PRICELESS MOMENT IN WINNETKA

Viking® 53" Ultra-Premium Outdoor Grill with TruSear™ Infrared Burner: $6,100
meat: $7,799lb

priceless.com

Creative Firm: **MCCANN ERICKSON, NEW YORK — NEW YORK, NY**
Creative Team: **CHRIS CEREDA, JOYCE KING THOMAS, SONIA ZOBEL, ROBERT FISCHER**
Client: **MASTERCARD AFFLUENT CAMPAIGN**

Creative Firm: **FRY HAMMOND BARR — ORLANDO, FL**
Creative Team: **TIM FISHER, SEAN BRUNSON, SANDRA LAWTON, JOHN DEEB, STEPHANIE RUELKE**
Client: **ORLANDO SCIENCE CENTER**

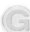

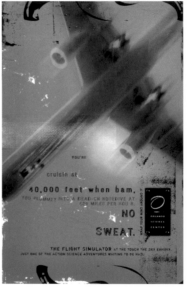

Creative Firm: **AD PLANET GROUP / ACE: DAYTONS ADVERTISING — SINGAPORE**
Creative Team: **LEO TECK CHONG, ALFRED TEO, CHEN YILONG, ANDREW LEONG KAR POH**
Client: **SINGAPORE TRAFFIC POLICE**

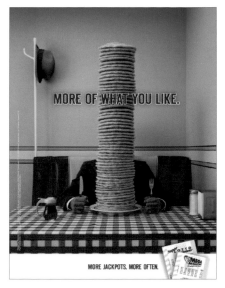
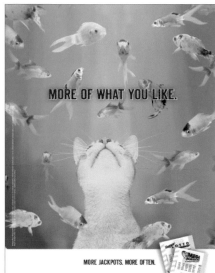

Creative Firm: **ALCONE MARKETING** — IRVINE, CA
Creative Team: **LUIS CAMANO, CARLOS MUSQUEZ, SHIVONNE MILLER, JULIE KIMURA**
Client: **CALIFORNIA LOTTERY**

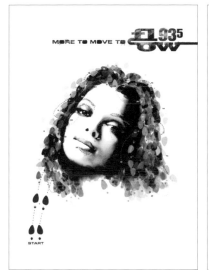
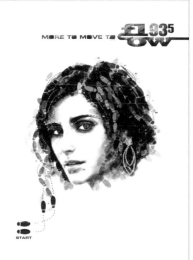

Creative Firm: **TAXI CANADA INC.** — TORONTO, ON, CANADA
Creative Team: **ZAK MROUEH, ROSE SAUQUILLO, JOHNNIE INGRAM, ALEXIS GROPPER, JEREMY DIMMOCK, AMANDA GASPARD**
Client: **FLOW 93.5**

Creative Firm: **CSC'S P2 COMMUNICATIONS SERVICES** — FALLS CHURCH, VA
Creative Team: **MARK RICHARDS, TERRY WILSON, LALITHA SUNDARAM**
Client: **CSC'S P2 COMMUNICATIONS SERVICES - SELF-PROMOTION**

Creative Firm: **RODGERS TOWNSEND — ST. LOUIS, MO**
Creative Team: **ERIK MATHRE, LIZ FORSYTHE, BILL ECKLOFF, CHERYL SPARKS**
Client: **THE BLACK REP**

Creative Firm: **MIKE SALISBURY EFFECTIVE CREATIVE STRATEGIES**
— VENICE, CA
Creative Team: **MIKE SALISBURY, JIM SHOEMAKER**
Client: **TRIUMPH USA**

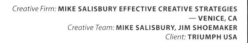
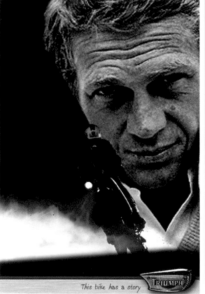
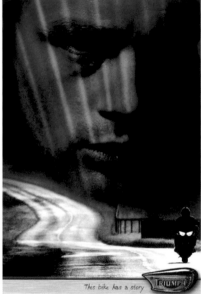

Creative Firm: **ALL MEDIA PROJECTS LIMITED — PORT OF SPAIN, TRINIDAD AND TOBAGO**
Creative Team: **CLINT WILLIAMS, MARISA CAMEJO, RICHARD RYAN, JULIEN GREENIDGE, JOSIANE KHAN**
Client: **BP TRINIDAD AND TOBAGO (BPTT)**

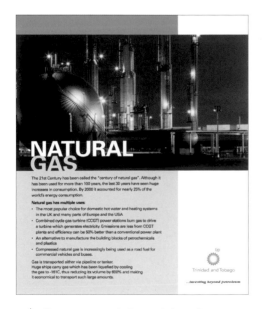
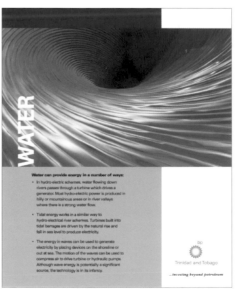
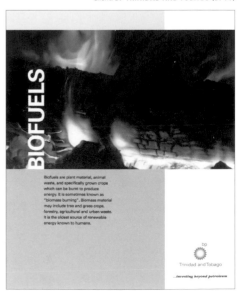

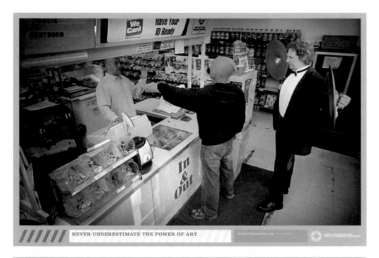

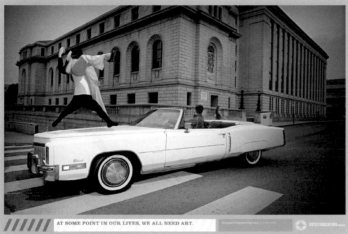

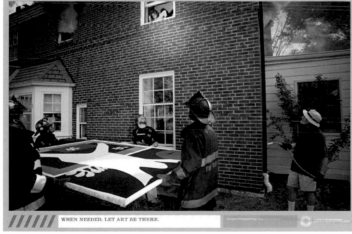

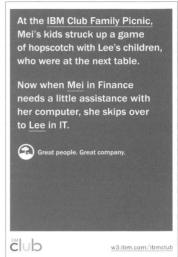

One day, you were working hard (as usual), and you stopped and saw this poster that told you that on _____, IBM Club will be hosting _____ Please join us at ⏰ ___

Soon you found yourself reading more posters.

At the IBM Club Family Picnic, Mei's kids struck up a game of hopscotch with Lee's children, who were at the next table.

Now when Mei in Finance needs a little assistance with her computer, she skips over to Lee in IT.

Great people. Great company.

Creative Firm: **VSA PARTNERS, INC. — CHICAGO, IL**
Creative Team: **CURT SCHREIBER, STEVE RYAN, ASHLEY LIPPARD, WENDY BELT**
Client: **IBM CORPORATION**

Creative Firm: **CMT — NEW YORK, NY**
Creative Team: **JAMES HITCHCOCK, AMIE NGUYEN, LINDA ZACK**
Client: **CMT**

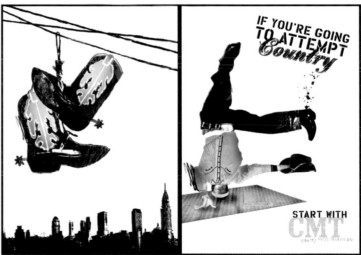

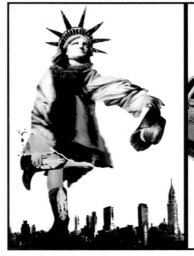

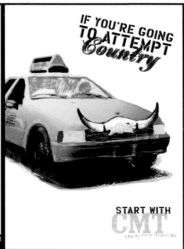

Creative Firm: **RODGERS TOWNSEND — ST. LOUIS, MO**
Creative Team: **TOM HUDDER, LUKE PARTRIDGE, JAKE EDINGER, JAMES SCHWARTZ, CHERYL SPARKS**
Client: **ARTS & EDUCATION COUNCIL OF GREATER ST. LOUIS**

189

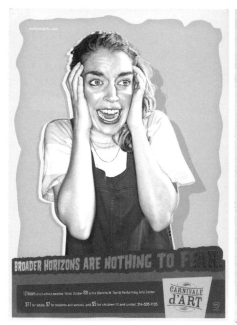
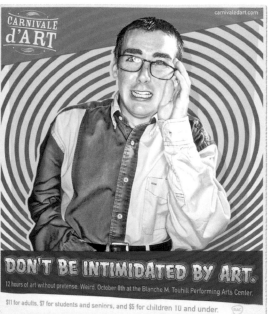
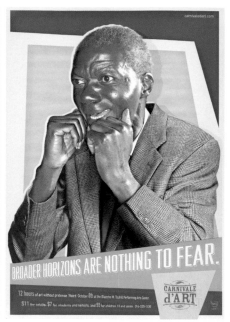

Creative Firm: **RODGERS TOWNSEND — ST. LOUIS, MO**
Creative Team: **TOM HUDDER, LUKE PARTRIDGE, MICHAEL MCCORMICK, BRIAN KUHLMAN, CHERYL SPARKS**
Client: **CARNIVALE D' ART**

Creative Firm: **ERIC CAI DESIGN CO. — BEIJING, CHINA**
Creative Team: **ERIC CAI SHI WEI, DUAN LIAN, ESTHER TAN YAN**
Client: **CITY CLUB MAGAZINE**

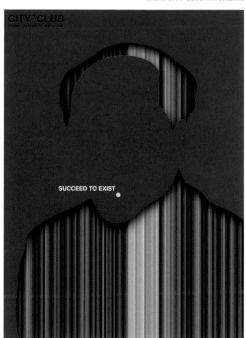

Creative Firm: **KOCH CREATIVE GROUP — WICHITA, KS**
Creative Team: **JASON GRAMKE, JASON FORTUNE, DUSTIN JOYCE, GAVIN PETERS**
Client: **FLINT HILLS RESOURCES**

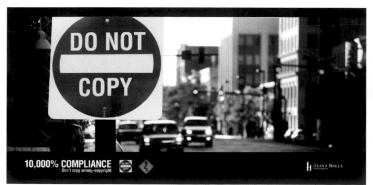
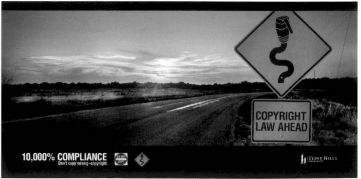

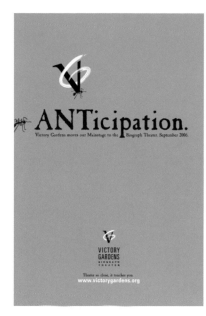

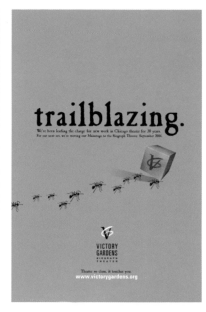

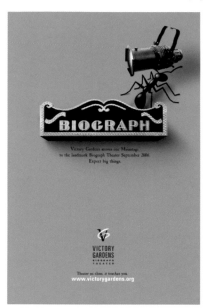

Creative Firm: **THE MONOGRAM GROUP — CHICAGO, IL**
Creative Team: **HAROLD WOODRIDGE, BRETT HAWTHORNE, CHRISTA VELBEL**
Client: **VICTORY GARDENS THEATER**

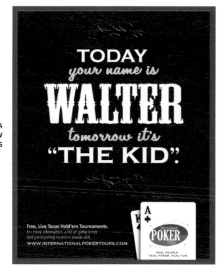

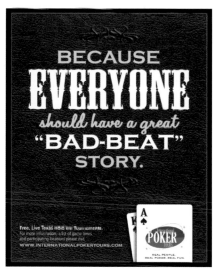

Creative Firm: **LEBOW — TORONTO, ON, CANADA**
Creative Team: **RONNIE LEBOW**
Client: **INTERNATIONAL POKER TOURS**

Creative Firm: **RODGERS TOWNSEND — ST. LOUIS, MO**
Creative Team: **TOM HUDDER, VALERIE TIRELLA, KAY COCHRAN, STEFAN HESTER, CHERYL SPARKS**
Client: **HUMANE SOCIETY OF MISSOURI**

WHO WAS POWEL CROSLEY JR.?

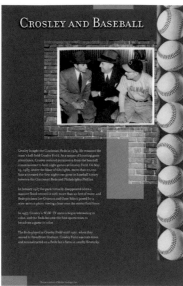

CROSLEY AND BASEBALL

A TIMELINE OF CROSLEY INVENTIONS

Creative Firm: **FIVE VISUAL COMMUNICATION & DESIGN — WEST CHESTER, OH**
Creative Team: **RONDI TSCHOPP**
Client: **MERCY HEALTH PARTNERS**

Creative Firm: **HULL CREATIVE GROUP — BROOKLINE, MA**
Creative Team: **CARYL H. HULL, HEIDI PRINCE, FOSTER PARENTS**
Client: **DARE FAMILY SERVICES**

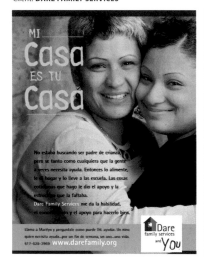

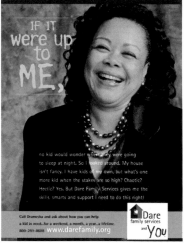

Creative Firm: **WESTERN MICHIGAN UNIVERSITY — KALAMAZOO, MI**
Creative Team: **PRAVIN SEVAK, ARVIND SEVAK, KALPESH PATEL**
Client: **PRAVIN C SEVAK**

Creative Firm: **SUBPLOT DESIGN INC. — VANCOUVER, BC, CANADA**
Creative Team: **MATTHEW CLARK, ROY WHITE, WALDY MARTENS**
Client: **RYDERS EYEWEAR**

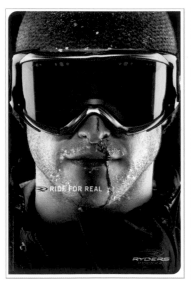

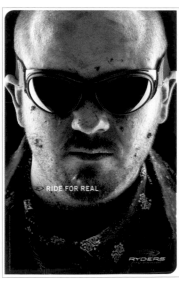

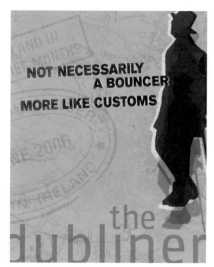
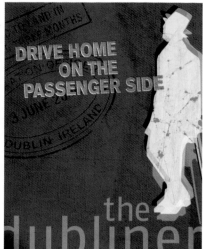

Creative Firm: **RODGERS TOWNSEND — ST. LOUIS, MO**
Creative Team: **TOM HUDDER, JENNY STORINO, JAKE EDINGER, CHERYL SPARKS**
Client: **THE DUBLINER**

Creative Firm: **ERIC CAI DESIGN CO. — BEIJING, CHINA**
Creative Team: **ERIC CAI SHI WEI, XU ZHI HONG**
Client: **NANJING MASSACRE MEMORIAL**

Creative Firm: **ADVANTAGE LTD — HAMILTON, BERMUDA**
Creative Team: **SAMI LILL, MEREDITH ANDREWS**
Client: **PARLIAMENTARY REGISTRY**

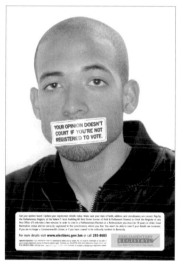
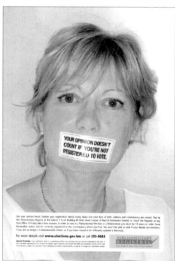

Creative Firm: **DAVIS DESIGN PARTNERS — HOLLAND, OH**
Creative Team: **MATT DAVIS, KAREN DAVIS, PEGGY FELIX**
Client: **PURDUE THEATRE (PURDUE UNIVERSITY)**

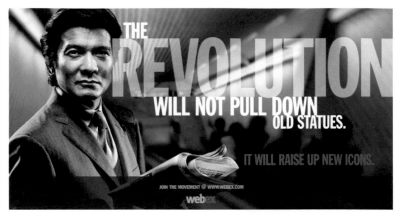

Creative Firm: **PUBLICIS DIALOG — SAN FRANCISCO, CA**
Creative Team: **JOE LIN, CHRISTOPHER ST. JOHN, THERESA LEE,**
SHAWN POE, CLAUDIA GOETZELMAN
Client: **WEBEX COMMUNICATIONS, INC.**

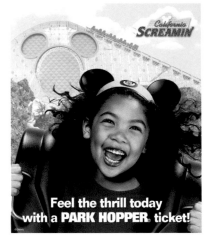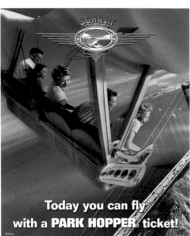

Creative Firm: **HULL CREATIVE GROUP — BROOKLINE, MA**
Creative Team: **CARYL H. HULL, DIANE RIPSTEIN, FAY FOTO**
Client: **TEMPLE SANAI**

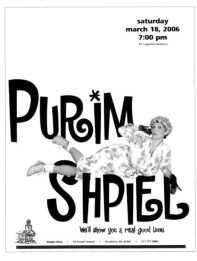

Creative Firm: **DISNEYLAND RESORT — ANAHEIM, CA**
Creative Team: **DATHAN SHORE, WES CLARK, JACQUELYN MOE, JIM ST. AMANT,**
SCOTT STARKEY, JANE ROHAN
Client: **DISNEYLAND RESORT**

Creative Firm: **RODGERS TOWNSEND — ST. LOUIS, MO**
Creative Team: **TOM HUDDER, JENNY STORINO, JAKE EDINGER, CHERYL SPARKS**
Client: **THE DUBLINER**

Creative Firm: **RODGERS TOWNSEND — ST. LOUIS, MO**
Creative Team: **TOM HUDDER, MARK ARNOLD, TODD MITCHELL, CHERYL SPARKS**
Client: **CIRCUS FLORA**

 Creative Firm: **ATOMZ I! PTE LTD — SINGAPORE**
Creative Team: **PATRICK LEE, ALBERT LEE, KESTREL LEE, LOUIS CHEW**
Client: **AGRI-FOOD & VETERINARY AUTHORITY OF SINGAPORE**

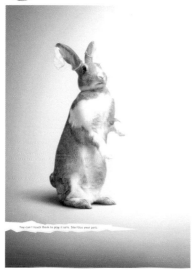
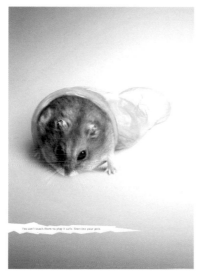
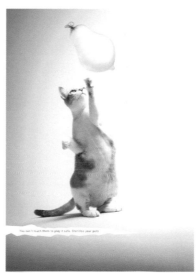

Creative Firm: **ALL MEDIA PROJECTS LIMITED — PORT OF SPAIN, TRINIDAD AND TOBAGO**
Creative Team: **CLINT WILLIAMS, CHRISTOPHER WILCOX, MARQUITA CELESTINE**
Client: **BP TRINIDAD AND TOBAGO (BPTT)**

Creative Firm: **AD PLANET GROUP / ACE: DAYTONS ADVERTISING — SINGAPORE**
Creative Team: **LEO TECK CHONG, ALFRED TEO, JOE TAN, SERENE GOH, BEN LIM, JAMES TAN**
Client: **SARA LEE SINGAPORE PTE LTD**

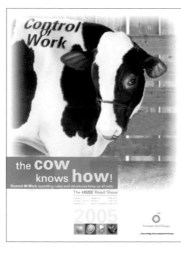

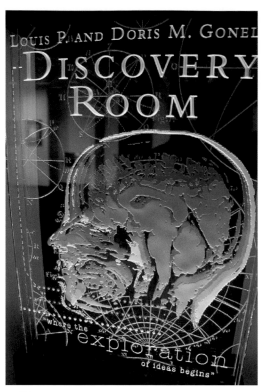

Creative Firm: **HUGHES HUNTER, INC. — THOUSAND OAKS, CA**
Creative Team: **JIM HUGHES, BRUCE POLKES, DENNIS RICCI, CAROL GRAVELLE**
Client: **LEXUS**

Creative Firm: **WALLACH GLASS STUDIO — SANTA ROSA, CA**
Creative Team: **CHRISTINA WALLACH, ARLENE RHODEN, TIM FELDMAN**
Client: **UC MERCED**

Creative Firm: **MAYHEM STUDIOS — LOS ANGELES, CA**
Creative Team: **CALVIN LEE**
Client: **FAMILY MEDICAL CENTER**

Creative Firm: **ASPREY CREATIVE — FITZROY, VICTORIA, AUSTRALIA**
Creative Team: **RITA PALMIERI TRSAN, PETER ASPREY**
Client: **TRE BICCHIERI**

Creative Firm: **RANDI WOLF DESIGN — GLASSBORO, NJ**
Creative Team: **RANDI WOLF, ASTRO SIGNS, JOHN & TRACIE SPERRATORE**
Client: **THE FOUNDERS INN BED & BREAKFAST**

Creative Firm: MODREN MARKETING CONCEPTS
— LOUISVILLE, KY
Creative Team: MARK GROVES
Client: MODREN MARKETING CONCEPTS

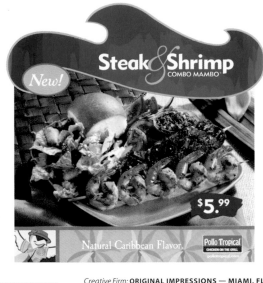

Creative Firm: ORIGINAL IMPRESSIONS — MIAMI, FL
Creative Team: RAFAEL BAEZA
Client: POLLO TROPICAL

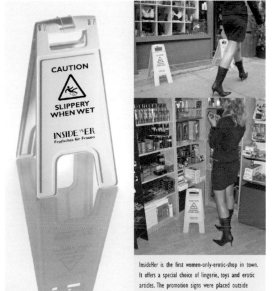

InsideHer is the first women-only-erotic-shop in town. It offers a special choice of lingerie, toys and erotic articles. The promotion signs were placed outside and inside of the shop to get the attention of female pedestrians and to invite them in.

Creative Firm: YOUNG & RUBICAM GMBH & CO. KG
— FRANKFURT AM MAIN, HESSEN, GERMANY
Creative Team: CHRISTIAN DAUL, MAJA MILOSEVIC,
ANNA-KARINA KORN, THOMAS BALZER
Client: INSIDEHER - EROTIC ACCESSORIES FOR WOMEN

Creative Firm: GAMMON RAGONESI ASSOCIATES
— NEW YORK, NY
Creative Team: MARY RAGONESI, JILLSHELLHORN
Client: NESTLE

Creative Firm: YOUNG & RUBICAM GMBH & CO. KG
— FRANKFURT AM MAIN, HESSEN, GERMANY
Creative Team: CHRISTIAN DAUL, UWE MARQUARDT,
MONIKA SPIRKL, BRUNO PETZ, HERIBERT BURKERT
Client: SHARKPROJECT E.V.

Creative Firm: ORIGINAL IMPRESSIONS — MIAMI, FL
Creative Team: RAFAEL BAEZA
Client: POLLO TROPICAL

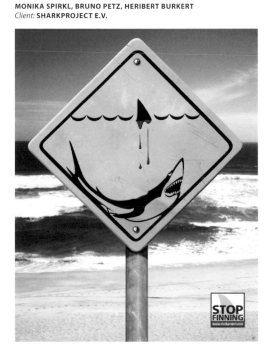

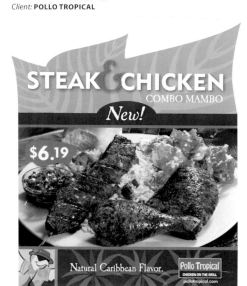

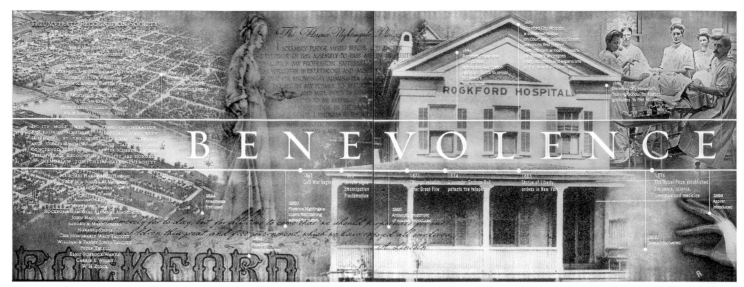

(P) *Creative Firm:* **WALLACH GLASS STUDIO — SANTA ROSA, CA**
Creative Team: **CHRISTINA WALLACH, ARLENE RHODEN, ART VIGER, JENNIFER SEROTA, TIM FELDMAN, NELS ACKERLUND**
Client: **ROCKFORD MEMORIAL HOSPITAL**

Creative Firm: **PETERSON MILLA HOOKS — MINNEAPOLIS, MN**
Creative Team: **DAVE PETERSON, GAYLE MALCOLM, ELLEN FREGO**
Client: **TARGET**

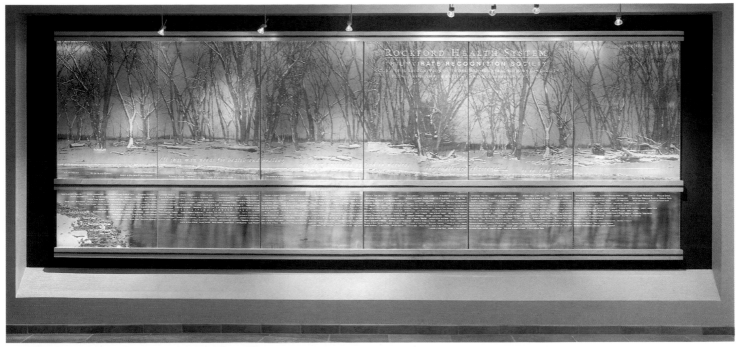

 Creative Firm: **WALLACH GLASS STUDIO — SANTA ROSA, CA**
Creative Team: **CHRISTINA WALLACH, ARLENE RHODEN, TIM FELDMAN, NELS ACKERLUND**
Client: **ROCKFORD MEMORIAL HOSPITAL**

Creative Firm: **QUALCOMM — SAN DIEGO, CA**
Creative Team: **FRANK BERNAS, CHRIS LEE**

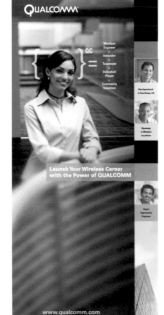

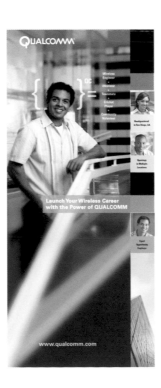

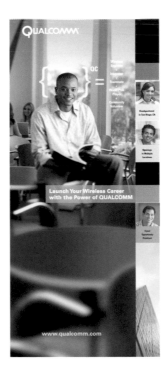

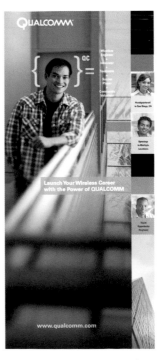

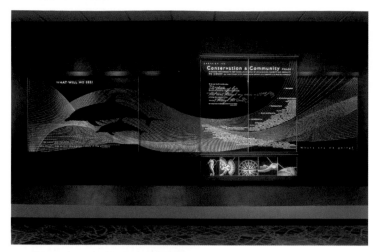

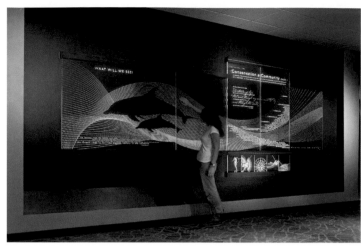

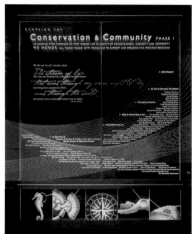

Creative Firm: **WALLACH GLASS STUDIO — SANTA ROSA, CA**
Creative Team: **CHRISTINA WALLACH, ARLENE RHODEN, TIM FELDMAN**
Client: **INDIANAPOLIS ZOO**

Creative Firm: **WINDCHASER PRODUCTS, INC — MARINA DEL REY, CA**
Creative Team: **NATHAN ADAMS, JOEY GARCIA**
Client: **WINDCHASER PRODUCTS, INC**

Creative Firm: **BETH SINGER DESIGN — ARLINGTON, VA**
Creative Team: **BETH SINGER, CHRIS HOCH, DEBORAH ECKBRETH, HOWARD SMITH**
Client: **AMERICAN ISRAEL PUBLIC AFFAIRS COMMITTEE**

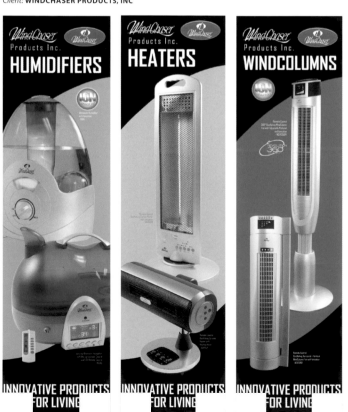

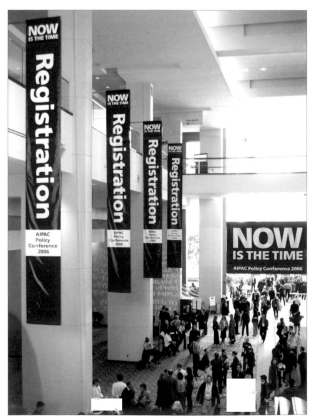

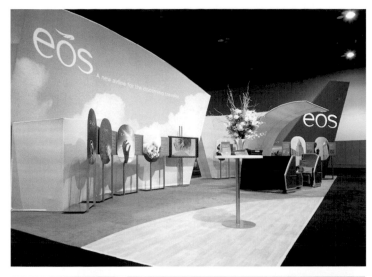

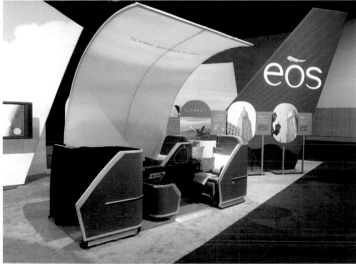

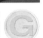

Creative Firm: **REVOLUZION ADVERTISING & DESIGN — NEUHAUSEN OB ECK, GERMANY**
Creative Team: **BERND LUZ, THOMAS BRECHT**
Client: **TÜRK+HILLINGER HEATING ELEMENTS**

Creative Firm: **HORNALL ANDERSON DESIGN WORKS — SEATTLE, WA**
Creative Team: **JACK ANDERSON, MARK POPICH, LARRY ANDERSON**
Client: **EOS AIRLINES**

Creative Firm: **MTV NETWORKS CREATIVE SERVICES — NEW YORK, NY**
Client: **MTV NETWORKS AFFILIATE SALES**

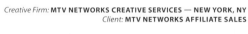

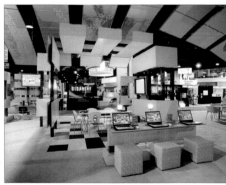

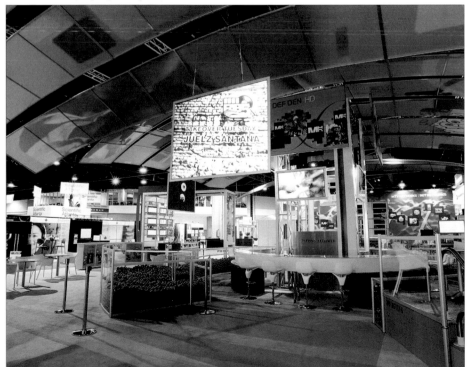

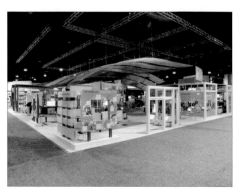

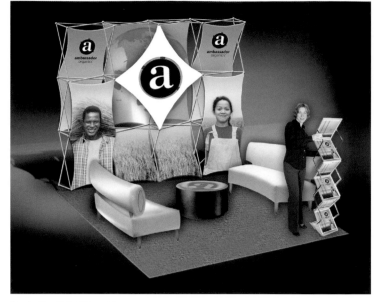

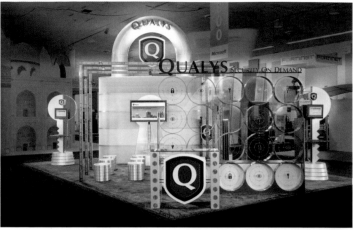

Creative Firm: **PURE DESIGN CO. LLC—LEVERETT, MA**
Creative Team: **DAN MISHKIND, MARY KATE MARCHAND**
Client: **GOOD FOOD ORGANICS, INC.**

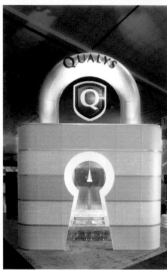

Creative Firm: **ORIGINAL IMPRESSIONS — MIAMI, FL**
Creative Team: **FRANK IRIAS**
Client: **ROYAL CARIBBEAN INTERNATIONAL**

Creative Firm: **GEE + CHUNG DESIGN — SAN FRANCISCO, CA**
Creative Team: **EARL GEE, ANDY CAULFIELD, HOOD EXHIBITS**
Client: **QUALYS, INC.**

Creative Firm: **JGA — SOUTHFIELD, MI**
Creative Team: **DAVID NELSON, TAMI JO URBAN, GORDON EASON**
Client: **PHOTO MARKETING ASSOCIATION**

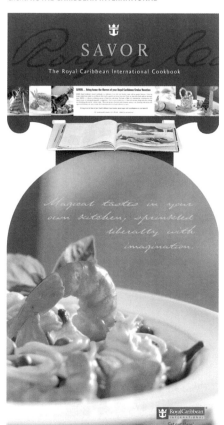

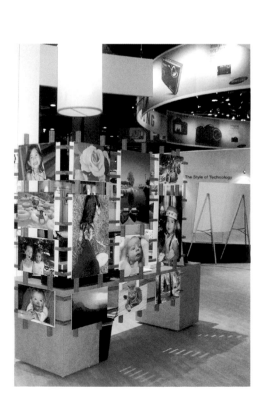

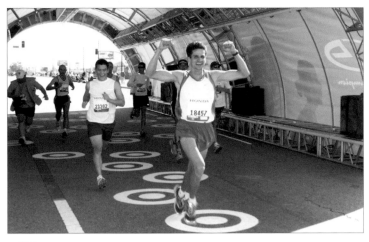

Creative Firm: **PETERSON MILLA HOOKS — MINNEAPOLIS, MN**
Creative Team: **DAVE PETERSON, AARON POLLOCK, CATHERINE IRMITER, ELLEN FREGO, MICHAEL SHARP**
Client: **TARGET**

Creative Firm: **THE MONOGRAM GROUP — CHICAGO, IL**
Creative Team: **HAROLD WOODRIDGE,**
CHIP BALCH, SAVERIO TRUGLIA
Client: **CHICAGO SYMPHONY ORCHESTRA**

Creative Firm: RODGERS TOWNSEND
— ST. LOUIS, MO
Creative Team: TOM HUDDER, TOM TOWNSEND, CHERYL SPARKS
Client: ST. LOUIS RAMS

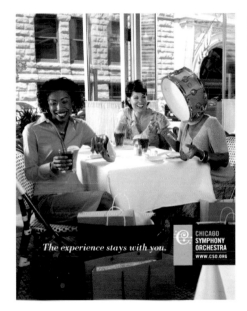

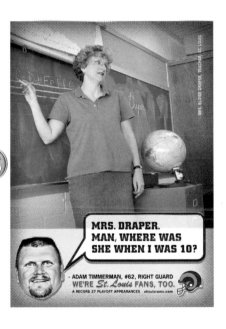

MRS. DRAPER.
MAN, WHERE WAS
SHE WHEN I WAS 10?

- ADAM TIMMERMAN, #62, RIGHT GUARD
WE'RE *St. Louis* FANS, TOO.

Creative Firm: **HOFFMAN/LEWIS — SAN FRANCISCO, CA**
Creative Team: **SHARON KRINSKY, JAMES CABRAL,**
RONDA DUNN, JASON HEADLEY
Client: **HENRY'S**

Creative Firm: **RODGERS TOWNSEND — ST. LOUIS, MO**
Creative Team: **TOM HUDDER, TOM TOWNSEND,**
CHERYL SPARKS
Client: **ST. LOUIS RAMS**

Creative Firm: RODGERS TOWNSEND — ST. LOUIS, MO
Creative Team: TOM HUDDER, TOM TOWNSEND,
CHERYL SPARKS
Client: ST. LOUIS RAMS

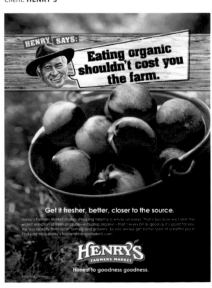

HENRY SAYS:
Eating organic
shouldn't cost you
the farm.

Get it fresher, better, closer to the source.

HENRY'S
FARMERS MARKET
Honest to goodness goodness.

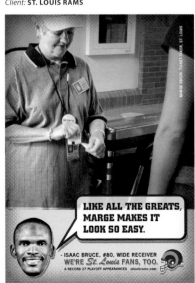

LIKE ALL THE GREATS,
MARGE MAKES IT
LOOK SO EASY.

- ISAAC BRUCE, #80, WIDE RECEIVER
WE'RE *St. Louis* FANS, TOO.

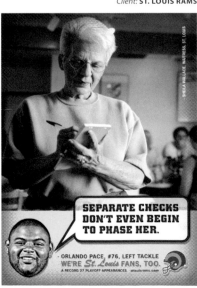

SEPARATE CHECKS
DON'T EVEN BEGIN
TO PHASE HER.

- ORLANDO PACE, #76, LEFT TACKLE
WE'RE *St. Louis* FANS, TOO.

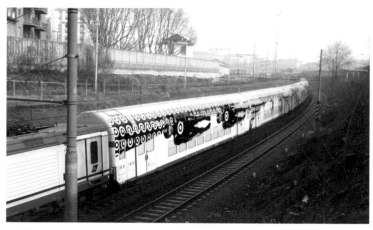

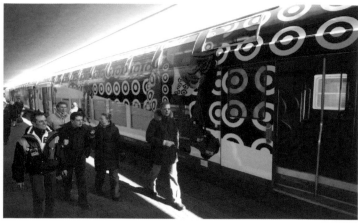

G1
Creative Firm: **PETERSON MILLA HOOKS — MINNEAPOLIS, MN**
Creative Team: **DAVE PETERSON, SUE KAASE, GAYLE MALCOLM, ELLEN FREGO, KENNETH WILLARDT**
Client: **TARGET**

Creative Firm: **HERE! NETWORKS — NEW YORK, NY**
Creative Team: **ERIC FELDMAN, MEGAN ELLIS**

Creative Firm: **VOICEBOX CREATIVE — SAN FRANCISCO, CA**
Creative Team: **JACQUES ROSSOUW, PATRICK McFARLIN**
Client: **FOSTER'S WINE ESTATES**

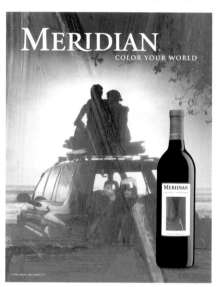

Creative Firm: **RODGERS TOWNSEND — ST. LOUIS, MO**
Creative Team: **TOM HUDDER, TOM TOWNSEND,**
CHERYL SPARKS
Client: **ST. LOUIS RAMS**

Creative Firm: **RODGERS TOWNSEND — ST. LOUIS, MO**
Creative Team: **TOM HUDDER, TOM TOWNSEND,**
CHERYL SPARKS
Client: **ST. LOUIS RAMS**

Creative Firm: **RODGERS TOWNSEND — ST. LOUIS, MO**
Creative Team: **TOM HUDDER, TOM TOWNSEND,**
CHERYL SPARKS
Client: **ST. LOUIS RAMS**

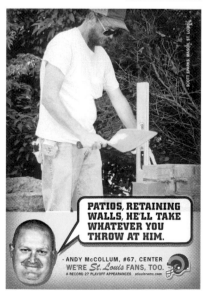

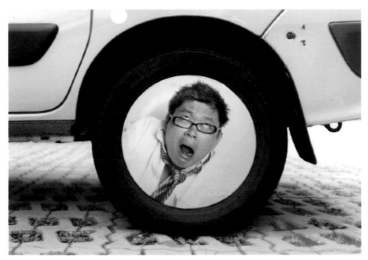

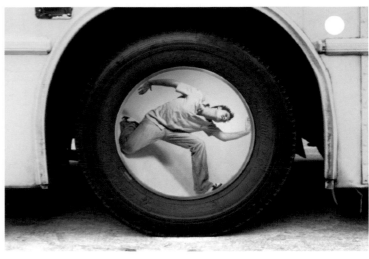

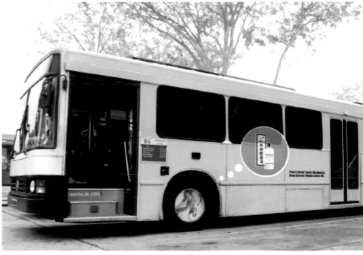

Creative Firm: **AD PLANET GROUP / ACE: DAYTONS ADVERTISING — SINGAPORE**
Creative Team: **LEO TECK CHONG, ALFRED TEO, AMOUS SEOW, JOE TAN, BEN LIM, JAMES TAN**
Client: **LKF MEDICAL COMPANY (PTE) LTD**

Creative Firm: **LEO BURNETT/YELLOW SHOES CREATIVE WEST, DISNEYLAND RESORT — ANAHEIM, CA**
Creative Team: **DATHAN SHORE, MARTY MULLER, WES CLARK, JACQUELYN MOE, JIM ST. AMANT, ROSANNA AGUILAR**
Client: **DISNEYLAND RESORT**

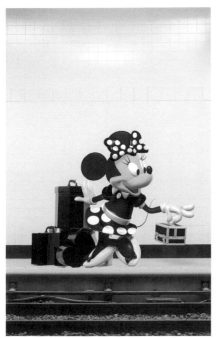

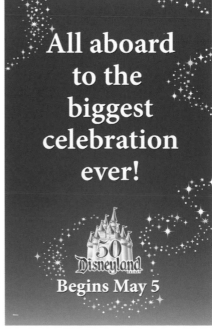

All aboard to the biggest celebration ever!

50 Disneyland
Begins May 5

Creative Firm: **MCCANN ERICKSON, NEW YORK — NEW YORK, NY**
Creative Team: **LESLIE SIMS, AUDREY HUFFENREUTER, JOYCE KING THOMAS, ANDREA KAYE, LEON STEELE, APRIL GALLO**
Client: **CITY OF NEW YORK, MAYOR BLOOMBERG'S OFFICE**

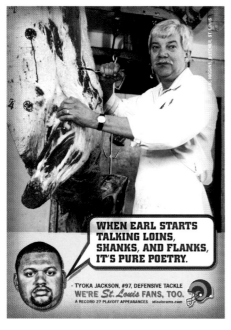
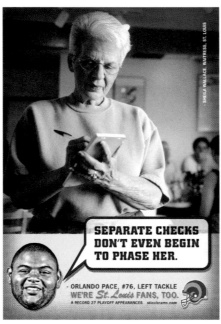

Creative Firm: **RODGERS TOWNSEND — ST. LOUIS, MO**
Creative Team: **TOM HUDDER, TOM TOWNSEND, CHERYL SPARKS**
Client: **ST. LOUIS RAMS**

Creative Firm: **LEO BURNETT/YELLOW SHOES CREATIVE WEST, DISNEYLAND RESORT — ANAHEIM, CA**
Creative Team: **DATHAN SHORE, MARTY MULLER, JACQUELYN MOE, JIM ST. AMANT, MIKE FIRMAN, ROSANNA AGUILAR**
Client: **DISNEYLAND RESORT**

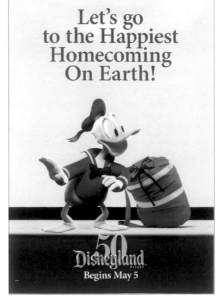
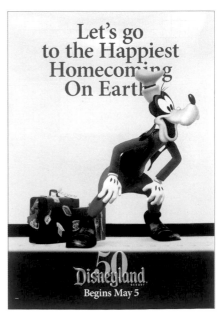

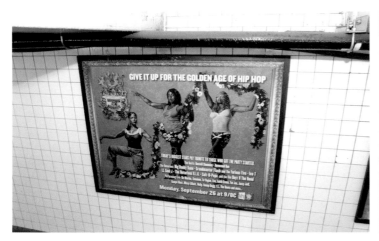

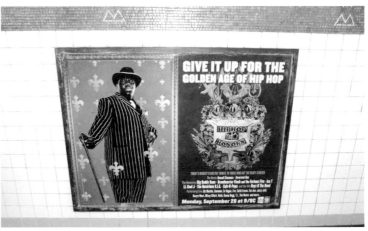

Creative Firm: **VH1 — NEW YORK, NY**
Client: **VH1**

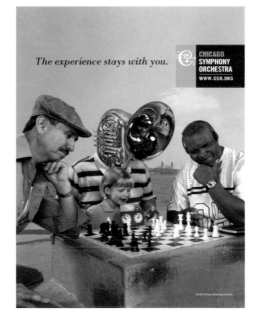

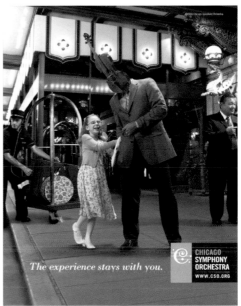

Creative Firm: **YELLOW SHOES CREATIVE WEST, DISNEYLAND RESORT
— ANAHEIM, CA**
Creative Team: **DATHAN SHORE, MARTY MULLER, JACQUELYN MOE,
WES CLARK**
Client: **DISNEYLAND RESORT**

Creative Firm: **THE MONOGRAM GROUP — CHICAGO, IL**
Creative Team: **HAROLD WOODRIDGE, CHIP BALCH, SAVERIO TRUGLIA**
Client: **CHICAGO SYMPHONY ORCHESTRA**

Creative Firm: **LEO BURNETT/YELLOW SHOES CREATIVE WEST, DISNEYLAND RESORT — ANAHEIM, CA**
Creative Team: **DATHAN SHORE, MARTY MULLER, JACQUELYN MOE, WES CLARK**
Client: **DISNEYLAND RESORT**

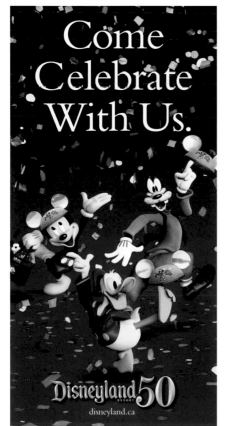

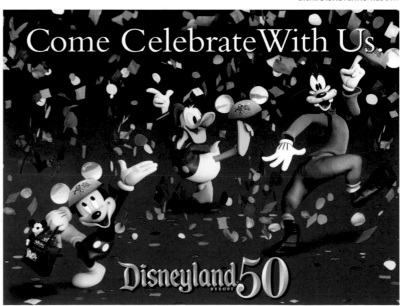

VEHICLE GRAPHICS

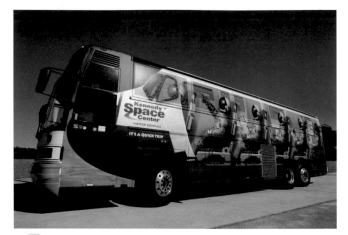

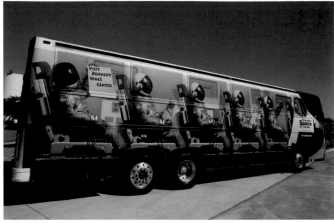

Creative Firm: **FRY HAMMOND BARR — ORLANDO, FL**
Creative Team: **TIM FISHER, RAY KILINSKI, TOM KANE, STEPHANIE RUELKE, ARTISTIC IMAGE**
Client: **KENNEDY SPACE CENTER**

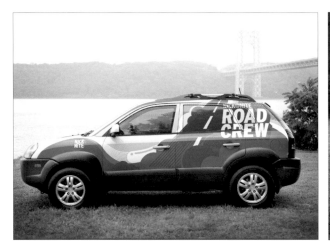

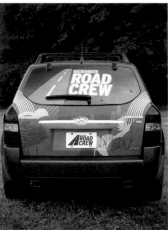

Creative Firm: **NICK AT NITE — NEW YORK, NY**
Creative Team: **KENNA KAY, NATIONAL TELEVISION, CATHERINE MULCAHY**
Client: **NICK AT NITE**

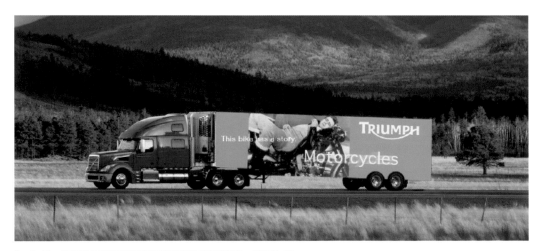

Creative Firm: **MIKE SALISBURY EFFECTIVE CREATIVE STRATEGIES — VENICE, CA**
Creative Team: **MIKE SALISBURY, GUSTAVO MORAIS**
Client: **TRIUMPH USA**

Creative Firm: **YELLOW SHOES CREATIVE WEST, DISNEYLAND RESORT — ANAHEIM, CA**
Creative Team: **SCOTT STARKEY, JACQUELYN MOE, CLAIRE BILBY**
Client: **DISNEYLAND RESORT**

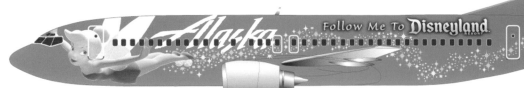

Creative Firm: **GAMMON RAGONESI ASSOCIATES — NEW YORK, NY**
Creative Team: **MARY RAGONESI, KELLY MUDGE, YARITSA ARENAS**
Client: **NESTLE**

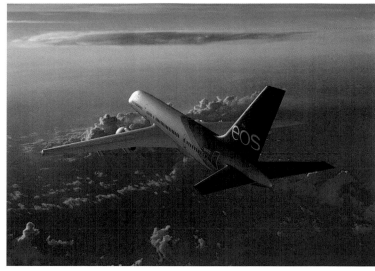

Creative Firm: **HORNALL ANDERSON DESIGN WORKS — SEATTLE, WA**
Creative Team: **J. ANDERSON, M. POPICH, D. BATES, L. ANDERSON, A. WICKLUND, L. RAYMUNDO, J. CARTER, Y. SHVETS**
Client: **EOS AIRLINES**

Creative Firm: **TTA ADVERTISING — PHOENIX, AZ**
Creative Team: **RUSTY PILE, ROB TINSMAN**
Client: **MONUMENT HOSPITALITY**

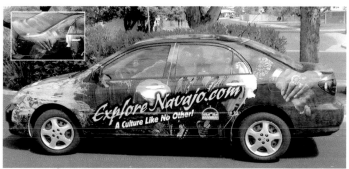

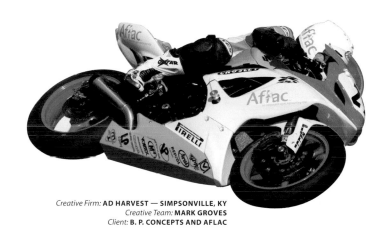

Creative Firm: **AD HARVEST — SIMPSONVILLE, KY**
Creative Team: **MARK GROVES**
Client: **B. P. CONCEPTS AND AFLAC**

Creative Firm: **YELLOW SHOES CREATIVE WEST, DISNEYLAND RESORT — ANAHEIM, CA**
Creative Team: **MIKE PUCHALSKI, MARTY MULLER, JACQUELYN MOE, WES CLARK, ANIKO BOTA, CLAIRE BILBY**
Client: **DISNEYLAND RESORT**

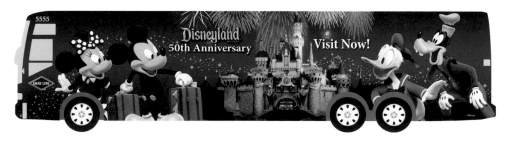

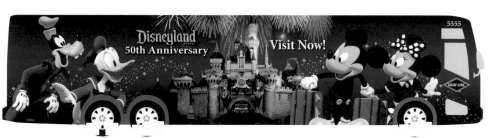

 Creative Firm: **MIRACLE GRAPHICS CO. WLL — MANAMA, BAHRAIN**
Creative Team: **KHALID JUMAN, JAY BHAGAWATI, PAUL WARRENER, GEIR ERDAL**
Client: **SHEIKH EBRAHIM CENTRE FOR CULTURE & RESEARCH**

Creative Firm: **RED CANOE — DEER LODGE, TN**
Creative Team: **DEB KOCH, KAREN PHILLIPS,**
CAROLINE KAVANAGH, DANIEL BEJAR, JEREMY LOTT
Client: **THOMAS NELSON PUBLISHERS**

 Creative Firm: **SCHOOL OF VISUAL ARTS — NEW YORK, NY**
Creative Team: **PAULA SCHER, RICHARD WILDE,**
LENNY NAAR, JULIA HOFFMAN
Client: **SCHOOL OF VISUAL ARTS**

Creative Firm: **VSA PARTNERS, INC. — CHICAGO, IL**
Creative Team: **CURT SCHREIBER, ASHLEY LIPPARD, AMY GLAIBERMAN,**
RICHARD RENNO, DREW BROOKS, ROBYN PAPROCKI
Client: **ATRIA BOOKS**

Creative Firm: **RED CANOE — DEER LODGE, TN**
Creative Team: **DEB KOCH, BELINDA BASS,**
CAROLINE KAVANAGH, ABM, RON LAMBERT, TOM PARKER
Client: **THOMAS NELSON PUBLISHERS**

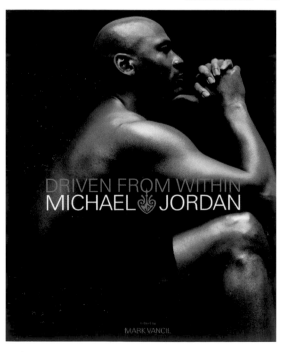

Creative Firm: **TD2, S.C. — MEXICO CITY, D.F., MEXICO**
Creative Team: **R. RODRIGO CORDOVA**
Client: **MICHELLE MORALES - WRITER**

Creative Firm: **RED CANOE — DEER LODGE, TN**
Creative Team: **DEB KOCH, BELINDA BASS, CAROLINE KAVANAGH,**
DR. TONY ZEISS, TYLER BOLEY
Client: **THOMAS NELSON PUBLISHERS**

Creative Firm: **DESIGN GUYS — MINNEAPOLIS, MN**
Creative Team: **STEVE SIKORA, BARRY TOWNSEND, DARRELL EAGER,**
POMCO GRAPHIC ARTS
Client: **NEENAH PAPER**

Creative Firm: **RED CANOE — DEER LODGE, TN**
Creative Team: **DEB KOCH, KAREN PHILLIPS, CAROLINE KAVANAGH,**
IAN LAWRENCE, KATHERINE ALBRECHT, LIZ MCINTYRE
Client: **THOMAS NELSON PUBLISHERS**

Creative Firm: **MIRACLE GRAPHICS CO. WLL — MANAMA, BAHRAIN**
Creative Team: **KHALID JUMAN, JAY BHAGAWATI, GEIR ERDEL**

Creative Firm: **ROBINLANDA.COM — NEW YORK, NY**
Creative Team: **ROBIN LANDA, DENISE ANDERSON, CHRISTOPHER NAVETTA, MENZA LAURA F.**
Client: **THOMSON**

Creative Firm: **UNIVERSITY OF SOUTH ALABAMA — MOBILE, AL**
Creative Team: **MATTHEW JOHNSON**
Client: **SWF PUBLISHING HAUS**

Creative Firm: **HULL CREATIVE GROUP — BROOKLINE, MA**
Creative Team: **CARYL H. HULL, JILL WINITZER**
Client: **JUSTIN, CHARLES & CO.**

Creative Firm: **RED CANOE — DEER LODGE, TN**
Creative Team: **DEB KOCH, KAREN PHILLIPS, CAROLINE KAVANAGH, HENRI SILBERMAN, STAR PARKER,**
Client: **THOMAS NELSON PUBLISHERS**

Creative Firm: **COASTLINES CREATIVE GROUP — VANCOUVER, BC, CANADA**
Creative Team: **BYRON DOWLER, PATRICK MCKENNA, GERRY NISKIN**
Client: **EDGE INTERNATIONAL**

Creative Firm: **HULL CREATIVE GROUP — BROOKLINE, MA**
Creative Team: **CARYL H. HULL, CAROLYN COLONNA**
Client: **JUSTIN, CHARLES & CO.**

Creative Firm: **ROBINLANDA.COM — NEW YORK, NY**
Creative Team: **ROBIN LANDA, DENISE ANDERSON, GISH JAMES**
Client: **THOMSON LEARNING**

Creative Firm: **VERY MEMORABLE DESIGN — NEW YORK, NY**
Creative Team: **MICHAEL PINTO**
Client: **JOHN WILEY & SONS, INC.**

 Creative Firm: **SCHOOL OF VISUAL ARTS — NEW YORK, NY**
Creative Team: **GENEVIERE WILLIAMS, CHI YOUNG CHO, HYE JUNG
CHUNG, ASHLEY GETINA, AVA SAVITSKY**
Client: **SCHOOL OF VISUAL ARTS**

Creative Firm: **RED CANOE — DEER LODGE, TN**
Creative Team: **DEB KOCH, MARK ROSS, CAROLINE KAVANAGH,
LAURA JENSEN WALKER,**
Client: **THOMAS NELSON PUBLISHERS**

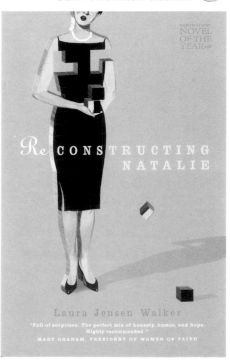

I DID NOT WANT TO GO THE NIKE MEETING.
I DIDN'T KNOW NIKE.
I DIDN'T THINK I LIKED NIKE.

Creative Firm: **VSA PARTNERS, INC. — CHICAGO, IL**
Creative Team: **CURT SCHREIBER, ASHLEY LIPPARD, AMY GLAIBERMAN, RICHARD RENNO, DREW BROOKS, ROBYN PAPROCKI**
Client: **ATRIA BOOKS**

Creative Firm: **NASSAR DESIGN — BROOKLINE, MA**
Creative Team: **NELIDA NASSAR**
Client: **HARVARD DESIGN SCHOOL**

Extending Modernism in The Monumental City

Creative Firm: **DESIGN GUYS — MINNEAPOLIS, MN**
Creative Team: **STEVE SIKORA, BARRY TOWNSEND, EAMES OFFICE, HERMAN MILLER, DANIEL OSTROFF, EAMES DEMETRIOS**
Client: **NEENAH PAPER**

Creative Firm: **MIRACLE GRAPHICS CO. WLL — MANAMA, BAHRAIN**
Creative Team: **KHALID JUMAN, JAY BHAGAWATI, GEIR ERDEL**

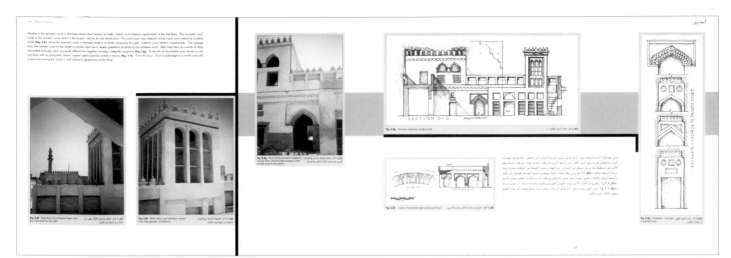

 Creative Firm: **MIRACLE GRAPHICS CO. WLL — MANAMA, BAHRAIN**
Creative Team: **KHALID JUMAN, JAY BHAGAWATI, PAUL WARRENER, GEIR ERDAL**
Client: **SHEIKH EBRAHIM CENTRE FOR CULTURE & RESEARCH**

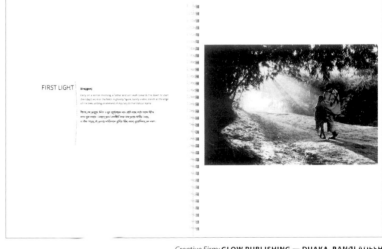

Creative Firm: **VH1 — NEW YORK, NY**
Client: **VH1**

Creative Firm: **GLOW PUBLISHING — DHAKA, BANGLADESH**
Creative Team: **LAURA BONAPACE, REENA ABRAHAM, GMB AKASH**
Client: **GMB AKASH**

Creative Firm: **MASTRO PHOTOGRAPHY+DESIGN — MOBILE, AL**
Creative Team: **MICHAEL MASTRO, ARCHBISHOP OSCAR H. LIPSCOMB, ANDY ZAK, JOHN STROPE**
Client: **ARCHDIOCESE OF MOBILE**

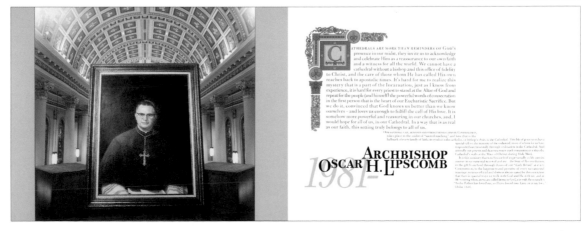

Creative Firm: **UIUC SCHOOL OF ART AND DESIGN — CHAMPAIGN, IL**
Creative Team: **JENNIFER GUNJI, NAN GOGGIN, DEANA MCDONAGH**
Client: **PROFESSOR DEANA MCDONAGH**

Creative Firm: **SCOTT ADAMS DESIGN ASSOCIATES — COLUMBUS, OH**
Creative Team: **SCOTT ADAMS, JARRON TERRY, NATHAN KRAFT**
Client: **NATIONWIDE REALTY INVESTORS**

Creative Firm: **DESIGNLORE — PHILADELPHIA, PA**
Creative Team: **LAURIE CHURCHMAN**
Client: **ARCADIA UNIVERSITY**

Creative Firm: **COMPANY STANDARD — BROOKLYN, NY**
Creative Team: **MELISSA GORMAN**
Client: **ARCADIA UNIVERSITY ART GALLERY**

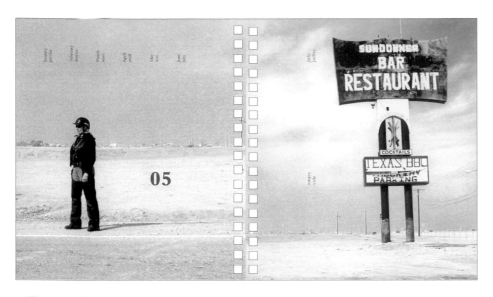

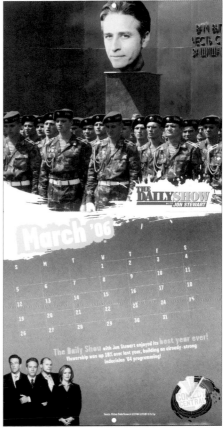

Creative Firm: **KOLEGRAM — GATNINEAU, QC, CANADA**
Creative Team: **GAETAN ALBERT, TONY FOUHSE, DWAYNE BROWN**
Client: **KOLEGRAM**

Creative Firm: **COMEDY CENTRAL — NEW YORK, NY**
Creative Team: **DZP , BRIAN DIECKS**

Creative Firm: **YELLOW SHOES CREATIVE WEST, DISNEYLAND RESORT — ANAHEIM, CA**
Creative Team: **DATHAN SHORE, WES CLARK, JACQUELYN MOE, KEVIN YONEDA**
Client: **DISNEYLAND RESORT**

Creative Firm: **EMERSON, WAJDOWICZ STUDIOS — NEW YORK, NY**
Creative Team: **LISA LAROCHELLE, YOKO YOSHIDA, MANNY MENDEZ, JUREK WAJDOWICZ, 17 MAGNUM PHOTOGRAPHERS**
Client: **MAGNUM PHOTOS AND SMART PAPERS**

Creative Firm: **THE HUMANE SOCIETY OF THE UNITED STATES — WASHINGTON, DC**
Creative Team: **PAULA JAWORSKI, ELIZABETH MCNULTY**
Client: **THE HUMANE SOCIETY OF THE UNITED STATES**

Creative Firm: **MTV OFF AIR CREATIVE — NEW YORK, NY**
Creative Team: **JEFFREY KEYTON, JIM DEBARROS, KAREN WEISS, CHIE ARAKI**
Client: **MTV NETWORKS**

Creative Firm: **FUTURA DDB — LJUBLANA, SLOVENIA**
Creative Team: **ZARE KERIN, MATJAZ ZORC**
Client: **BELINKA**

Creative Firm: **AMERICAN RED CROSS BLOOD SERVICES, WEST DIVISION — POMONA, CA**
Creative Team: **MARC JACKSON, SAUNDRA DAVISON, DONNA ANAYA, STEPHEN WHITBURN**

Creative Firm: **ALL MEDIA PROJECTS LIMITED — PORT OF SPAIN, TRINIDAD AND TOBAGO**
Creative Team: **CLINT WILLIAMS, CATHLEEN JONES, MARISA CAMEJO, ANTHONY MOORE, JULIEN GREENIDGE, JOSIANE KHANI**
Client: **BP TRINIDAD AND TOBAGO (BPTT)**

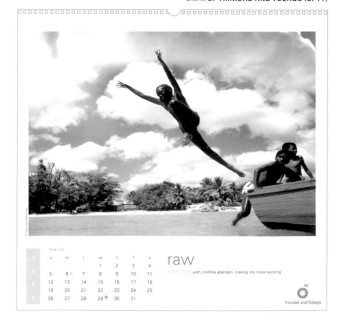

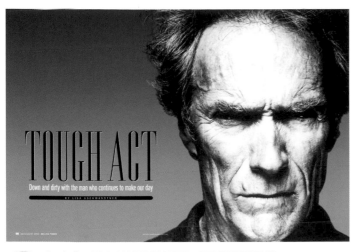

TOUGH ACT

Down and dirty with the man who continues to make our day

BY LISA GSCHWANDTNER

Creative Firm: SELLING POWER MAGAZINE — FREDERICKSBURG, VA
Creative Team: COLLEEN QUINNELL, PATRICK SWIRC / CORBIS OUTLINE
Client: SELLING POWER

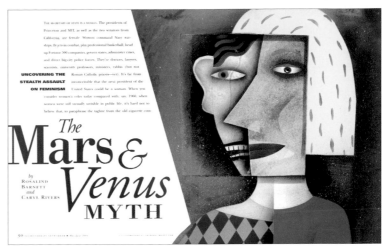

UNCOVERING THE
STEALTH ASSAULT
ON FEMINISM

The
Mars &
Venus
MYTH

by
ROSALIND
BARNETT
and
CARYL RIVERS

Creative Firm: DEVER DESIGNS — LAUREL, MD
Creative Team: JEFFREY DEVER, JIM DANDY/IMAGES.COM
Client: PSYCHOTHERAPY NETWORKER MAGAZINE

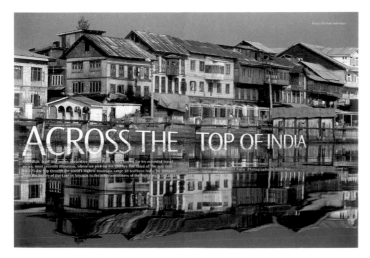

ACROSS THE TOP OF INDIA

Creative Firm: EMPHASIS MEDIA LIMITED — HONG KONG
Creative Team: TERESITA KHAW
Client: THAI AIRWAYS INTERNATIONAL

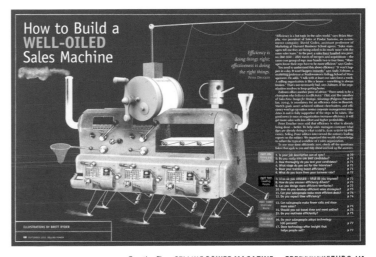

How to Build a
WELL-OILED
Sales Machine

*Efficiency is
doing things right;
effectiveness is doing
the right things.*
PETER DRUCKER

ILLUSTRATIONS BY BRETT RYDER

Creative Firm: SELLING POWER MAGAZINE — FREDERICKSBURG, VA
Creative Team: COLLEEN QUINNELL, BRETT RYDER
Client: SELLING POWER

Creative Firm: DEVER DESIGNS — LAUREL, MD
Creative Team: JEFREY DEVER, KRISTIN DEUÉL DUFFY, WILLIAM RIESER
Client: AIPCS MAGAZINE

Creative Firm: SELLING POWER MAGAZINE — FREDERICKSBURG, VA
Creative Team: MICHAEL AUBRECHT, BROOKS KRAFT / CORBIS
Client: SELLING POWER

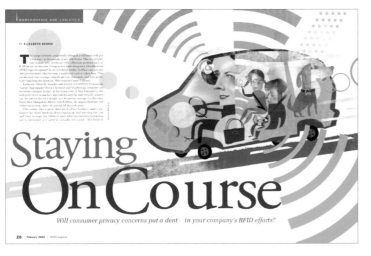

WAREHOUSING AND LOGISTICS

BY ELIZABETH BENNIE

Staying
On Course

Will consumer privacy concerns put a dent in your company's RFID efforts?

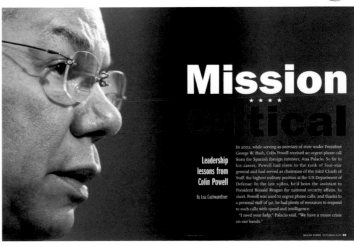

Mission
Critical

Leadership
lessons from
Colin Powell

By Lisa Gschwandtner

In 2002, while serving as secretary of state under President George W. Bush, Colin Powell received an urgent phone call from the Spanish foreign minister, Ana Palacio. So far in his career, Powell had risen to the rank of four-star general and had served as chairman of the Joint Chiefs of Staff, the highest military position in the US Department of Defense. In the late 1980s, he'd been the assistant to President Ronald Reagan for national security affairs. In short, Powell was used to urgent phone calls, and thanks to a personal staff of 90, he had plenty of resources to respond to such calls with speed and intelligence.

"I need your help," Palacio said. "We have a major crisis on our hands."

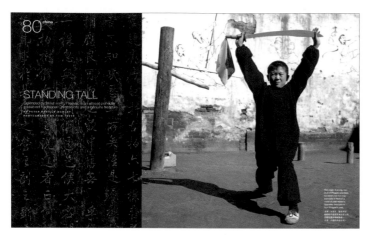

80 china

STANDING TALL

by
KATY BUTLER

Alice in Neuroland

CAN MACHINES
TEACH US TO
BE MORE HUMAN?

china

Creative Firm: **EMPHASIS MEDIA LIMITED — HONG KONG**
Creative Team: **PERCY CHUNG, HOWARD LEUNG, JENNIFER SPENCER-KENTRUP**
Client: **CATHAY PACIFIC AIRWAYS**

Creative Firm: **DEVER DESIGNS — LAUREL, MD**
Creative Team: **JEFFREY DEVER, AARON JASINSKI**
Client: **PSYCHOTHERAPY NETWORKER MAGAZINE**

Creative Firm: **BUSINESS TRAVEL NEWS — MALVERNE, NY**
Creative Team: **TERESA M. CARBONI, DIGITAL VISION**
Client: **BUSINESS TRAVEL NEWS**

Creative Firm: **CCM IN-HOUSE — WEST ORANGE, NJ**
Creative Team: **STEPHEN LONGO, JENNIFER BASSORA, JOHN FARISCHON,
CHRISTOPHER WARZOCHA, PATRICK BOBER, TREBOR RICADELA**
Client: **COUNTY COLLEGE OF MORRIS**

Creative Firm: **SELLING POWER MAGAZINE — FREDERICKSBURG, V4**
Creative Team: **COLLEEN QUINNELL**
Client: **SELLING POWER**

Creative Firm: **EMPHASIS MEDIA LIMITED — HONG KONG**
Creative Team: **LOCKY LAI**
Client: **CHINA AIRLINES**

Creative Firm: **SELLING POWER MAGAZINE — FREDERICKSBURG, VA**
Creative Team: **MICHAEL AUBRECHT, BELLE MELLOR**
Client: **SELLING POWER**

Creative Firm: **BUSINESS TRAVEL NEWS — MALVERNE, NY**
Creative Team: **TERESA M. CARBONI, PAUL STODDARD**
Client: **BUSINESS TRAVEL NEWS**

Creative Firm: **EMPHASIS MEDIA LIMITED — HONG KONG**
Creative Team: **TERESITA KHAW, JENNIFER SPENCER-KENTRUP**
Client: **THAI AIRWAYS INTERNATIONAL**

Creative Firm: **SELLING POWER MAGAZINE — FREDERICKSBURG, VA**
Creative Team: **TARVER HARRIS, JON KRAUSE**
Client: **SELLING POWER**

Creative Firm: **DEVER DESIGNS — LAUREL, MD**
Creative Team: **JEFFREY DEVER, ROBERT PIZZO**
Client: **APICS MAGAZINE**

Creative Firm: **DEVER DESIGNS — LAUREL, MD**
Creative Team: **JEFFREY DEVER, CHARLIE POWELL**
Client: **LIBERTY MAGAZINE**

Creative Firm: **SELLING POWER MAGAZINE — FREDERICKSBURG, VA**
Creative Team: **MICHAEL AUBRECHT, ROBERT PIZZO**
Client: **SELLING POWER**

Creative Firm: **SELLING POWER MAGAZINE — FREDERICKSBURG, VA**
Creative Team: **TARVER HARRIS**
Client: **SELLING POWER**

Creative Firm: **BUSINESS TRAVEL NEWS — MALVERNE, NY**
Creative Team: **TERESA M. CARBONI, PHOTODISC**
Client: **BUSINESS TRAVEL NEWS**

Creative Firm: **BUSINESS TRAVEL NEWS — MALVERNE, NY**
Creative Team: **TERESA M. CARBONI, DARREN HOPES**
Client: **BUSINESS TRAVEL NEWS**

Creative Firm: **SELLING POWER MAGAZINE — FREDERICKSBURG, VA**
Creative Team: **TARVER HARRIS, SERGE BLOCH**
Client: **SELLING POWER**

Creative Firm: **EYEBALLNYC — NEW YORK, NY**
Creative Team: L. SHUR, J. BEVAN, R. SIMONIAN, F. SAENZ RECIO, J. BRENNICK, T. JURKIEWICZ, M. EASTWOOD, E. EHRICH, G. HEFFRON, S. MEISE
Client: **VOGUE ITALIA**

Creative Firm: **MPHASIS ON FRONTIER — DENVER, CO**
Creative Team: **DANA BARAK**
Client: **WILD BLUE YONDER MAGAZINE**

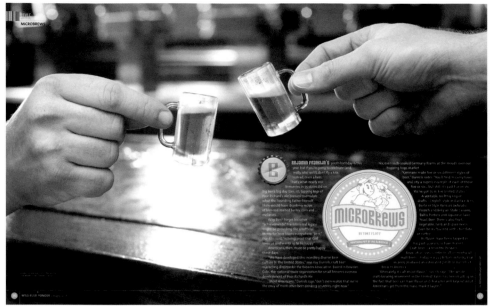

Creative Firm: **MPHASIS ON FRONTIER — DENVER, CO**
Creative Team: **BRYANT FERNANDEZ, JOE HANCOCK**
Client: **WILD BLUE YONDER MAGAZINE**

Creative Firm: **STELLAR DEBRIS — HADANO-SHI, KANAGAWA-KEN, JAPAN**
Creative Team: **CHRISTOPHER JONES**
Client: **RENO-TAHOE AMERICAN MARKETING ASSOCIATION**

Creative Firm: **MPHASIS ON FRONTIER — DENVER, CO**
Creative Team: **BRYANT FERNANDEZ, HOWARD SOKOL**
Client: **WILD BLUE YONDER MAGAZINE**

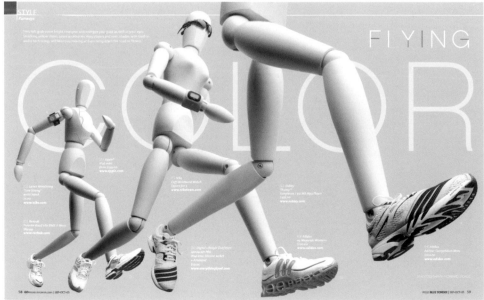

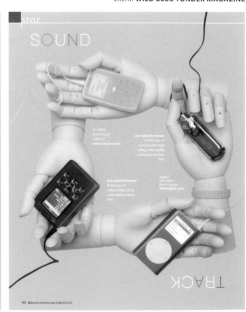

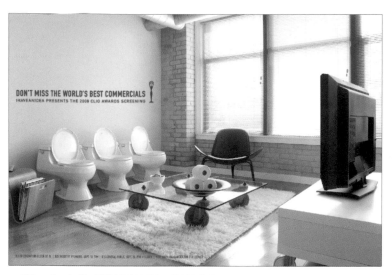

Creative Firm: **TAXI CANADA INC. — TORONTO, ON, CANADA**
Creative Team: **ZAK MROUEH, MARK SCOTT, IRFAN KHAN, DEREK SHAPTON, MARK PROLE, BRUCE ELLIS**
Client: **IHAVEANIDEA**

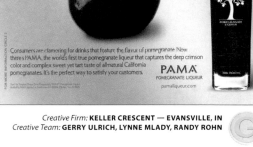

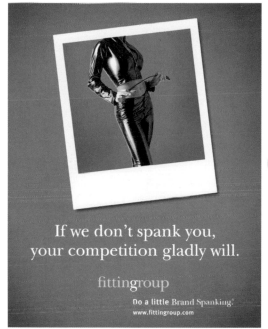

Creative Firm: **KELLER CRESCENT — EVANSVILLE, IN**
Creative Team: **GERRY ULRICH, LYNNE MLADY, RANDY ROHN**

Creative Firm: **FITTING GROUP — PITTSBURGH, PA**
Creative Team: **TRAVIS NORRIS, BECKY THURNER**
Client: **FITTING GROUP**

Creative Firm: **GREENLIGHT DESIGNS — N. HOLLYWOOD, CA**
Creative Team: **TAMI MAHNKEN, DARRYL SHELLY, MELISSA IRWIN, SHAUN WOOD**
Client: **LIONSGATE FILMS**

Creative Firm: **RODGERS TOWNSEND — ST. LOUIS, MO**
Creative Team: **TOM HUDDER, LUKE PARTRIDGE, MICHAEL MCCORMICK, JEFF MINTON, CHERYL SPARKS**
Client: **AT&T**

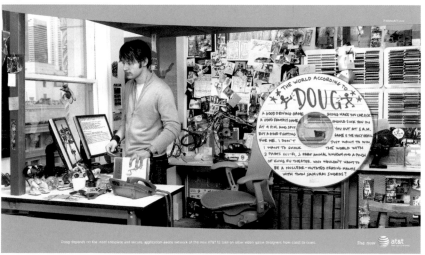

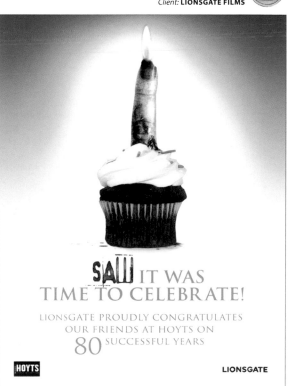

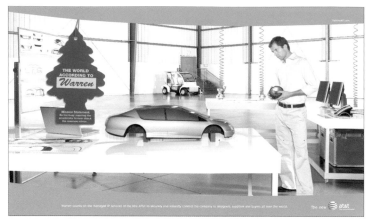 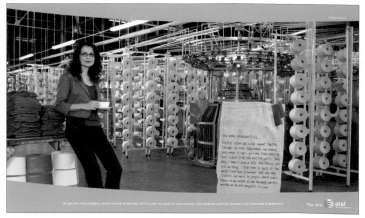

 Creative Firm: **RODGERS TOWNSEND — ST. LOUIS, MO**
Creative Team: **TOM HUDDER, LUKE PARTRIDGE, MICHAEL MCCORMICK, JEFF MINTON, CHERYL SPARKS**
Client: **AT&T**

Creative Firm: **RODGERS TOWNSEND — ST. LOUIS, MO**
Creative Team: **TOM HUDDER, LUKE PARTRIDGE, MICHAEL MCCORMICK, JEFF MINTON, CHERYL SPARKS**
Client: **AT&T**

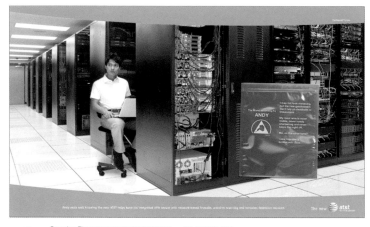 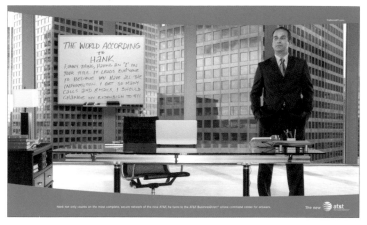

 Creative Firm: **RODGERS TOWNSEND — ST. LOUIS, MO**
Creative Team: **TOM HUDDER, LUKE PARTRIDGE, MICHAEL MCCORMICK, JEFF MINTON, CHERYL SPARKS**
Client: **AT&T**

Creative Firm: **RODGERS TOWNSEND — ST. LOUIS, MO**
Creative Team: **TOM HUDDER, LUKE PARTRIDGE, MICHAEL MCCORMICK, JEFF MINTON, CHERYL SPARKS**
Client: **AT&T**

Creative Firm: **RODGERS TOWNSEND — ST. LOUIS, MO**
Creative Team: **TOM HUDDER, LUKE PARTRIDGE, MICHAEL MCCORMICK, JEFF MINTON, CHERYL SPARKS**
Client: **AT&T**

Creative Firm: **RODGERS TOWNSEND — ST. LOUIS, MO**
Creative Team: **TOM HUDDER, LUKE PARTRIDGE, MICHAEL MCCORMICK, JEFF MINTON, CHERYL SPARKS**
Client: **AT&T**

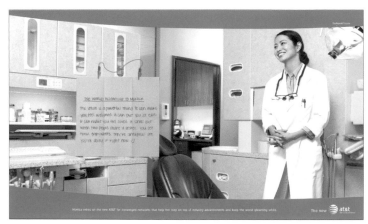 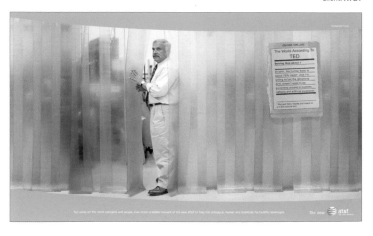

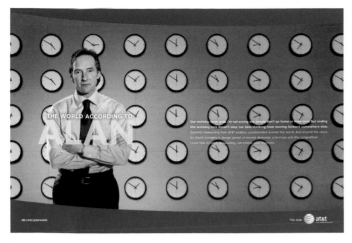

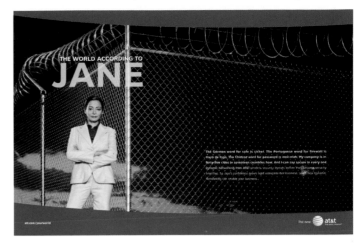

Creative Firm: **RODGERS TOWNSEND — ST. LOUIS, MO**
Creative Team: **TOM HUDDER, MIKE DILLON, FRANK SCHOTT, CHERYL SPARKS**
Client: **AT&T**

Creative Firm: **RODGERS TOWNSEND — ST. LOUIS, MO**
Creative Team: **TOM HUDDER, FRANK SCHOTT, CHRIS HANLEY, CHERYL SPARKS**
Client: **AT&T**

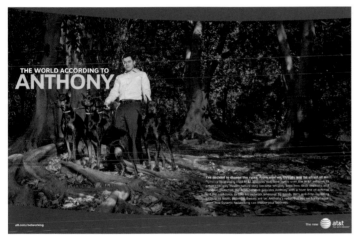

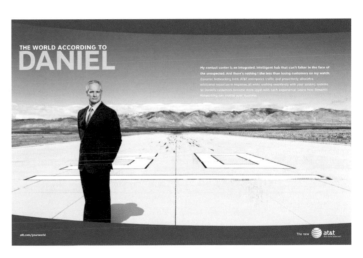

Creative Firm: **RODGERS TOWNSEND — ST. LOUIS, MO**
Creative Team: **TOM HUDDER, MARK ARNOLD, TODD MITCHELL, FRANK SCHOTT, CHERYL SPARKS**
Client: **AT&T**

Creative Firm: **RODGERS TOWNSEND — ST. LOUIS, MO**
Creative Team: **TOM HUDDER, LUKE PARTRIDGE, MICHAEL MCCORMICK, FRANK SCHOTT, CHERYL SPARKS,**
Client: **AT&T**

Creative Firm: **RODGERS TOWNSEND — ST. LOUIS, MO**
Creative Team: **TOM HUDDER, MARK ARNOLD, TODD MITCHELL, FRANK SCHOTT, CHERYL SPARKS**
Client: **AT&T**

Creative Firm: **RODGERS TOWNSEND — ST. LOUIS, MO**
Creative Team: **TOM HUDDER, MARK ARNOLD, TODD MITCHELL, FRANK SCHOTT, CHERYL SPARKS**
Client: **AT&T**

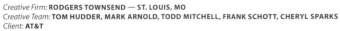

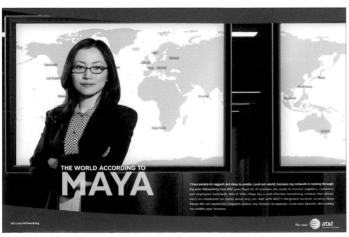

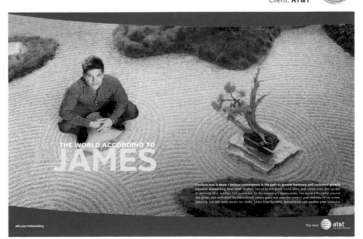

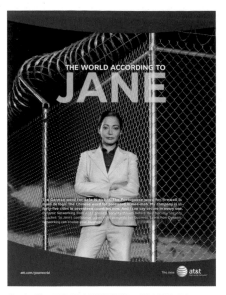

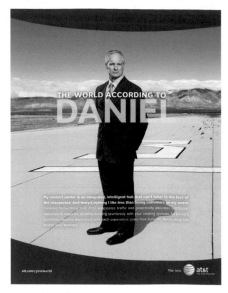

Creative Firm: RODGERS TOWNSEND — ST. LOUIS, MO
Creative Team: TOM HUDDER, MIKE DILLON, FRANK SCHOTT, CHERYL SPARKS
Client: AT&T

Creative Firm: RODGERS TOWNSEND — ST. LOUIS, MO
Creative Team: TOM HUDDER, MIKE DILLON, FRANK SCHOTT, CHERYL SPARKS
Client: AT&T

Creative Firm: RODGERS TOWNSEND — ST. LOUIS, MO
Creative Team: TOM HUDDER, LUKE PARTRIDGE, MICHAEL MC CORMICK, FRANK SCHOTT, CHERYL SPARKS
Client: AT&T

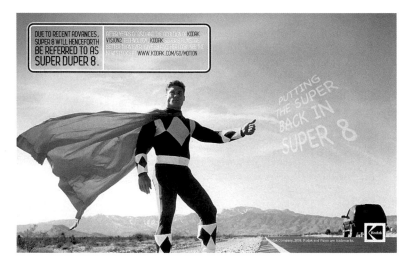

Creative Firm: BUCK & PULLEYN — PITTSFORD, NY
Creative Team: DAN MULCAHY, DONA BAGLEY, PJ GALGAY, BRENDA BRODSKY, SUE STOJANOVICH
Client: KODAK ENTERTAINMENT IMAGING

Creative Firm: RODGERS TOWNSEND — ST. LOUIS, MO
Creative Team: TOM HUDDER, MARK ARNOLD, TODD MITCHELL, FRANK SCHOTT, CHERYL SPARKS
Client: AT&T

Creative Firm: RODGERS TOWNSEND — ST. LOUIS, MO
Creative Team: TOM HUDDER, MARK ARNOLD, TODD MITCHELL, FRANK SCHOTT, CHERYL SPARKS
Client: AT&T

Creative Firm: RODGERS TOWNSEND — ST. LOUIS, MO
Creative Team: TOM HUDDER, MARK ARNOLD, TODD MITCHELL, FRANK SCHOTT, CHERYL SPARKS
Client: AT&T

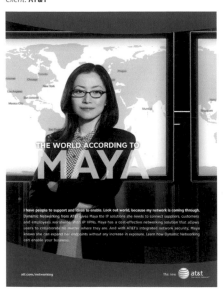

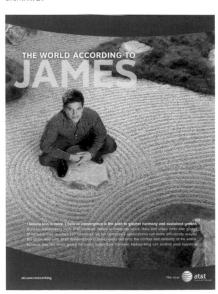

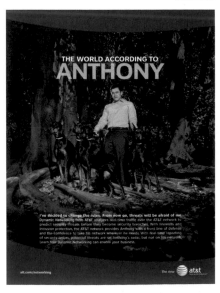

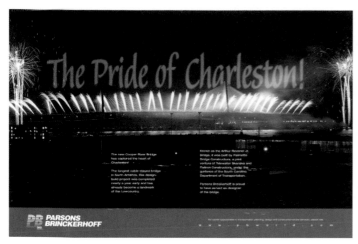

Creative Firm: **PARSONS BRINCKERHOFF — NEW YORK, NY**
Creative Team: **ANA TIBURCIO-RIVERA, TOM MALCOLM, TONY WINN**
Client: **PARSONS BRINCKERHOFF**

Creative Firm: **SHIMOKOCHI-REEVES — LOS ANGELES, CA**
Creative Team: **MAMORU SHIMOKOCHI, ANNE REEVES, MARTY LIPKIN**
Client: **ANGSTROM LIGHTING**

Creative Firm: **NEURON SYNDICATE INC. — SANTA MONICA, CA**
Creative Team: **SEAN ALATORRE, RYAN CRAMER**
Client: **WARNER BROS.**

Creative Firm: **MT&L PUBLIC RELATIONS LTD.**
— HALIFAX, NS, CANADA
Creative Team: **PAUL WILLIAMS, GETTY IMAGES STOCK**
Client: **HALIFAX PORT AUTHORITY**

Creative Firm: **HITCHCOCK FLEMING & ASSOCIATES INC. — AKRON, OH**
Creative Team: **NICK BETRO, TODD MOSER, GREG PFIFFNER, MARK COLLINS**
Client: **LP BUILDING PRODUCTS**

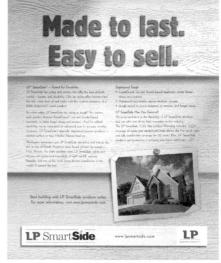

Creative Firm: **SPIKE TV — NEW YORK, NY**
Creative Team: **BOB SALAZAR, NIELS SCHUURMANS,**
GREG DALY
Client: **SPIKE**

Creative Firm: **BOOMM! MARKETING & COMMUNICATIONS**
— **WESTCHESTER, IL**
Client: **ALCAN PACKAGING**

Creative Firm: **RODGERS TOWNSEND — ST. LOUIS, MO**
Creative Team: **TOM HUDDER,**
TOM TOWNSEND, CHERYL SPARKS
Client: **SBC COMMUNICATIONS, INC**

Creative Firm: **RODGERS TOWNSEND — ST. LOUIS, MO**
Creative Team: **TOM HUDDER, LUKE PARTRIDGE, MICHAEL MCCORMICK, CHERYL SPARKS**
Client: **SBC COMMUNICATIONS, INC**

Creative Firm: **BRIGHT ORANGE ADVERTISING — RICHMOND, VA**
Creative Team: **BRUCE GOLDMAN, DANIEL GOLDMAN**
Client: **OAKLEA PRESS**

Creative Firm: **SILVER COMMUNICATIONS INC — NEW YORK, NY**
Creative Team: **GREGG SIBERT, CHRISTINA WEISSMAN, JEFF EWEN**
Client: **BNY BROKERAGE**

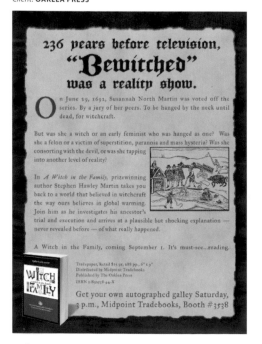

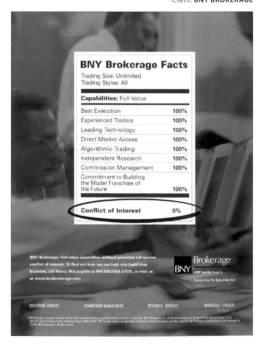

Creative Firm: **RODGERS TOWNSEND — ST. LOUIS, MO**
Creative Team: **TOM HUDDER,**
TON TOWNSEND
Client: **SBC COMMUNICATIONS, INC**

Creative Firm: **TAXI CANADA INC.—TORONTO, ON, CANADA**
Creative Team: **ZAK MROUEH, JOHNNIE INGRAM, RON SMRCZEK,**
ALEXIS GROPPER, TRACY HAAPAMAKI, TOM FEILER
Client: **IHAVEANIDEA**

Creative Firm: **BSY ASSOCIATES INC. — HOLMDEL, NJ**
Creative Team: **LARRY RAVINETT, GORDON FORSYTH IV,**
JOHN BRADY
Client: **NATIONAL RETAIL SYSTEMS INC.**

Creative Firm: **RODGERS TOWNSEND — ST. LOUIS, MO**
Creative Team: **TOM HUDDER, LUKE PARTRIDGE, MICHAEL MCCORMICK,**
JEFF MINTON, CHERYL SPARKS
Client: **AT&T**

Creative Firm: **VANPELT CREATIVE — GARLAND, TX**
Creative Team: **CHIP VANPELT, BRYAN MATTHEWS, LEWIS LEE**
Client: **VARI-LITE**

Creative Firm: **SILVER COMMUNICATIONS INC — NEW YORK, NY**
Creative Team: **GREGG SIBERT, CHRISTINA WEISSMAN, JEFF EWEN**
Client: **BNY BROKERAGE**

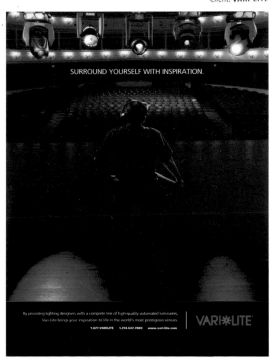

MAGAZINE AD, *BUSINESS TO BUSINESS*, CAMPAIGN

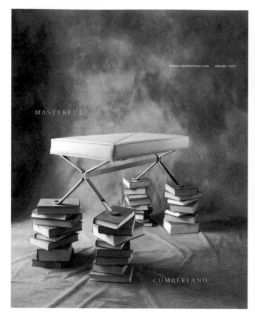

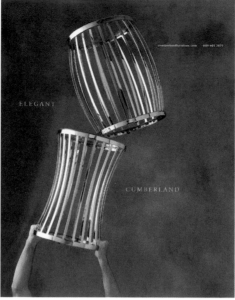

 Creative Firm: **BBK STUDIO — GRAND RAPIDS, MI**
Creative Team: **KEVIN BUDELMANN, BRIAN HAUCH,
CHUCK SHOTWELL**
Client: **CUMBERLAND FURNITURE**

Creative Firm: **GREENFIELD/BELSER LTD. — WASHINGTON, DC**
Creative Team: **BURKEY BELSER, GEORGE KELL,
CHRIS ATKIN, JAIME CHIRINOS**
Client: **CHOATE HALL & STEWART LLP**

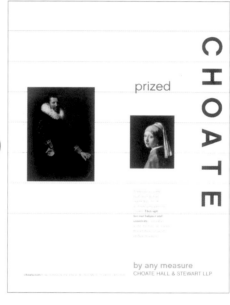

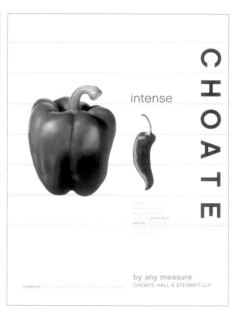

 Creative Firm: **YOUNG & RUBICAM GMBH & CO. KG — FRANKFURT AM MAIN, HESSEN, GERMANY**
Creative Team: **UWE MARQUARDT, CHRISTIAN DAUL, INGMAR KRANNICH, KAJO STRAUCH**
Client: **NEUDORFF**

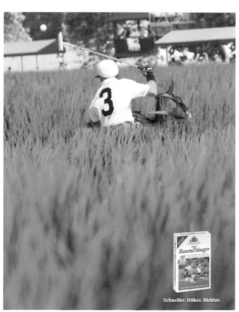

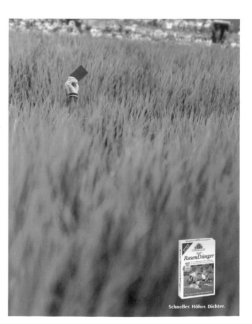

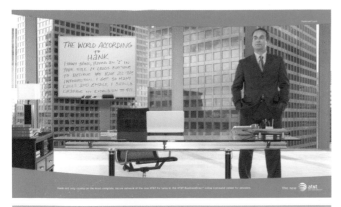

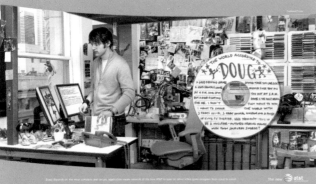

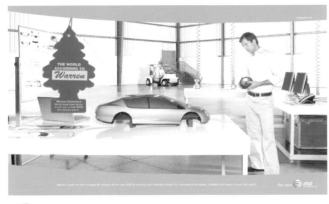

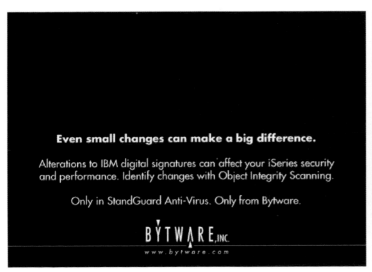

Creative Firm: **RODGERS TOWNSEND — ST. LOUIS, MO**
Creative Team: **TOM HUDDER, LUKE PARTRIDGE, MICHAEL MCCORMICK, CHRIS HANLEY, CHERYL SPARKS**
Client: **AT&T**

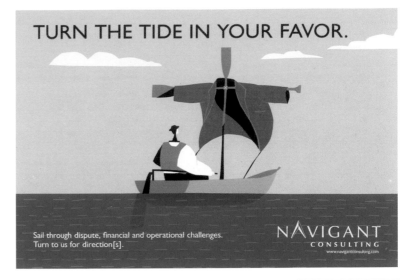

TURN THE TIDE IN YOUR FAVOR.

Sail through dispute, financial and operational challenges.
Turn to us for direction[s].

N/\VIGANT
CONSULTING
www.navigantconsulting.com

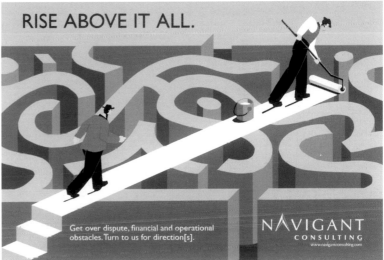

RISE ABOVE IT ALL.

Get over dispute, financial and operational
obstacles. Turn to us for direction[s].

N/\VIGANT
CONSULTING
www.navigantconsulting.com

Creative Firm: **GREENFIELD/BELSER LTD. — WASHINGTON, DC**
Creative Team: **BURKEY BELSER, JOE WALSH, CRAIG FRAZIER, GEORGE KELL, CHRIS ATKIN**
Client: **NAVIGANT CONSULTING**

Creative Firm: **STELLAR DEBRIS — HADANO-SHI, KANAGAWA-KEN, JAPAN**
Creative Team: **CHRISTOPHER JONES**
Client: **BYTWARE, INC.**

Even small changes can make a big difference.

Alterations to IBM digital signatures can affect your iSeries security
and performance. Identify changes with Object Integrity Scanning.

Only in StandGuard Anti-Virus. Only from Bytware.

BYTWARE,INC.
www.bytware.com

"May the horse be with you."

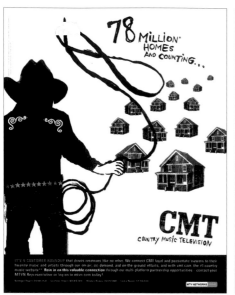

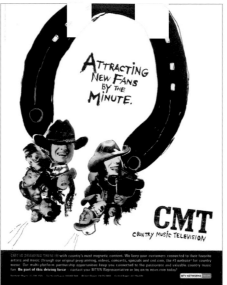

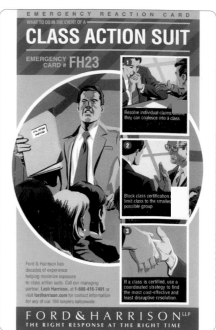

Creative Firm: **CMT — NEW YORK, NY**
Creative Team: **JAMES HITCHCOCK, MICHAEL ENGLEMAN, AMIE NGUYEN, LINDA ZACK**
Client: **CMT**

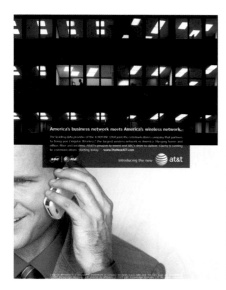

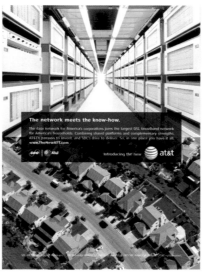

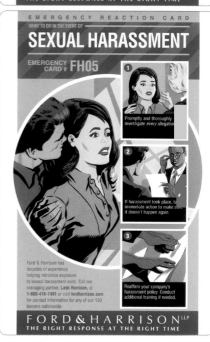

Creative Firm: **RODGERS TOWNSEND — ST. LOUIS, MO**
Creative Team: **TOM HUDDER, TOM TOWNSEND**
Client: **SBC COMMUNICATIONS, INC**

Creative Firm: **SILVER COMMUNICATIONS INC — NEW YORK, NY**
Creative Team: **GREGG SIBERT, CHRISTINA WEISSMAN, JEFF EWEN**
Client: **ADP CLEARING & OUTSOURCING SERVICES**

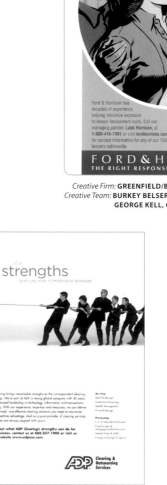

Creative Firm: **GREENFIELD/BELSER LTD. — WASHINGTON, DC**
Creative Team: **BURKEY BELSER, MATT MASON, MARK THOMAS,
GEORGE KELL, GENE SHAFFER, JAIME CHIRINOS**
Client: **FORD & HARRISON, LLP**

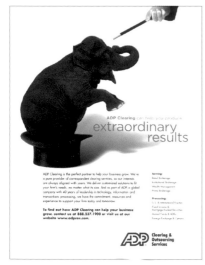

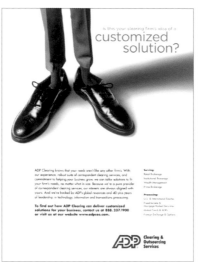

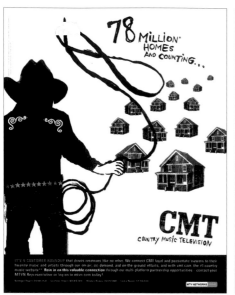

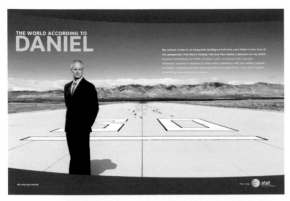

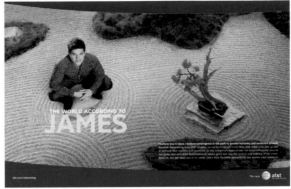

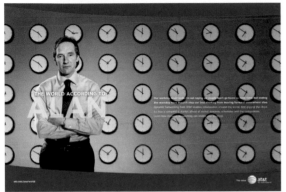

Creative Firm: **RODGERS TOWNSEND — ST. LOUIS, MO**
Creative Team: **TOM HUDDER, LUKE PARTRIDGE, MARK ARNOLD, FRANK SCHOTT**
Client: **AT&T**

Creative Firm: **RTS RIEGER TEAM WERBEAGENTUR GMBH — LEINFELDEN-ECHTERDINGEN, GERMANY**
Creative Team: **UTE WITZMANN, CHRISTIAN GRIMM**
Client: **CHRISTIAN WINKLER GMBH & CO. KG**

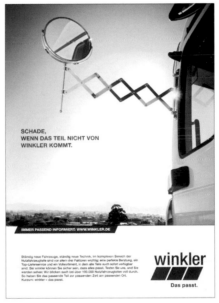

Creative Firm: **LEVERAGE MARKETING GROUP — NEWTOWN, CT**
Creative Team: **DAVID GOODWICK , RICH BRZOZOWSKI, TOM MARKS**
Client: **GE SECURITY**

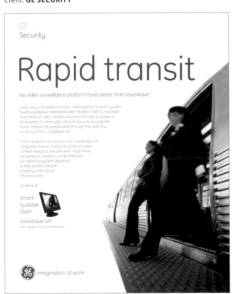

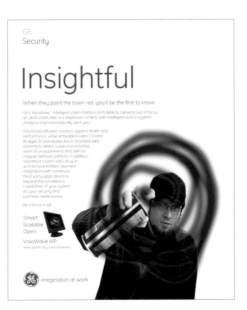

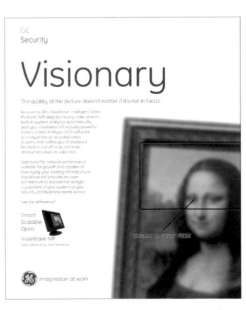

Creative Firm: **RODGERS TOWNSEND — ST. LOUIS, MO**
Creative Team: **TOM HUDDER, LUKE PARTRIDGE, MICHAEL MCCORMICK, CHRIS HANLEY, CHERYL SPARKS**
Client: **AT&T**

Creative Firm: **THE MONOGRAM GROUP — CHICAGO, IL**
Creative Team: **HAROLD WOODRIDGE, CHIP BALCH, CHRISTA VELBEL**
Client: **MFC CAPITAL**

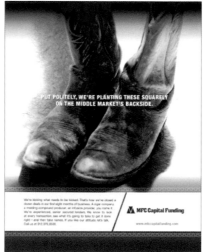

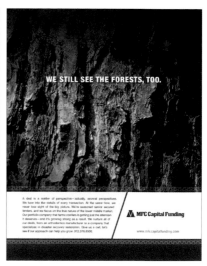

Creative Firm: **RODGERS TOWNSEND — ST. LOUIS, MO**
Creative Team: **TOM HUDDER, LUKE PARTRIDGE, MARK ARNOLD, FRANK SCHOTT, CHERYL SPARKS**
Client: **AT&T**

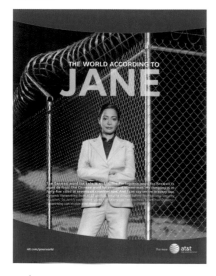

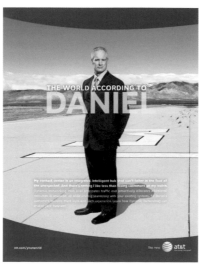

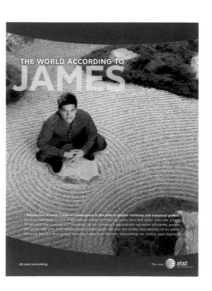

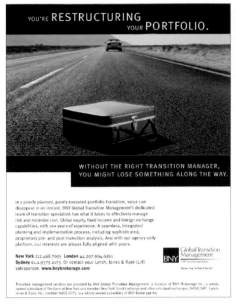

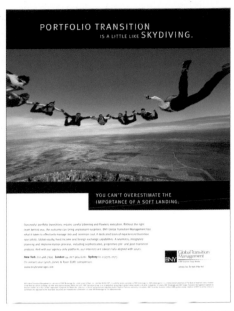

Creative Firm: **SILVER COMMUNICATIONS INC — NEW YORK, NY**
Creative Team: **GREGG SIBERT, CHRISTINA WEISSMAN, JEFF EWEN**
Client: **BNY GLOBAL TRANSITION MANAGEMENT**

Creative Firm: **RTS RIEGER TEAM WERBEANGETUR GMBH — LEINFELDEN-ECHTERDINGEN, GERMANY**
Creative Team: **ANNETTE PIENTKA, FRIEDERIKE APEL, SIEGRIED SCHAAL**
Client: **NEOMAN BUS GMBH**

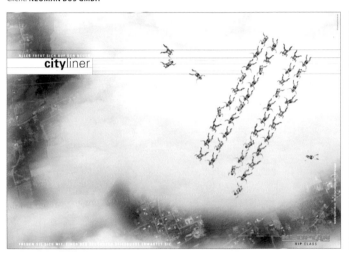

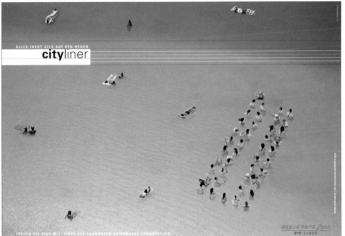

Creative Firm: **GREENFIELD/BELSER LTD. — WASHINGTON, DC**
Creative Team: **BURKEY BELSER, SIOBHAN DAVIS, ALYSON FIELDMAN, BRANDEE CAHIR**
Client: **WEINTRAUB GENSHLEA CHEDIAK**

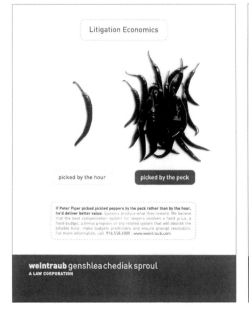

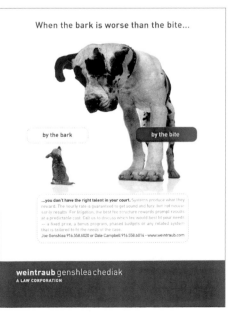

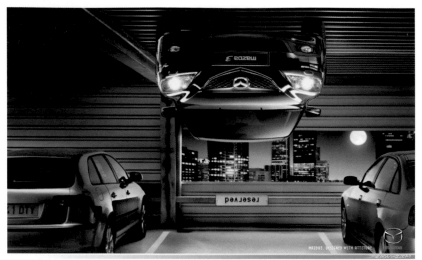

Creative Firm: JWT DUESSELDORF — DUESSELDORF, NRW, GERMANY
Creative Team: EDDY GREENWOOD, JOHN ABEL, MARTIJN OORT,
NORBERT ANDRUP, ELKE BOLL, ALEXANDRA LAUFF
Client: MAZDA MOTOR EUROPE

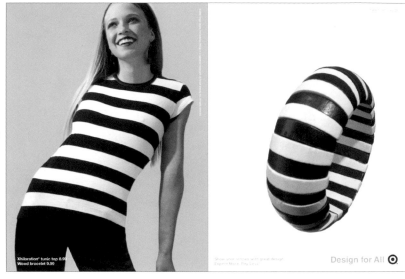

Creative Firm: PETERSON MILLA HOOKS — MINNEAPOLIS, MN
Creative Team: DAVE PETERSON, ERIKA WALDEN, CATHERINE IRMITER,
ELLEN FREGO, KEN BARLAGE
Client: TARGET

Creative Firm: PURPLE FOCUS PVT. LTD.
— INDORE, MADHYA PRADESH, INDIA
Creative Team: SATYAJIT RAI, JITENDRA RAMPURIA,
VINOD BHARGAV, PURPLE PRODUCTIONS
Client: PINNACLE INDUSTRIES

Creative Firm: ENGINE, LLC — SAN FRANCISCO, CA
Creative Team: LOTUS CHILD, GEOFF SKIGEN
Client: MEDJOOL

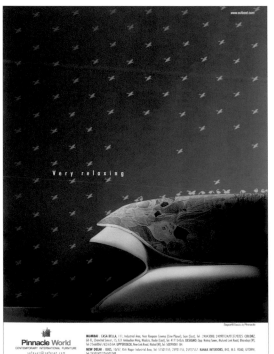

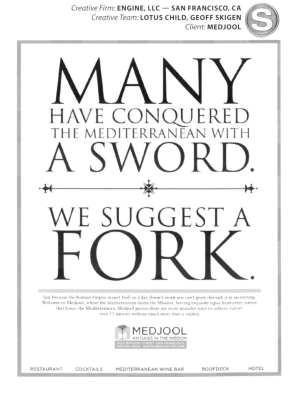

Creative Firm: **NEURON SYNDICATE INC. — SANTA MONICA, CA**
Creative Team: **RYAN CRAMER, SEAN ALATORRE**
Client: **WARNER BROS.**

Creative Firm: **JWT DUESSELDORF — DUESSELDORF, NRW, GERMANY**
Creative Team: **EDDY GREENWOOD, JOHN ABEL, BO HYLEN, BLAKE DUERDEN, ELKE BOLL, ALEXANDRA LAUFF**
Client: **MAZDA MOTOR EUROPE**

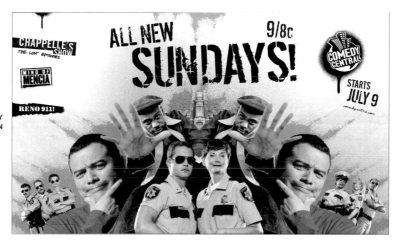

Creative Firm: **COMEDY CENTRAL — NEW YORK, NY**
Creative Team: **SHILO, ROLYN BARTHELMAN**

Creative Firm: **SPIKE TV — NEW YORK, NY**
Creative Team: **ANDRE RAZO, BOB SALAZAR, NIELS SCHUURMANS**
Client: **SPIKE**

Creative Firm: **COMEDY CENTRAL — NEW YORK, NY**
Creative Team: **CHARLES HAMILTON, STEPHEN KAMSLER, ROLYN BARTHELMAN**

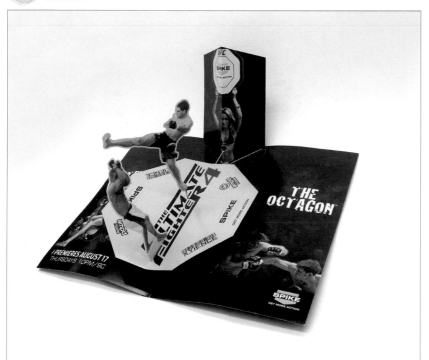

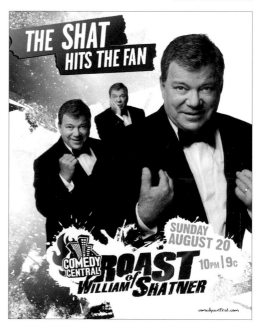

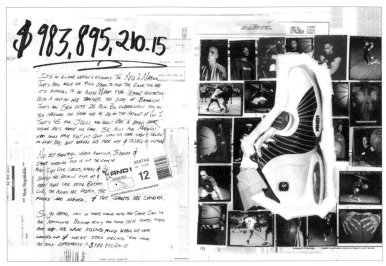

Creative Firm: **160 OVER 90** — PHILADELPHIA, PA
Creative Team: **DARRYL CILLI, JIM WALLS, DAN SHEPELAVY, GIACOMO CIMINELLO, STEPHEN PENNING, BRENDAN QUINN**
Client: **AND1 BASKETBALL**

Creative Firm: **COMEDY CENTRAL** — NEW YORK, NY
Creative Team: **STEPHEN KAMSLER, JOHN LEFTERATOS, ROLYN BARTHELMAN**

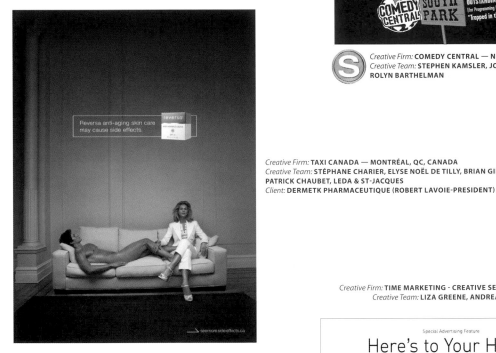

Creative Firm: **TAXI CANADA** — MONTRÉAL, QC, CANADA
Creative Team: **STÉPHANE CHARIER, ELYSE NOËL DE TILLY, BRIAN GILL, ROBERTO BAIBICH, PATRICK CHAUBET, LEDA & ST-JACQUES**
Client: **DERMETK PHARMACEUTIQUE (ROBERT LAVOIE-PRESIDENT)**

Creative Firm: **TIME MARKETING - CREATIVE SERVICES** — NEW YORK, NY
Creative Team: **LIZA GREENE, ANDREA COSTA, CINDY MURPHY**
Client: **KELLOGG'S**

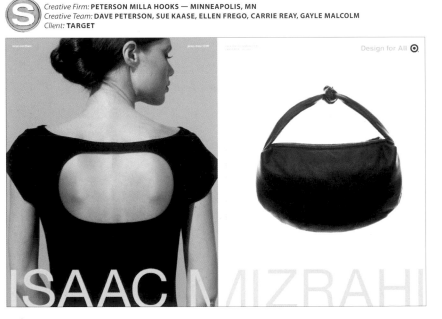

Creative Firm: **PETERSON MILLA HOOKS** — MINNEAPOLIS, MN
Creative Team: **DAVE PETERSON, SUE KAASE, ELLEN FREGO, CARRIE REAY, GAYLE MALCOLM**
Client: **TARGET**

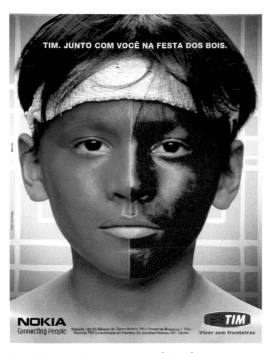

Creative Firm: **MENDES PUBLICIDADE — BELÉM, PARÁ, BRAZIL**
Creative Team: **OSWALDO MENDES, MARCELO AMORIM**
Client: **TIM NORTE**

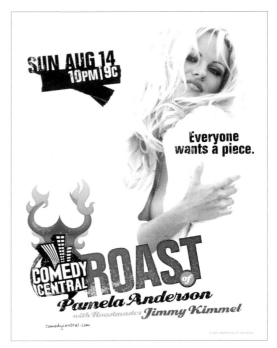

Creative Firm: **COMEDY CENTRAL — NEW YORK, NY**
Creative Team: **ROLYN BARTHELMAN, STEPHEN KAMSLER**

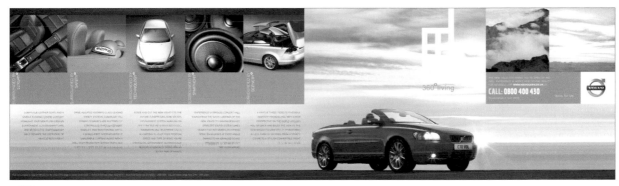

Creative Firm: **BURROWS — BRENTWOOD, ESSEX, UNITED KINGDOM**
Creative Team: **ROYDON HEARNE, DARRYL SMITH, AARON HULSIZER, LUCY WELDON**
Client: **VOLVO CARS**

Creative Firm: **HERE! NETWORKS — NEW YORK, NY**
Creative Team: **ERIC FELDMAN, MEGAN ELLIS**

Creative Firm: **160 OVER 90 — PHILADELPHIA, PA**
Creative Team: **DARRYL CILLI, JIM WALLS, GIACOMO CIMINELLO, BRUNO BISANG, BRENDAN QUINN**
Client: **DAVIN WHEELS**

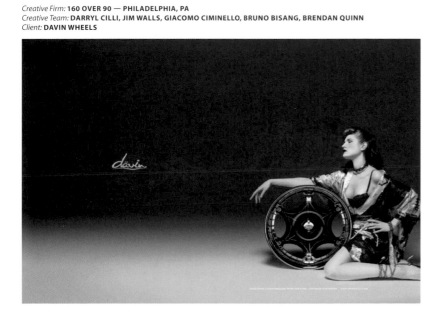

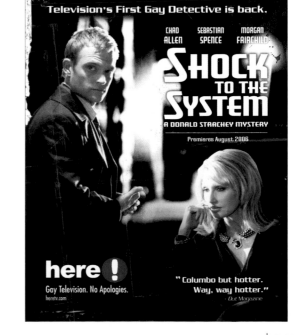

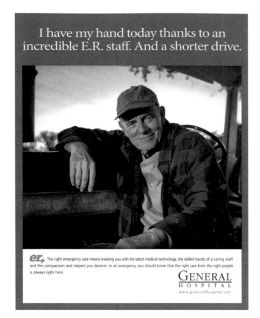

Creative Firm: **CREATIVE ALLIANCE — LOUISVILLE, KY**
Creative Team: **SCOTT BOSWELL, MARK ROSENTHAL**
Client: **CHS HOSPITALS**

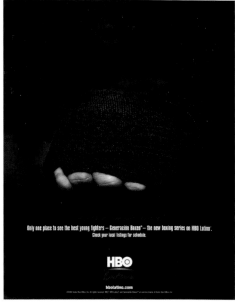

Creative Firm: **HBO OFF-AIR CREATIVE SERVICES — NEW YORK, NY**
Creative Team: **VENUS DENNISON, ANA RACELIS, CARLOS TEJEDA, JOSE MENDEZ**
Client: **HBO LATINO**

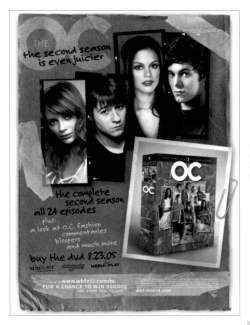

Creative Firm: **NEURON SYNDICATE INC. — SANTA MONICA, CA**
Creative Team: **SEAN ALATORRE, RYAN CRAMER, JASON BURNAM, PHIL MCKENNA**
Client: **WARNER BROS.**

Creative Firm: **RODGERS TOWNSEND — ST. LOUIS, MO**
Creative Team: **TOM HUDDER, RYAN SMITH, TODD MITCHELL, CHERYL SPARKS**
Client: **ST. LOUIS CHILDREN'S HOSPITAL**

S Creative Firm: **COMEDY CENTRAL — NEW YORK, NY**
Creative Team: **BUCK, LAURIE HINZMAN WHITE**

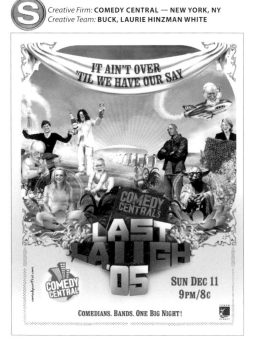

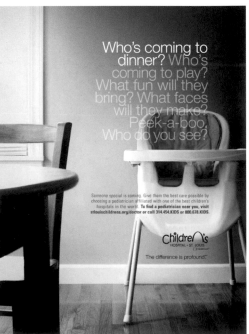

EAT FOR YOUR HEART'S SAKE What you eat, or decide not to eat, significantly affects your risk for heart disease. *By Robert H. Eckel, M.D.*

Creative Firm: **TIME MARKETING - CREATIVE SERVICES — NEW YORK, NY**
Creative Team: **LIZA GREENE, RAY RUALO, CINDY MURPHY, TIM CALLAHAN**
Client: **TIME MAGAZINE**

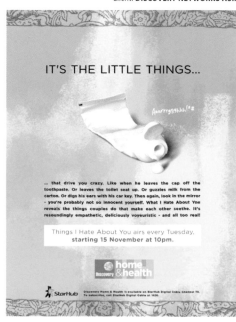

Creative Firm: **SILVER CREATIVE GROUP — SOUTH NORWALK, CT**
Creative Team: **PAUL ZULLO, TRACY WAXENBERG, SUZANNE PETROW**
Client: **THOMPSON BRANDS**

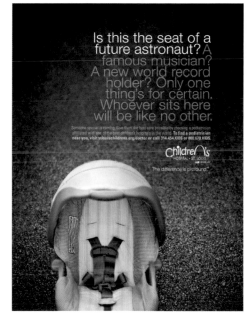

Creative Firm: **RODGERS TOWNSEND — ST. LOUIS, MO**
Creative Team: **TOM HUDDER, RYAN SMITH, TODD MITCHELL, CHERYL SPARKS**
Client: **ST. LOUIS CHILDREN'S HOSPITAL**

Creative Firm: **PLANET ADS AND DESIGN P/L — SINGAPORE**
Creative Team: **MICHELLE LAURIDSEN, HAL SUZUKI, KITANO TOMOYA**
Client: **DISCOVERY NETWORKS ASIA**

Creative Firm: **COMEDY CENTRAL — NEW YORK, NY**
Creative Team: **ROLYN BARTHELMAN, STEPHEN KAMSLER**

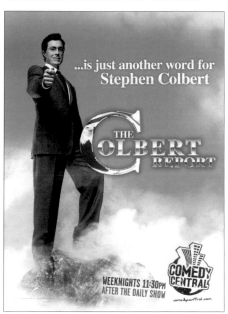

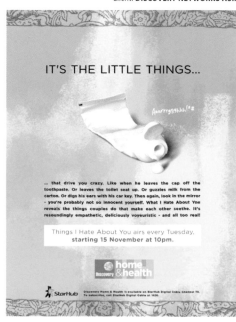

243

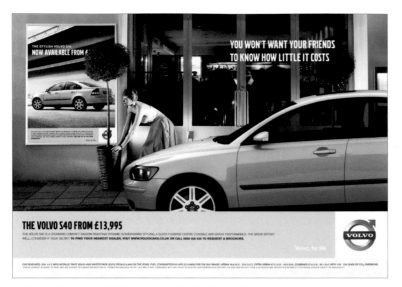

Creative Firm: **BURROWS — BRENTWOOD, ESSEX, UNITED KINGDOM**
Creative Team: **ROYDON HEARNE, ANDREW NICHOLSON, AARON HULSIZER, LUCY WELDON**
Client: **VOLVO CARS UK**

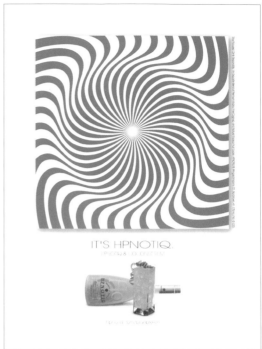

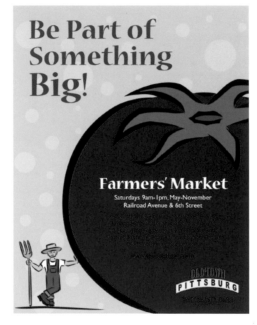

Creative Firm: **LEKASMILLER DESIGN — WALNUT CREEK, CA**
Creative Team: **LANA IP, TINA LEKAS MILLER**
Client: **MAIN STREET PROPERTIES**

Creative Firm: **HERE! NETWORKS — NEW YORK, NY**
Creative Team: **ERIC FELDMAN, MEGAN ELLIS**

Creative Firm: **CREATIVE ALLIANCE — LOUISVILLE, KY**
Creative Team: **SCOTT BOSWELL, MARK ROSENTHAL**
Client: **CHS HOSPITALS**

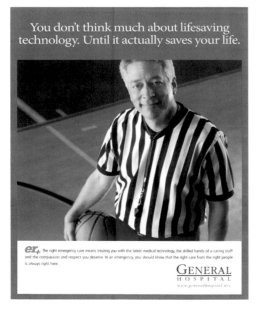

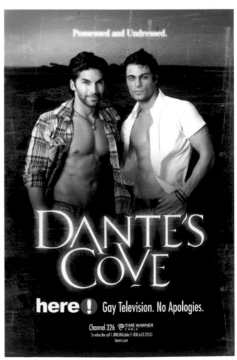

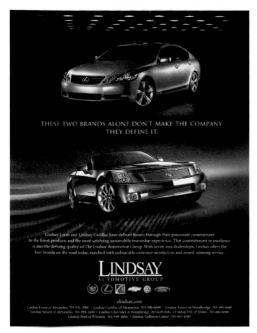

Creative Firm: **SIMPATICO DESIGN STUDIO — ALEXANDRIA, VA**
Creative Team: **AMY SIMPSON**
Client: **LINDSAY LEXUS AND LINDSAY CADILLAC**

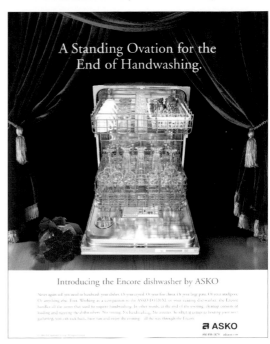

Creative Firm: **VANPELT CREATIVE — GARLAND, TX**
Creative Team: **CHIP VANPELT, TODD BRASHEAR, J.W. BURKEY**
Client: **AM APPLIANCE GROUP**

Creative Firm: **ENGINE, LLC — SAN FRANCISCO, CA**
Creative Team: **LOTUS CHILD, GEOFF SKIGEN**
Client: **MEDJOOL**

Creative Firm: **BURROWS — BRENTWOOD, ESSEX, UNITED KINGDOM**
Creative Team: **ROYDON HEARNE, MARK ELLIS, AARON HULSIZER, LUCY WELDON**
Client: **VOLVO CARS UK**

Creative Firm: **COMEDY CENTRAL — NEW YORK, NY**
Creative Team: **MICHELLE WILLEMS, LAURIE HINZMAN WHITE**

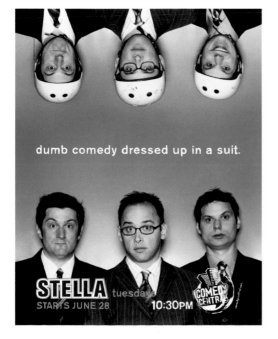

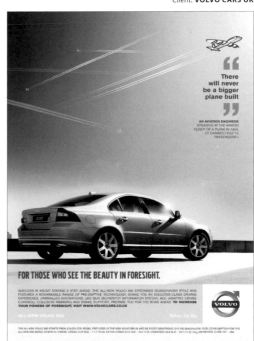

245

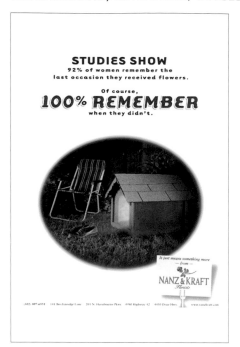

STUDIES SHOW
92% of women remember the
last occasion they received flowers.

Of course,
100% REMEMBER
when they didn't.

*It just means something more
— from —*
NANZ & KRAFT
Florists

Creative Firm: **CREATIVE ALLIANCE — LOUISVILLE, KY**
Creative Team: **JOE ADAMS, SCOTT BOSWELL**
Client: **NANZ & KRAFT FLORISTS**

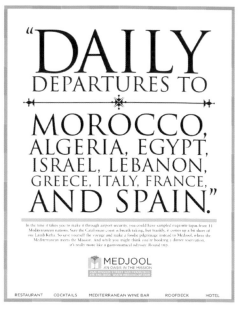

"DAILY
DEPARTURES TO
MOROCCO,
ALGERIA, EGYPT,
ISRAEL, LEBANON,
GREECE, ITALY, FRANCE,
AND SPAIN."

MEDJOOL
AN OASIS IN THE MISSION

RESTAURANT COCKTAILS MEDITERRANEAN WINE BAR ROOFDECK HOTEL

Creative Firm: **ENGINE, LLC — SAN FRANCISCO, CA**
Creative Team: **LOTUS CHILD, GEOFF SKIGEN**
Client: **MEDJOOL**

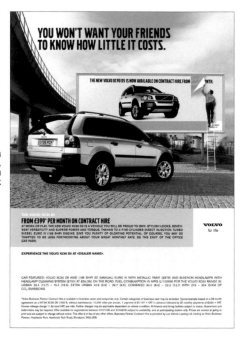

YOU WON'T WANT YOUR FRIENDS
TO KNOW HOW LITTLE IT COSTS.

THE NEW VOLVO XC90 D5 IS NOW AVAILABLE ON CONTRACT HIRE FROM £ONTH.

VOLVO
for life

Creative Firm: **BURROWS — BRENTWOOD, ESSEX, UNITED KINGDOM**
Creative Team: **ROYDON HEARNE, ANDREW NICHOLSON,
AARON HULSIZER, LUCY WELDON**
Client: **VOLVO CARS UK**

Creative Firm: **FUTURA DDB — LJUBLJANA, SLOVENIA**
Creative Team: **ZORAN GABRIJAN, MARKO VICIC,
ZARE KERIN, MARUSA KOZELJ**
Client: **DONAT**

(S) *Creative Firm:* **PETERSON MILLA HOOKS — MINNEAPOLIS, MN**
Creative Team: **DAVE PETERSON, ERIKA WALDEN, CATHERINE IRMITER, ELLEN FREGO, KEN BARLAGE**
Client: **TARGET**

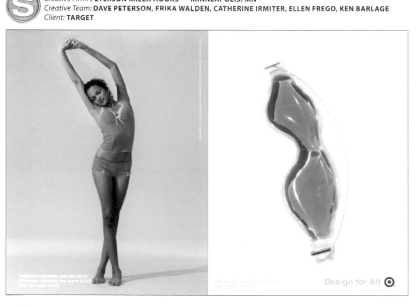

Design for All

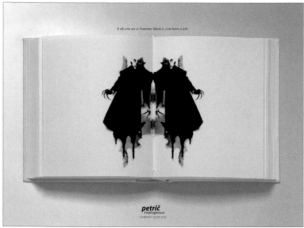

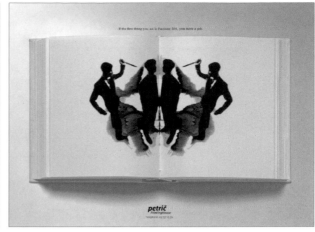

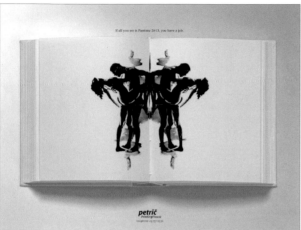

Creative Firm: **FUTURA DDB — LJUBLANA, SLOVENIA**
Creative Team: **ZARE KERIN, ZORAN GABRIAJAN, MIHA GROBLER**
Client: **PRINTING HOUSE PETRIC**

Creative Firm: **PETERSON MILLA HOOKS — MINNEAPOLIS, MN**
Creative Team: **DAVE PETERSON, SUE KAASE, ELLEN FREGO,**
CARRIE REAY, GAYLE MALCOLM
Client: **TARGET**

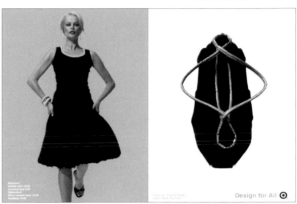

Creative Firm: **PETESON MILLA HOOKS —MINNEAPOLIS, MN**
Creative Team: **DAVE PETERSON, JENNY SHEARS, CARRIE REAY, ILAN RUBIN**
Client: **TARGET**

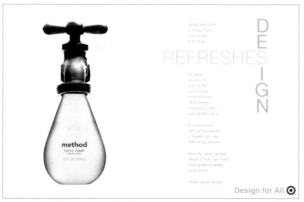

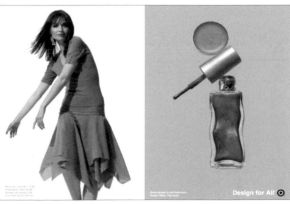

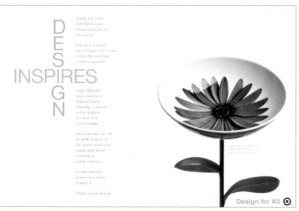

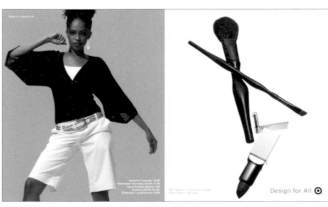

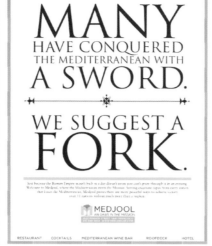

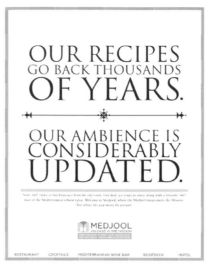

Creative Firm: **ENGINE, LLC— SAN FRANCISCO, CA**
Creative Team: **LOTUS CHILD, GEOFF SKIGEN**
Client: **MEDJOOL**

Creative Firm: **160 OVER 90 — PHILADELPHIA, PA**
Creative Team: **DARRYL CILLI, JIM WALLS, GIACOMO CIMINELLO, BRUNO BISANG, BRENDAN QUINN**
Client: **DAVIN WHEELS**

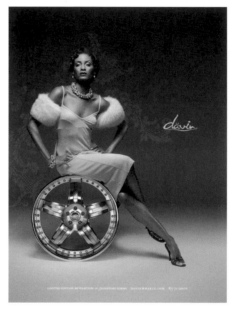

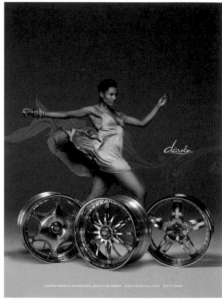

Creative Firm: **30SIXTY ADVERTISING+DESIGN, INC. — LOS ANGELES, CA**
Creative Team: **HENRY VIZCARRA, PÄR LARSSON, KASEY CHATILA, BRUCE VENTANILLA**
Client: **MGM HOME ENTERTAINMENT**

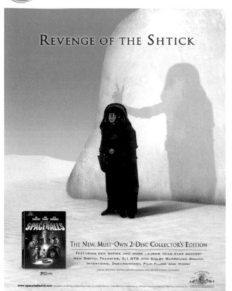

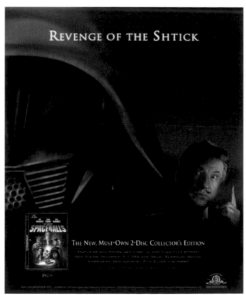

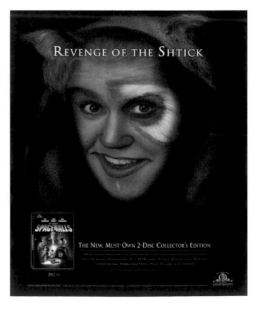

Creative Firm: **LAUNCH CREATIVE MARKETING**
Creative Team: **BRUCE BUTCHER, CHRISTINE MONAHAN**
Client: **UNITED STATIONERS**

Creative Firm: **ADVANTAGE LTD — HAMILTON, BERMUDA**
Creative Team: **SHEILA SEMOS, SAMI LILL**
Client: **BELCO LTD.**

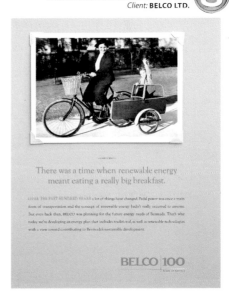

 Creative Firm: **PETERSON MILLA HOOKS — MINNEAPOLIS, MN**
Creative Team: **DAVE PETERSON, SUE KAASE, GAYLE OBODZINSKI, ELLEN FREGO, KENNETH WILLARDT, CATHERINE IRMITER**
Client: **TARGET**

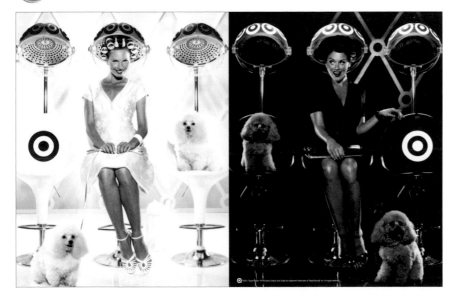

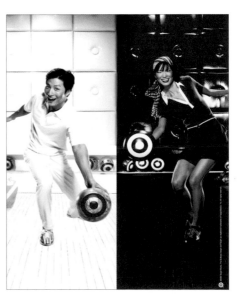

Creative Firm: **DESIGN NUT — KENSINGTON, MD**
Creative Team: **BRENT ALMOND, TIMOTHY WORRELL, THOMAS DEMARCO**
Client: **TIMOTHY PAUL CARPETS + TEXTILES**

Creative Firm: **NAMARO GRAPHIC DESIGNS, INC. — RHINEBECK, NY**
Creative Team: **NADINE ROBBINS, WENDY MACOMBER**
Client: **ORTHOPEDIC ASSOCIATES OF DUTCHESS COUNTY**

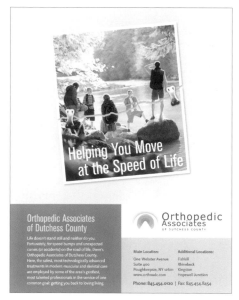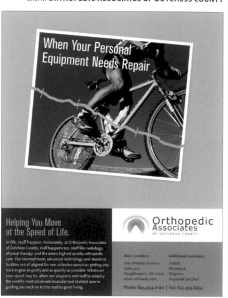

Creative Firm: **D'ADDA, LORENZINI, VIGORELLI, BBDO — ROME, ITALY**
Creative Team: **GIANPIERO VIGORELLI, ALESSANDRO FRUSCELLA, LETIZIA ZIACO, RITA DELLA PORTA, LUCA BERNASCONI**
Client: **NBC UNIVERSAL GLOBAL NETWORKS ITALIA SRL**

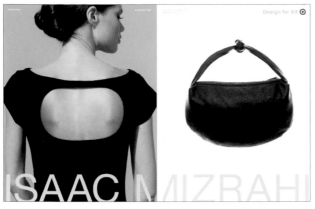

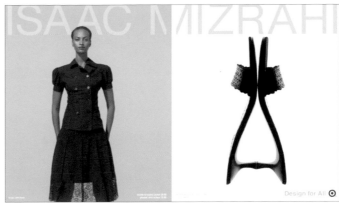

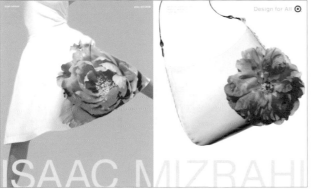

Creative Firm: **PETERSON MILLA HOOKS — MINNEAPOLIS, MN**
Creative Team: **DAVE PETERSON, SUE KAASE, ELLEN FREGO, CARRIE REAY, GAYLE MALCOLM**
Client: **TARGET**

Creative Firm: **CREATIVE ALLIANCE — LOUISVILLE, KY**
Creative Team: **SCOTT BOSWELL, MARK ROSENTHAL, ALBERT LEGGETT**
Client: **CABBAGE PATCH SETTLEMENT HOUSE**

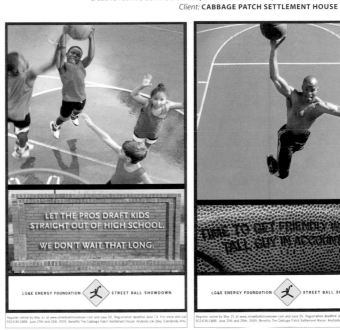

Creative Firm: **INTERNO OTTO SRL — ROME, ITALY**
Creative Team: **MICHELE BELSANTI, ROBERTO MENELAO, VALERIO DE BERARDINIS**
Client: **NBC UNIVERSAL GLOBAL NETWORKS ITALIA SRL**

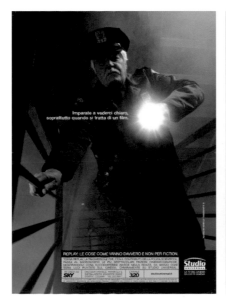

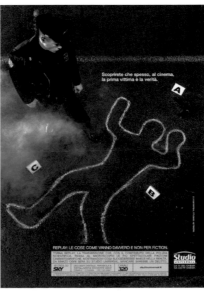

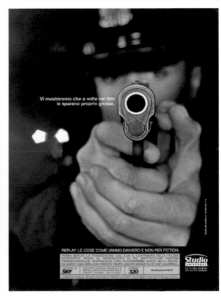

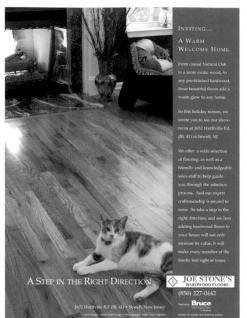

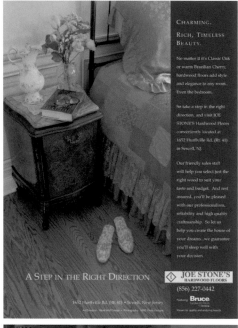

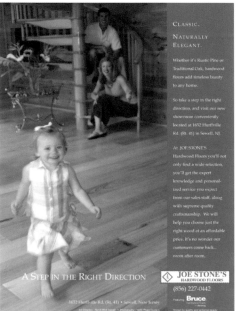

INVITING...

A WARM
WELCOME HOME.

From casual Natural Oak
to a more exotic wood, to
any pre-finished hardwood,
these beautiful floors add a
warm glow to any home.

So this holiday season, we
invite you to see our show-
room at 1652 Hurffville Rd.
(Rt. 41) in Sewell, NJ.

We offer a wide selection
of flooring, as well as a
friendly and knowledgeable
sales staff to help guide
you through the selection
process. And our expert
craftmanship is second to
none. So take a step in the
right direction, and see how
adding hardwood floors to
your house will not only
increase its value, it will
make every member of the
family feel right at home.

A STEP IN THE RIGHT DIRECTION

JOE STONE'S
HARDWOOD FLOORS
(856) 227-0442

1652 Hurffville Rd. (Rt. 41) • Sewell, New Jersey

CHARMING.

RICH, TIMELESS
BEAUTY.

No matter if it's Classic Oak
or warm Brazilian Cherry,
hardwood floors add style
and elegance to any room.
Even the bedroom.

So take a step in the right
direction, and visit JOE
STONE'S Hardwood Floors
conveniently located at
1652 Hurffville Rd. (Rt. 41)
in Sewell, NJ.

Our friendly sales staff
will help you select just the
right wood to suit your
taste and budget. And rest
assured, you'll be pleased
with our professionalism,
reliability and high quality
craftmanship. So let us
help you create the house of
your dreams...we guarantee
you'll sleep well with
your decision.

A STEP IN THE RIGHT DIRECTION

JOE STONE'S
HARDWOOD FLOORS
(856) 227-0442

1652 Hurffville Rd. (Rt. 41) • Sewell, New Jersey

CLASSIC.

NATURALLY
ELEGANT.

Whether it's Rustic Pine or
Traditional Oak, hardwood
floors add timeless beauty
to any home.

So take a step in the right
direction, and visit our new
showroom conveniently
located at 1652 Hurffville
Rd. (Rt. 41) in Sewell, NJ.

At JOE STONE'S
Hardwood Floors you'll not
only find a wide selection,
you'll get the expert
knowledge and personal-
ized service you expect
from our sales staff, along
with supreme quality
craftmanship. We will
help you choose just the
right wood at an affordable
price. It's no wonder our
customers come back,
room after room.

A STEP IN THE RIGHT DIRECTION

JOE STONE'S
HARDWOOD FLOORS
(856) 227-0442

1652 Hurffville Rd. (Rt. 41) • Sewell, New Jersey

Creative Firm: **RANDI WOLF DESIGN — GLASSBORO, NJ**
Creative Team: **RANDI WOLF, NANCY SIMPSON, JOE STONE**
Client: **JOE STONE'S HARDWOOD FLOORS**

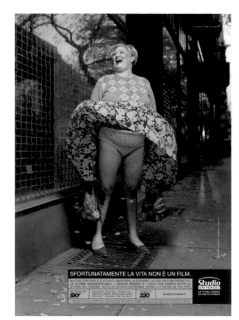

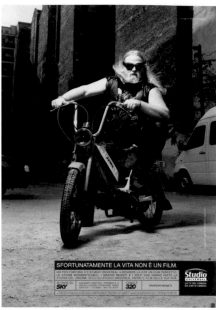

Creative Firm: **D'ADDA, LORENZINI, VIGORELLI, BBDO — ROME, ITALY**
Creative Team: **GIANPIERO VIGORELLI, NICOLA LAMPUGNANI, LETIZIA ZIACO, RITA DELLA PORTA, LUCA BERNASCONI**
Client: **NBC UNIVERSAL GLOBAL NETWORKS ITALIA SRL**

Creative Firm: **160 OVER 90 — PHILADELPHIA, PA**
Creative Team: **DARRYL CILLI, JIM WALLS, DAN SHEPELAVY, GIACOMO CIMINELLO, STEVE PENNING, BRENDAN QUINN**
Client: **AND1 BASKETBALL**

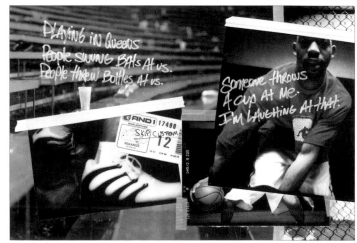

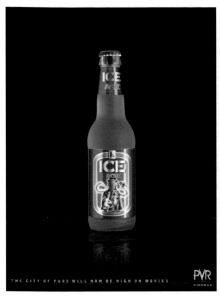
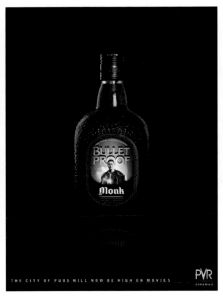
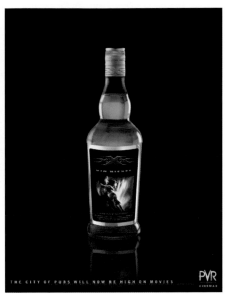

Creative Firm: **REDIFFUSION DYR — NEW DELHI, INDIA**
Creative Team: **ANIRUDH VERMA, PRADYUMNA CHAUHAN, PRAMOD PURANIK, SUDHIR GAUTAM**
Client: **PVR CINEMAS**

Creative Firm: **FUTURA DDB — LJUBLANA, SLOVENIA**
Creative Team: **ZORAN GABRIJAN, ZARE KERIN, MIHA GROBLER, JANEZ PUKSIC**
Client: **PIVK**

Creative Firm: **MADARA DESIGN — LANCASTER, PA**
Creative Team: **JOHN MADARA, JOHN ZESWITZ, BILL SIMONE**
Client: **JOHN A. WEIERBACH II, DMD**

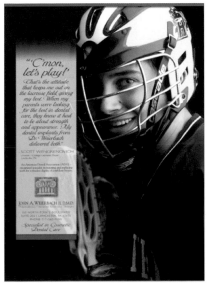
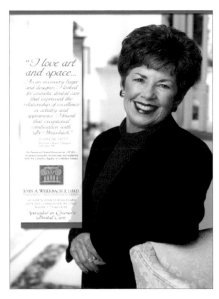

MAGAZINE AD, *CONSUMER*, CAMPAIGN

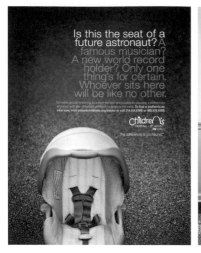

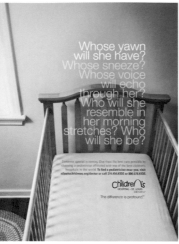

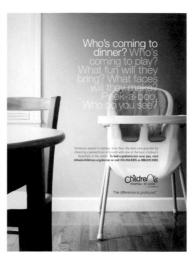

Creative Firm: **RODGERS TOWNSEND — ST. LOUIS, MO**
Creative Team: **TOM HUDDER, RYAN SMITH, TODD MITCHELL, CHERYL SPARKS**
Client: **ST. LOUIS CHILDREN'S HOSPITAL**

Creative Firm: **PHP COMMUNICATIONS — BIRMINGHAM, AL**
Creative Team: **BRYAN CHACE, LYNN SMITH**
Client: **THE CROSSINGS AT DEERFOOT**

Creative Firm: **LEKASMILLER DESIGN — WALNUT CREEK, CA**
Creative Team: **LANA IP, TINA LEKAS MILLER**
Client: **CASTELLANA HOMES**

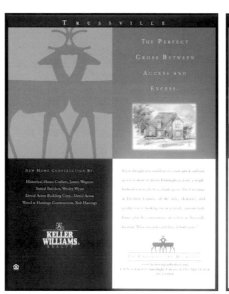

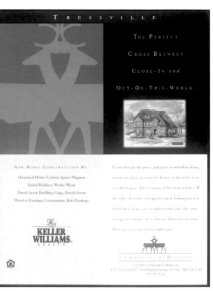

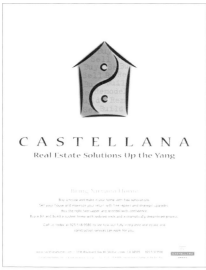

Creative Firm: **RTS RIEGER TEAM WERBEAGENTUR GMBH — LEINFELDEN-ECHTERDINGEN, GERMANY**
Creative Team: **UTE WITZMANN, ANTJE KRAY, WALFGANG KRÖPER, MARKUS KOCH**
Client: **METABOWERKE GMBH**

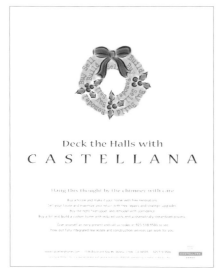

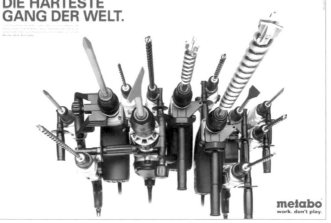

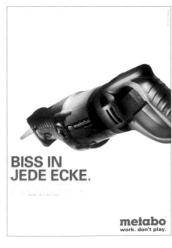

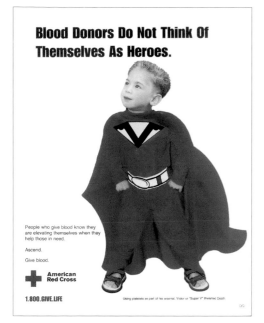

Creative Firm: AMERICAN RED CROSS BLOOD SERVICES,
WEST DIVISION — POMONA, CA
Creative Team: MARC JACKSON, SAUNDRA
KEENAN DAVISON, DONNA ANAYA

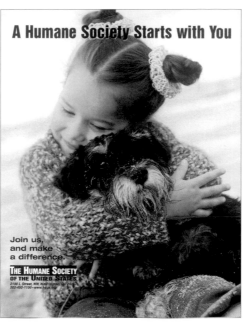

Creative Firm: THE HUMANE SOCIETY OF THE UNITED STATES
— WASHINGTON, DC
Creative Team: PAULA JAWORSKI
Client: THE HUMANE SOCIETY OF THE UNITED STATES

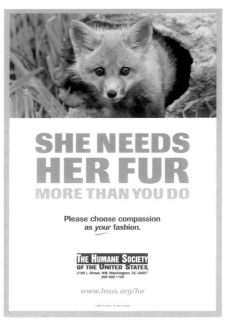

Creative Firm: THE HUMANE SOCIETY OF THE UNITED STATES
— WASHINGTON, DC
Creative Team: PAULA JAWORSKI
Client: THE HUMANE SOCIETY OF THE UNITED STATES

Creative Firm: ACART COMMUNICATIONS — OTTAWA, ON, CANADA
Creative Team: RYAN ABBOTT, KERRY CAVLOVIC, VERNON LAI, JOHN STARESINIC
Client: ACART COMMUNICATIONS

Creative Firm: & WOJDYLA ADVERTISING — CHICAGO, IL
Creative Team: MICHAEL JOHN, FRANKIE TRULL, DAVID WOJDYLA,
BARBARA LIVINGSTON
Client: FOUNDATION FOR BIOMEDICAL RESEARCH

Creative Firm: MTV OFF AIR CREATIVE — NEW YORK, NY
Creative Team: JEFFREY KEYTON, JIM DEBARROS, LANCE RUSOFF, THOMAS BERGER,
SARAH JAMES, NICK SONDERUP
Client: MTV NETWORKS

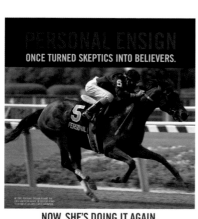

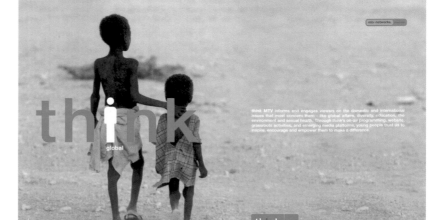

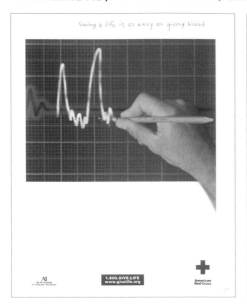

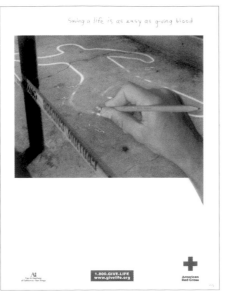

Creative Firm: ART INSTITUE OF CALIFORNIA, SAN DIEGO — SAN DIEGO, CA
Creative Team: LOGAN BAILEY
Client: AMERICAN RED CROSS BLOOD SERVICES

Creative Firm: THE HUMANE SOCIETY OF THE UNITED STATES — WASHINGTON, DC
Creative Team: PAULA JAWORSKI
Client: THE HUMANE SOCIETY OF THE UNITED STATES

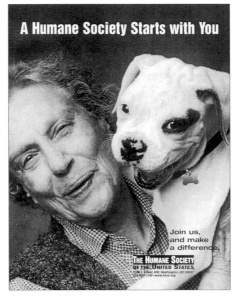

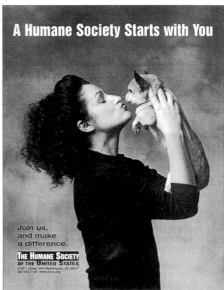

Creative Firm: THE HUMANE SOCIETY OF THE UNITED STATES — WASHINGTON, DC
Creative Team: PAULA JAWORSKI
Client: THE HUMANE SOCIETY OF THE UNITED STATES

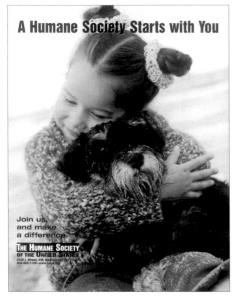

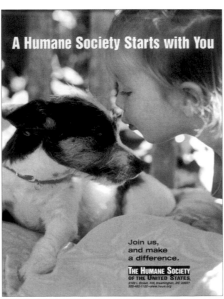

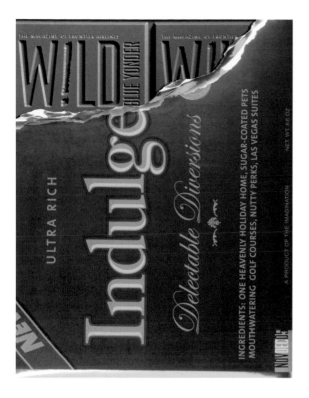

Creative Firm: **MPHASIS ON FRONTIER — DENVER, CO**
Creative Team: **BRYANT FERNANDEZ,**
BRUCE FERNANDEZ FUTAGO IMAGES
Client: **WILD BLUE YONDER MAGAZINE**

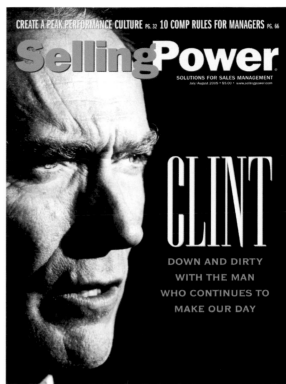

Creative Firm: **SELLING POWER MAGAZINE — FREDERICKSBURG, VA**
Creative Team: **COLLEEN QUINNELL, BRYN COLTON / CORBIS**
Client: **SELLING POWER**

Creative Firm: **ALOFT GROUP, INC. — NEWBURYPORT, MA**
Creative Team: **DON CRANE, ROBBIE MACDONALD**
Client: **DICTAPHONE HEALTHCARE**

Creative Firm: **EYEBALLNYC — NEW YORK, NY**
Client: **VOGUE ITALIA**

Creative Firm: **EMPHASIS MEDIA LIMITED — HONG KONG**
Creative Team: **PERCY CHUNG, HOWARD LEUNG,
JENNIFER SPENCER-KENTRUP**
Client: **CATHAY PACIFIC AIRWAYS**

Creative Firm: **MPHASIS ON FRONTIER — DENVER, CO**
Creative Team: **JEFF SWAIM**
Client: **WILD BLUE YONDER MAGAZINE**

Creative Firm: **THE DESIGN STUDIO AT KEAN UNIVERSITY — UNION, NJ**
Creative Team: **STEVEN BROWER, BRIAN RUTTACAÚOLE**
Client: **OFFICE OF RESEARCH & SPONSORED PROGRAMS**

Creative Firm: **EMPHASIS MEDIA LIMITED — HONG KONG**
Creative Team: **PERCY CHUNG, RAYMOND HO,
JENNIFER SPENCER-KENTRUP**
Client: **CATHAY PACIFIC AIRWAYS**

Creative Firm: **STAN GELLMAN GRAPHIC DESIGN INC. — ST. LOUIS, MO**
Creative Team: **MEG ZELENOVICH, BRITNI EGGERS, MEGAN MILLER,
BRYAN WAKELAND, JILL FRANTTI, BARRY TILSON**
Client: **ST. LOUIS COMMERCE MAGAZINE**

Creative Firm: THINKHOUSE CREATIVE — ATLANTA, GA
Client: COX ENTERPRISES, INC.

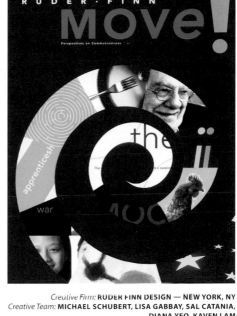

Creative Firm: RUDER FINN DESIGN — NEW YORK, NY
Creative Team: MICHAEL SCHUBERT, LISA GABBAY, SAL CATANIA,
DIANA YEO, KAVEN LAM
Client: RUDER FINN INC.

Creative Firm: EMPHASIS MEDIA LIMITED — HONG KONG
Creative Team: JULIE MAN, JENNIFER SPENCER-KENTRUP
Client: PERNOD RICARD ASIA

Creative Firm: PEO — TORONTO, ON, CANADA
Creative Team: ASH KOUSA R.G.D., JENNIFER COOMBES,
CONNIE MUCKLESTONE
Client: ENGINEERING DIMENSIONS MAGAZINE

Creative Firm: STAN GELLMAN GRAPHIC DESIGN INC. — ST. LOUIS, MO
Creative Team: MEG ZELENOVICH, BRITNI EGGERS, MEGAN MILLER,
BRYAN WAKELAND, JILL FRANTTI, BARRY TILSON
Client: ST. LOUIS COMMERCE MAGAZINE

Creative Firm: **DEVER DESIGNS — LAUREL, MD**
Creative Team: **JEFFREY DEVER, PAUL ANDERSON**
Client: **PSYCHOTHERAPY NETWORKER MAGAZINE**

Creative Firm: **STAN GELLMAN GRAPHIC DESIGN INC. — ST. LOUIS, MO**
Creative Team: **MEG ZELENOVICH, BRITNI EGGERS, MEGAN MILLER, BRYAN WAKELAND, JILL FRANTTI, BARRY TILSON**
Client: **ST. LOUIS COMMERCE MAGAZINE**

Creative Firm: **EMPHASIS MEDIA LIMITED — HONG KONG**
Creative Team: **ALISON LAM, CONNIE CHU**
Client: **DRAGONAIR**

Creative Firm: **THINKHOUSE CREATIVE — ATLANTA, GA**
Client: **COX ENTERPRISES, INC.**

Creative Firm: **EMPHASIS MEDIA LIMITED — HONG KONG**
Creative Team: **ALISON LAM, CONNIE CHU**
Client: **DRAGONAIR**

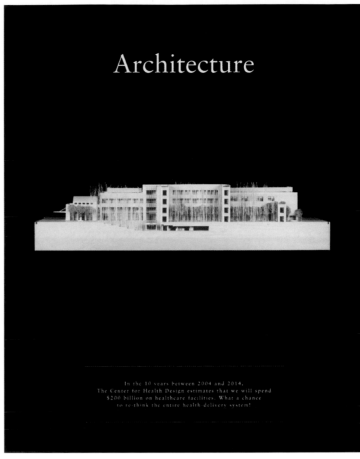

 Creative Firm: **CAHAN & ASSOCIATES — ZEELAND, MI**
Creative Team: **T. RICHARDS, E. ADAMS, C. RHINELANDER, S. FRYKHOLM, C. MALCOLM, G. STROBEL, M. CAPOTOSTO**
Client: **HERMAN MILLER, INC.**

 Creative Firm: **TAYLOR DESIGN — STAMFORD, CT**
Creative Team: **DAN TAYLOR, HANNAH FICHANDLER, ANDREW LICHTENSTEIN, DON HAMERMAN, AARON MERSHON**
Client: **SARAH LAWRENCE COLLEGE**

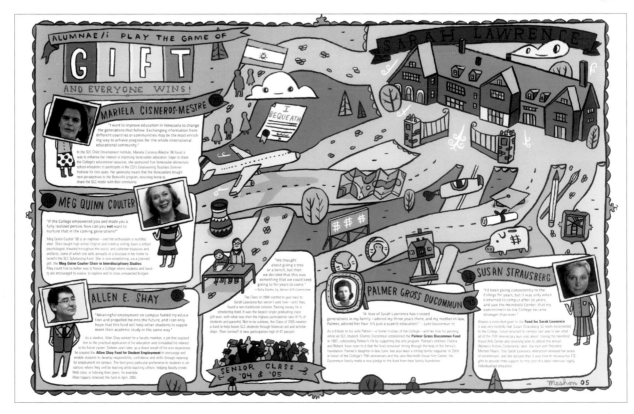

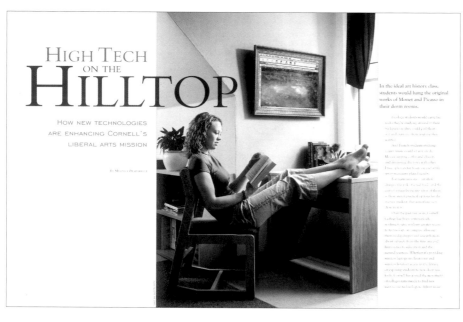

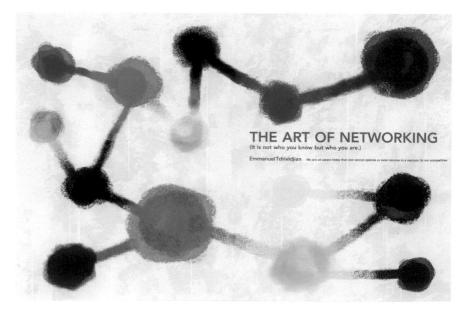

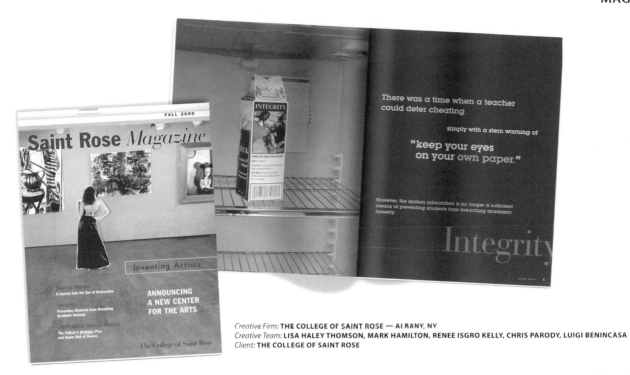

Creative Firm: **THE COLLEGE OF SAINT ROSE — ALBANY, NY**
Creative Team: **LISA HALEY THOMSON, MARK HAMILTON, RENEE ISGRO KELLY, CHRIS PARODY, LUIGI BENINCASA**
Client: **THE COLLEGE OF SAINT ROSE**

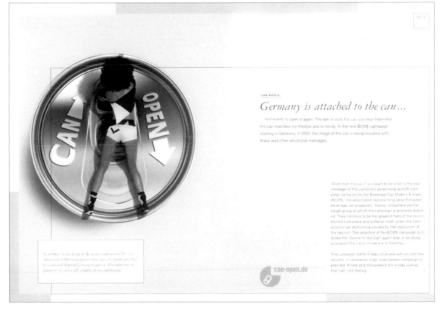

Creative Firm: **RTS RIEGER TEAM WERBEAGENTUR GMBH — DÜSSELDORF, GERMANY**
Creative Team: **MICHAELA MÜLLER, ULRICH GIELISCH**
Client: **BALL PACKAGING EUROPE HOLDING GMBH & CO. KG**

Creative Firm: **FIVESTONE — BUFORD, GA**
Creative Team: **JASON LOCY, PATRICIO JUAREZ**
Client: **INJOY**

Creative Firm: **ERWIN ZINGER GRAPHIC DESIGN** — GRONINGEN, GRONINGEN, NETHERLANDS
Creative Team: **ERWIN ZINGER, MARIO MORTIER**
Client: **AVENTURA ENTERTAINMENT**

Creative Firm: **ALOFT GROUP, INC.** — NEWBURYPORT, MA
Creative Team: **DON CRANE, ROBBIE MACDONALD**
Client: **DICTAPHONE HEALTHCARE**

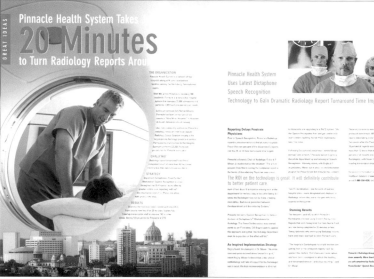

Creative Firm: **CCM** — WEST ORANGE, NJ
Creative Team: **STEPHEN LONGO, JENNIFER BASSORA, JOHN FARISCHON, CHRISTOPHER WARZOCHA**
Client: **COUNTY COLLEGE OF MORRIS**

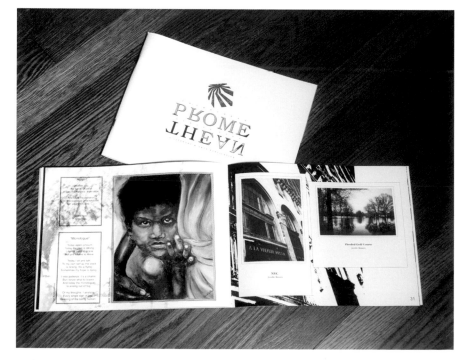

SKYWriting
by CITATIONSHARES

Inside:
Introducing the
Only 20-Hour JetCard

Ultimate Business Tool

High Standards

DESTINATIONS

FLIGHTS OF FANCY

Anguilla

Wallblake Airport (AXA)
12 minutes away

This is the most captivating of Caribbean Isles. Those who visit return again and again. The water and weather are mesmerizing, the resort lifestyle is enthralling and the hospitality is unforgettable. Its seclusion makes it an exclusive destination for elite travelers.

The island of Anguilla, at the top of the chain of Caribbean islands, is a pristine paradise celebrated for its 33 powder-white beaches, epicurean pleasures and laid-back lifestyle. Visitors find world-class pampering in luxurious resorts and welcome repose in the many secluded bays.

On the coveted West End, the Kor Hotel Group is creating another exclusive Viceroy property. The beachfront villas and resort residences will embrace the climate by blending indoors and outdoors. See viceroyanguilla.com, or call the onsite residential sales agents at 264.497.0757.

Creative Firm: **HORNALL ANDERSON DESIGN WORKS — SEATTLE, WA**
Creative Team: **JACK ANDERSON, KATHY SAITO, HENRY YIU, ALAN COPELAND**
Client: **CITATIONSHARES**

N·E·W·S

faculty FOCUS

Ovations

Creative Firm: **REDPOINT DESIGN DIRECTION — MIDLAND, MI**
Creative Team: **CLARK MOST**
Client: **CENTRAL MICHIGAN UNIVERSITY**

Creative Firm: **HORNALL ANDERSON DESIGN WORKS — SEATTLE, WA**
Creative Team: **JACK ANDERSON, KATHY SAITO, HENRY YIU, ALAN COPELAND**
Client: **CITATIONSHARES**

SKYWriting
by CitationShares

Inside:
CitationShares & Residual Value

Value-Added Programs

Meet Your Representatives

DESTINATIONS

UP, UP, AND FAIRWAY

This article, which first appeared in the July/August 2005 issue of Departures magazine, has been reprinted with permission.

Faster than you can say "pooling your resources," savvy golfers have discovered that with careful planning foursomes can fly by private jet to their favorite resorts—for not much more than it costs to go first-class. John Steinbreder hops aboard.

Creative Firm: **YELLOW SHOES CREATIVE WEST, DISNEYLAND RESORT — ANAHEIM, CA**
Creative Team: **DATHAN SHORE, WES CLARK, MARTY MULLER, JACQUELYN MOE, KEVIN YONEDA**
Client: **DISNEYLAND RESORT**

Creative Firm: **PHOENIX CREATIVE GROUP, LLC — POTOMAC FALLS, VA**
Creative Team: **NICOLE KASSOLIS, SEAN MULLINS, KATHLEEN RUSH, MATTHEW BORKOWSKI, JUPITER IMAGES**
Client: **HOMESTEAD FUNDS**

Creative Firm: **FIRST MARKETING — POMPANO BEACH, FL**
Creative Team: **DAN GARLENSKI, JESS FARBER, MAURICIO ABELA, KEITH JOHNSON, ADRIANA NAYLOR, MICHAEL CADIEUX**
Client: **REGENT SEVEN SEAS CRUISES**

Creative Firm: **SPLASH PRODUCTIONS PTE LTD — SINGAPORE**
Creative Team: **STANLEY TAP**
Client: **CLUB RAINBOW SINGAPORE**

Creative Firm: **VH1 — NEW YORK, NY**
Client: **VH1**

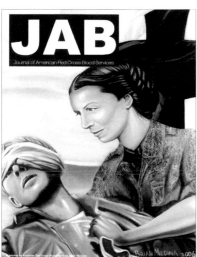

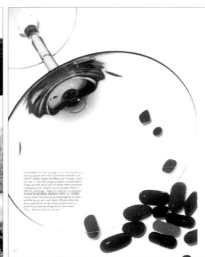

Creative Firm: **AMERICAN RED CROSS BLOOD SERVICES, WEST DIVISION — POMONA, CA**
Creative Team: **M. JACKSON, D. ANAYA, S. WHITBURN, R. HERON, MD, G. GARRATTY, PHD FRC PATH, B. MEDINA, S. DAVISON**
Client: **PUBLIC AFFAIRS & COMMUNICATIONS DEPT.**

Creative Firm: **PUBLICIS DIALOG — SAN FRANCISCO, CA**
Creative Team: **CHRISTOPHER ST. JOHN, THERESA LEE, JASON BLACK, BRIAN TYLER**
Client: **GREATER SAN FRANCISCO AD CLUB**

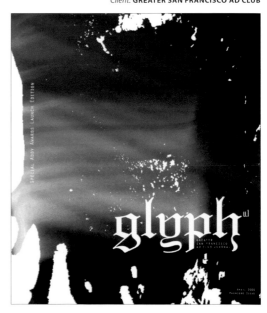

Creative Firm: **RODGERS TOWNSEND — ST. LOUIS, MO**
Creative Team: **TOM HUDDER, MARK ARNOLD, TODD MITCHELL, CHERYL SPARKS**
Client: **AT&T YELLOW PAGES**

Creative Firm: **RODGERS TOWNSEND — ST. LOUIS, MO**
Creative Team: **TOM HUDDER, MARK ARNOLD, TODD MITCHELL, CHERYL SPARKS**
Client: **AT&T YELLOW PAGES**

Creative Firm: **RODGERS TOWNSEND — ST. LOUIS, MO**
Creative Team: **TOM HUDDER, MARK ARNOLD, TODD MITCHELL, CHERYL SPARKS**
Client: **AT&T YELLOW PAGES**

Creative Firm: **RODGERS TOWNSEND — ST. LOUIS, MO**
Creative Team: **TOM HUDDER, MARK ARNOLD, TODD MITCHELL, CHERYL SPARKS**
Client: **AT&T YELLOW PAGES**

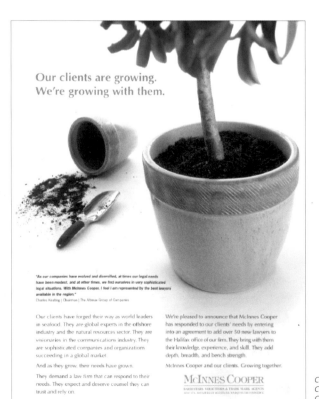

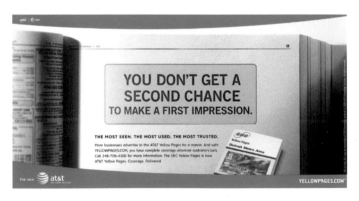

Creative Firm: **RODGERS TOWNSEND — ST. LOUIS, MO**
Creative Team: **TOM HUDDER, MARK ARNOLD, TODD MITCHELL, CHERYL SPARKS**
Client: **AT&T YELLOW PAGES**

Creative Firm: **MT&L PUBLIC RELATIONS LTD. — HALIFAX, NS, CANADA**
Creative Team: **DANNY GODFREY, PAUL WILLIAMS, JOHN SHERLOCK, SARAH MOSES**
Client: **MCINNES COOPER**

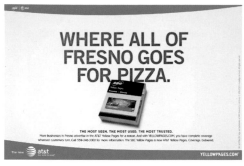

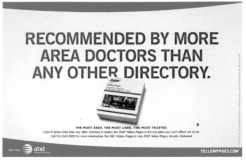

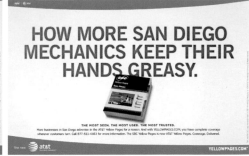

Creative Firm: **RODGERS TOWNSEND — ST. LOUIS, MO**
Creative Team: **TOM HUDDER, MARK ARNOLD, TODD MITCHELL, CHERYL SPARKS**
Client: **AT&T YELLOW PAGES**

Creative Firm: **RODGERS TOWNSEND — ST. LOUIS, MO**
Creative Team: **TOM HUDDER, MARK ARNOLD, TODD MITCHELL, CHERYL SPARKS**
Client: **AT&T YELLOW PAGES**

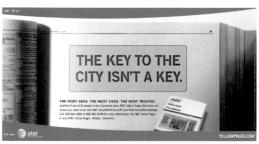

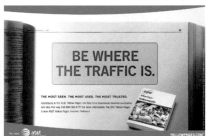

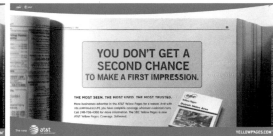

NEWSPAPER AD, *PUBLIC SERVICE,* CAMPAIGN

Creative Firm: **ALL MEDIA PROJECTS LIMITED — PORT OF SPAIN, TRINIDAD AND TOBAGO**
Creative Team: **ANTHONY MOORE, JOSIANE KHAN, GLENN FORTE, BERTRAND DE PEAZA**
Client: **BP TRINIDAD AND TOBAGO (BPTT)**

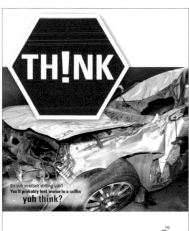

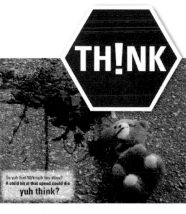

Creative Firm: **ALL MEDIA PROJECTS LIMITED — PORT OF SPAIN, TRINIDAD AND TOBAGO**
Creative Team: **ANTHONY MOORE, GLENN FORTE, CATHLEEN JONES, REVELINO GUEVARA, CARL HARDING,**
Client: **SFA COMMUNICATIONS**

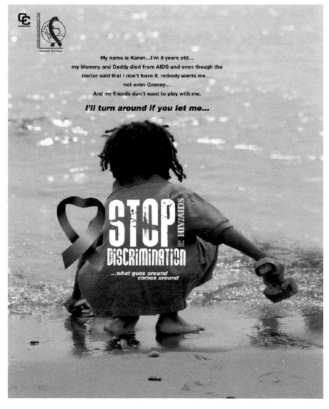

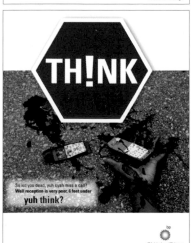

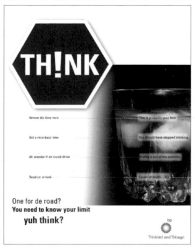

HO HO HU HOMELESS

Christmas isn't Merry for everyone. More than 300 Bermudians will be sleeping rough this winter, including women and children. So as you carve your big juicy turkey, please spare them a thought. Better still, show that you care by giving a donation to The Bermuda Salvation Army. **Call Carmelita on 292 0601** or send a cheque to P.O. Box HM 2259, Hamilton HM JX, made out to 'The Bermuda Salvation Army'. Thank you for your support.

Creative Firm: **ADVANTAGE LTD — HAMILTON, BERMUDA**
Creative Team: **SAMI LILL**
Client: **SALVATION ARMY**

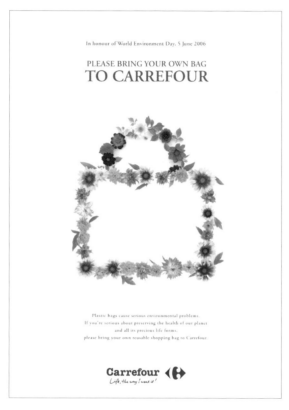

Creative Firm: **PLANET ADS AND DESIGN P/L — SINGAPORE**
Creative Team: **HAL SUZUKI, MICHELLE LAURIDSEN, HANS IBRAHIM**
Client: **CARREFOUR SINGAPORE PTE LTD**

Creative Firm: **MENDES PUBLICIDADE — BELÉM, PARÁ, BRAZIL**
Creative Team: **OSWALDO MENDES, MARCELO AMORIM**
Client: **INSTITUTO CRIANÇA VIDA**

Creative Firm: **ACART COMMUNICATIONS — OTTAWA, ON, CANADA**
Creative Team: **TOM MEGGINSON, JOHN STARESINIC, JAVIER FRUTOS, VERNON LAI, CHANTAL VALLERAND, DONNA STOTT**
Client: **VIA RAIL CANADA**

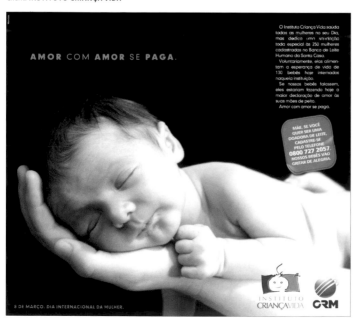

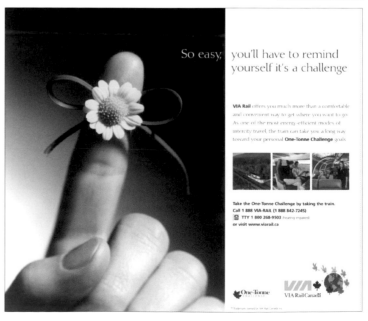

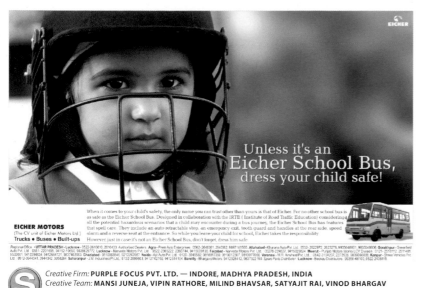

Unless it's an
Eicher School Bus,
dress your child safe!

EICHER MOTORS
(The CV unit of Eicher Motors Ltd.)
Trucks • Buses • Built-ups

When it comes to your child's safety, the only name you can trust other than yours is that of Eicher. For no other school bus is as safe as the Eicher School Bus. Designed in collaboration with the IRTE (Institute of Road Traffic Education) considering all the potential hazardous scenarios that a child may encounter during a bus journey, the Eicher School Bus has features that spell care. They include an auto retractable step, an emergency exit, tooth guard and handles at the rear side, speed alarm and a reverse seat at the entrance. So while you leave your child for school, Eicher takes the responsibility. However, just in case it's not an Eicher School Bus, don't forget, dress him safe.

Creative Firm: **PURPLE FOCUS PVT. LTD. — INDORE, MADHYA PRADESH, INDIA**
Creative Team: **MANSI JUNEJA, VIPIN RATHORE, MILIND BHAVSAR, SATYAJIT RAI, VINOD BHARGAV**
Client: **EICHER MOTORS LTD.**

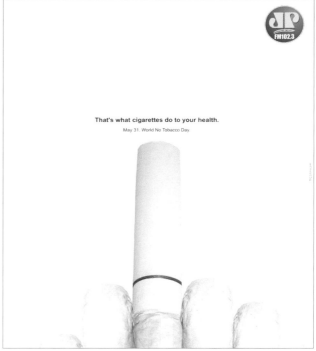

That's what cigarettes do to your health.

May 31. World No Tobacco Day

Creative Firm: **DC3/UNICOM — BELÉM, PARÁ, BRAZIL**
Creative Team: **ALEXANDRE HELMUT, STEVEN DOLZANE, GLAUCO LIMA, HAROLDO VALENTE**
Client: **JOVEM PAN FM**

Creative Firm: **TV LAND — NEW YORK, NY**
Creative Team: **KIM ROSENDLUM, DOMINQUE VITALI, KEVIN HARTMAN, CHELSEA MOST, MONIQUE SANKEY, TONY D'ORIO**
Client: **TV LAND**

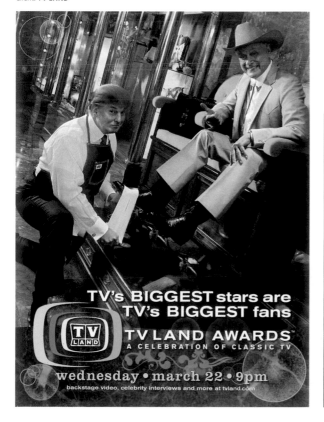

TV's **BIGGEST** stars are
TV's **BIGGEST** fans
TV LAND AWARDS
A CELEBRATION OF CLASSIC TV
wednesday • march 22 • 9pm
backstage video, celebrity interviews and more at tvland.com

Creative Firm: **YOUNG & RUBICAM GMBH & CO. KG — FRANKFURT AM MAIN, HESSEN, GERMANY**
Creative Team: **CHRISTIAN DAUL, BRUNO PETZ**
Client: **HARLEY DAVIDSON FACTORY**

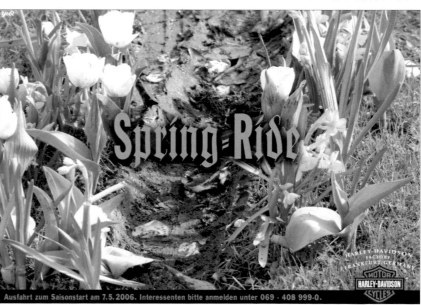

Spring Ride

Ausfahrt zum Saisonstart am 7.5.2006. Interessenten bitte anmelden unter 069 - 408 999-0.

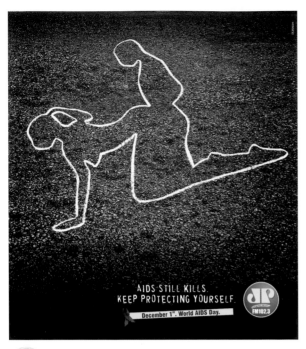

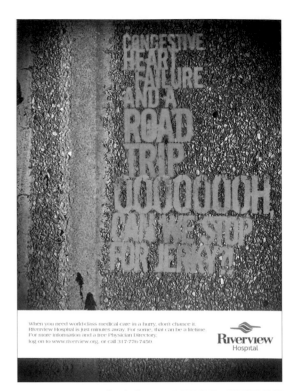

Creative Firm: **DC3/UNICOM — BELÉM, PARÁ, BRAZIL**
Creative Team: **ALEXANDRE HELMUT, RENATA SEGTOWICK,**
GLAUCO LIMA, HAROLDO VALENTE
Client: **JOVEM PAN FM**

Creative Firm: **KELLER CRESCENT — EVANSVILLE, IN**
Creative Team: **RANDALL ROHN, LEE BRYANT, RANDY ROHN**
Client: **RIVERVIEW HOSPITAL**

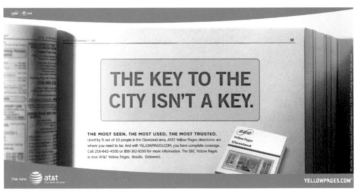

Creative Firm: **RODGERS TOWNSEND — ST. LOUIS, MO**
Creative Team: **TOM HUDDER, MARK ARNOLD,**
TODD MITCHELL, CHERYL SPARKS
Client: **AT&T YELLOW PAGES**

Creative Firm: **DC3/UNICOM — BELÉM, PARÁ, BRAZIL**
Creative Team: **ALEXANDRE HELMUT, FERNANDO FAÇANHA, DANIEL JACOB,**
GLAUCO LIMA, HAROLDO VALENTE
Client: **JOVEM PAN FM**

Creative Firm: **DC3/UNICOM — BELÉM, PARÁ, BRAZIL**
Creative Team: **ALEXANDRE HELMUT, FERNANDO FAÇANHA, DANIEL JACOB,**
GLAUCO LIMA, HAROLDO VALENTE,
Client: **ORM CABO**

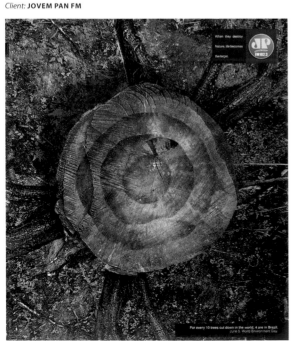

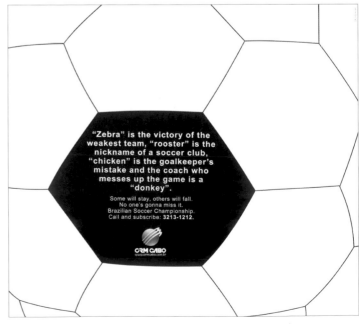

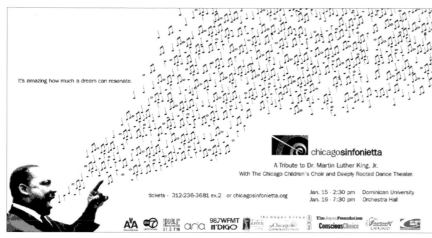

It's amazing how much a dream can resonate.

chicagosinfonietta

A Tribute to Dr. Martin Luther King, Jr.
With The Chicago Children's Choir and Deeply Rooted Dance Theater.

tickets - 312-236-3681 ex.2 or chicagosinfonietta.org

Jan. 15 - 2:30 pm Dominican University
Jan. 16 - 7:30 pm Orchestra Hall

Creative Firm: **THE UNGAR GROUP — CHICAGO, IL**
Creative Team: **TOM UNGAR, JIM FURRH**
Client: **CHICAGO SINFONIETTA**

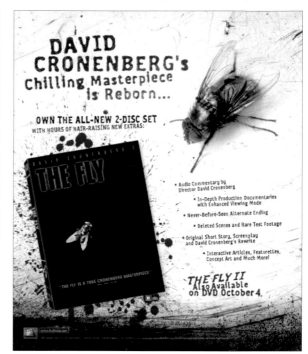

Creative Firm: **NEURON SYNDICATE INC. — SANTA MONICA, CA**
Creative Team: **SEAN ALATORRE, RYAN CRAMER, TIM CALIA**
Client: **20TH CENTURY FOX**

Creative Firm: **BUCK & PULLEYN — PITTSFORD, NY**
Creative Team: **DAN MULCAHY, ANNE ESSE, CHRIS CAPONE, STEVE SAFRAN**
Client: **UNITY HEALTH SYSTEM**

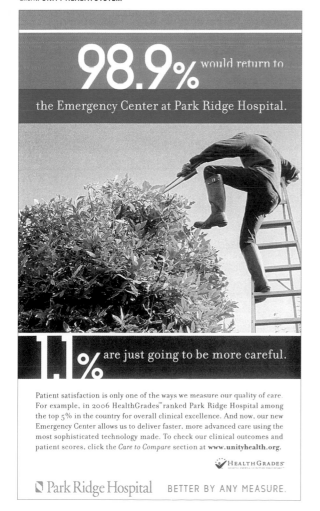

98.9% would return to

the Emergency Center at Park Ridge Hospital.

1.1% are just going to be more careful.

Patient satisfaction is only one of the ways we measure our quality of care. For example, in 2006 HealthGrades™ ranked Park Ridge Hospital among the top 5% in the country for overall clinical excellence. And now, our new Emergency Center allows us to deliver faster, more advanced care using the most sophisticated technology made. To check our clinical outcomes and patient scores, click the *Care to Compare* section at **www.unityhealth.org**.

HEALTHGRADES

Park Ridge Hospital BETTER BY ANY MEASURE.

Creative Firm: **DC3/UNICOM — BELÉM, PARÁ, BRAZIL**
Creative Team: **DANIEL JACOB, RENATA SEGTOWICK, ALEXANDRE HELMUT, GLAUCO LIMA, HAROLDO VALENTE**
Client: **JOVEM PAN FM**

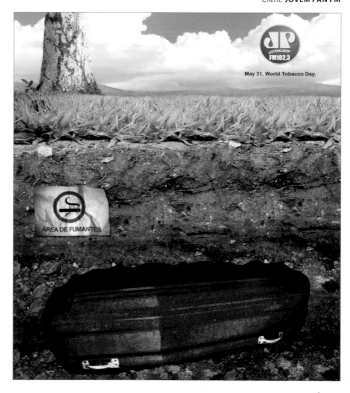

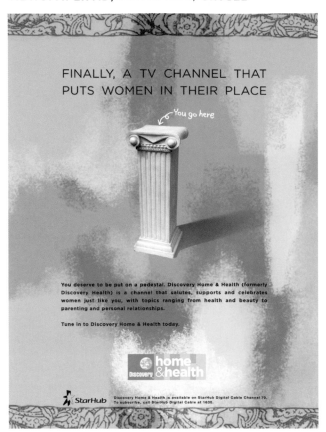

FINALLY, A TV CHANNEL THAT
PUTS WOMEN IN THEIR PLACE

↙ You go here

You deserve to be put on a pedestal. Discovery Home & Health (formerly
Discovery Health) is a channel that salutes, supports and celebrates
women just like you, with topics ranging from health and beauty to
parenting and personal relationships.

Tune in to Discovery Home & Health today.

Discovery home & health

StarHub Discovery Home & Health is available on StarHub Digital Cable Channel 70.
To subscribe, call StarHub Digital Cable at 1630.

Creative Firm: **PLANET ADS AND DESIGN P/L — SINGAPORE**
Creative Team: **HAL SUZUKI, SUZANNE LAURIDSEN, KITANO TOMOYA**
Client: **DISCOVERY NETWORKS ASIA**

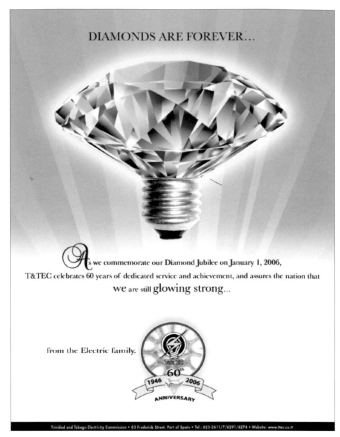

DIAMONDS ARE FOREVER...

As we commemorate our Diamond Jubilee on January 1, 2006,
T&TEC celebrates 60 years of dedicated service and achievement, and assures the nation that
we are still glowing strong...

from the Electric family.

1946 60th 2006
ANNIVERSARY

Trinidad and Tobago Electricity Commission • 63 Frederick Street, Port of Spain • Tel.: 623-2611/7/6291/6274 • Website: www.ttec.co.tt

Creative Firm: **ALL MEDIA PROJECTS LIMITED — PORT OF SPAIN, TRINIDAD AND TOBAGO**
Creative Team: **ANTHONY MOORE, CHRISTOPHER WILCOX, CARL HARDING**
Client: **TRINIDAD AND TOBAGO ELECTRICITY COMMISSION (T&TEC)**

Creative Firm: **GRIFFO — BELÉM, PARÁ, BRAZIL**
Creative Team: **EDGAR CARDOSO, SERGIO BASTOS, ANTÔNIO NATSUO**
Client: **ORM**

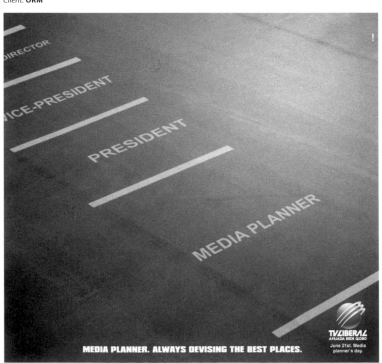

DIRECTOR
VICE-PRESIDENT
PRESIDENT
MEDIA PLANNER

TV LIBERAL
AFILIADA REDE GLOBO
June 21st. Media
planner's day.

MEDIA PLANNER. ALWAYS DEVISING THE BEST PLACES.

Creative Firm: **DC3/UNICOM — BELÉM, PARÁ, BRAZIL**
Creative Team: **DANIEL JACOB, RENATA SEGTOWICK, ALEXANDRE HELMUT,**
GLAUCO LIMA, HAROLDO VALENTE,
Client: **JOVEM PAN FM**

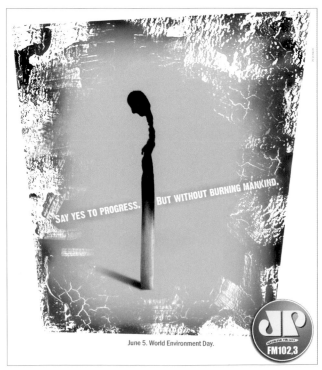

SAY YES TO PROGRESS, BUT WITHOUT BURNING MANKIND.

June 5. World Environment Day.

JP FM102,3

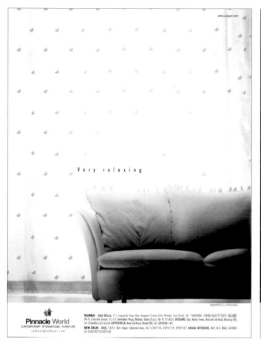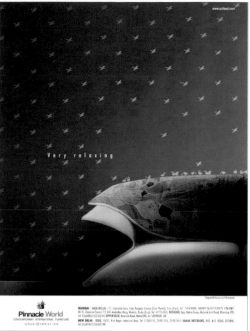

Creative Firm: **PURPLE FOCUS PVT. LTD. — INDORE, MADHYA PRADESH, INDIA**
Creative Team: **SATYAJIT RAI, JITENDRA RAMPURIA, VINOD BHARGAV, PURPLE PRODUCTIONS**
Client: **PINNACLE INDUSTRIES**

Creative Firm: **GRIFFO — BELÉM, PARÁ, BRAZIL**
Creative Team: **EDGAR CARDOSO, SERGIO BASTOS, ANTÔNIO NATSUO**
Client: **ORM**

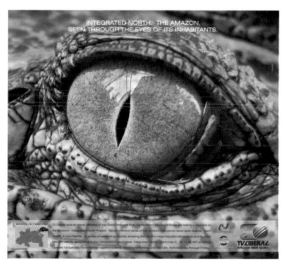

Creative Firm: **YELLOW SHOES CREATIVE WEST, DISNEYLAND RESORT — ANAHEIM, CA**
Creative Team: **SCOTT STARKEY, WES CLARK, JACQUELYN MOE, JIM ST. AMANT**
Client: **DISNEYLAND RESORT**

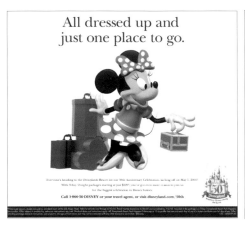

All dressed up and just one place to go.

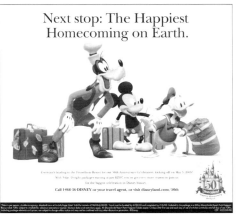

Next stop: The Happiest Homecoming on Earth.

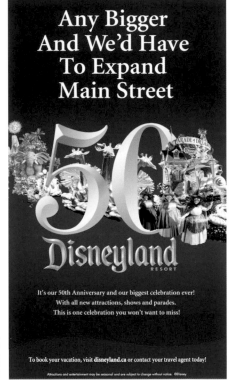

Any Bigger And We'd Have To Expand Main Street

50

Disneyland RESORT

It's our 50th Anniversary and our biggest celebration ever! With all new attractions, shows and parades. This is one celebration you won't want to miss!

To book your vacation, visit disneyland.ca or contact your travel agent today!

Attractions and entertainment may be seasonal and are subject to change without notice. ©Disney

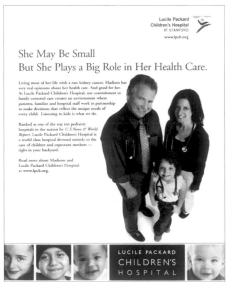

She May Be Small But She Plays a Big Role in Her Health Care.

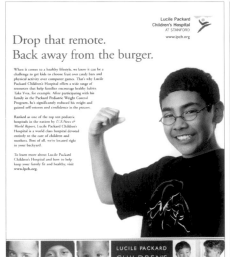

Drop that remote. Back away from the burger.

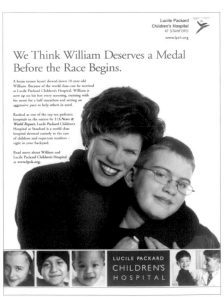

We Think William Deserves a Medal Before the Race Begins.

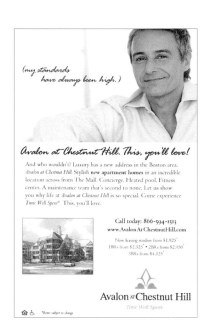
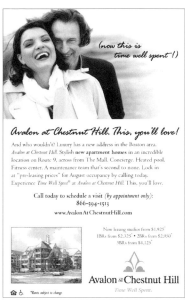
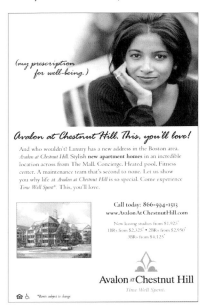

Creative Firm: **PRIMARY DESIGN, INC. — HAVERHILL, MA**
Creative Team: **KRISTEN LOSSMAN, SHARYN ROGERS, JULES EPSTEIN**
Client: **AVALON AT CHESTNUT HILL, AVALON BAY COMMUNITIES**

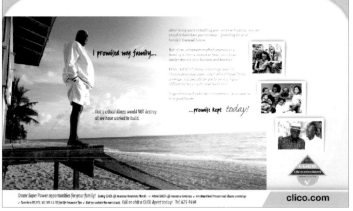

Creative Firm: **ALL MEDIA PROJECTS LIMITED — PORT OF SPAIN, TRINIDAD AND TOBAGO**
Creative Team: **CLINT WILLIAMS, MARISA CAMEJO, SHELLEY HOSEIN, ANTHONY MOORE, DAMIAN BENGOCHEA, DEBBIE GARRAWAY**
Client: **CLICO**

Creative Firm: **YELLOW SHOES CREATIVE WEST, DISNEYLAND RESORT — ANAHEIM, CA**
Creative Team: **SCOTT STARKEY, MARTY MULLER, JACQUELYN MOE, WES CLARK, JIM ST. AMANT**
Client: **DISNEYLAND RESORT**

Creative Firm: **YELLOW SHOES CREATIVE WEST, DISNEYLAND RESORT — ANAHEIM, CA**
Creative Team: **SCOTT STARKEY, WES CLARK, MARTY MULLER, JACQUELYN MOE, JIM ST. AMANT**
Client: **DISNEYLAND RESORT**

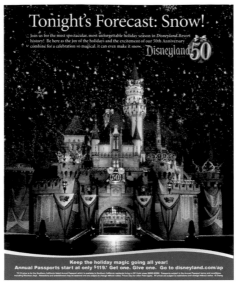

Creative Firm: **YELLOW SHOES CREATIVE WEST, DISNEYLAND RESORT — ANAHEIM, CA**
Creative Team: **SCOTT STARKEY, WES CLARK, JANE ROHAN, MARTY MULLER, JACQUELYN MOE, JIM ST. AMANT**
Client: **DISNEYLAND RESORT**

Creative Firm: **GRIFFO — BELÉM, PARÁ, BRAZIL**
Creative Team: **EDGAR CARDOSO, SERGIO BASTOS, ANTÔNIO NATSUO**
Client: **ORM**

Creative Firm: **THE UNGAR GROUP — CHICAGO, IL**
Creative Team: **TOM UNGAR, JIM FURRH**
Client: **ROGERS AUTO GROUP**

Creative Firm: **LEO BURNETT/YELLOW SHOES CREATIVE WEST, DISNEYLAND RESORT — ANAHEIM, CA**
Creative Team: **SCOTT STARKEY, MARTY MULLER, WES CLARK, JACQUELYN MOE, JIM ST. AMANT, MIKE PUCHALSKI**
Client: **DISNEYLAND RESORT**

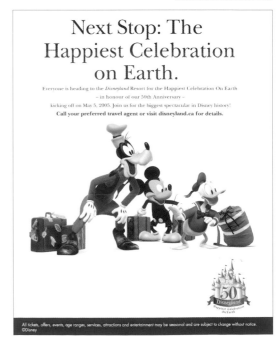

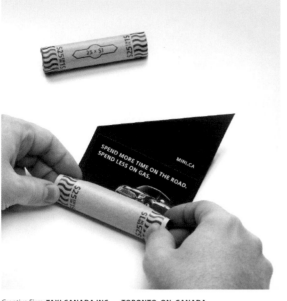

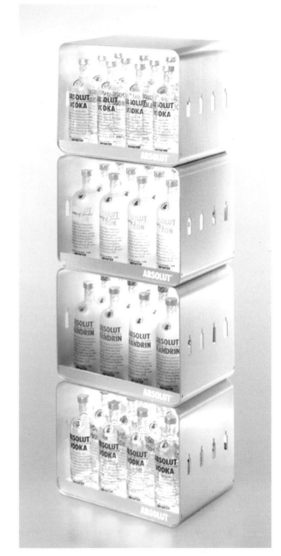

Creative Firm: **TAXI CANADA INC. — TORONTO, ON, CANADA**
Creative Team: **ZAK MROUEH, TROY MCGUINESS, JORDAN DOUCETTE, LYNNETTE FERNANDES, BARRY TEPLICKY, DARYN SUTHERLAND**
Client: **MINI CANADA**

Creative Firm: **G2 — NEW YORK, NY**
Creative Team: **JEFFREY BRANT, MICHAEL KESHNER**
Client: **PLYMOUTH**

Creative Firm: **G2 — NEW YORK, NY**
Creative Team: **HARRY CHONG, MICHAEL KESHNER**
Client: **ABSOLUT SPIRITS CO.**

Creative Firm: **HBO OFF-AIR CREATIVE SERVICES — NEW YORK, NY**
Creative Team: **JOSE MENDEZ, IVY CALAHORRANO, LARRY BURNETT, VENUS DENNISON**
Client: **HBO MEDIA RELATIONS**

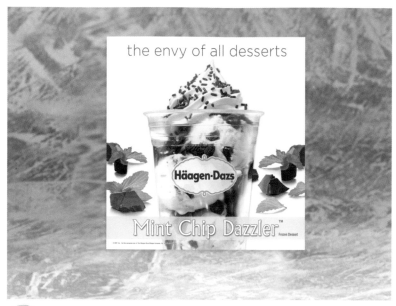

the envy of all desserts

Häagen·Dazs

Mint Chip Dazzler™ *Frozen Dessert*

Creative Firm: **GAMMON RAGONESI ASSOCIATES — NEW YORK, NY**
Creative Team: **MARY RAGONESI, JUNG SUE LEE**
Client: **NESTLE**

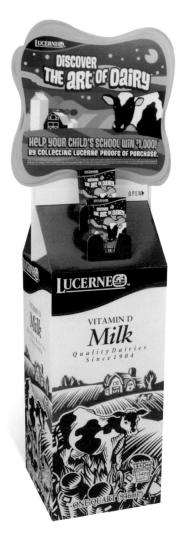

LUCERNE®

DISCOVER THE ART OF DAIRY

HELP YOUR CHILD'S SCHOOL WIN $1,000!
BY COLLECTING LUCERNE PROOFS OF PURCHASE.

LUCERNE®

VITAMIN D
Milk
*Quality Dairies
Since 1904*

ONE QUART (946ml)

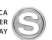
Creative Firm: **ALCONE MARKETING — IRVINE, CA**
Creative Team: **LUIS CAMANO, SHIVONNE MILLER**
Client: **SAFEWAY**

Creative Firm: **G2 — NEW YORK, NY**
Creative Team: **HARRY CHONG, MICHAEL KESHNER**
Client: **ABSOLUT SPIRITS CO.**

ABSOLUT®

Creative Firm: **TOM FOWLER, INC. — NORWALK, CT**
Creative Team: **MARY ELLEN BUTKUS, BRIEN O'REILLY**
Client: **HONEYWELL CONSUMER PRODUCTS**

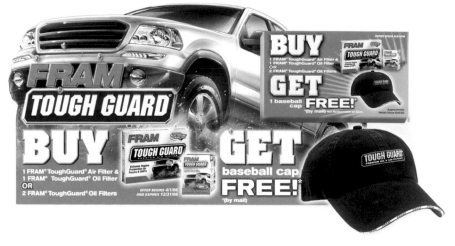

FRAM TOUGH GUARD

BUY
1 FRAM® ToughGuard® Air Filter &
1 FRAM® ToughGuard® Oil Filter
OR
2 FRAM® ToughGuard® Oil Filters

GET baseball cap FREE!*
*(by mail)

OFFER BEGINS 4/1/06
AND EXPIRES 12/31/06

BUY
1 FRAM® ToughGuard® Air Filter &
1 FRAM® ToughGuard® Oil Filter
OR
2 FRAM® ToughGuard® Oil Filters

GET 1 baseball cap FREE!*
*(by mail)

TOUGH GUARD

Creative Firm: AGENCY X ADS — SAN FRANCISCO, CA
Creative Team: LOTUS CHILD, JENNIFER ELIAS
Client: SMARTSCO

Creative Firm: LAUNCH CREATIVE MARKETING — CHICAGO, IL
Creative Team: MICHELLE MORALES
Client: KELLOGGS

Creative Firm: G2 — NEW YORK, NY
Creative Team: HARRY CHONG, MICHAEL KESHNER
Client: LEVEL

Creative Firm: GAMMON RAGONESI ASSOCIATES — NEW YORK, NY
Creative Team: MARY RAGONESI, SANDRA PEREZ
Client: NESTLE

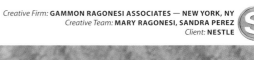

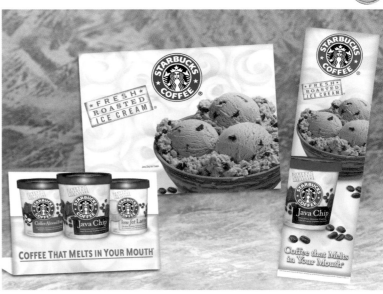

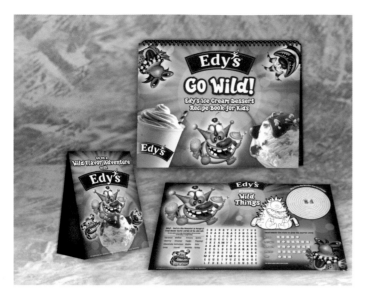

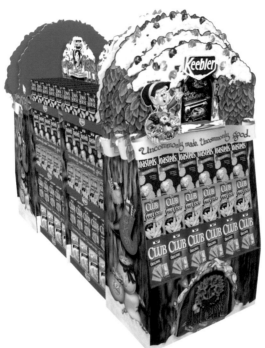

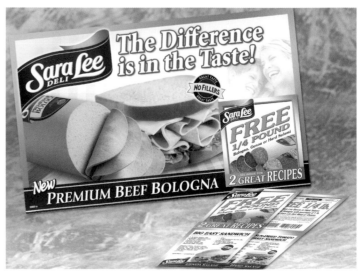

Creative Firm: **GAMMON RAGONESI ASSOCIATES — NEW YORK, NY**
Creative Team: **MARY RAGONESI, KELLY CRISWELL**
Client: **NESTLE**

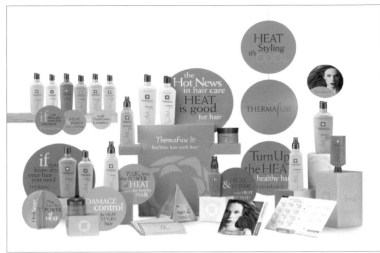

Creative Firm: **JONI RAE AND ASSOCIATES — ENCINO, CA**
Creative Team: **JONI RAE RUSSELL, BEVERLY TRENGOVE**
Client: **THERMAFUSE**

Creative Firm: **LAUNCH CREATIVE MARKETING — CHICAGO, IL**
Creative Team: **MICHELLE MORALES**
Client: **KELLOGGS**

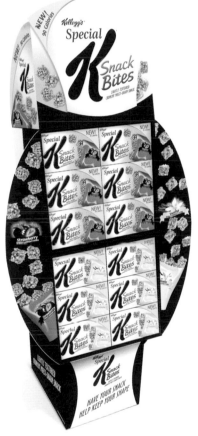

Creative Firm: **LAUNCH CREATIVE MARKETING — CHICAGO, IL**
Creative Team: **MICHELLE MORALES**
Client: **KELLOGGS**

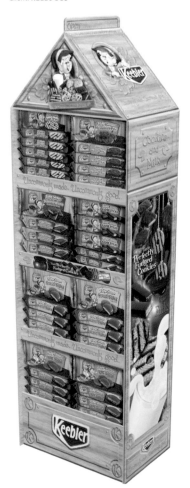

Creative Firm: **NICOSIA CREATIVE EXPRESSO, LTD. — NEW YORK, NY**
Creative Team: **PATRICIA DOCAMPO, AILEEN RIORDAN**
Client: **PROCTER & GAMBLE**

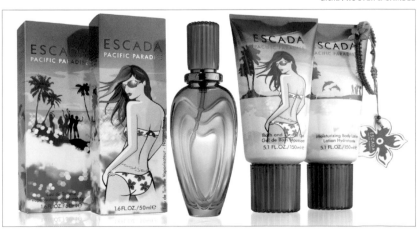

Creative Firm: **DESIGN RESOURCE CENTER — NAPERVILLE, IL**
Creative Team: **JOHN NORMAN, MELANIEGIBB**
Client: **SENARIO, LLC**

Creative Firm: **DESIGN RESOURCE CENTER — NAPERVILLE, IL**
Creative Team: **JOHN NORMAN, MELANIE GIBB**
Client: **SENARIO, LLC**

Creative Firm: **ADDISON WHITNEY — CHARLOTTE, NC**
Creative Team: **TREY WALSH, KIMBERLEE DAVIS, KRISTIN HAGER**
Client: **VERBATIM**

Creative Firm: **ACOSTA DESIGN INC — NEW YORK, NY**
Creative Team: **MAURICIO ACOSTA**
Client: **BIG ELECTRONIC GAMES LTD.**

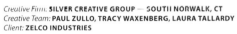

Creative Firm: **SILVER CREATIVE GROUP** — **SOUTH NORWALK, CT**
Creative Team: **PAUL ZULLO, TRACY WAXENBERG, LAURA TALLARDY**
Client: **ZELCO INDUSTRIES**

Creative Firm: **DESIGN RESOURCE CENTER** — **NAPERVILLE, IL**
Creative Team: **JOHN NORMAN, MELANIE GIBB**
Client: **SENARIO, LLC**

Creative Firm: **DESIGN RESOURCE CENTER** — **NAPERVILLE, IL**
Creative Team: **JOHN NORMAN, MELANIE GIBB**
Client: **SENARIO, LLC**

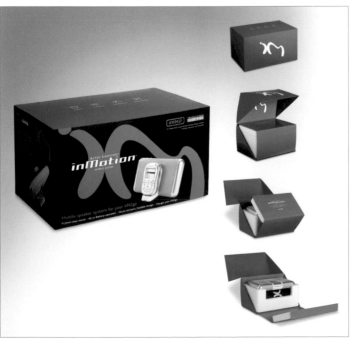

Creative Firm: **MNA CREATIVE** — **DANBURY, CT**
Creative Team: **HELEN MURPHY, KEN MACEY**
Client: **ALTEC LANSING**

FOOD PACKAGING

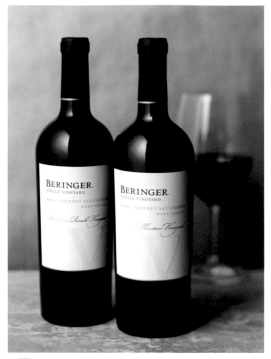

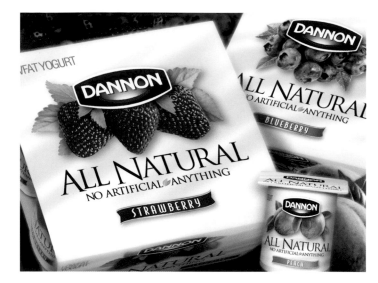

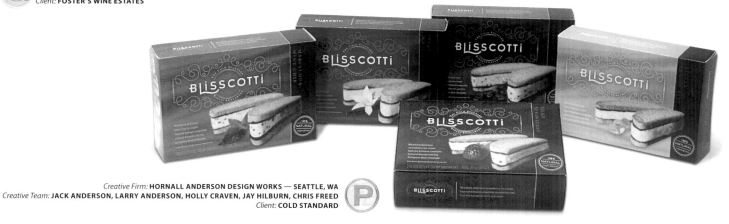

Creative Firm: **WALLACE CHURCH, INC.** — **NEW YORK, NY**
Creative Team: **STAN CHURCH, LAWRENCE HAGGERTY**
Client: **PEPPERIDGE FARM**

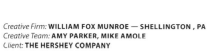
Creative Firm: **SCOTT VISION COMMUNICATION** — **TAIPEI, TAIWAN**

Creative Firm: **OPTIMA GROUP** — **HIGHLAND PARK, IL**
Creative Team: **CAROL GRABOWSKI-DAVIS**
Client: **LAKE CHAMPLAIN CHOCOLATES**

Creative Firm: **WILLIAM FOX MUNROE** — **SHELLINGTON , PA**
Creative Team: **AMY PARKER, MIKE AMOLE**
Client: **THE HERSHEY COMPANY**

Creative Firm: **CASSATA & ASSOCIATES** — **SCHAUMBURG, IL**
Creative Team: **JAMES MISKEVICS, JIM WOLFE**
Client: **THE WM. WRIGLEY COMPANY**

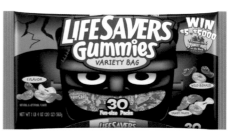

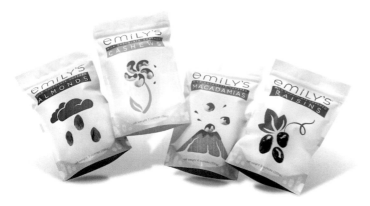

Creative Firm: **HORNALL ANDERSON DESIGN WORKS — SEATTLE, WA**
Creative Team: **JACK ANDERSON, KATHY SAITO, SONJA MAX, HENRY YIU, YURI SHVET**
Client: **AMES INTERNATIONAL**

Creative Firm: **BRAND ENGINE — SAUSALITO, CA**
Creative Team: **ANDREW OTTO, MEGHAN ZODROW, KONRAD TSE**
Client: **PLUM ORGANICS**

Creative Firm: **LIBBY PERSZYK KATHMAN — CINCINNATI, OH**
Creative Team: **BEN SAUER, DAVE BARRETTE, BRENDA MAHAN**
Client: **HERSHEY FOODS CORPORATION**

Creative Firm: **FAINE-OLLER PRODUCTIONS — SEATTLE, WA**
Creative Team: **CATHERINE OLLER, BRUCE HALE, CHRISTOPHER CONRAD, PATTY WITTMAN**
Client: **COLESON FOODS, INC.**

Creative Firm: **VOICEBOX CREATIVE — SAN FRANCISCO, CA**
Creative Team: **SEAN ZIEGLER, VOICEBOX TEAM**
Client: **FOSTER'S WINE ESTATES**

Creative Firm: **GAMMON RAGONESI ASSOCIATES — NEW YORK, NY**
Creative Team: **MARY RAGONESI, JILL SHELLHORN**
Client: **NESTLE**

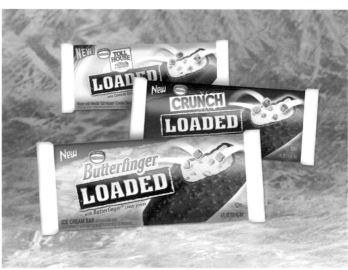

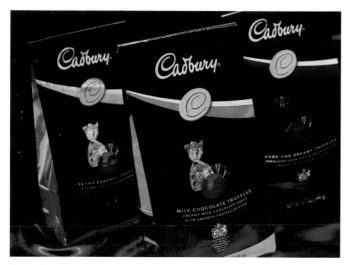

Creative Firm: **LIBBY PERSZYK KATHMAN — CINCINNATI, OH**
Creative Team: **BEN SAUER, DAVE BARRETTE, DEREK RILLO, KELLY SMITH**
Client: **HERSHEY COMPANY**

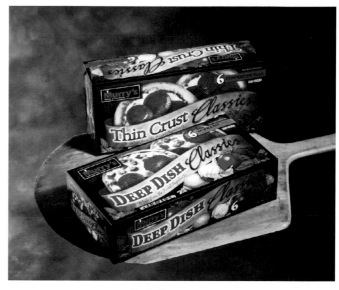

Creative Firm: **WILLIAM FOX MUNROE — SHLLINGTON , PA**
Creative Team: **SCOTT HOUTZ, STEPHANIE BENNETT**
Client: **MURRY'S. INC**

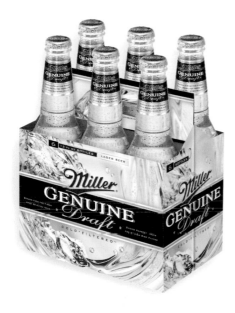

Creative Firm: **OPTIMA GROUP — HIGHLAND PARK, IL**
Creative Team: **SARA BELSKIS, JIM PIETRUSZYNSKI, ADAM FERGUSON**
Client: **MILLER BREWING CO.**

Creative Firm: **FLOWDESIGN INC. — NORTHVILLE, MI**
Creative Team: **DAN MATAUCH, DENNIS NALEZYTY, KRYSTINA VOSS**
Client: **DIVINE VODKA**

Creative Firm: **ZUNDA GROUP LLC — SOUTH NORWALK, CT**
Creative Team: **CHARLES ZUNDA, DANIEL PRICE, GARY ESPOSITO, MICHAEL LELEUX, AMY DRESNER-YULES**
Client: **THE DANNON COMPANY, INC.**

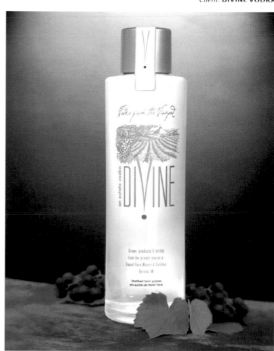

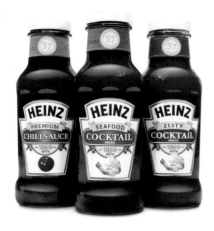

Creative Firm: **WALLACE CHURCH, INC. — NEW YORK, NY**
Creative Team: **STAN CHURCH, HEATHER ALLEN**
Client: **HJ HEINZ COMPANY**

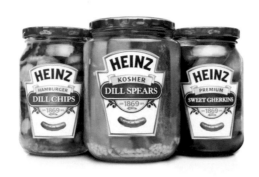

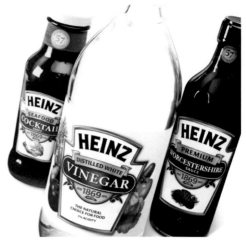

Creative Firm: **SCOTT VISION COMMUNICATION — TAIPEI, TAIWAN**

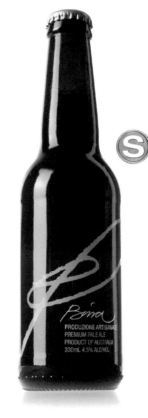

Creative Firm: **ASPREY CREATIVE — FITZROY, VICTORIA, AUSTRALIA**
Creative Team: **GEORGE MARGARITIS, PETER ASPREY**
Client: **PIZZA E BIRRA**

Creative Firm: **VOICEBOX CREATIVE — SAN FRANCISCO, CA**
Creative Team: **JACQUES ROSSOUW**
Client: **MARIN FRENCH CHEESE COMPANY**

Creative Firm: **CBX — NEW YORK, NY**
Client: **GENERAL MILLS**

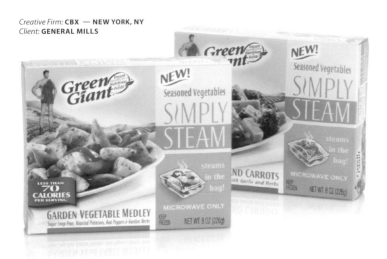

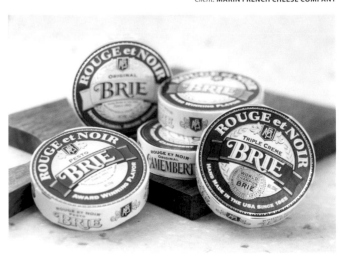

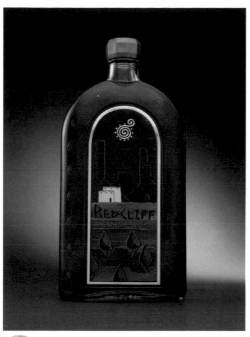

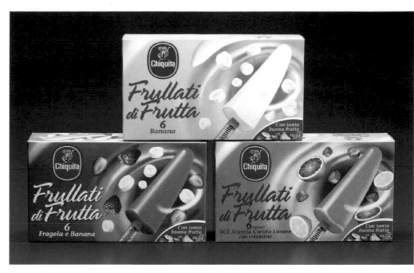

Creative Firm: **TANGRAM STRATEGIC DESIGN — NOVARA, ITALY**
Creative Team: **ENRICO SEMPI, ANTONELLA TREVISAN, ANDREA SEMPI,
KENJI SUMURA**
Client: **CHIQUITA ITALIA**

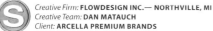
Creative Firm: **FLOWDESIGN INC.— NORTHVILLE, MI**
Creative Team: **DAN MATAUCH**
Client: **ARCELLA PREMIUM BRANDS**

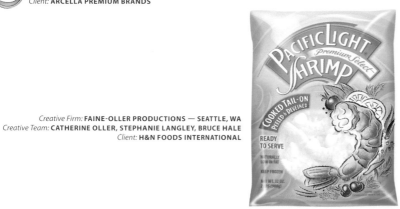

Creative Firm: **FAINE-OLLER PRODUCTIONS — SEATTLE, WA**
Creative Team: **CATHERINE OLLER, STEPHANIE LANGLEY, BRUCE HALE**
Client: **H&N FOODS INTERNATIONAL**

Creative Firm: **HORNALL ANDERSON DESIGN WORKS — SEATTLE, WA**
Creative Team: **JACK ANDERSON, LARRY ANDERSON, JAY HILBURN, BRUCE STIGLER,
ELMER DELA CRUZ, DAYMON BRUCK, HAYDEN SCHOEN**
Client: **WIDMER BROTHERS BREWERY**

Creative Firm: **MAGNETO BRAND ADVERTISING — PORTLAND, OR**
Creative Team: **R. CRAIG OPFER, JEFF PAUL, JAY FAWCETT, MIKE TERRY**
Client: **ARGYLE WINERY**

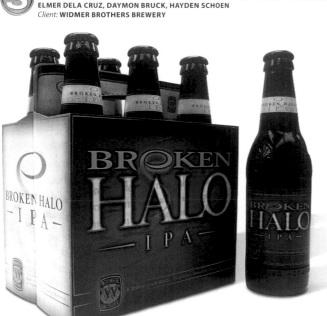

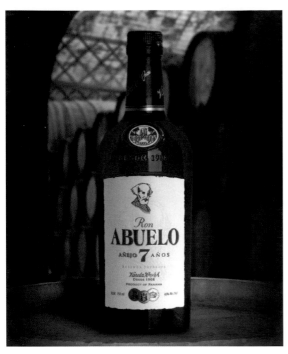

Creative Firm: **FLOWDESIGN INC.** — NORTHVILLE, MI
Creative Team: **DAN MATAUCH**
Client: **VARELA HERMANOS, S.A.**

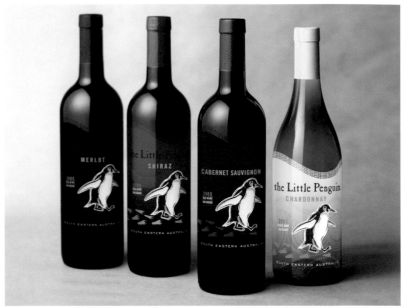

Creative Firm: **VOICEBOX CREATIVE** — SAN FRANCISCO, CA
Creative Team: **JACQUES ROSSOUW, MELISSA MAUREZE**
Client: **FOSTER'S WINE ESTATES**

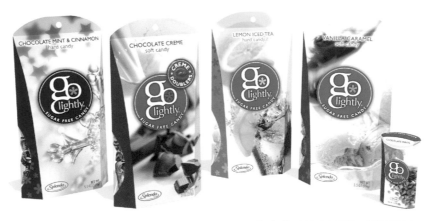

Creative Firm: **SCOTT VISION COMMUNICATION** — TAIPEI, TAIWAN

Creative Firm: **BRAND ENGINE** — SAUSALITO, CA
Creative Team: **ERIC READ, MEGHAN ZODROW, ROBERT BURNS, AILEEN KENDLE-SMITH**
Client: **PACKAGE DESIGN MAGAZINE: DESIGN CHALLENGE 2005**

Creative Firm: **WILLIAM FOX MUNROE** — SHELLINGTON , PA
Creative Team: **AMY PARKER, MIKE AMOLF**
Client: **THE HERSHEY COMPANY**

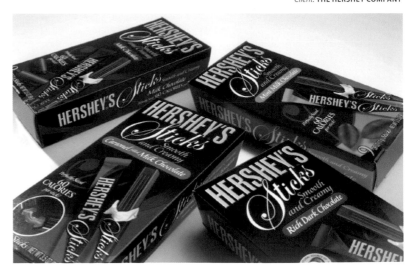

Creative Firm: **FUTURA DDB** — LJUBLANA, SLOVENIA
Creative Team: **ZARE KERIN, MARKO VICIC, MARKO PISKUR**
Client: **DANA**

Creative Firm: **HORNALL ANDERSON DESIGN WORKS** — SEATTLE, WA
Creative Team: **LISA CERVENY, SONJA MAX, BELINDA BOWLING,
ENSI MOFASSER, KATHY SAITO, BETH GRIMM, JULIE JACOBSON**
Client: **TAHITIAN NONI**

Creative Firm: **GAMMON RAGONESI ASSOCIATES** — NEW YORK, NY
Creative Team: **MARY RAGONESI, MICHAEL CAMPASANO**
Client: **NESTLE**

Creative Firm: **LEWIS MOBERLY** — LONDON, UNITED KINGDOM
Creative Team: **MARY LEWIS, JOANNE SMITH, PAUL CILIA LA CORTE**
Client: **ADRIATIC DISTILLERS**

Creative Firm: **FLOWDESIGN INC.** — NORTHVILLE, MI
Creative Team: **DAN MATAUCH, DENNIS NALEZYTY, KRYSTINA VOSS**
Client: **THANASI FOODS**

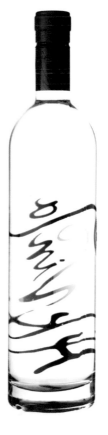

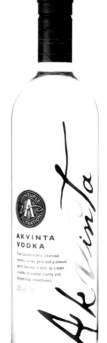

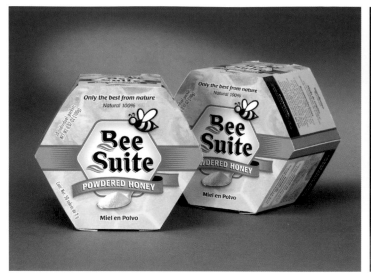

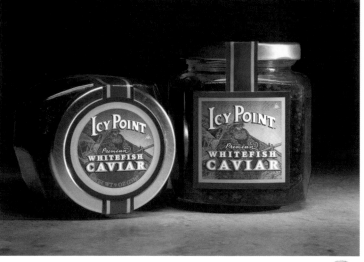

Creative Firm: **TD2, S.C. — MEXICO CITY, D.F., MEXICO**
Creative Team: **R. RODRIGO CORDOVA, JOSE LUIS (PAT) PATIÑO, LAURA CORDOBA**
Client: **NATURITZ**

Creative Firm: **MARK OLIVER, INC. — SOLVANG, CA**
Creative Team: **MARK OLIVER, PATTY DEVLIN-DRISKEL**
Client: **OCEAN BEAUTY SEAFOODS**

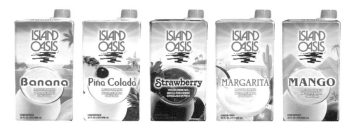

Creative Firm: **ISLAND OASIS — WALPOLE, MA**
Creative Team: **PETE BUHLER**
Client: **ISLAND OASIS**

Creative Firm: **STERLING CROSS CREATIVE — SONOMA, CA**
Creative Team: **PEGGY CROSS, JULIE BUTTS**
Client: **DIAGEO CHATEAU & ESTATE WINES**

Creative Firm: **KELLER CRESCENT — EVANSVILLE, IN**
Creative Team: **GERRY ULRICH, LYNNE MLADY, RANDALL ROHN**
Client: **HEAVEN HILL**

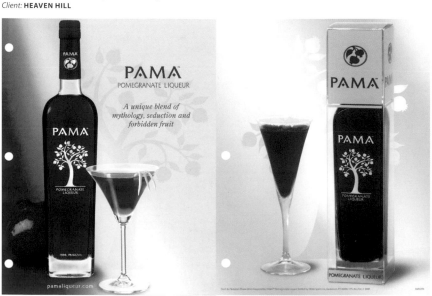

Creative Firm: **ZUNDA GROUP LLC — SOUTH NORWALK, CT**
Creative Team: **CHARLES ZUNDA, DANIEL PRICE, GARY ESPOSITO, DONALD WINTMAN, JEAN LEGROS**
Client: **GREAT BRANDS OF EUROPE, INC.**

Creative Firm: **DESIGN NORTH, INC. — RACINE, WI**
Creative Team: **GWEN GRANZOW, FRANK ULLENBERG, KAYTEE MOSHER**
Client: **BIRDS EYE FOOD**

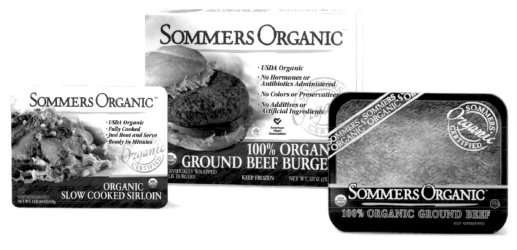

Creative Firm: **BAER DESIGN GROUP — EVANSTON, IL**
Creative Team: **DAVE SEIDLER, TODD BAER**
Client: **SOMMERS ORGANIC**

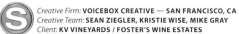
Creative Firm: **VOICEBOX CREATIVE — SAN FRANCISCO, CA**
Creative Team: **SEAN ZIEGLER, KRISTIE WISE, MIKE GRAY**
Client: **KV VINEYARDS / FOSTER'S WINE ESTATES**

Creative Firm: **FLOWDESIGN INC. — NORTHVILLE, MI**
Creative Team: **DAN MATAUCH, DENNIS NALEZYTY**
Client: **PIEDMONT DISTILLERS, INC.**

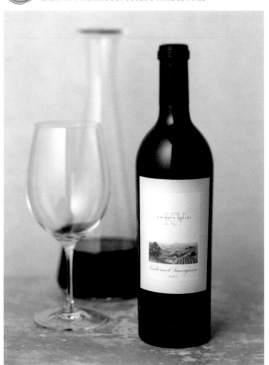

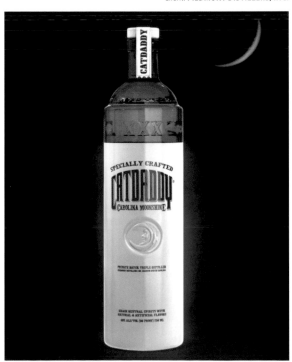

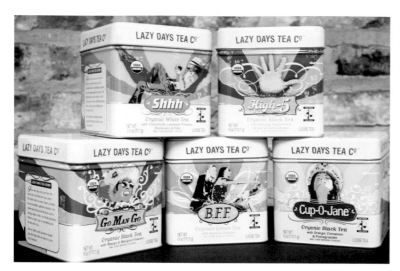

Creative Firm: **BAER DESIGN GROUP — EVANSTON, IL**
Creative Team: **DAVE SEIDLER, TODD BAER, MELISSA LANE**
Client: **LAZY DAYS TEA CO.**

Creative Firm: **LIBBY PERSZYK KATHMAN — CINCINNATI, OH**
Creative Team: **MATT BAUGHAN, KATE THOMAN**
Client: **PROCTER & GAMBLE**

Creative Firm: **DESIGN RESOURCE CENTER — NAPERVILLE, IL**
Creative Team: **JOHN NORMAN, MELANIE GIBB**
Client: **CHARMS MARKETING, COMPANY**

Creative Firm: **HORNALL ANDERSON DESIGN WORKS — SEATTLE, WA**
Creative Team: **JACK ANDERSON, LARRY ANDERSON, JAY HILBURN, HENRY YIU, BRUCE STIGLER, ELMER DELA CRUZ, BRUCE BRANSON-MEYER**
Client: **WIDMER BROTHERS BREWERY**

Creative Firm: **PRAXIS DISEÑADORES S.C. — MEXICO CITY, D.F., MEXICO**
Creative Team: **NADYA VILLEGAS, JUAN CARLOS ROJAS**
Client: **QUALTIA ALIMENTOS**

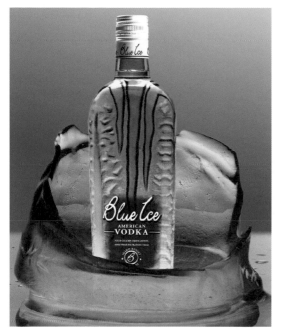

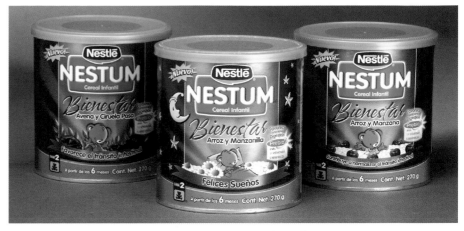

Creative Firm: **TD2, S.C. — MEXICO CITY, D.F., MEXICO**
Creative Team: **R. RODRIGO CORDOVA, MARIANA MORA, ADALBERTO ARENAS**
Client: **NESTLE BABY FOOD**

Creative Firm: **FLOWDESIGN INC. — NORTHVILLE, MI**
Creative Team: **DAN MATAUCH**
Client: **21ST CENTURY SPIRITS**

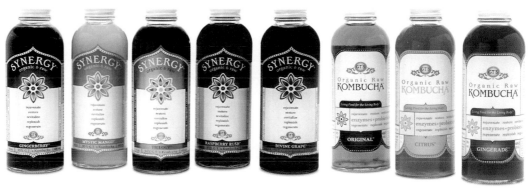

Creative Firm: **HORNALL ANDERSON DESIGN WORKS — SEATTLE, WA**
Creative Team: **LISA CERVENY, MARY HERMES, HILLARY RADBILL, TIFFANY PLACE, ELMER DELA CRUZ, BECKON WYLD, JOHN ANDERLE**
Client: **MILLENNIUM**

 Creative Firm: **MARK OLIVER, INC. — SOLVANG, CA**
Creative Team: **MARK OLIVER, PATTY DEVLIN-DRISKEL**
Client: **OCEAN BEAUTY SEAFOODS**

Creative Firm: **LIBBY PERSZYK KATHMAN — CINCINNATI, OH**
Creative Team: **VICTOR JANTZEN, GARY CIERADKOWSK**
Client: **BIG RED COLA**

Creative Firm: **VOICEBOX CREATIVE — SAN FRANCISCO, CA**
Creative Team: **JACQUES ROSSOUW, KRISTIE WISE**
Client: **RODNEY STRONG VINEYARDS**

Creative Firm: **LIBBY PERSZYK KATHMAN — CINCINNATI, OH**
Creative Team: **ANDREW TESNAR, GARY CIERADKOWSKI**
Client: **PROCTER & GAMBLE**

Creative Firm: **PURE DESIGN CO. LLC — LEVERETT, MA**
Creative Team: **DAN MISHKIND, JOHN ROULAC**
Client: **NUTIVA**

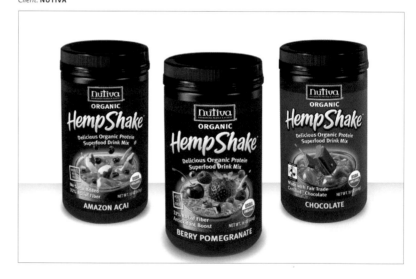

Creative Firm: **SCOTT VISION COMMUNICATION — TAIPEI, TAIWAN**

Creative Firm: **GAMMON RAGONESI ASSOCIATES — NEW YORK, NY**
Creative Team: **MARY RAGONESI, JILL SHELLHORN**
Client: **NESTLE**

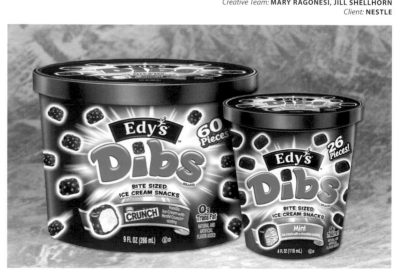

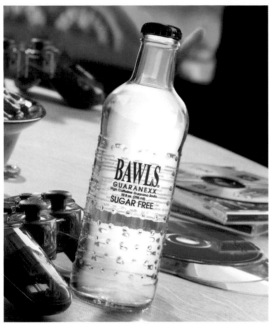

Creative Firm: **CBX** — NEW YORK, NY

Creative Firm: **FLOWDESIGN INC.** — NORTHVILLE, MI
Creative Team: **DAN MATAUCH**
Client: **HOBARAMA CORP.**

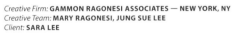
Creative Firm: **CBX** — NEW YORK, NY
Client: **SENECA FOODS**

Creative Firm: **FLOWDESIGN INC.** — NORTHVILLE, MI
Creative Team: **DAN MATAUCH, DENNIS NALEZYTY**
Client: **HAWAII SEA SPIRITS, LLC**

Creative Firm: **GAMMON RAGONESI ASSOCIATES** — NEW YORK, NY
Creative Team: **MARY RAGONESI, JUNG SUE LEE**
Client: **SARA LEE**

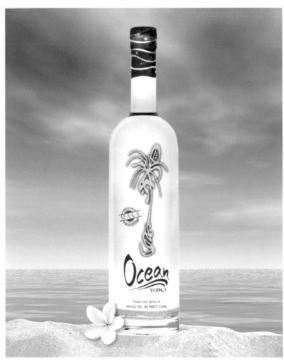

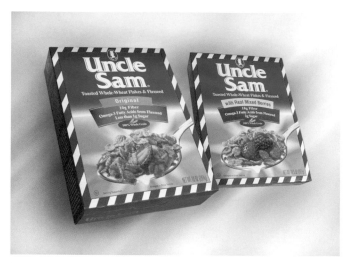

Creative Firm: **SHIMOKOCHI-REEVES — LOS ANGELES, CA**
Creative Team: **MAMORU SHIMOKOCHI, ANNE REEVES**
Client: **U.S. MILLS, INC.**

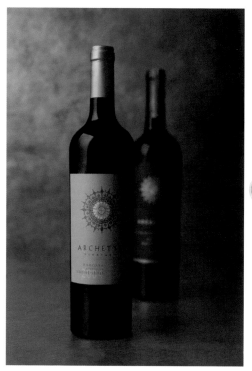

Creative Firm: **SCOTT VISION COMMUNICATION — TAIPEI, TAIWAN**

Creative Firm: **STERLING CROSS CREATIVE — SONOMA, CA**
Creative Team: **PEGGY CROSS, JULIE BUTTS**
Client: **DIAGEO CHATEAU & ESTATE WINES**

Creative Firm: **SCOTT VISION COMMUNICATION — TAIPEI, TAIWAN**
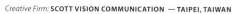

Creative Firm: **FUTURA DDB — LJUBLANA, SLOVENIA**
Creative Team: **ZARE KERIN, MARKO VICIC, MARKO PISKUR**
Client: **DANA**

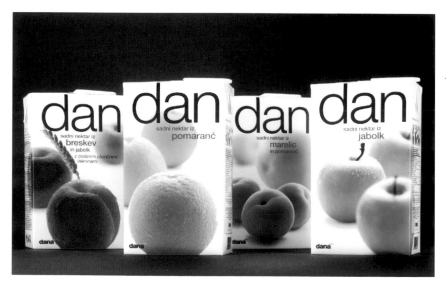

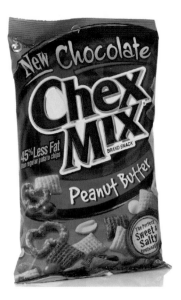

Creative Firm: **CBX — NEW YORK, NY**
Client: **GENERAL MILLS**

Creative Firm: **ASPREY CREATIVE — FITZROY, VICTORIA, AUSTRALIA**
Creative Team: **GEORGE MARGARITIS, PETER ASPREY**
Client: **NATIONAL FOODS**

Creative Firm: **WILLIAM FOX MUNROE — SHELLINGTON, PA**
Creative Team: **AMY PARKER, MIKE AMOLE, JINGER BL ANTZ, RICK RHOADES**
Client: **THE HERSHEY COMPANY**

Creative Firm: **MARK OLIVER, INC. — SOLVANG, CA**
Creative Team: **MARK OLIVER, PATTY DRISKEL, DOUGLAS SCHNEIDER, JOHN BURNS**
Client: **TRIBE MEDITERRANEAN**

Creative Firm: **BERRY DESIGN INC — ALPHARETTA, GA**
Creative Team: **BOB BERRY, CHIP WALLER**
Client: **BISTRO FOODS INC**

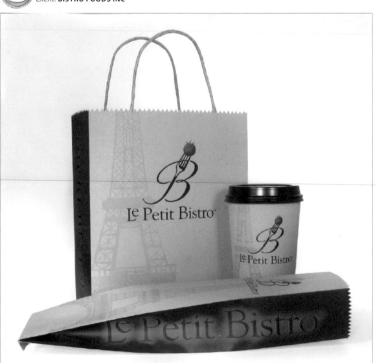

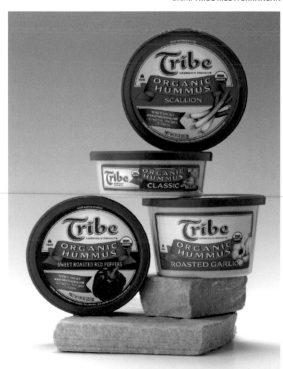

FOOD PACKAGING

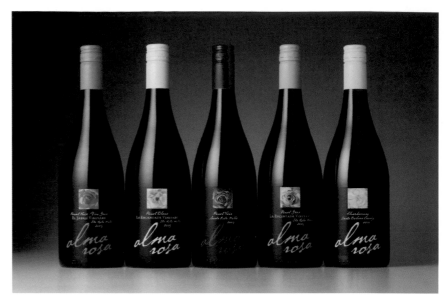

Creative Firm: **MARK OLIVER, INC. — SOLVANG, CA**
Creative Team: **MARK OLIVER, PATTY DRISKEL, LESLIE WU**
Client: **ALMA ROSA WINERY**

Creative Firm: **VOICEBOX CREATIVE — SAN FRANCISCO, CA**
Creative Team: **JACQUES ROSSOUW, KRISTIE WISE**
Client: **SBRAGIA FAMILY VINEYARDS**

Creative Firm: **ASPREY CREATIVE — FITZROY, VICTORIA, AUSTRALIA**
Creative Team: **GEORGE MARGARITIS, PETER ASPREY**
Client: **MASTERFOODS SNACKFOOD**

Creative Firm: **WILLIAM FOX MUNROE — SHELLINGTON , PA**
Creative Team: **AMY PARKER, MIKE AM OLE**
Client: **THE HERSHEY COMPANY**

Creative Firm: **HORNALL ANDERSON DESIGN WORKS — SEATTLE, WA**
Creative Team: **JACK ANDERSON, JAMES TEE, TIFFANY PLACE, LAUREN DIRUSSO, KRIS DELANEY, JOHN ANDERLE**
Client: **BOSTON MARKET**

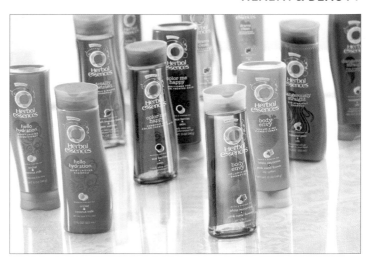

Creative Firm: LIBBY PERSZYK KATHMAN — CINCINNATI, OH
Creative Team: NATHAN HENDRICKS, MICHELLE RAFIE, CATHY BAKER, ERIK PIETILA,
AMY SCHWARTZ, MATT MOSES
Client: PROCTER & GAMBLE

Creative Firm: JONI RAE AND ASSOCIATES — ENCINO, CA
Creative Team: JONI RAE RUSSELL, BEVERLY TRENGOVE
Client: THERMAFUSE

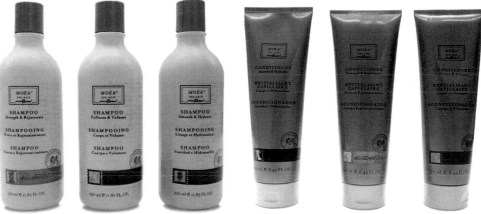

Creative Firm: HORNALL ANDERSON DESIGN WORKS — SEATTLE, WA
Creative Team: LISA CERVENY, SONJA MAX, BELINDA BOWLING, ENSI MOFASSER, KATHY SAITO, BETH GRIMM, JULIE JACOBSON
Client: TAHITIAN NONI

Creative Firm: WALLACE CHURCH, INC. — NEW YORK, NY
Creative Team: STAN CHURCH, JOHN BRUNO
Client: THE GILLETTE COMPANY

Creative Firm: LANDOR ASSOCIATES — CINCINNATI, OH
Creative Team: TESSA WESTERMEYER, VALERIE AURILIO, TRACEY LANZ, EMILY MASON,
KELLY LARBES, ANNE GIBBLE
Client: PROCTER & GAMBLE

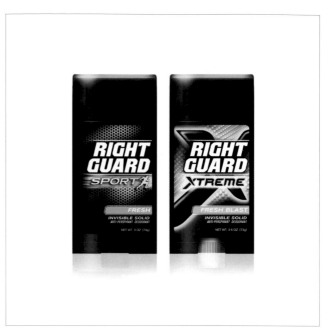

Creative Firm: **LIBBY PERSZYK KATHMAN — CINCINNATI, OH**
Creative Team: **JOHN METZ, JODI SENA, HOLLY SHOEMAKER, EMMA BRACEY,**
STEPHANIE CRAIR, ROBIN HORST
Client: **PROCTER & GAMBLE**

Creative Firm: **WALLACE CHURCH, INC. — NEW YORK, NY**
Creative Team: **STAN CHURCH, JOHN BRUNO**
Client: **THE GILLETTE COMPANY**

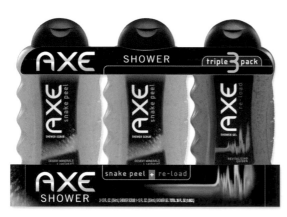

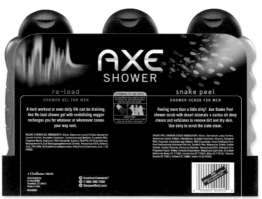

Creative Firm: **TOM FOWLER, INC. — NORWALK, CT**
Creative Team: **ELIZABETH P. BALL**
Client: **UNILEVER**

Creative Firm: **LIBBY PERSZYK KATHMAN — CINCINNATI, OH**
Creative Team: **BETH MALONE**
Client: **PROCTER & GAMBLE**

Creative Firm: **ZUNDA GROUP LLC — SOUTH NORWALK, CT**
Creative Team: **CHARLES ZUNDA, SIRI KORSGREN**
Client: **PRESTIGE BRANDS, INC.**

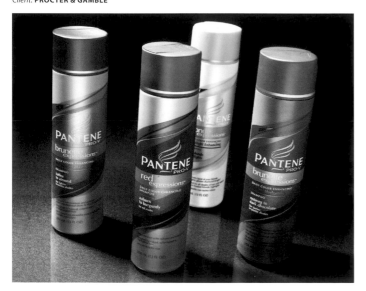

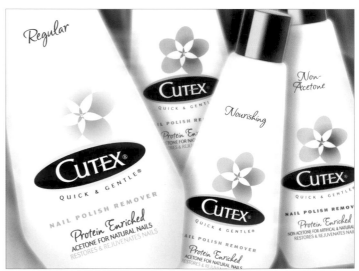

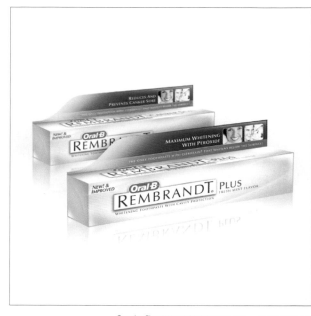

Creative Firm: **TOM FOWLER, INC. — NORWALK, CT**
Creative Team: **ELIZABETH P. BALL**
Client: **UNILEVER**

Creative Firm: **WALLACE CHURCH, INC. — NEW YORK, NY**
Creative Team: **STAN CHURCH, JOHN BRUNO**
Client: **THE GILLETTE COMPANY**

Creative Firm: **HORNALL ANDERSON DESIGN WORKS — SEATTLE, WA**
Creative Team: **LISA CERVENY, SONJA MAX, BELINDA BOWLING, ENSI MOFASSER, KATHY SAITO, BETH GRIMM, JULIE JACOBSON**
Client: **TAHITIAN NONI**

Creative Firm: **LIBBY PERSZYK KATHMAN — CINCINNATI, OH**
Creative Team: **LIZ GRUBOW, SUSAN ZINADER**
Client: **PROCTER & GAMBLE**

Creative Firm: **ZUNDA GROUP LLC — SOUTH NORWALK, CT**
Creative Team: **CHARLES ZUNDA**
Client: **SUPREME BRANDS, INC.**

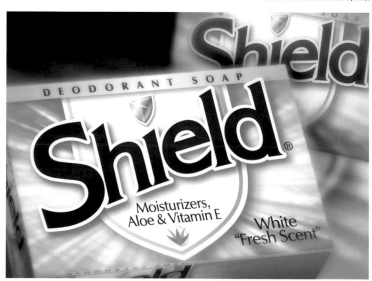

305

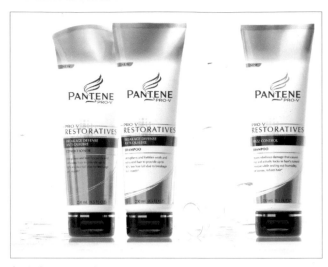

Creative Firm: **LIBBY PERSZYK KATHMAN — CINCINNATI, OH**
Creative Team: **BETH MALONE**
Client: **PROCTER & GAMBLE**

Creative Firm: **PURE DESIGN CO. LLC — LEVERETT, MA**
Creative Team: **DAN MISHKIND, ROBYN TISDALE SCOTT**
Client: **PURELY SHEA**

Creative Firm: **DESIGN RESOURCE CENTER — NAPERVILLE, IL**
Creative Team: **JOHN NORMAN, MELANIE GIBB**
Client: **ULTA CORPORATION**

Creative Firm: **LIBBY PERSZYK KATHMAN — CINCINNATI, OH**
Creative Team: **NANCY ANDREW, ALLY MCEWAN, JOHN MIKULA, DANE HEITHAUS**
Client: **NOVARTIS CONSUMER HEALTH, INC.**

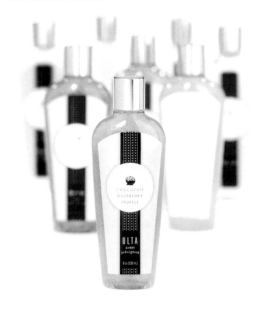

Creative Firm: **PRAXIS DISEÑADORES S.C. — MEXICO CITY, D.F., MEXICO**
Creative Team: **FLORENCIA GUTIERREZ**
Client: **PROCTER AND GAMBLE BRAZIL LTDA.**

Creative Firm: **ALTERNATIVES — NEW YORK, NY**
Creative Team: **CARRI CORBETT, LYNN MARFEY**
Client: **SUDZ BY KISS MY FACE**

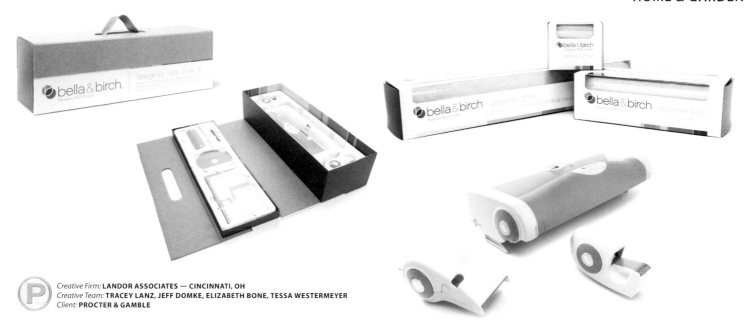

Creative Firm: **LANDOR ASSOCIATES — CINCINNATI, OH**
Creative Team: **TRACEY LANZ, JEFF DOMKE, ELIZABETH BONE, TESSA WESTERMEYER**
Client: **PROCTER & GAMBLE**

Creative Firm: **FUTURA DDB — LJUBLANA, SLOVENIA**
Creative Team: **ZARE KERIN, MARKO OMAHEN, RICCARDO CALIN**
Client: **BELINKA**

Creative Firm: **WILLIAM FOX MUNROE — SHELLINGTON , PA**
Creative Team: **BRIAN HARPER, MATT KENNEDY**
Client: **LOWES**

Creative Firm: **GAMMON RAGONESI ASSOCIATES — NEW YORK, NY**
Creative Team: **MARY RAGONESI, JILL SHELLHORN, JUNG SUE LEE**
Client: **MOEN**

Creative Firm: **KOLANO DESIGN** — PITTSBURGH, PA
Creative Team: **BILL KOLANO, TIM CARRERA**
Client: **SCOTT CALLAHAN** — CALLAHAN & CHASE LLC

Creative Firm: **CBX** — NEW YORK, NY
Client: **THE SCOTTS COMPANY**

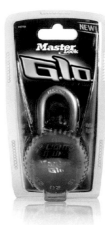

Creative Firm: **CBX** — NEW YORK, NY
Client: **MASTER LOCK COMPANY**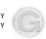

Creative Firm: **FLOWDESIGN INC.** — NORTHVILLE, MI
Creative Team: **DAN MATAUCH, DENNIS NALEZYTY, KRYSTINA VOSS**
Client: **PUNATI CHEMICAL CORP.**

Creative Firm: **DESIGN RESOURCE CENTER** — NAPERVILLE, IL
Creative Team: **JOHN NORMAN, MELANIE GIBB**
Client: **DEFLECTO CORPORATION**

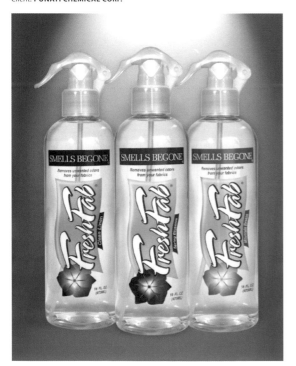

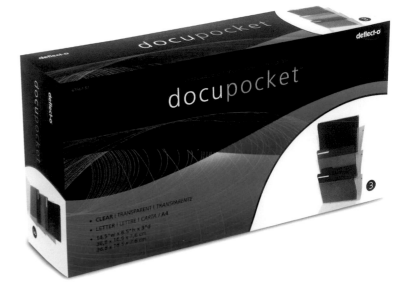

Creative Firm: **ISLAND OASIS — WALPOLE, MA**
Creative Team: **IAIN SHIPPERD**
Client: **ISLAND OASIS**

Creative Firm: **SUNSPOTS CREATIVE — FRANKLIN LAKES, NJ**
Creative Team: **RICK BONELLI, DAVE VIOREANU, DEENA HARTLEY**
Client: **SUPPLIES GUYS**

LABELS & TAGS

XOXO

If you're looking for Happiness in a soap bar, XOXO is for you! Sweet sun-ripened raspberry will hug and kiss your body every time you soak or shower. The scent is so cheerful, it will energize your spirit. Be joyous, gleeful, and full of sugar berries... Get wet with Savage!

ALMONDZILLA

Coming to a shower near you! Almondzilla will roam your body with it's mighty lather battling dirt and evil bacteria. Almondzilla will stop at nothing to get you clean and then once this soap reaches victory over all uncleanliness – only then will it disappear down the drain!... Get wet with Savage!

Creative Firm: **MORNINGSTAR DESIGN, INC. — FREDERICK, MD**
Creative Team: **MISTI MORNINGSTAR, MELISSA NEAL, EMILY POTTHAST**

Creative Firm: **MORNINGSTAR DESIGN, INC. — FREDERICK, MD**
Creative Team: **MISTI MORNINGSTAR, MELISSA NEAL**

REGULATED MATERIALS

Creative Firm: **JACK NADEL INTERNATIONAL — LOS ANGELES, CA**
Creative Team: **SHELLEY SLUBOWSKI, AMYLIN PHARMECEUTICALS ART DIRECTION**
Client: **AMYLIN PHARMACEUTICALS / ELI LILLY**

Creative Firm: **TM&N DESIGN AND BRAND CONSULTANTS LTD. — HONG KONG**
Creative Team: **LEILA NACHTIGALL, JILLIAN LEE, SAMSON SUNG, VENUS CHAN, LIEM CHEUNG**
Client: **PURAPHARM INTERNATIONAL (HONG KONG) LIMITED**

Creative Firm: **ASPREY CREATIVE — FITZROY, VICTORIA, AUSTRALIA**
Creative Team: **RITA PALMIERI TRSAN, PETER ASPREY**
Client: **CARLSON HEALTH**

Creative Firm: **CBX — NEW YORK, NY**
Client: **MCNEIL CONSUMER & SPECIALTY PHARMACEUTICALS**

Creative Firm: **ASPREY CREATIVE — FITZROY, VICTORIA, AUSTRALIA**
Creative Team: **RITA PALMIERI TRSAN, PETER ASPREY**
Client: **CARLSON HEALTH**

Creative Firm: **TRIPLE 888 STUDIOS — PARRAMATTA, NSW, AUSTRALIA**
Creative Team: **TRIPLE 888 CREATIVE TEAM**
Client: **SIRTEX MEDICAL**

Creative Firm: **PATRICK HENRY CREATIVE PROMOTIONS, INC. — STAFFORD, TX**
Creative Team: **PHCP PRESTIGE ART TEAM, SMITH PHOTOGRAPHY**
Client: **INTERSTATE HOTELS AND RESORTS**

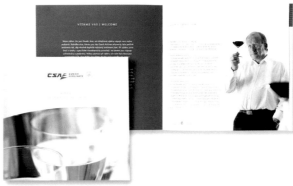

Creative Firm: **KARAKTER — LONDON, UNITED KINGDOM**
Creative Team: **CLIVE ROHALD, MEI WING CHAN, KAM DEVSI, SHAHAR SILBERSHATZ, PIERRE VINSOT**
Client: **CSA CZECH AIRLINES**

Creative Firm: **JOHN KNEAPLER DESIGN — NEW YORK, NY**
Creative Team: **JOHN KNEAPLER, COLLEEN SHEA, BOB SHEA**
Client: **HACKENSACK UNIVERSITY MEDICAL CENTER**

Creative Firm: **PATRICK HENRY CREATIVE PROMOTIONS, INC. — STAFFORD, TX**
Creative Team: **KENNETH WEAVER, CLEVELAND MENU PRINTING**
Client: **COLUMBIA SUSSEX CORPORATION**

Creative Firm: **PATRICK HENRY CREATIVE PROMOTIONS, INC. — STAFFORD, TX**
Creative Team: **DAVID ROCABADO, MICHAEL HASKINS PHOTOGRAPHY**
Client: **BENNIGAN'S GRILL AND TAVERN**

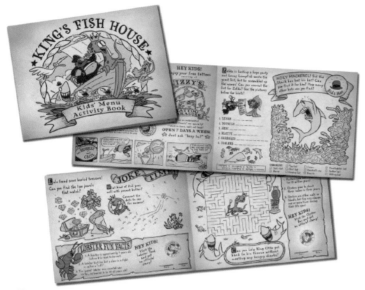

Creative Firm: **30SIXTY ADVERTISING+DESIGN, INC. — LOS ANGELES, CA**
Creative Team: **HENRY VIZCARRA, DAVID FUSCELLARO, LEE BARETT, JOHN LOTER**
Client: **KING'S SEAFOOD COMPANY**

Creative Firm: **PATRICK HENRY CREATIVE PROMOTIONS, INC. — STAFFORD, TX**
Creative Team: **PHCP PRESTIGE ART TEAM**
Client: **HILTON HOTELS CORPORATION**

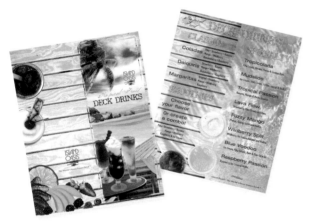

Creative Firm: **ISLAND OASIS — WALPOLE, MA**
Creative Team: **IAIN SHIPPERD**
Client: **ISLAND OASIS**

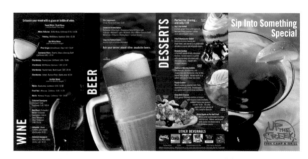

Creative Firm: **ISLAND OASIS — WALPOLE, MA**
Creative Team: **IAIN SHIPPERD**
Client: **ISLAND OASIS**

Creative Firm: **BERRY DESIGN INC — ALPHARETTA, GA**
Creative Team: **BOB BERRY, JULIE ACQUESTA**
Client: **UP THE CREEK**

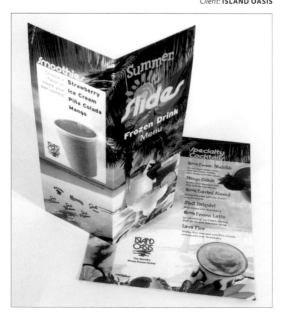

Creative Firm: **PATRICK HENRY CREATIVE PROMOTIONS, INC. — STAFFORD, TX**
Creative Team: **PHCP PRESTIGE ART TEAM**
Client: **PHILLIPS SEAFOOD RESTAURANTS**

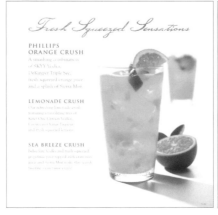
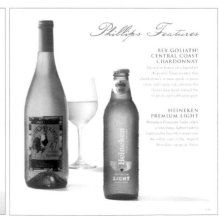

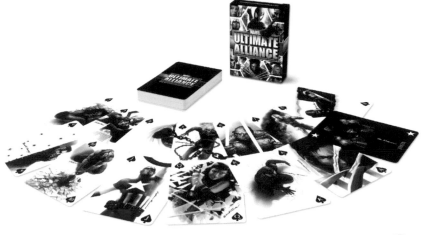

Creative Firm: **IGNITED MINDS, LLC — MARINA DEL REY, CA**
Creative Team: **OOGIE LEE, PERRY SIEWERT, KEU CHA, SCHAWK, INC.**
Client: **ACTIVISION**

Creative Firm: **HORNALL ANDERSON DESIGN WORKS — SEATTLE, WA**
Creative Team: **LISA CERVENY, MARY HERMES, JULIA LAPINE, JANA NISHI, BELINDA BOWLING, LAUREN DIRUSSO, ELMER DELA CRUZ**
Client. **O.C. TANNER**

Creative Firm: **HORNALL ANDERSON DESIGN WORKS — SEATTLE, WA**
Creative Team: **JACK ANDERSON, DAVID BATES, SONJA MAX, HOLLY CRAVEN**
Client: **NORDSTROM**

Creative Firm: **ACOSTA DESIGN INC — NEW YORK, NY**
Creative Team: **MAURICIO ACOSTA**
Client: **NCG**

Creative Firm: **WALLACE CHURCH, INC. — NEW YORK, NY**
Creative Team: **STAN CHURCH, JODI LUBRICH, RICH RICKABY**
Client: **WALLACE CHURCH, INC.**

Creative Firm: **ALL MEDIA PROJECTS LIMITED — PORT OF SPAIN, TRINIDAD AND TOBAGO**
Creative Team: **CATHLEEN JONES, KIRIE ISHMAEL, MARISA CAMEJO, JULIEN GREENIDGE, JOSIANE KHAN**
Client: **BP TRINIDAD AND TOBAGO (BPTT)**

PROMOTIONAL PACKAGING

Creative Firm: VH1 — NEW YORK, NY
Client: VH1

Creative Firm: MIND & MEDIA — ALEXANDRIA, VA
Creative Team: CHRIS AMMON, TROY THOMPSON, SARA ISACSON
Client: ARMY NATIONAL GAURD

Creative Firm: JACK NADEL INTERNATIONAL — LOS ANGELES, CA
Creative Team: SHELLEY SLUBOWSKI, AMYLIN PHARMECEUTICALS ART DIRECTION
Client: AMYLIN PHARMACEUTICALS / ELI LILLY

Creative Firm: JONI RAE AND ASSOCIATES — ENCINO, CA
Creative Team: JONI RAE RUSSELL, BEVERLY TRENGOVE
Client: THERMAFUSE

Creative Firm: TRIPLE 888 STUDIOS
— PARRAMATTA, NSW, AUSTRALIA
Creative Team: TRIPLE 888 CREATIVE TEAM
Client: MAXWELL J. BUSHBY

Creative Firm: AOL | 360 CREATIVE — NEW YORK, NY
Creative Team: ANTHONY FARIA, MARIO ARIAS, RICHARD TAYLOR, AUDREY BREINDEL, ERIKA ALONSO
Client: AOL MEDIA NETWORKS

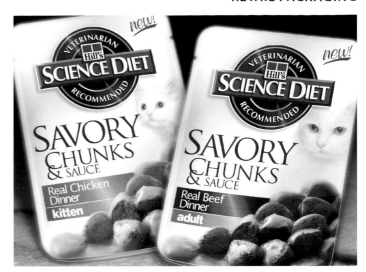

Creative Firm: JGA — SOUTHFIELD, MI
Creative Team: DAVID NELSON, TAMI JO URBAN, KATHI MCWILLIAMS
Client: KIRKLAND'S

Creative Firm: ZUNDA GROUP LLC — SOUTH NORWALK, CT
Creative Team: CHARLES ZUNDA, TODD NICKEL, MARK ISENHART
Client: HILL'S PET NUTRITION, INC.

Creative Firm: HORNALL ANDERSON DESIGN WORKS — SEATTLE, WA
Creative Team: LISA CERVENY, MARY HERMES, HOLLY CRAVEN, BELINDA BOWLING, MARY CHIN HUTCHINSON, TIFFANY PLACE
Client: BENJAMIN MOORE

Creative Firm: TOM FOWLER, INC. — NORWALK, CT
Creative Team: MARY ELLEN BUTKUS, ELIZABETH P. BALL, MARIE FORJAN
Client: ACME UNITED CORPORATION

Creative Firm: HEDGEHOG DESIGN LIMITED — NORTH POINT, HONG KONG
Creative Team: GARY MAN, KIT CHUNG, ANDY NEE
Client: HAPPY KID TOY GROUP LTD.

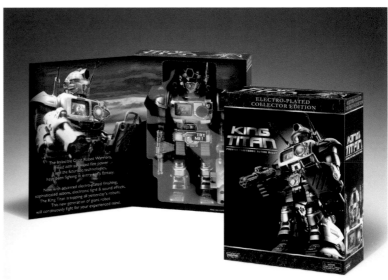

Creative Firm: **JGA** — **SOUTHFIELD, MI**
Creative Team: **KEN NISCH, KATHI MCWILLIAMS**
Client: **LAURA SECORD**

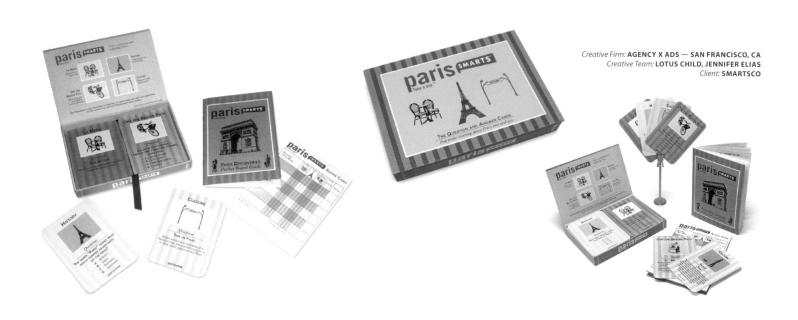

Creative Firm: **AGENCY X ADS** — **SAN FRANCISCO, CA**
Creative Team: **LOTUS CHILD, JENNIFER ELIAS**
Client: **SMARTSCO**

Creative Firm: **SCOTT VISION COMMUNICATION** — **TAIPEI, TAIWAN**

Creative Firm: **HEDGEHOG DESIGN LIMITED** — **NORTH POINT, HONG KONG**
Creative Team: **GARY MAN, KENNY KOON, ANDY NEE**
Client: **HAPPY KID TOY GROUP LTD.**

Creative Firm: **TRIPLE 888 STUDIOS — PARRAMATTA, NSW, AUSTRALIA**
Creative Team: **TRIPLE 888 CREATIVE TEAM**
Client: **SHELDON & HAMMOND**

Creative Firm: **WILLIAM FOX MUNROE — SHELLINGTON, PA**
Creative Team: **AMY PARKER, MIKE AMOLE**
Client: **WOODSCAPE ARTKITS, INC**

Creative Firm: **AGENCY X ADS — SAN FRANCISCO, CA**
Creative Team: **LOTUS CHILD, DENISE ST. LOUIS**
Client: **ALICE RADIO**

Creative Firm: **WILLIAM FOX MUNROE — SHELLINGTON, PA**
Creative Team: **MARY MALLIS, MATT KENNEDY, STEPHANIE BENNETT,
JOSH SAMOLEWICZ**
Client: **EDUCATE, INC.**

Creative Firm: **CROSLEY RADIO — LOUISVILLE, KY**
Creative Team: **MARK GROVES**
Client: **CROSLEY RADIO**

Creative Firm: **CROSLEY RADIO — LOUISVILLE, KY**
Creative Team: **MARK GROVES**
Client: **CROSLEY RADIO**

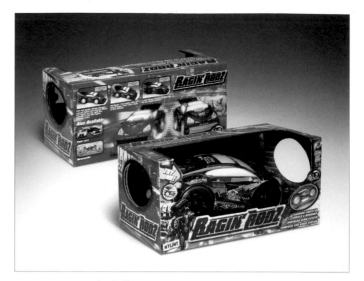

Creative Firm: **HEDGEHOG DESIGN LIMITED — NORTH POINT, HONG KONG**
Creative Team: **GARY MAN, KIT CHUNG, SCOTT NG**
Client: **FUNRISE TOYS LIMITED**

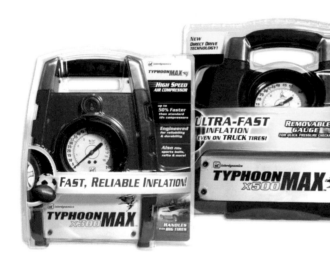

Creative Firm: **TOM FOWLER, INC. — NORWALK, CT**
Creative Team: **MARY ELLEN BUTKUS, THOMAS G. FOWLER**
Client: **INTERDYNAMICS**

Creative Firm: **HEDGEHOG DESIGN LIMITED — NORTH POINT, HONG KONG**
Creative Team: **GARY MAN, KIT CHUNG, ANDY NEE**
Client: **HAPPY KID TOY GROUP LTD.**

Creative Firm: **INTERROBANG DESIGN COLLABORATIVE, INC. — RICHMOND, VT**
Creative Team: **MARK D. SYLVESTER**
Client: **TDK ELECTRONICS CORPORATION**

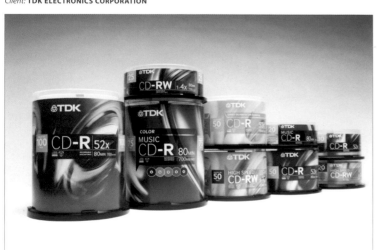

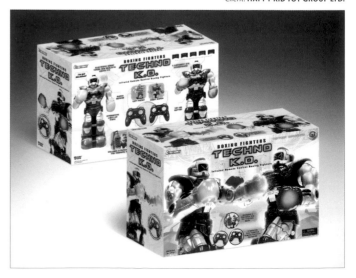

Creative Firm: **VH1 — NEW YORK, NY**
Client: **VH1**

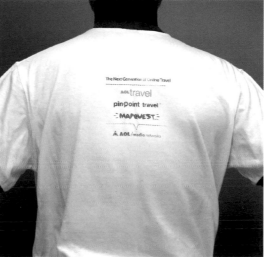

Creative Firm: **AOL | 360 CREATIVE — NEW YORK, NY**
Creative Team: **ANTHONY FARIA, KIMBERLY GEISER, TOM POLLEY, ERIKA ALONSO**
Client: **AOL MEDIA NETWORKS**

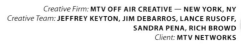

Creative Firm: **MTV OFF AIR CREATIVE — NEW YORK, NY**
Creative Team: **JEFFREY KEYTON, JIM DEBARROS, LANCE RUSOFF, SANDRA PENA, RICH BROWD**
Client: **MTV NETWORKS**

Creative Firm: **ISLAND OASIS — WALPOLE, MA**
Creative Team: **PETE BUHLER**
Client: **ISLAND OASIS**

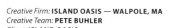

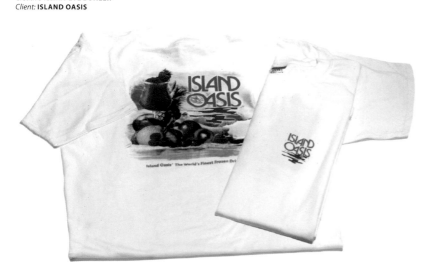

Creative Firm: **JACK NADEL INTERNATIONAL — LOS ANGELES, CA**
Creative Team: **SCOTT BROWN**
Client: **D.A.R.E. AMERICA MERCHANDISE**

Creative Firm: **OCTAVO DESIGNS — FREDERICK, MD**
Creative Team: **SUE HOUGH**
Client: **THE TEMPLE, A PAUL MITCHELL PARTNER SCHOOL**

Creative Firm: **G2 — NEW YORK, NY**
Creative Team: **JASON BORZOUYEH**
Client: **G2**

Creative Firm: **MTV OFF AIR CREATIVE — NEW YORK, NY**
Creative Team: **JEFFREY KEYTON, JIM DEBARROS, RICHARD BROWD, SANDRA PENA**
Client: **MTV NETWORKS**

Creative Firm: **BBK STUDIO — GRAND RAPIDS, MI**
Creative Team: **MICHELE CHARTIER, KEVIN BUDELMANN**
Client: **SPOUT**

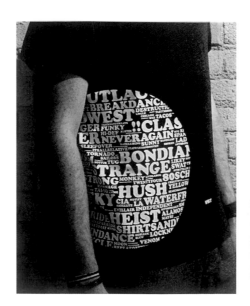

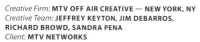

Creative Firm: **30SIXTY ADVERTISING+DESIGN, INC. — LOS ANGELES, CA**
Creative Team: **HENRY VIZCARRA, PÄR LARSSON, MOT POTIVES, BRUCE VENTANILLA, TUYET VONG**
Client: **UNIVERSAL STUDIOS HOME ENTERTAINMENT**

Creative Firm: **NEURON SYNDICATE INC. — SANTA MONICA, CA**
Creative Team: **RYAN CRAMER, SEAN ALATORRE, JASON BURNHAM, PHIL MCKENNA**
Client: **WARNER BROS. HOME ENTERTAINMENT**

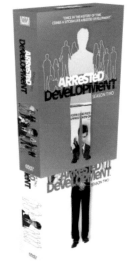

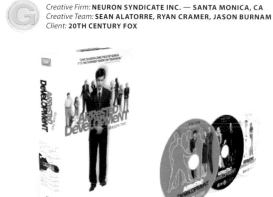

Creative Firm: **NEURON SYNDICATE INC. — SANTA MONICA, CA**
Creative Team: **SEAN ALATORRE, RYAN CRAMER, JASON BURNAM**
Client: **20TH CENTURY FOX**

Creative Firm: **AMATO IMAGE DESIGN — TEMPE, AZ**
Creative Team: **TONY AMATO, MICHAEL WOODALL,**
Client: **THE BIG BOTTOM BAND**

Creative Firm: **NEURON SYNDICATE INC. — SANTA MONICA, CA**
Creative Team: **SEAN ALATORRE, RYAN CRAMER, JASON BURNAM, JUSTINA WANG**
Client: **20TH CENTURY FOX**

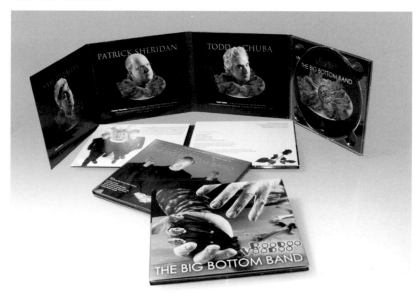

Creative Firm: **STUDIOERIN — JUPITER, FL**
Creative Team: **ERIN STARKS, FIELDS OF FOREL, ENRIQUE PALACIOS, ZAC COLLINS, STEVIE SAGER**
Client: **FIELDS OF FOREL**

Creative Firm: **NEURON SYNDICATE INC. — SANTA MONICA, CA**
Creative Team: **RYAN CRAMER, SEAN ALATORRE, JASON BURNAM, TIM CALIA**
Client: **20TH CENTURY FOX**

Creative Firm: **STUDIO FIVE — NEW YORK, NY**
Creative Team: **TATIANA AROCHA**
Client: **EXPANSION TEAM**

Creative Firm: **THE DESIGN STUDIO AT KEAN UNIVERSITY — UNION, NJ**
Creative Team: **STEVEN BROWER, BARBARA RÚSTICK**
Client: **THE AFFLIATE ARTISTS OF KEAN UNIVERSITY**

Creative Firm: **AGENCY X ADS — SAN FRANCISCO, CA**
Creative Team: **LOTUS CHILD, DENISE ST. LOUIS**
Client: **ALICE RADIO**

Creative Firm: **AMATO IMAGE DESIGN — TEMPE, AZ**
Creative Team: **TONY AMATO**
Client: **PHILLIP STRANGE**

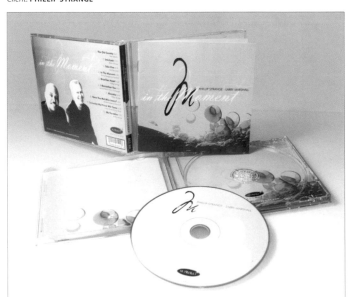

Creative Firm: **BIGWIG DESIGN — SAN FRANCISCO, CA**
Creative Team: **RICHARD LEEDS, FRANCOIS BURLAND, PAUL MAHDER**
Client: **TOO FAR**

Creative Firm: **COMPANY STANDARD — BROOKLYN, NY**
Creative Team: **MELISSA GORMAN, TATIANA AROCHA**
Client: **DEFINITIVE JUX**

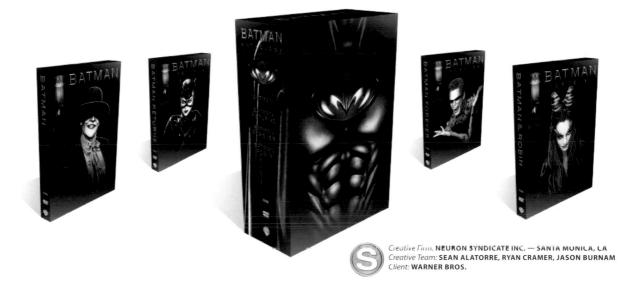

Creative Firm: **NEURON SYNDICATE INC. — SANTA MONICA, CA**
Creative Team: **SEAN ALATORRE, RYAN CRAMER, JASON BURNAM**
Client: **WARNER BROS.**

Creative Firm: **AMATO IMAGE DESIGN — TEMPE, AZ**
Creative Team: **TONY AMATO, MICHAEL WOODALL**
Client: **WARREN JONES**

Creative Firm: **BURROWS — BRENTWOOD, ESSEX, UNITED KINGDOM**
Creative Team: **ROYDON HEARNE, DARRYL SMITH, AARON HULSIZER, LUCY WELDON**
Client: **VOLVO CARS UK**

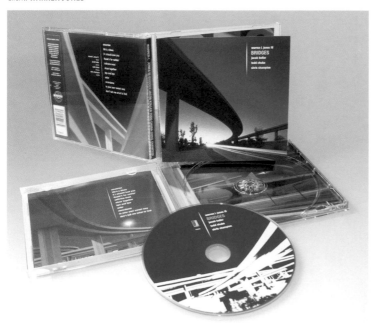

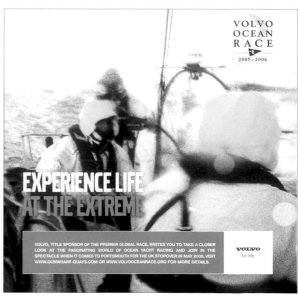

DVD'S, CD'S

Creative Firm: **RIORDON DESIGN — OAKVILLE, ON, CANADA**
Creative Team: **SHIRLEY RIORDON**
Client: **PAUL BALOCHE / INTEGRITY MUSIC**

Creative Firm: **EPOS, INC. — SANTA MONICA, CA**
Creative Team: **KIMIYO NISHIO, GABRIELLE RAUMBERGER**
Client: **OLIVIA NEWTON-JOHN PRODUCTIONS**

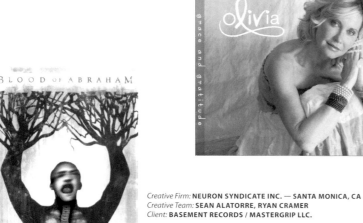

Creative Firm: **NEURON SYNDICATE INC. — SANTA MONICA, CA**
Creative Team: **SEAN ALATORRE, RYAN CRAMER**
Client: **BASEMENT RECORDS / MASTERGRIP LLC.**

Creative Firm: **AMATO IMAGE DESIGN — TEMPE, AZ**
Creative Team: **TONY AMATO, MICHAEL WOODALL**
Client: **JERRY DONATO**

Creative Firm: **TODD CHILDERS GRAPHIC DESIGN — BOWLING GREEN, OH**
Creative Team: **TODD CHILDERS, BRADLEY WILBER**
Client: **NINA ASSIMAKOPOULOS**

NORTHEAST DECIDUOUS FOREST

NATURE OF AMERICA

Creative Firm: **UNITED STATES POSTAL SERVICE — ARLINGTON, VA**
Creative Team: **ETHEL KESSLER, JOHN DAWSON**
Client: **UNITED STATES POSTAL SERVICE**

Creative Firm: **UNITED STATES POSTAL SERVICE — ARLINGTON, VA**
Creative Team: **ETHEL KESSLER, TIM O'BRIEN, GREG BERGER**
Client: **UNITED STATES POSTAL SERVICE**

Creative Firm: **RICK SEALOCK — KITCHENER, ON, CANADA**
Creative Team: **MICHAEL AUBRECHT, RICK SEALOCK**
Client: **SELLING POWER INC. MAGAZINE**

Creative Firm: **PLAYBOY ENTERPRISES INTERNATIONAL, INC. — CHICAGO, IL**
Creative Team: **TOM STAEBLER, DAVE MCKEAN**
Client: **PLAYBOY MAGAZINE**

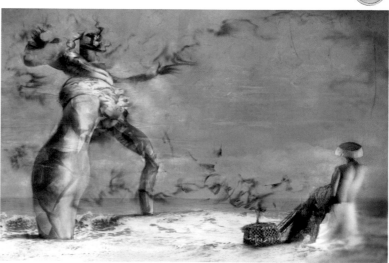

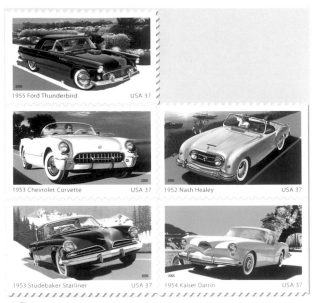

Creative Firm: **UNITED STATES POSTAL SERVICE — ARLINGTON, VA**
Creative Team: **CARL HERRMAN, ART FITZPATRICK**
Client: **UNITED STATES POSTAL SERVICE**

Creative Firm: **PLAYBOY ENTERPRISES INTERNATIONAL, INC. — CHICAGO, IL**
Creative Team: **YUKO SHIMIZU, ROB WILSON, TOM STAEBLER**
Client: **PLAYBOY MAGAZINE**

Creative Firm: **DESIGN NUT — KENSINGTON, MD**
Creative Team: **BRENT ALMOND**
Client: **FAMILY TIES PROJECT**

Creative Firm: **WENDELL MINOR DESIGN — WASHINGTON, CT**
Creative Team: **WENDELL MINOR, FLORENCE MINOR, AL CETTA**
Client: **HARPERCOLLINS**

Creative Firm: **UNITED STATES POSTAL SERVICE — ARLINGTON, VA**
Creative Team: **DERRY NOYES, JOHN MATTOS**
Client: **UNITED STATES POSTAL SERVICE**

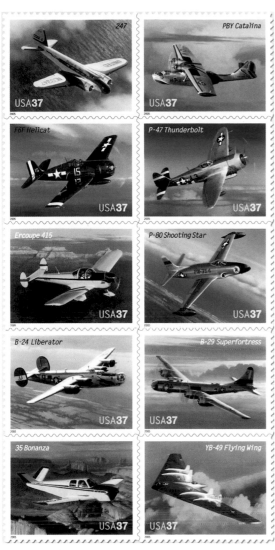

Creative Firm: **UNITED STATES POSTAL SERVICE — ARLINGTON, VA**
Creative Team: **PHIL JORDAN, WILLIAM S. PHILLIPS**
Client: **UNITED STATES POSTAL SERVICE**

Creative Firm: **PLAYBOY ENTERPRISES INTERNATIONAL, INC. — CHICAGO, IL**
Creative Team: **ISTVAN BANYAI, SCOTT ANDERSON, TOM STAEBLER**
Client: **PLAYBOY MAGAZINE**

Creative Firm: **SABINGRAFIK, INC. — CARLSBAD, CA**
Creative Team: **TRACY SABIN, BRIDGET SABIN**
Client: **SEAFARER BAKING COMPANY**

Creative Firm: **MENDES PUBLICIDADE — BELÉM, PARÁ, BRAZIL**
Creative Team: **OSWALDO MENDES, MARCELO AMORIM**
Client: **TIM NORTE**

Creative Firm: **PLAYBOY ENTERPRISES INTERNATIONAL, INC. — CHICAGO, IL**
Creative Team: **CRAIG MULLINS, ROB WILSON, TOM STAEBLER**
Client: **PLAYBOY MAGAZINE**

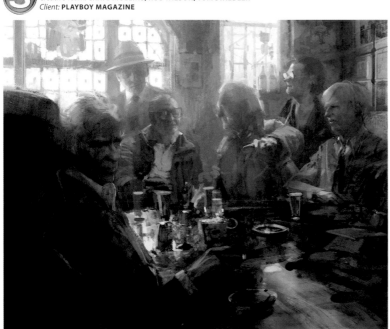

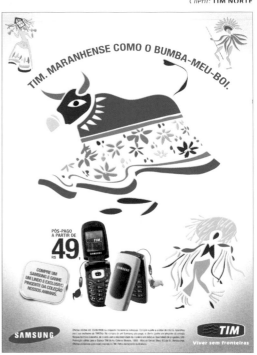

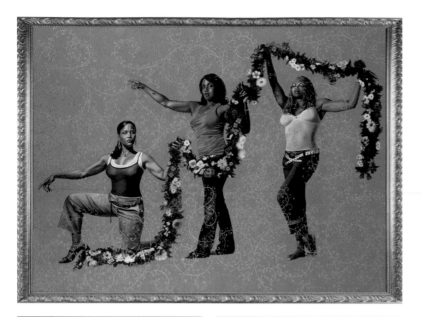

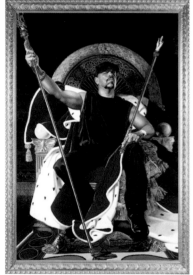

Creative Firm: **AMERICAN RED CROSS BLOOD SERVICES, WEST DIVISION — POMONA, CA**
Creative Team: **BRIAN MEDINA**

Creative Firm: **VH1 — NEW YORK, NY**
Client: **VH1**

Creative Firm: **UNITED STATES POSTAL SERVICE — ARLINGTON, VA**
Creative Team: **HOWARD PAINE, MICHAEL DEAS**
Client: **UNITED STATES POSTAL SERVICE**

Creative Firm: **PLAYBOY ENTERPRISES INTERNATIONAL, INC. — CHICAGO, IL**
Creative Team: **MIRKO ILIC, ROB WILSON, TOM STAEBLER**
Client: **PLAYBOY MAGAZINE**

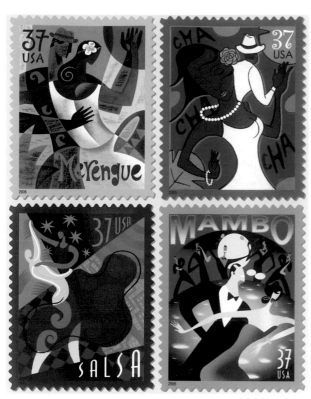

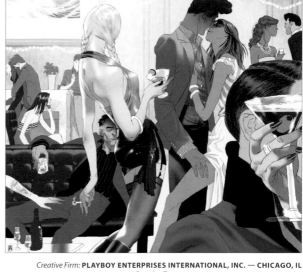

Creative Firm: **PLAYBOY ENTERPRISES INTERNATIONAL, INC. — CHICAGO, IL**
Creative Team: **TOMER HANUKA, TOM STAEBLER**
Client: **PLAYBOY MAGAZINE**

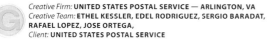

Creative Firm: **UNITED STATES POSTAL SERVICE — ARLINGTON, VA**
Creative Team: **ETHEL KESSLER, EDEL RODRIGUEZ, SERGIO BARADAT,
RAFAEL LOPEZ, JOSE ORTEGA,**
Client: **UNITED STATES POSTAL SERVICE**

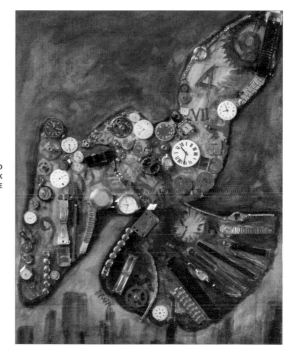

Creative Firm: **MPHASIS ON FRONTIER — DENVER, CO**
Creative Team: **DANA BARAK**
Client: **WILD BLUE YONDER MAGAZINE**

Creative Firm: **UNITED STATES POSTAL SERVICE
— ARLINGTON, VA**
Creative Team: **RICHARD SHEAFF, ALBERT SLARK**
Client: **UNITED STATES POSTAL SERVICE**

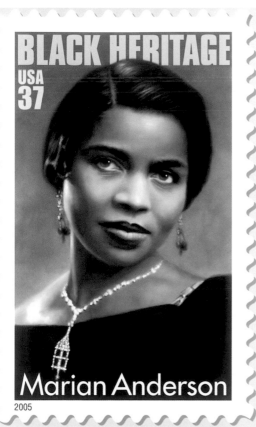

Creative Firm: **PLAYBOY ENTERPRISES INTERNATIONAL, INC. — CHICAGO, IL**
Creative Team: **CATHIE BLECK, ROB WILSON, TOM STAEBLER**
Client: **PLAYBOY MAGAZINE**

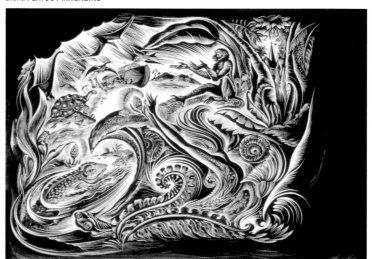

Creative Firm: **UNITED STATES POSTAL SERVICE — ARLINGTON, VA**
Creative Team: **CARL HERRMAN, WILL WILSON**
Client: **UNITED STATES POSTAL SERVICE**

Creative Firm: **PLAYBOY ENTERPRISES INTERNATIONAL, INC. — CHICAGO, IL**
Creative Team: **NICHOLAS WILTON, TOM STAEBLER**
Client: **PLAYBOY MAGAZINE**

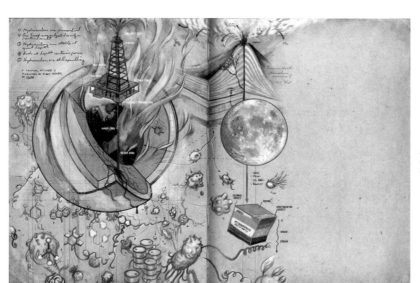

Creative Firm: **PLAYBOY ENTERPRISES INTERNATIONAL, INC. — CHICAGO, IL**
Creative Team: **JAMES JEAN, SCOTT ANDERSON, TOM STAEBLER**
Client: **PLAYBOY MAGAZINE**

Creative Firm: **WENDELL MINOR DESIGN — WASHINGTON, CT**
Creative Team: **WENDELL MINOR, CECILIA YUNG, GUNTA ALEXANDER**
Client: **PUTNAM**

Creative Firm: **PLAYBOY ENTERPRISES INTERNATIONAL, INC. — CHICAGO, IL**
Creative Team: **ROB WILSON, SCOTT ANDERSON, TOM STAEBLER**
Client: **PLAYBOY MAGAZINE**

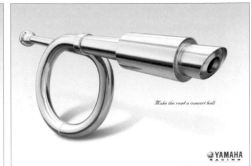

Creative Firm: **YOUNG & RUBICAM GMBH & CO. KG — FRANKFURT AM MAIN, HESSEN, GERMANY**
Creative Team: **CHRISTIAN DAUL, GUIDO MASSON, LOTHAR GRIM,
KLAUS GERBER, CLAUDIA SCHOENHALS**
Client: **LUX AG**

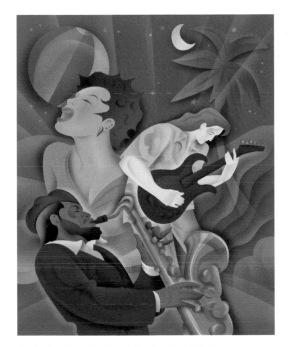

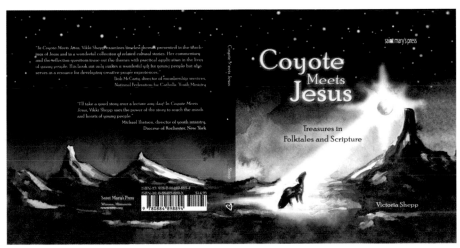

Creative Firm: **PERNSTEINER CREATIVE GROUP, INC. — ST LOUIS PARK, MN**
Creative Team: **TODD PERNSTEINER, ERIK LERVOLD**
Client: **SAINT MARY'S PRESS**

Creative Firm: **RONI HICKS & ASSOCIATES — CARLSBAD, CA**
Creative Team: **TRACY SABIN, STEPHEN SHARP**
Client: **4S RANCH**

Creative Firm: **QUALCOMM — SAN DIEGO, CA**
Creative Team: **CHRIS LEE, MICHAEL SCHWAB**

Creative Firm: **RICK SEALOCK — KITCHENER, ON, CANADA**
Creative Team: **MARK ALLEN, RICK SEALOCK**
Client: **TEMERLIN ADVERTISING INSTITUTE, SMU**

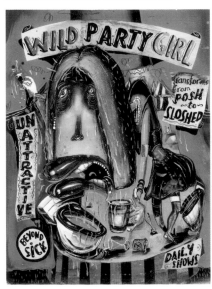

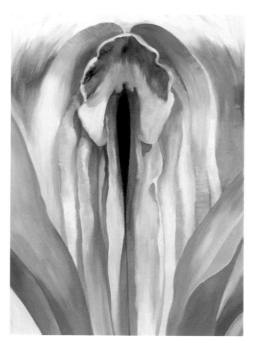

Creative Firm: PLAYBOY ENTERPRISES INTERNATIONAL, INC.
— CHICAGO, IL
Creative Team: ROBERTO PARADA, TOM STAEBLER
Client: PLAYBOY MAGAZINE

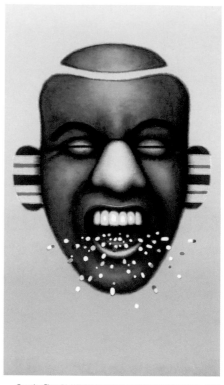

Creative Firm: UNITED STATES POSTAL SERVICE
— ARLINGTON, VA
Creative Team: DERRY NOYES, DREW STRUZAN
Client: UNITED STATES POSTAL SERVICE

Creative Firm: PLAYBOY ENTERPRISES INTERNATIONAL, INC.
— CHICAGO, IL
Creative Team: ED PASCHKE, TOM STAEBLER
Client: PLAYBOY MAGAZINE

Creative Firm: PLAYBOY ENTERPRISES INTERNATIONAL, INC. — CHICAGO, IL
Creative Team: ROBERTO PARADA, TOM STAEBLER
Client: PLAYBOY MAGAZINE

Creative Firm: WENDELL MINOR DESIGN — WASHINGTON, CT
Creative Team: WENDELL MINOR, JEAN CRAIGHEAD GEORGE, MARTHA RAGO, NEIL SWAAB
Client: HARPERCOLLINS

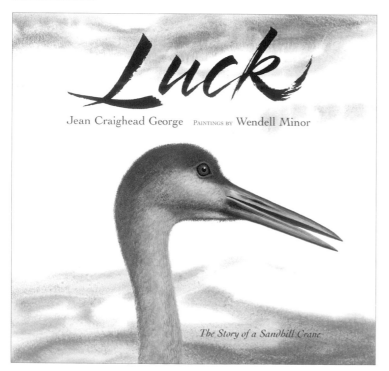

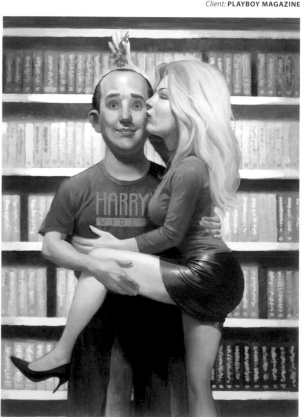

Creative Firm: **PLAYBOY ENTERPRISES INTERNATIONAL, INC. — CHICAGO, IL**
Creative Team: **TIFENN PYTHON, TOM STAEBLER**
Client: **PLAYBOY MAGAZINE**

Creative Firm: **ASPREY CREATIVE — FITZROY, VICTORIA, AUSTRALIA**
Creative Team: **GEORGE MARGARITIS, PETER ASPREY**
Client: **MASTERFOODS SNACKFOOD**

Creative Firm: **PLAYBOY ENTERPRISES INTERNATIONAL, INC. — CHICAGO, IL**
Creative Team: **JORDIN ISIP, TOM STAEBLER**
Client: **PLAYBOY MAGAZINE**

Creative Firm: **CHALMERS STUDIO — TRUMANSBURG, NY**
Creative Team: **CHERYL CHALMERS**
Client: **CHERYL CHALMERS**

Creative Firm: **PLAYBOY ENTERPRISES INTERNATIONAL, INC. — CHICAGO, IL**
Creative Team: **KENT WILLIAMS, TOM STAEBLER**
Client: **PLAYBOY MAGAZINE**

CREATIVE ACHIEVEMENT, *PHOTOGRAPHY*

Creative Firm: **WALT DENSON — SAUSALITO, CA**
Creative Team: **WALT DENSON, STEVE PETERS**
Client: **WALT DENSON**

Creative Firm: **MANHATTAN GROUP LLC — NEW YORK, NY**
Creative Team: **RICK BARD**
Client: **MANHATTAN BRIDE**

Creative Firm: **DREW GARDNER PHOTOGRAPHY — NAPERVILLE, IL**
Creative Team: **DREW GARDNER**
Client: **DREW GARDNER**

Creative Firm: **STUDIO JMV LLC — MIAMI, FL**
Creative Team: **JOSE VIDAURRE, JASON VENTURA**

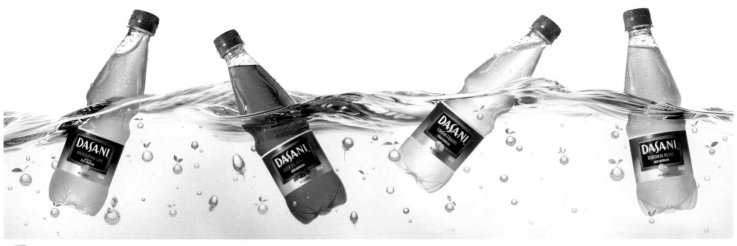

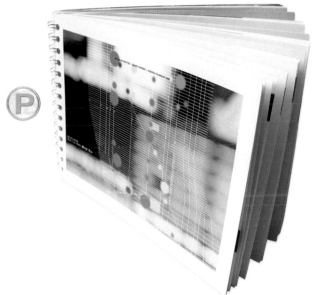

6 perfect bridal looks ...

Creative Firm: **WALT DENSON — SAUSALITO, CA**
Creative Team: **WALT DENSON**
Client: **WALT DENSON**

Creative Firm: **MANHATTAN GROUP LLC — NEW YORK, NY**
Creative Team: **RICK BARD**
Client: **MANHATTAN BRIDE**

Creative Firm: **DAVID J. BOOKBINDER — GLOUCESTER, MA**
Creative Team: **DAVID J. BOOKBINDER**
Client: **CRESCENT HILL BOOKS**

Creative Firm: **MANHATTAN GROUP LLC — NEW YORK, NY**
Creative Team: **RICK BARD**
Client: **MANHATTAN BRIDE**

Creative Firm: **RANDI WOLF DESIGN — GLASSBORO, NJ**
Creative Team: **RANDI WOLF**
Client: **MAIN STREET GLASSBORO**

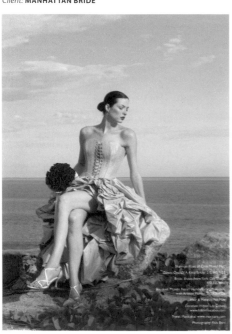

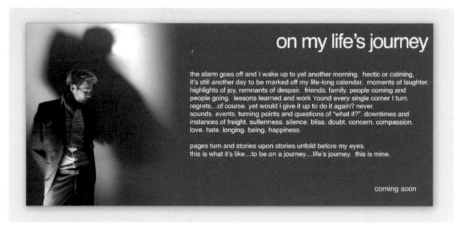

on my life's journey

the alarm goes off and I wake up to yet another morning. hectic or calming. it's still another day to be marked off my life-long calendar. moments of laughter. highlights of joy. remnants of despair. friends. family. people coming and people going. lessons learned and work 'round every single corner I turn. regrets…of course. yet would i give it up to do it again? never. sounds. events. turning points and questions of "what if?". downtimes and instances of freight. sullenness. silence. bliss. doubt. concern. compassion. love. hate. longing. being. happiness.

pages turn and stories upon stories unfold before my eyes. this is what it's like…to be on a journey…life's journey. this is mine.

coming soon

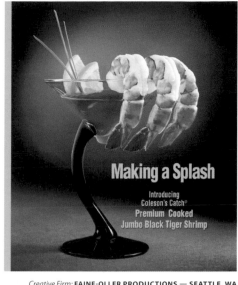

Creative Firm: KELLY CARROLL — LOUISVILLE, KY
Creative Team: KELLY CARROLL, JOSHUA LAKES
Client: JOSHUA LAKES

Creative Firm: FAINE-OLLER PRODUCTIONS — SEATTLE, WA
Creative Team: CATHERINE OLLER, CHRISTOPHER CONRAD
Client: COLESON FOODS, INC.

Creative Firm: TV LAND — NEW YORK, NY
Creative Team: KIM ROSENBLUM, DOMINIQUE VITALI, KEVIN HARTMAN, CHELSEA MOST, TONY D'ORIO
Client: TV LAND

Creative Firm: EMERSON, WAJDOWICZ STUDIOS — NEW YORK, NY
Creative Team: JUREK WAJDOWICZ, LISA LAROCHELLE, MANNY MENDEZ, STEVEN MANNING, PETER BIRO, SCOTT ANGER AND OTHERS
Client: INTERNATIONAL RESCUE COMMITTEE

Creative Firm: AMERICAN RED CROSS BLOOD SERVICES, WEST DIVISION — POMONA, CA
Creative Team: SAUNDRA KEENAN DAVISON

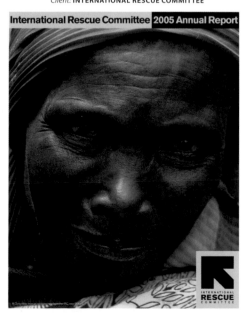

Creative Firm: **DEVON ENERGY - IN HOUSE — OKLAHOMA CITY, OK**
Creative Team: **SCOTT RAFFE, TIM LANGENBERG**
Client: **DEVON ENERGY CORPORATION**

Creative Firm: **MTV OFF AIR CREATIVE — NEW YORK, NY**
Creative Team: **JEFFREY KEYTON, JIM DEBARROS, CHRISTOPHER TRUCH, KAREN WEISS, NICK SONDERUP, MATHIAS CLAMER**
Client: **MTV NETWORKS**

 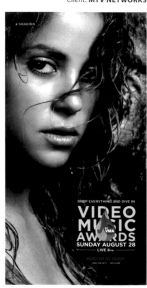

Creative Firm: **MANHATTAN GROUP LLC — NEW YORK, NY**
Creative Team: **RICK BARD**
Client: **MANHATTAN BRIDE**

Creative Firm: **MANHATTAN GROUP LLC — NEW YORK, NY**
Creative Team: **RICK BARD**
Client: **MANHATTAN BRIDE**

Creative Firm: **MANHATTAN GROUP LLC — NEW YORK, NY**
Creative Team: **RICK BARD**
Client: **MANHATTAN BRIDE**

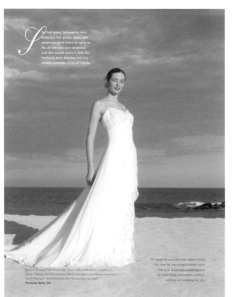 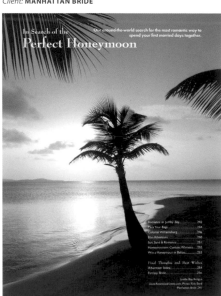 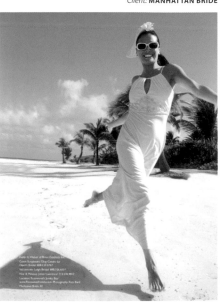

Creative Firm: **PETTINATO PHOTOGRAPHY** — NAPERVILLE, IL
Creative Team: **TONY PETTINATO**
Client: **TONY PETTINATO**

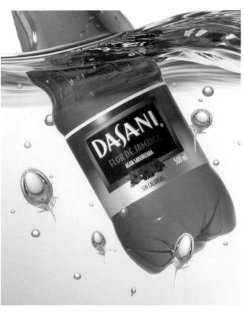

Creative Firm: **STUDIO JMV LLC** — MIAMI, FL
Creative Team: **JOSE VIDAURRE, JUAN JOSE POSADA**
Client: **DASANI/COCACOLA**

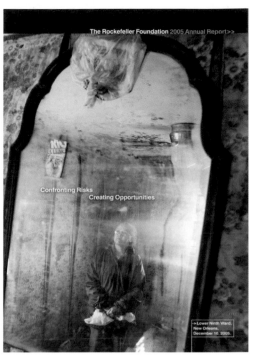

Creative Firm: **EMERSON, WAJDOWICZ STUDIOS**
— NEW YORK, NY
Creative Team: **JUREK WAJDOWICZ, LISA LAROCHELLE,
MANNY MENDEZ, JONAS BENDIKSEN**
Client: **THE ROCKEFELLER FOUNDATION**

Creative Firm: **EMERSON, WAJDOWICZ STUDIOS** — NEW YORK, NY
Creative Team: **L. LAROCHELLE, J. WAJDOWICZ, Y. YOSHIDA,
M. MENDEZ, P. PETTERSSON, R. HAVIV, B. STEVENS, P. BONET,
S. BOELSCH AND OTHERS**
Client: **MÉDECINS SANS FRONTIÈRES /
DOCTORS WITHOUT BORDERS**

Creative Firm: **MANHATTAN GROUP LLC** — NEW YORK, NY
Creative Team: **RICK BARD**
Client: **MANHATTAN BRIDE**

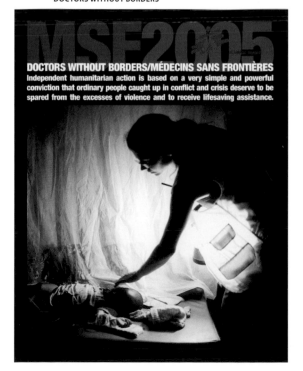

CONSUMER TV, *SINGLE*

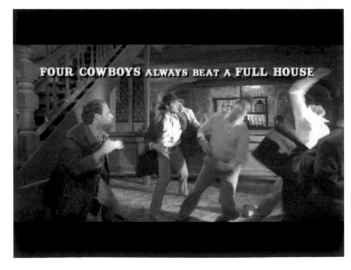

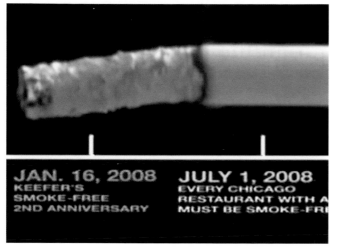

Creative Firm: **THE UNGAR GROUP — CHICAGO, IL**
Creative Team: **TOM UNGAR, ALLA DONINA, ASHLEY NATH, JONATHAN UNGAR, DAVE O'DONNELL**
Client: **KEEFER'S STEAK AND SEAFOOD**

Creative Firm: **BRUKETA&ZINIC — ZAGREB, CROATIA (HRVATSKA)**
Creative Team: **MOE MINKARA, TONKA LUJANAC, MIRAN TOMICIC, KOMAKINO, HOBO**
Client: **DUGRAF**

Creative Firm: **HITCHCOCK FLEMING & ASSOCIATES INC. — AKRON, OH**
Creative Team: **NICK BETRO, SCOTT KRISTOFF, GREG PFIFFNER, MARK COLLINS**
Client: **GEAUGA LAKE**

Creative Firm: **JWT DÜSSELDORF — DUESSELDORF, NRW, GERMANY**
Creative Team: **EDDY GREENWOOD, JOHN ABEL, MICHAEL FUETER, ELKE BOLL, CONSTANTINE WRAGE**
Client: **MAZDA MOTOR EUROPE**

Creative Firm: **MCCANN ERICKSON KOREA — SEOUL, KOREA (SOUTH)**
Creative Team: **JH CHO, SANGJIN KIM, MOONSUN CHOI, MINJUNG SONG, SANG YOUN KIM**
Client: **COCA-COLA KOREA**

Creative Firm: **MCCANN ERICKSON, NEW YORK — NEW YORK, NY**
Creative Team: **ERIC GOLDSTEIN, CHRIS CEREDA, JOYCE KING THOMAS, JULIE ANDARIESE, FRANK TODARO, ADAM BECKMAN**
Client: **MASTERCARD**

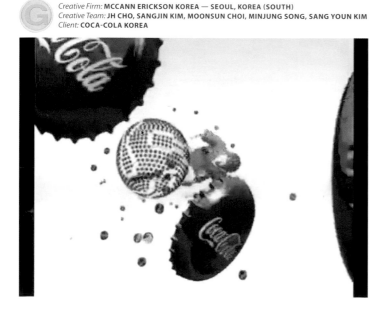

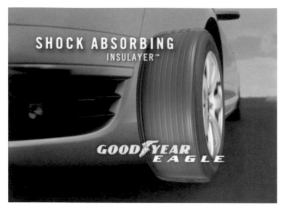

Creative Firm: **HITCHCOCK FLEMING & ASSOCIATES INC. — AKRON, OH**
Creative Team: **NICK BETRO, MAGGIE HARRIS, TODD MOSER**
Client: **GOODYEAR TIRE & RUBBER COMPANY**

Creative Firm: **NICKELODEON — NEW YORK, NY**
Creative Team: **FRANK CZUCHAN, HELENE MILLER- ALENSTEIN,**
KATIE FITZPARTICK, ANNA YOON
Client: **NICK CREATIVE RESOURCES**

Creative Firm: **NICK AT NITE — NEW YORK, NY**
Creative Team: **KENNA KAY, PALOMA RAMIREZ, KURT HARTMAN, GEORGE BATES,**
LAURA BELGRAY, PENNY MAILANDER
Client: **NICK AT NITE**

Creative Firm: **MCCANN ERICKSON, NEW YORK — NEW YORK, NY**
Creative Team: **GAIL BARLOW, SASHA SHOR, BILL OBERLANDER,**
JOYCE KING THOMAS, BONNIE BEDEL, JIM JENKINS
Client: **AD COUNCIL**

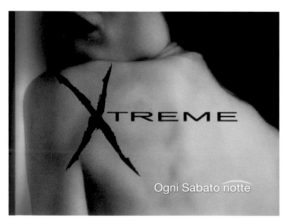

Creative Firm: **NBC UNIVERSAL GLOBAL NETWORKS ITALIA — ROME, ITALY**
Client: **STUDIO UNIVERSAL**

Creative Firm: **PHP COMMUNICATIONS — BIRMINGHAM, AL**
Creative Team: **BRYAN CHACE, JASON RUHA, RUTH GREER**
Client: **BRADFORD HEALTH SERVICES**

Creative Firm: **DIESTE HARMEL & PARTNERS — DALLAS, TX**
Creative Team: **ALDO QUEVEDO, JAIME ANDRADE,**
GABRIEL PUERTO, ALEX TOEDTLI,
JOSE SUASTE, JOHN COSTELLO
Client: **BUDWEISER**

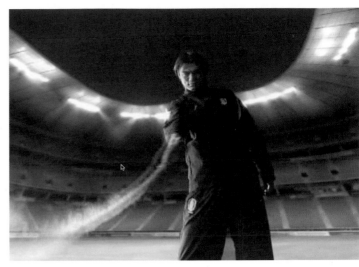

Creative Firm: **MCCANN ERICKSON, NEW YORK — NEW YORK, NY**
Creative Team: **JOYCE KING THOMAS, BILL OBERLANDER, JEFF TAYLOR, DAVID LEVY, TONI LIPARI, RICK LEMOINE**
Client: **SHARPIE MINI**

Creative Firm: **MCCANN ERICKSON KOREA — SEOUL, KOREA (SOUTH)**
Creative Team: **JH CHO, SANGJIN KIM, MOONSUN CHOI, MINJUNG SONG, SANG YOUN KIM**
Client: **COCA-COLA KOREA**

Creative Firm: **PENNY/OHLMANN/NEIMAN — DAYTON, OH**
Creative Team: **PAUL LINDAMOOD**
Client: **KETTERING MEDICAL CENTER**

Creative Firm: **DIESTE HARMEL & PARTNERS — DALLAS, TX**
Creative Team: **ALDO QUEVEDO, CARLOS TOURNE, PATRICIA MARTINEZ, RAYMUNDO VALDEZ, DIEGO DUPRAT**
Client: **CLOROX, PINESOL**

Creative Firm: **PETERSON MILLA HOOKS — MINNEAPOLIS, MN**
Creative Team: **DAVE PETERSON, JENNY SHEARS, GAYLE MALCOLM, ALDO HERTZ**
Client: **TARGET**

Creative Firm: **KELLER CRESCENT — EVANSVILLE, IN**
Creative Team: **RANDALL ROHN, NANCY KIRKPATRICK, NAIYANA HARDY, CARSON CATLIN, JOHN MENELLA**
Client: **MORGAN HOSPITAL**

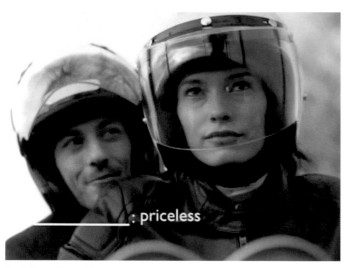

Creative Firm: **MCCANN ERICKSON, NEW YORK — NEW YORK, NY**
Creative Team: **JOYCE KING THOMAS, PETER JONES, CHRIS CEREDA, GREG LOTUS, CHRISTIAN BERGER, ADAM PETOFSKY**
Client: **MASTERCARD**

Creative Firm: **DIESTE HARMEL & PARTNERS — DALLAS, TX**
Creative Team: **ALDO QUEVEDO, MACK SIMPSON, ROBERTO SAUCEDO, JUAN DANIEL NAVAS, IGNACIO ROMERO, JASSON TISSER, JOHN COSTELLO**
Client: **GATORADE**

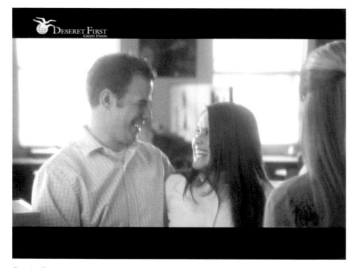

Creative Firm: **BONNEVILLE COMMUNICATIONS — SALT LAKE CITY , UT**
Creative Team: **ERIC MORGAN**
Client: **DESERET FIRST CREDIT UNION**

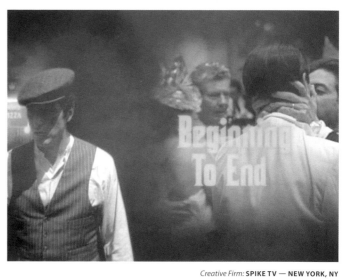

Creative Firm: **SPIKE TV — NEW YORK, NY**
Creative Team: **SUE KIM, TERRY MINOGUE, CLIFF SCHWARTZ, JUSTIN GALLAHER, ALAN ROLL, NEILS SCHUURMANS**
Client: **SPIKE**

Creative Firm: **PETERSON MILLA HOOKS — MINNEAPOLIS, MN**
Creative Team: **DAVE PETERSON , DANIEL CHU, GAYLE MALCOLM, ALDO HERTZ**
Client: **TARGET**

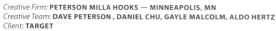

Creative Firm: **MCCANN ERICKSON, NEW YORK — NEW YORK, NY**
Creative Team: **JOYCE KING THOMAS, BILL OBERLANDER, JEFF TAYLOR, DAVID LEVY, TONI LIPARI, RICK LEMOINE**
Client: **SHARPIE MINI**

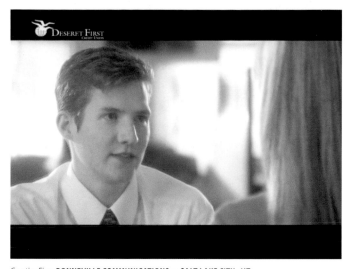

Creative Firm: **BONNEVILLE COMMUNICATIONS — SALT LAKE CITY , UT**
Creative Team: **ERIC MORGAN**
Client: **DESERET FIRST CREDIT UNION**

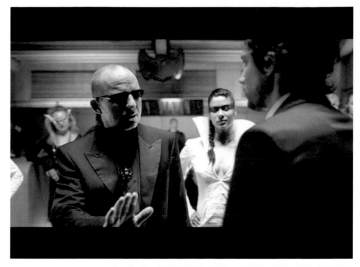

Creative Firm: **JWT DUESSELDORF — DUESSELDORF, NRW, GERMANY**
Creative Team: **EDDY GREENWOOD, JOHN ABEL, CHRISTIAN LYNGBYE, IGOR KARPALOV,
ELKE BOLL, CONSTANTINE WRAGE**
Client: **MAZDA MOTOR EUROPE**

Creative Firm: **DIESTE HARMEL & PARTNERS — DALLAS, TX**
Creative Team: **ALDO QUEVEDO, JAIME ANDRADE, GABRIEL PUERTO, ALEX TOEDTLI,
JOSE SUASTE, JOHN COSTELLO**
Client: **BUDWEISER**

Creative Firm: **MCCANN ERICKSON, NEW YORK — NEW YORK, NY**
Creative Team: **CINDY CASARES, KRISTAL KINDER, JOYCE KING THOMAS, JIM MCKENNAN,
KATHY LOVE, MIKE BORIS**
Client: **WENDY'S**

Creative Firm: **PETERSON MILLA HOOKS — MINNEAPOLIS, MN**
Creative Team: **DAVE PETERSON, BETHANY NAGY, MICHAEL SHARP, GARY TASSONE**
Client: **TARGET**

Creative Firm: **MCCANN ERICKSON, NEW YORK — NEW YORK, NY**
Creative Team: **JOYCE KING THOMAS, BILL OBERLANDER, LARRY PLATT, TOM SULLIVAN,
JUDI NIERMAN, MARK ROMANEK**
Client: **NIKON**

P *Creative Firm:* **FRY HAMMOND BARR — ORLANDO, FL**
Creative Team: **TIM FISHER, SEAN BRUNSON, SANDRA LAWTON, SHANNON HALLARE, NTH DEGREE**
Client: **ORLANDO SCIENCE CENTER**

Creative Firm: **MCCANN ERICKSON, NEW YORK/JOYCE KING THOMAS ECD/CCO — NEW YORK, NY**
Creative Team: **AUDREY HUFFENREUTER, LESLIE SIMS, PETER JONES, TIM DILLINGHAM, LISA BRANDRIFF, KATHY KUHN**
Client: **MASTERCARD**

S *Creative Firm:* **TV LAND — NEW YORK, NY**
Creative Team: **KIM ROSENBLUM, DOMINIQUE VITALI, KEVIN HARTMAN, CHELSEA MOST**
Client: **TV LAND**

Creative Firm: **CMT — NEW YORK, NY** **S**
Creative Team: **JAMES HITCHCOCK, MICHAEL ENGLEMAN, JEFF NICHOLS, AMIE NGUYEN, SCOTT MCDONALD, SCOTT GERLOCK**
Client: **CMT**

Creative Firm: **FRY HAMMOND BARR — ORLANDO, FL**
Creative Team: **TIM FISHER, TOM KANE, JOHN LOGAN, SEAN BRUNSON, MELISSA COONEY, RADIUM**
Client: **BRIGHT HOUSE NETWORKS**

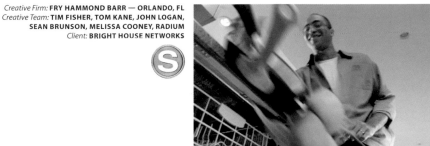

Creative Firm: **MCCANN ERICKSON KOREA — SEOUL, KOREA (SOUTH)**
Creative Team: **JUNG-HYUN SHON, BH AHN, CU KIM, NAM-GIL KIM**
Client: **DAEDONG CONSTRUCTION**

Creative Firm: **CMT — NEW YORK, NY**
Creative Team: **JAMES HITCHCOCK, MICHAEL ENGLEMAN, JEFF NICHOLS, VALERIE CARRILLO, BRAND NEW SCHOOL (NY)**
Client: **CMT**

Creative Firm: **2 TICKS & THE DOG PRODUCTIONS, INC. — WARREN, OH**
Creative Team: **JIM FOGARTY, MATT SMITH**
Client: **BOB HAGAN**

Creative Firm: **BONNEVILLE COMMUNICATIONS — SALT LAKE CITY , UT**
Creative Team: **ERIC MORGAN**
Client: **DESERET FIRST CREDIT UNION**

Creative Firm: **MCCANN ERICKSON, NEW YORK /
JOYCE KING THOMAS CCO — NEW YORK, NY**
Creative Team: **MARCO CIGNINI, JESSE POTACK, STEVE OHLER,
SAM CERNICHIARI, PEIRRE LIPTON, TRAVIS BRITTON**
Client: **STAPLES**

Creative Firm: **CMT — NEW YORK, NY**
Creative Team: **JAMES HITCHCOCK, MICHAEL ENGLEMAN,
JEFF NICHOLS, VALERIE CARRILLO**
Client: **CMT**

Creative Firm: **ACART COMMUNICATIONS — OTTAWA, ON, CANADA**
Creative Team: **TOM MEGGINSON, VERNON LAI, CRAIG CEBRYK,
KELLY MACNAULL, CHANTAL VALLERAND**
Client: **OTTAWA SENATORS HOCKEY CLUB**

Creative Firm: **MTV ON AIR PROMOS — NEW YORK, NY**
Creative Team: **MATT JABLIN, JOE STEVENS, SHEREE SHU,
PAT DONNELLY, REGINA CROWLEY, CRANDALL MILLER**
Client: **MTV**

Creative Firm: **BONNEVILLE COMMUNICATIONS
— SALT LAKE CITY , UT**
Creative Team: **ERIC MORGAN**
Client: **HUNTSMAN CANCER INSTITUTE**

Creative Firm: **IM-AJ COMMUNICATIONS & DESIGN, INC.**
— WEST KINGSTON, RI
Creative Team: **JAMI OUELLETTE, KRIS ALLARD**
Client: **CROSSROADS RHODE ISLAND**

Creative Firm: **IM-AJ COMMUNICATIONS & DESIGN, INC.**
— WEST KINGSTON, RI
Creative Team: **JAMI OUELLETTE, KRIS ALLARD**
Client: **RHODE ISLAND HOUSING**

Creative Firm: **KELLER CRESCENT — EVANSVILLE, IN**
Creative Team: **RANDALL ROHN, LEE BRYANT, RANDY ROHN,
JOHN CHADDOCK, CARSON CATLIN**
Client: **RIVERVIEW HOSPITAL**

Creative Firm: **A3 DESIGN — CHARLOTTE, NC**
Creative Team: **ALAN ALTMAN, AMANDA ALTMAN**
Client: **MATTAMY HOMES**

Creative Firm: **PHP COMMUNICATIONS — BIRMINGHAM, AL**
Creative Team: **BRYAN CHACE, JASON RUHA, RUTH GREER**
Client: **BRADFORD HEALTH SERVICES**

Creative Firm: **NBC UNIVERSAL GLOBAL NETWORKS ITALIA — ROME, ITALY**
Client: **STUDIO UNIVERSAL**

Creative Firm: **NICKELODEON — NEW YORK, NY**
Creative Team: **FRANK CZUCHAN, MARIANNE VOLCHEK, SAMANTHA BERGER, AARON MCDANNELL**

Creative Firm: **NICKTOONS — NEW YORK, NY**
Creative Team: **TERRY MCCORMICK, SUE KIM, YORK CAPISTRANO**
Client: **NICKTOONS NETWORK**

Creative Firm: **NBC UNIVERSAL GLOBAL NETWORKS ITALIA — ROME, ITALY**
Client: **STUDIO UNIVERSAL**

Creative Firm: **NICKELODEON — NEW YORK, NY**
Creative Team: **FRANK CZUCHAN, STACY KAPNER, AARON MCDANNELL,
SAMANTHA BERGER, JASON ZEMLICKA**
Client: **NICK CREATIVE RESOURCES**

Creative Firm: **MTV ON AIR PROMOS — NEW YORK, NY**
Creative Team: **AARON STOLLER, MATTHEW GIULVEZAN, BART SMITH, BRYAN NEWMAN, CRANDALL MILLER, PAUL GOLDMAN**
Client: **MTV**

Creative Firm: **MTV ON AIR PROMOS — NEW YORK, NY**
Creative Team: **ANTONIO MCDONALD, KADINE ANCKLE, GRAYSON ROSS, DAVID FERRARA, ANDREA PURCIGLIOTTI, LUKE CHOI**
Client: **MTV2**

Creative Firm: **MTV ON AIR PROMOS — NEW YORK, NY**
Creative Team: **DAVID HOROWITZ, BETSY BLAKEMORE, MARTIN AHLGREN, NATHAN BYRNE, PAUL GOLDMAN**
Client: **MTV**

Creative Firm: **MTV ON AIR PROMOS — NEW YORK, NY**
Creative Team: **MATT JABLIN, SEYI PETER-THOMAS, SHEREE SHU, PAT DONNELLY, MARK SNELGROVE, REBECCA GWYNNE**
Client: **MTVU**

Creative Firm: **NICKTOONS — NEW YORK, NY**
Creative Team: **TERRY MCCORMICK, SUE KIM, KEN WEBB**
Client: **NICKTOONS NETWORK**

Creative Firm: **PENNY/OHLMANN/NEIMAN — DAYTON, OH**
Creative Team: **PAUL LINDAMOOD**
Client: **KETTERING MEDICAL CENTER**

Creative Firm: **RODGERS TOWNSEND — ST. LOUIS, MO**
Creative Team: **TOM HUDDER, MIKE DILLON, BOB WENDT, DIGITAL KITCHEN**
Client: **AT&T**

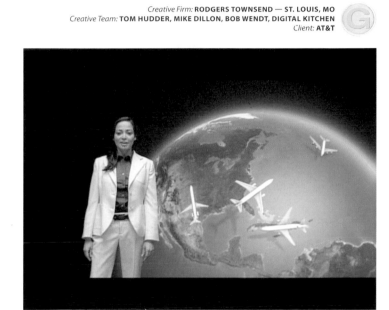

Creative Firm: **RODGERS TOWNSEND — ST. LOUIS, MO**
Creative Team: **TOM HUDDER, MIKE DILLON, BOB WENDT, STEFAN WUERNITZER, DIGITAL KITCHEN**
Client: **AT&T**

Creative Firm: **HERE! NETWORKS — NEW YORK, NY**
Creative Team: **ERIC FELDMAN**

PUBLIC SERVICE TV, *SINGLE*

Creative Firm: **TAXI CANADA INC. — TORONTO, ON, CANADA**
Creative Team: **ZAK MROUEH, ANNE MARIE MARTIGNAGO, REGINALD PIKE , CHRISTINA HUMPHRIES, TERRY TOMPKINS, RENEE MACCARTHY**
Client: **COVENANT HOUSE**

Creative Firm: **BONNEVILLE COMMUNICATIONS — SALT LAKE CITY , UT**
Creative Team: **STEPHEN WUNDERLI**
Client: **DESERET INDUSTRIES**

Creative Firm: **& WOJDYLA ADVERTISING — CHICAGO, IL**
Creative Team: **DAVID WOJDYLA, DONNA MARIE ARTUSO, BARRY SEIDMAN**
Client: **FOUNDATION FOR BIOMEDICAL RESEARCH**

Creative Firm: **BONNEVILLE COMMUNICATIONS — SALT LAKE CITY , UT**
Creative Team: **STEPHEN WUNDERLI**
Client: **DESERET INDUSTRIES**

Creative Firm: **NICKELODEON — NEW YORK, NY**
Creative Team: **FRANK CZUCHAN, HOLLY GREGORY, SAMANTHA BERGER, ANNA YOON**
Client: **NICK CREATIVE RESOURCES**

 Creative Firm: **BONNEVILLE COMMUNICATIONS — SALT LAKE CITY , UT**
Creative Team: **STEPHEN WUNDERLI**
Client: **DESERET INDUSTRIES**

Creative Firm: **& WOJDYLA ADVERTISING — CHICAGO, IL**
Creative Team: **MICHAEL JOHN, FRANKIE TRULL, DAVID WOJDYLA, BAXTER BLACK**
Client: **FOUNDATION FOR BIOMEDICAL RESEARCH**

Creative Firm: **CAKE — POMONA, CA**
Creative Team: **KEVIN RAICH**
Client: **AMERICAN RED CROSS BLOOD SERVICES, WEST DIVISION**

Creative Firm: **MTV ON AIR PROMOS — NEW YORK, NY**
Creative Team: **ALAN HARRIS, GINA HARRELL, MARYSE ALBERTI, RICHARD LASALLE, BRAD TURNER, DAN O'SULLIVAN**
Client: **MTV**

Creative Firm: *MCCANN ERICKSON, NEW YORK — NEW YORK, NY*
Creative Team: **STEVE OHLER, GEORGE DEWEY, REGAN WARNER, JOYCE KING THOMAS, DAVID SHANE, CORI H. RANZER**
Client: **UNITED NATIONS**

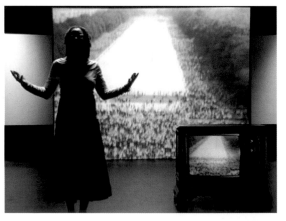

Creative Firm: **TV LAND — NEW YORK, NY**
Creative Team: **K. ROSENBLUM, D. NEWMAN, S. PETERSON, K. FIELDS, C. MOST, T. MONYEE, J. GOODE, B. SIA**
Client: **TV LAND**

Creative Firm: *SPIKE TV — NEW YORK, NY*
Creative Team: **LOEPOLTO GOUT, TERRY MINOGUE, OBI ONYEJEKWE, BOB SALAZAR, KEIF MATERA, NIELS SCHUURMANS**
Client: **SPIKE**

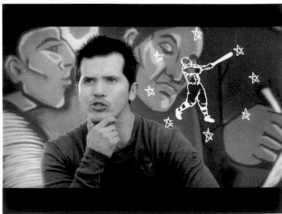

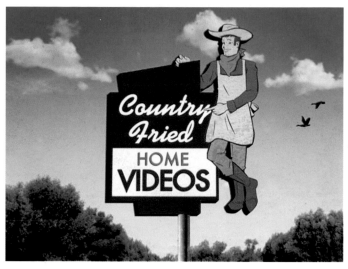

Creative Firm: **CMT — NEW YORK, NY**
Creative Team: **JAMES HITCHCOCK, MICHAEL ENGLEMAN, AMIE NGUYEN, ADOLESCENT**
Client: **CMT**

Creative Firm: **NBC UNIVERSAL GLOBAL NETWORKS ITALIA — ROME, ITALY**
Client: **STUDIO UNIVERSAL**

Creative Firm: **MTV ON AIR DESIGN — NEW YORK, NY**
Creative Team: **JEFFREY KEYTON, ROMY MANN, RODGER BELKNAP, RAFFAELA SACCONE, PSYOP**
Client: **MTV ON AIR DESIGN**

Creative Firm: **TV LAND — NEW YORK, NY**
Creative Team: **KIM ROSENBLUM, KENNA KAY, MARC NAHAS, MELISSA NEELEY, JOHN KARIAN, CATHERINE MULCAHY**
Client: **TV LAND**

Creative Firm: **KARACTERS DESIGN GROUP/DDB CANADA — VANCOUVER, BC, CANADA**
Creative Team: **MARIA KENNEDY, DANIEL JENETT, MONICA MARTINEZ, CATHARINE CHESTERMAN, CLINTON HUSSEY, HELEN WYNNE**
Client: **CANADIAN TOURISM COMMISSION**

Creative Firm: **SPIKE TV — NEW YORK, NY**
Creative Team: **BUCK , REG PUNLA, ALAN ROLL, JEN BROGLE, BOB SALAZAR**
Client: **SPIKE**

Creative Firm: **CMT — NEW YORK, NY**
Creative Team: **JAMES HITCHCOCK, MICHAEL ENGLEMAN, AMIE NGUYEN, DAVID BENNETT, FULLTANK**
Client: **CMT**

Creative Firm: **CMT — NEW YORK, NY**
Creative Team: **JAMES HITCHCOCK, MICHAEL ENGLEMAN, AMIE NGUYEN, DAVID WRIGHT, TRANSISTOR (LA) ,**
Client: **CMT**

Creative Firm: **NICKELODEON — NEW YORK, NY**
Creative Team: **THERESA FITZGERALD, TAMAR SAMIR, ADOLESCENT, KATIE BRACK, MCPAUL SMITH, CHRISTINA AUGUSTINOS**
Client: **NICKELODEON ON-AIR**

Creative Firm: **NBC UNIVERSAL GLOBAL NETWORKS ITALIA — ROME, ITALY**
Client: **STUDIO UNIVERSAL**

Creative Firm: **NBC UNIVERSAL GLOBAL NETWORKS ITALIA — ROME, ITALY**
Client: **STUDIO UNIVERSAL**

Creative Firm: **NBC UNIVERSAL GLOBAL NETWORKS ITALIA — ROME, ITALY**
Client: **STUDIO UNIVERSAL**

Creative Firm: **SPIKE TV — NEW YORK, NY**
Creative Team: **OBI ONYEJEKWE, TERRY MINOGUE, SCOTT FISHMAN, NIELS SCHUURMANS, JUSTIN GALLAHER, ALAN ROLL**
Client: **SPIKE**

Creative Firm: **NBC UNIVERSAL GLOBAL NETWORKS ITALIA — ROME, ITALY**
Client: **STUDIO UNIVERSAL**

Creative Firm: **NBC UNIVERSAL GLOBAL NETWORKS ITALIA — ROME, ITALY**
Client: **STUDIO UNIVERSAL**

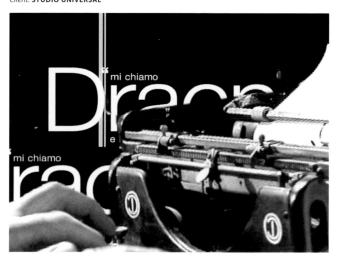

Creative Firm: **CMT — NEW YORK, NY**
Creative Team: **JAMES HITCHCOCK, MICHAEL ENGLEMAN, AMIE NGUYEN, EYEBALL NYC**
Client: **CMT**

Creative Firm: **CMT — NEW YORK, NY**
Creative Team: **JAMES HITCHCOCK, MICHAEL ENGLEMAN, JEFF NICHOLS, EYEBALL NYC**
Client: **CMT**

Creative Firm: **NBC UNIVERSAL GLOBAL NETWORKS ITALIA — ROME, ITALY**
Client: **STUDIO UNIVERSAL**

Creative Firm: **NICKELODEON — NEW YORK, NY**
Creative Team: **THERESA FITZGERALD, TAMAR SAMIR, ADOLESCENT, RICH BARRY, MIKE SARNOSKI, VIRCILLO JOHN**
Client: **NICKELODEON ON-AIR**

Creative Firm: **CMT — NEW YORK, NY**
Creative Team: **JAMES HITCHCOCK, MICHAEL ENGLEMAN, CARLA DAENINCKX, BRAND NEW SCHOOL (NY)**
Client: **CMT**

Creative Firm: **NBC UNIVERSAL GLOBAL NETWORKS ITALIA — ROME, ITALY**
Client: **STUDIO UNIVERSAL**

Creative Firm: **NICKELODEON — NEW YORK, NY**
Creative Team: **THERESA FITZGERALD, TAMAR SAMIR, ANTHONY ZAZZI, TASO MASTORAKIS, JONATHAN JUDGE, ROSS ALVORD**
Client: **NICKELODEON ON-AIR**

Creative Firm: **MTV ON AIR DESIGN — NEW YORK, NY**
Creative Team: **JEFFREY KEYTON, ROMY MANN, RODGER BELKNAP, DAVID MCELWAINE, RAFFAELA SACCONE**
Client: **MTV ON AIR DESIGN**

Creative Firm: **CMT — NEW YORK, NY**
Creative Team: **JAMES HITCHCOCK, MICHAEL ENGLEMAN, CARLA DAENINCKX, SCOTT GERLOCK, RYAN ROWLAND, FREESTYLE COLLECTIVE**
Client: **CMT**

Creative Firm: **LOGO — NEW YORK, NY**
Creative Team: **NANCY BENNETT, TOM BAYER, GARRETT WAGNER, GREG HAHN, DAVID BARRON**
Client: **LOGO PROGRAMMING**

IN-THEATER

Creative Firm: **TAXI CANADA INC. — TORONTO, ON, CANADA**
Creative Team: **ZAK MROUEH, DAVE DOUGLASS, PETE BRETON, JENNIFER METE, BRIAN LEE HUGHES, AARON DARK**
Client: **WORLD OF COMEDY**

CORPORATE FILM

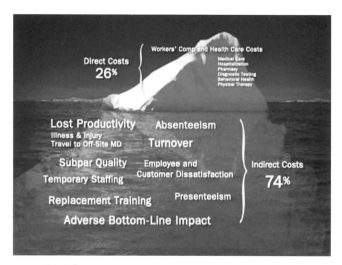

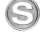
Creative Firm: **KAREN SKUNTA & COMPANY — CLEVELAND, OH**
Creative Team: **KAREN SKUNTA, RON GOLDFARB, JOHN LAGUARDIA, KEVIN PERLIC, JAMIE FINKELHOR, JENNIFER MAXWELL**
Client: **WHOLE HEALTH MANAGEMENT INC.**

PUBLIC SERVICE

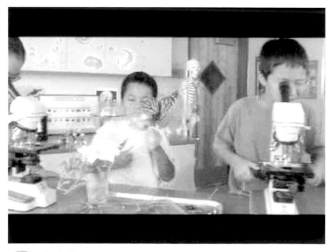

Creative Firm: **EFFECTIVENESS THROUGH COMMUNICATION — EL CAJON, CA**
Creative Team: **ALLISON FIERLIT**
Client: **ELEMENTARY INSTITUTE OF SCIENCE**

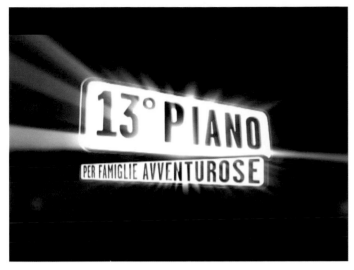

Creative Firm: **NBC UNIVERSAL GLOBAL NETWORKS ITALIA — ROME, ITALY**
Client: **13TH FLOOR**

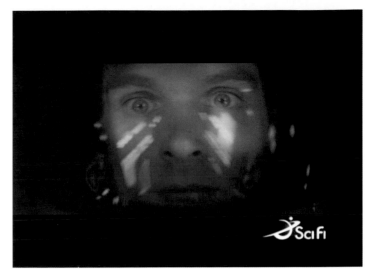

Creative Firm: **NBC UNIVERSAL GLOBAL NETWORKS ITALIA — ROME, ITALY**
Client: **SCI FI CHANNEL**

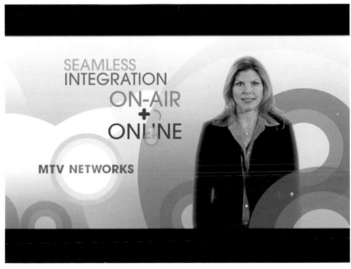

Creative Firm: **MTV NETWORKS CREATIVE SERVICES — NEW YORK, NY**

Creative Firm: **MTV NETWORKS CREATIVE SERVICES — NEW YORK, NY**

Creative Firm: **G2 — NEW YORK, NY**
Creative Team: **KC TAGLIANO**
Client: **G2**

SALES FILM

AOL Health reaches 1.6MM monthly unique A50+ [2]

Creative Firm: **AOL | 360 CREATIVE — NEW YORK, NY**
Creative Team: **ANTHONY FARIA, RICHARD TAYLOR, ERIC LANE, HELEN LEE, ERIKA ALONSO**
Client: **AOL MEDIA NETWORKS**

Creative Firm: **AOL | 360 CREATIVE — NEW YORK, NY**
Creative Team: **DAVID DEBENEDETTO, MARIO ARIAS, JEFF BAYSON, ERIKA ALONSO**
Client: **AOL MEDIA NETWORKS**

Creative Firm: **AOL | 360 CREATIVE — NEW YORK, NY**
Creative Team: **DAVID DEBENEDETTO, CHICO CONDE, JACK TIRANASAR, ERIC LANE, TOM POLLEY, ERIKA ALONSO**
Client: **AOL MEDIA NETWORKS**

Creative Firm: **AOL | 360 CREATIVE — NEW YORK, NY**
Creative Team: **DAVID DEBENEDETTO, ERIKA ALONSO**
Client: **AOL MEDIA NETWORKS**

364

TRAINING FILM

Creative Firm: **MIND & MEDIA — ALEXANDRIA, VA**
Creative Team: **ROBERT DEEGE, BERRY BLANTON, JULIE NOONE, JASON HUNTER**
Client: **ARMY NATIONAL GAURD**

AUDIO-VISUAL

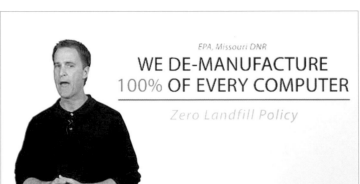

Creative Firm: **SNAP CREATIVE — ST. CHARLES, MO**
Creative Team: **ANGELA NEAL, HILARY CLEMENTS**
Client: **EPC**

RADIO, *SINGLE*

Entry Title: **JIMMY4 - YOUTH CENTS**
Creative Firm: **BONNEVILLE COMMUNICATIONS — SALT LAKE CITY , UT**
Creative Team: **ERIC MORGAN**
Client: **DESERET FIRST CREDIT UNION**

Entry Title: **JIMMY7 - 50TH ANNIVERSARY**
Creative Firm: **BONNEVILLE COMMUNICATIONS — SALT LAKE CITY , UT**
Creative Team: **ERIC MORGAN**
Client: **DESERET FIRST CREDIT UNION**

Entry Title: **JIMMY1 - 15YR MORTGAGE**
Creative Firm: **BONNEVILLE COMMUNICATIONS — SALT LAKE CITY , UT**
Creative Team: **ERIC MORGAN**
Client: **DESERET FIRST CREDIT UNION**

Entry Title: **JIMMY3 - HOME LOANS**
Creative Firm: **BONNEVILLE COMMUNICATIONS — SALT LAKE CITY , UT**
Creative Team: **ERIC MORGAN**
Client: **DESERET FIRST CREDIT UNION**

Entry Title: **TO HAVE & TO HOLD**
Creative Firm: **ADVANTAGE LTD — HAMILTON, BERMUDA**
Creative Team: **SAMI LILL**
Client: **WOMEN'S RESOURCE CENTRE**

Entry Title: **CALIFORNIA CLASSICS (:30)**
Creative Firm: **HOFFMAN/LEWIS — SAN FRANCISCO, CA**
Creative Team: **SHARON KRINSKY, PATTI BOTT**
Client: **BEV MO**

Entry Title: **DRIVE SAFETY-THINK!**
Creative Firm: **ALL MEDIA PROJECTS LIMITED — PORT OF SPAIN, TRINIDAD AND TOBAGO**
Creative Team: **ANTHONY MOORE, JOSIANE KHAN, RICHARD AHONG**
Client: **BP TRINIDAD AND TOBAGO (BPTT)**

Entry Title: **FIVE CENT SALE: HOOKED SALE ON (:60)**
Creative Firm: **HOFFMAN/LEWIS — SAN FRANCISCO, CA**
Creative Team: **SHARON KRINSKY, PATTI BOTT**
Client: **BEV MO**

Entry Title: **BUTTERFLIES, PANTHERS & BIRDS, OH MY!**
Creative Firm: **2 WOMEN & A COMPUTER — GAINESVILLE, FL**
Creative Team: **LINDA CONWAY CORRELL, LARRY LYALL, STEPHEN BAKER, MIRROR IMAGE**
Client: **DAY QUILTERS OF ALACHUA COUNTY**

Entry Title: **HAUNT RADIO (:30)**
Creative Firm: **HITCHCOCK FLEMING & ASSOCIATES INC.— AKRON, OH**
Creative Team: **NICK BETRO, GREG PFIFFNER, MIKE MICKLEY**
Client: **GEAUGA LAKE**

Entry Title: **OCTOBERFEST RADIO (:30)**
Creative Firm: **HITCHCOCK FLEMING & ASSOCIATES INC. — AKRON, OH**
Creative Team: **NICK BETRO, GREG PFIFFNER, MIKE MICKLEY**
Client: **GEAUGA LAKE**

Entry Title: **FIVE CENT SALE: HOOKED SALE ON (:30)**
Creative Firm: **HOFFMAN/LEWIS — SAN FRANCISCO, CA**
Creative Team: **SHARON KRINSKY, PATTI BOTT**
Client: **BEV MO**

Entry Title: **JIMMY8 - FOOTBALL**
Creative Firm: **BONNEVILLE COMMUNICATIONS — SALT LAKE CITY , UT**
Creative Team: **ERIC MORGAN**
Client: **DESERET FIRST CREDIT UNION**

Entry Title: **TWO-FERS**
Creative Firm: **KELLER CRESCENT — EVANSVILLE, IN**
Creative Team: **RANDALL ROHN, JOHN CHADDOCK, RANDY ROHN, JOHN MENELLA**
Client: **MCDONALDS**

Entry Title: **INNER VOICE**
Creative Firm: **KELLER CRESCENT — EVANSVILLE, IN**
Creative Team: **RANDALL ROHN, JOHN CHADDOCK, RANDY ROHN**
Client: **LOCAL MCDONALDS**

Entry Title: **WHOOPIE DOOPIE DOO**
Creative Firm: **KELLER CRESCENT — EVANSVILLE, IN**
Creative Team: **RANDALL ROHN, JOHN CHADDOCK, RANDY ROHN**
Client: **SPRINT/UBIQUITEL**

Entry Title: **SAME AS IT EVER WAS RADIO**
Creative Firm: **CREATIVE ALLIANCE — LOUISVILLE, KY**
Creative Team: **ERIC HAHN**
Client: **EON US**

RADIO, *CAMPAIGN*

Entry Title: **DESERET FIRST CREDIT UNION CAMPAIGN 05**
Creative Firm: **BONNEVILLE COMMUNICATIONS — SALT LAKE CITY , UT**
Creative Team: **ERIC MORGAN**
Client: **DESERET FIRST CREDIT UNION**

Entry Title: **DESERET FIRST CREDIT UNION CAMPAIGN 06**
Creative Firm: **BONNEVILLE COMMUNICATIONS — SALT LAKE CITY , UT**
Creative Team: **ERIC MORGAN**
Client: **DESERET FIRST CREDIT UNION**

Entry Title: **VOLVO - "YOU WON'T WANT YOUR FRIENDS TO KNOW"**
Creative Firm: **BURROWS — BRENTWOOD, ESSEX, UNITED KINGDOM**
Creative Team: **ROYDON HEARNE, AARON HULSIZER, LUCY WELDON**
Client: **VOLVO CARS UK**

Entry Title: **STOP HIV/AIDS DISCRIMINATION**
Creative Firm: **ALL MEDIA PROJECTS LIMITED — PORT OF SPAIN, TRINIDAD AND TOBAGO**
Creative Team: **ANTHONY MOORE, CARL HARDING, RICHARD AHONG**
Client: **SFA COMMUNICATIONS**

Entry Title: **QUIZ SHOW/NICKNAMES/SMALL BUSINESS/BIG THINKING**
Creative Firm: **MCCANN ERICKSON, NEW YORK — NEW YORK, NY**
Creative Team: **MIKE JOINER, YANA GOODSTEIN, JOYCE KING THOMAS, STEVE OHLER, KIRK CAMPION, JUDI NIERMAN**
Client: **BUDGET**





Creative Firm: **ALOFT GROUP, INC. — NEWBURYPORT, MA**
Creative Team: **MATT BOWEN, DON CRANE, BRENT MARTINO, ROBBIE MACDONALD, STEVEN BALESTA**
Client: **ALOFT GROUP, INC.**

ONLINE CATALOGS

Creative Firm: **SINGULARITY DESIGN, INC. — PHILADELPHIA, PA**
Creative Team: **CHRIS COUNTER, JOSHUA COHEN, JEFF GREENHOUSE**
Client: **CARLISLE WIDE PLANK FLOORS**

BANNER ADS, *SINGLE*

Creative Firm: **CRITICAL MASS INC. — CALGARY, AB, CANADA**
Creative Team: **ANDREW ZOLLER, ROB SAWCHUCK, SANJAI DAVE, DUANE WHEATCROFT, CHANTELLE ZANDBEEK**
Client: **LAS VEGAS CONVENTION AND VISITORS AUTHORITY**

Creative Firm: **AOL | 360 CREATIVE — NEW YORK, NY**
Creative Team: **DAVID DEBENEDETTO, CHICO CONDE, CHANTAL BOTANA, BRUCE KIMERER, ERIKA ALONSO,**
Client: **AOL MEDIA NETWORKS**

THE VOVLO XC90 D5
FROM £399 A MONTH*

FROM £399 A MONTH

CLICK HERE
FOR MORE

Creative Firm: **BURROWS — BRENTWOOD, ESSEX, UNITED KINGDOM**
Creative Team: **ROYDON HEARNE, ANDREW NICHOLSON,**
MICHAEL NAMAN, AARON HULSIZER, LUCY WELDON
Client: **VOLVO CARS UK**

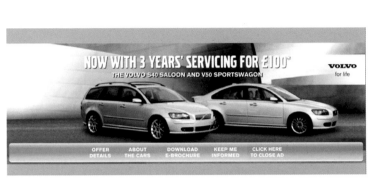

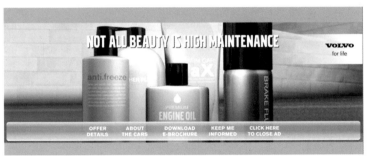

Creative Firm: **BURROWS — BRENTWOOD, ESSEX,**
UNITED KINGDOM
Creative Team: **ROYDON HEARNE, MARK ELLIS,**
DARRYL SMITH, AARON HULSIZER, LUCY WELDON
Client: **VOLVO CARS UK**

Creative Firm: **BURROWS — BRENTWOOD, ESSEX, UNITED KINGDOM**
Creative Team: **ROYDON HEARNE, DARRYL SMITH, AARON HULSIZER,**
DARREN POORE, LUCY WELDON
Client: **VOLVO CARS UK**

Creative Firm: **BURROWS — BRENTWOOD, ESSEX, UNITED KINGDOM**
Creative Team: **ROYDON HEARNE, ANDREW NICHOLSON,**
DARRYL SMITH, AARON HULSIZER, LUCY WELDON
Client: **VOLVO CARS UK**

Creative Firm: **BURROWS — BRENTWOOD, ESSEX, UNITED KINGDOM**
Creative Team: **ROYDON HEARNE, DARRYL SMITH,**
AARON HULSIZER, LUCY WELDON
Client: **VOLVO CARS UK**

 Creative Firm: **GIDEON MULTIMEDIA — SPLIT , CROATIA (HRVATSKA)**
Creative Team: **ALEN ALEBIC, VEDRAN ELEZ, SINISA ERCEGOVAC, SANJA MIROSEVIC, VLADIMIR STERLE, MARIO BARICEVIC**
Client: **O'REILLY & JONES DISTRIBUTON**

Creative Firm: **GIDEON MULTIMEDIA — SPLIT , CROATIA (HRVATSKA)**
Creative Team: **ALEN ALEBIC, VEDRAN ELEZ, SINISA ERCEGOVAC, SANJA MIROSEVIC, VLADIMIR STERLE, MARIO BARICEVIC**
Client: **TOURIST BOARD OF BRELA**

Creative Firm: **GIDEON MULTIMEDIA — SPLIT , CROATIA (HRVATSKA)**
Creative Team: **ALEN ALEBIC, VEDRAN ELEZ, SINISA ERCEGOVAC, SANJA MIROSEVIC, VLADIMIR STERLE, MARIO BARICEVIC**
Client: **TOURIST BOARD OF SPLIT**

Creative Firm: **INFORMATION EXPERTS** — RESTON, VA
Creative Team: **RONA KILMER, MARK HENRY**
Client: **WORLD BANK**

Creative Firm: **ZUNDA GROUP LLC** — SOUTH NORWALK, CT
Creative Team: **CHARLES ZUNDA, DANIEL PRICE, JOHN GEOGHEGAN**
Client: **ZUNDA GROUP LLC**

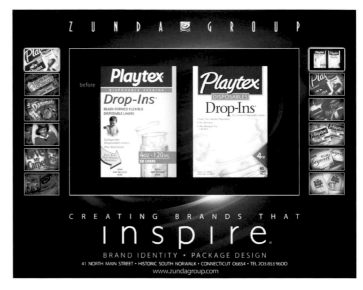

Creative Firm: **RUSTY GEORGE DESIGN** — TACOMA, WA
Creative Team: **BURT CRISMORE, RUSTY GEORGE DESIGN**
Client: **DEPARTMENT OF NATURAL RESOURCES**

Creative Firm: **KUTOKA INTERACTIVE** — MONTREAL, QC, CANADA
Creative Team: **RICHARD VINCENT, TANYA CLAESSENS, NADINE ROBERT,
CHRISTINE MIMEAULT, ALEXANDER LESSARD**

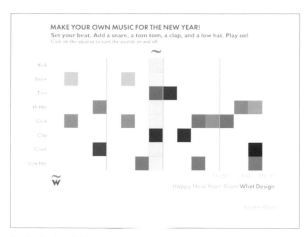

Creative Firm: **WHET DESIGN, INC. — NEW YORK, NY**
Creative Team: **CHERYL OPPENHEIM, YOHEI TAKESHITA, STEVE GU**
Client: **WHET DESIGN, INC.**

Creative Firm: **WHET DESIGN, INC. — NEW YORK, NY**
Creative Team: **CHERYL OPPENHEIM, JOHN WATERS, YOHEI TAKESHITA**
Client: **WHET DESIGN, INC.**

Creative Firm: **DESIGN 446 — MANASQUAN, NJ**
Creative Team: **BRIAN STERN**
Client: **DESIGN 446**

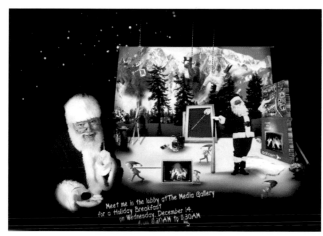

Creative Firm: **AOL | 360 CREATIVE — NEW YORK, NY**
Creative Team: **ANTHONY FARIA, CHICO CONDE, BARRY GARBARINO, ERIKA ALONSO**
Client: **AOL MEDIA NETWORKS**

Creative Firm: **JPL PRODUCTIONS — HARRISBURG, PA**
Creative Team: **CHELSIE MARKEL, KATY BASTAS, JAMY KUNJAPPU, SERENA FEDOR**
Client: **THE HERSHEY COMPANY**

Creative Firm: **CRITICAL MASS — CALGARY, AB, CANADA**
Creative Team: **RICHARD ALBORNOZ, COLIN LEACH**
Client: **ALBERTSONS**

E-ZINES

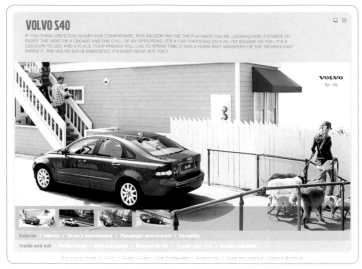

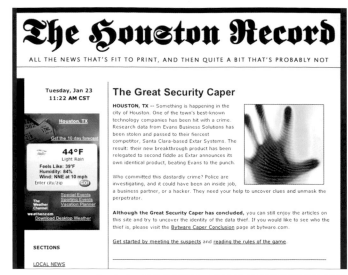

Creative Firm: **BURROWS — BRENTWOOD, ESSEX, UNITED KINGDOM**
Creative Team: **ROYDON HEARNE, ED SMITH, JON JUKES, AARON HULSIZER, LUCY WELDON**
Client: **VOLVO CARS UK**

Creative Firm: **STELLAR DEBRIS — HADANO-SHI, KANAGAWA-KEN, JAPAN**
Creative Team: **CHRISTOPHER JONES**
Client: **BYTWARE, INC.**

GAMES

Creative Firm: **LEVERAGE MARKETING GROUP — NEWTOWN, CT**
Creative Team: **DAVID GOODWICK, MIKE NOVIA, BECKY KOROL, MATT JAY, TOM MARKS, HARRIET POLANSKY**
Client: **NOVACHEM**

Creative Firm: **INFORMATION EXPERTS — RESTON, VA**
Creative Team: **ELICIA ROBERTS, ADRIENNE YOUNG**
Client: **BELLSOUTH**

Creative Firm: **COMEDY CENTRAL — NEW YORK, NY**
Creative Team: **KAREN LA CHIANA, BEN WINIARCZK, JESSE WILLMON, JULIE ANN PIETRANGELO, BETH LEWAND, PAUL BEDDOE-STEPHENS**
Client: **COMEDY CENTRAL**

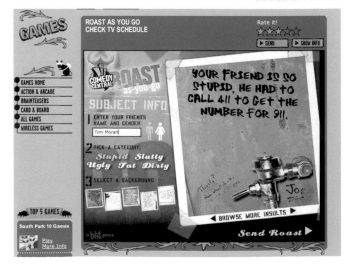

Creative Firm: **ACART COMMUNICATIONS — OTTAWA, ON, CANADA**
Creative Team: **SOPHIE JALBERT, SARAH DESCHAMPS, VERNON LAI, TOM MEGGINSON, CASEY TOURANGEAU, JASON HAMILTON**
Client: **CANADIAN AUTOMOBILE ASSOCIATION**
WWW.CANADASROADS.COM

Creative Firm: **WHET DESIGN, INC. — NEW YORK, NY**
Creative Team: **CHERYL OPPENHEIM, YOHEI TAKESHITA, STEVE GU**
Client: **NATIONAL MUSEUM OF WOMEN IN THE ARTS**
WWW.COSTOMISPOT.COM/NMWA/DH

Creative Firm: **PHP COMMUNICATIONS — BIRMINGHAM, AL**
Creative Team: **BRYAN CHACE, LYNN SMITH, DREW SMITH**
Client: **LEADERSHIP BIRMINGHAM**
WWW.LEADERSHIPBIRMINGHAM.ORG

Creative Firm: **VERY MEMORABLE DESIGN — NEW YORK, NY**
Creative Team: **MICHAEL PINTO**
Client: **PBS.ORG**
WWW.PBS.ORG/NOW/SHOWS/234/ELECTION-2006-TOOL.HTML

Creative Firm: **PHP COMMUNICATIONS — BIRMINGHAM, AL**
Creative Team: **BRYAN CHACE, KELLY POIRIER, DREW SMITH**
Client: **YOUTH LEADERSHIP FORUM**
WWW.YLFBHAM.COM

Creative Firm: **Q — WIESBADEN, GERMANY**
Creative Team: **THILO VON DEBSCHITZ, MARKUS REWELAND,
GERHARD HEILAND, LAURENZ NIELBOCK, ALEXANDER WEINL**
Client: **BOEHRINGER INGELHEIM**
WWW.TINGUELY.SEEMEGROW.DE

Creative Firm: **LF BANKS + ASSOCIATES — PHILADELPHIA, PA**
Creative Team: **LORI BANKS, TRAVIS SCHNUPP**
Client: **FELDMAN SHEPHERD WOHLGELERNTER TANNER & WEINSTOCK**
WWW.SPINABIFIDALAW.COM

Creative Firm: **RODGERS TOWNSEND — ST. LOUIS, MO**
Creative Team: **TOM HUDDER, SCOTT LAWSON, MIKE HALBROOK, SHAUN YOUNG**
Client: **NETWORK FOR GOOD**
RODGERSTOWNSEND.COM/INTERACTIVE/NETWORK FORGOOD

Creative Firm: **SINGULARITY DESIGN, INC. — PHILADELPHIA, PA**
Creative Team: **OWEN LINTON, JOSHUA COHEN**
Client: **AMERICAN RED CROSS - SEPA CHAPTER**
WWW.REDCROSS-PHILLY.ORG

Creative Firm: **Q — WIESBADEN, GERMANY**
Creative Team: **MARCEL KUMMERER, THILO VON DEBSCHITZ,
MATTHIAS SCHAAB**
Client: **GALERIE Q**
WWW. ARTCOUNTDOWN.COM

Creative Firm: **MARK DEITCH & ASSOCIATES, INC. — BURBANK, CA**
Creative Team: **DVORJAC RIEMERSMA**
Client: **TEMPLE ALIYAH**
WWW.TEMPLEALIYAH.ORG

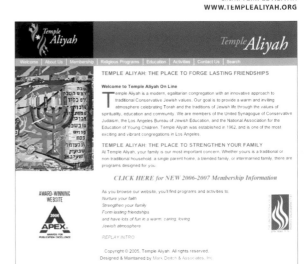

Creative Firm: **30SIXTY ADVERTISING+DESIGN, INC. — LOS ANGELES, CA**
Creative Team: **HENRY VIZCARRA, DUY NGUYEN,
KASEY CHATILA, RICHARD HILARY**
Client: **PARAMOUNT HOME ENTERTAINMENT**
WWW.FERRISBUELLERONDVD.COM

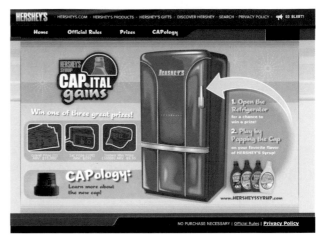
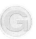

Creative Firm: **JPL PRODUCTIONS — HARRISBURG, PA**
Creative Team: **CHRIS BUCHHOLZ, JIM ROBBINS, MATTHEW BYERS,
JAMY KUNJAPPU, SERENA FEDOR**
Client: **THE HERSHEY COMPANY**
WWW.HERSHEYS.COM/SYRUPCAP

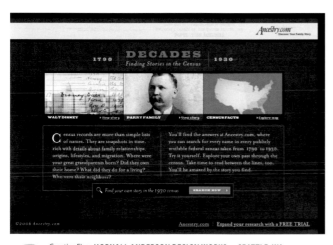

Creative Firm: **HORNALL ANDERSON DESIGN WORKS — SEATTLE, WA**
Creative Team: **JAMIE MONBERG, HANS KREBS, JOE KING,
JASON HICKNER, ADRIEN LO, ERICA GOLDSMITH**
Client: **MY FAMILY**
CENSUS.ANCESTRY.COM/MICROSITE/CENSUS COMPLETE.ASPX

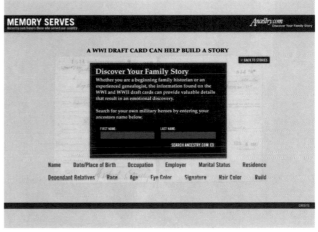

Creative Firm: **HORNALL ANDERSON DESIGN WORKS — SEATTLE, WA**
Creative Team: **NATHAN YOUNG, JOHN CLOSE,
JAMIE MONBERG, ADRIEN LO, ROEL NAVA, MICHELE GODFREY**
Client: **MY FAMILY**
WWW.MEMORYSERVES.COM

Creative Firm: **VERY MEMORABLE DESIGN — NEW YORK, NY**
Creative Team: **MICHAEL PINTO, GWENEVERE SINGLEY**
Client: **SESAME WORKSHOP**
WWW.SESAMEWORKSHOP.ORG/PINKYDINKYDOO/

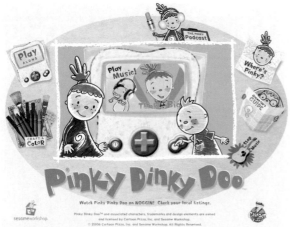

Creative Firm: **ZERO GRAVITY DESIGN GROUP — SMITHTOWN, NY**
Creative Team: **ZERO GRAVITY DESIGN GROUP**
Client: **WOLFFER ESTATE VINEYARD & STABLES**
WWW.WOLFFER.COM

Creative Firm: **PRIMARY DESIGN, INC.** — HAVERHILL, MA
Creative Team: **JEN DICKERT, VITA MARINOVA**
Client: **DIRK AND LUCY HERMAN**
WWW.DIRKANDLUCY.COM

Creative Firm: **ZERO GRAVITY DESIGN GROUP** — SMITHTOWN, NY
Client: **TONY D'MATTIA**
WWW.FIZBAND.COM

Creative Firm: **DOUG WILLIAMS & ASSOCIATES**
— VANCOUVER, WA
Creative Team: **CASEY KRIMMEL**
Client: **CARLA THOMPSON**
WWW.CARLATHOMPSON.COM

Creative Firm: **CMT** — NEW YORK, NY
Creative Team: **MARTIN CLAYTON, DONNA PRIESMEYER, LORI REEVES,
BEN FRANK, CALVIN GILBERT, JASON HILL**
Client: **CMT / CMT.COM**
WWW.CMT.COM/SHOWS/EVENTS/CMT_MUSIC_AWARDS/
2006/INDEX.JHTML

Creative Firm: **HORNALL ANDERSON DESIGN WORKS** — SEATTLE, WA
Creative Team: **MARK POPICH, HANS KREBS, JAMIE MONBERG, MOBIAM**
Client: **EOS AIRLINES**
WWW.EOSAIRLINES.COM

Creative Firm: **400LB.COMMUNICATIONS** — PITTSBURGH, PA
Creative Team: **NATHAN KRESS, CLINTON GODLESKY**
Client: **SHADY SIDE ACADEMY, PITTSBURGH, PA**
WWW.SHADYSIDEHOCKEY.COM

Creative Firm: **CMT** — NEW YORK, NY
Creative Team: **MARTIN CLAYTON, DONNA PRIESMEYER,
LORI REEVES, MARSHALL WOKSA, CALVIN GILBERT, JASON HILL**
Client: **CMT/CMT.COM**
WWW.CMT.COM/MUSIC/EVENTS/ACM/2006

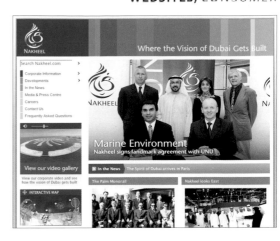

Creative Firm: **GRAFIK MARKETING COMMUNICATIONS**
— ALEXANDRIA, VA
Creative Team: **ARTHUR HSU, JOHNNY VITOROVICH,**
KATHERINE SLACK, HAL SWETNAM, FABIO SILVA
Client: **EYA**
WWW.EYA.COM

Creative Firm: **FUTUREBRAND — NEW YORK, NY**
Creative Team: **STEVE AARON, CARLSON YU, MIKE SHEEHAN,**
TOM LI, SEP SEYEDI, LYUTHA AL-HABSY
Client: **NAKHEEL**
WWW.NAKHEEL.AE/

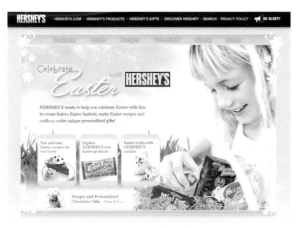

Creative Firm. **JPL PRODUCTIONS — HARRISBURG, PA**
Creative Team: **CHELSIE MARKEL, KATY BASTAS, JAMY KUNJAPPU,**
SERENA FEDOR
Client: **THE HERSHEY COMPANY**
WWW.HERSHEYS.COM/EASTER

Creative Firm: **CJ DESIGN — SANTA CRUZ, CA**
Creative Team: **CHRIS MARK, JT MUDGE**
Client: **AZORES.COM**
WWW.AZORES.COM/

Creative Firm: **KIKU OBATA & COMPANY — ST. LOUIS, MO**
Creative Team: **TROY GUZMAN, TERESA NORTON-YOUNG, STEADY RAIN**
Client: **JAZZ CRUISES, LLC**
WWW.THESMOOTHJAZZCRUISE.COM

Creative Firm: **DESIGN 446 — MANASQUAN, NJ**
Creative Team: **BRIAN STERN**
Client: **RE/MAX**
WWW.SKYVIEWLIVING.COM

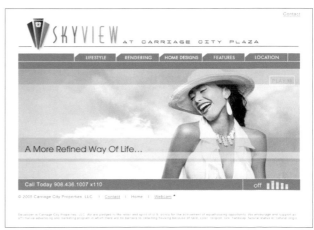

Creative Firm: **HITCHCOCK FLEMING & ASSOCIATES INC. — AKRON, OH**
Creative Team: **NICK BETRO, LARRY YODER, JAMES KIEL,**
MIKE MICKLEY, GREG PFIFFNER
Client: **GOODYEAR TIRE & RUBBER COMPANY**
WWW.DUNLOPTIRES.COM/DRIVERSSEAT

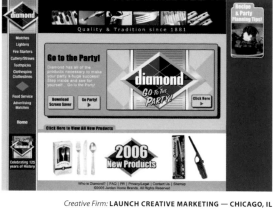

Creative Firm: **LAUNCH CREATIVE MARKETING — CHICAGO, IL**
Creative Team: **JIM GELDER**
Client: **JARDEN**
WWW.DIAMONDBRANDS.COM

Creative Firm: **RODGERS TOWNSEND — ST. LOUIS, MO**
Creative Team: **ERIK MATHRE, RON COPELAND,**
RYAN MCMICHAEL, MIKE HALBROOK, MARK BATEMAN
Client: **SBC COMMUNICATIONS, INC**
WWW.YOURATT.COM/DESTINATION/TREE/INDEX.CFM

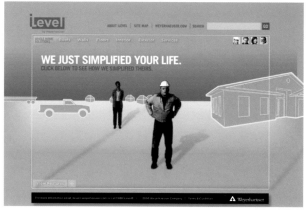

Creative Firm: **HORNALL ANDERSON DESIGN WORKS — SEATTLE, WA**
Creative Team: **J. MONBERG, C. COLLINSWORTH, A. LO, N. YOUNG, J. HICKNER, J. KING,**
D. ROBINSON, J. HILBURN, D. KENOYER, E. GOLDSMITH, J. TEE
Client: **WEYERHAEUSER CORP.**
WWW.ILEVEL.COM

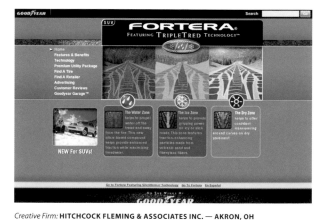

Creative Firm: **HITCHCOCK FLEMING & ASSOCIATES INC. — AKRON, OH**
Creative Team: **NICK BETRO, RENE MCCANN, JAMES KIEL, STEVE LAMB, ERIC HARTLINE**
Client: **GOODYEAR TIRE & RUBBER COMPANY**
WWW.GOODYEARFORTERA.COM./TRIPLETRED

Creative Firm: **TODD CHILDERS GRAPHIC DESIGN — BOWLING GREEN, OH**
Creative Team: **TODD CHILDERS, BONNIE MITCHELL, SUE WEISSHAAR**
Client: **BOWLING GREEN STATE UNIVERSITY SCHOOL OF ART**
WWW.BGSU.EDU/DEPARTMENTS/ART

Creative Firm: **KIKU OBATA & COMPANY — ST. LOUIS, MO**
Creative Team: **TROY GUZMAN, TERESA NORTON-YOUNG, STEADY RAIN**
Client: **JAZZ CRUISES, LLC**
WWW.JAZZCRUISESLLC.COM

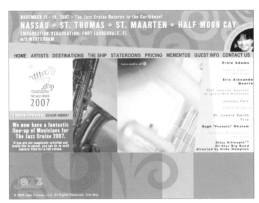

Creative Firm: **KIKU OBATA & COMPANY — ST. LOUIS, MO**
Creative Team: **TROY GUZMAN, TERESA NORTON-YOUNG,
STEADY RAIN**
Client: **JAZZ CRUISES, LLC**
WWW.THEJAZZCRUISE.COM

Creative Firm: **MCCANN ERICKSON, NEW YORK — NEW YORK, NY**
Creative Team: **CRAIG MARKUS, SHALOM AUSLANDER,
JOYCE KING THOMAS, CORI H. BOUDIN , BRENDAN GIBBONS,
PETE FRITZ**
Client: **VERIZON WIRELESS**
HTTPS://VERIZONSUBMISSION.WGEXCHANGE.COM

Creative Firm: **STUDIOERIN — JUPITER, FL**
Client: **RAYMOND ACEVEDO/AFTERWORLD RECORDS**
WWW.AFTERWORLDRECORDS.NET

Creative Firm: **TAXI — MONTRÉAL, QUÉBEC, CANADA**
Creative Team: **DOMINIQUE TRUDEAU, JESSICA MANCHESTER,
ÉMILIE TRUDEAU-RABINOWICZ, MECANO, LA FABRIQUE D'IMAGES, APOLLO**
Client: **DERMETK PHARMACEUTIQUE (ROBERT LAVOIE-PRESIDENT)**
WWW.SEEMORESIDEEFFECTS.CA

Creative Firm: **BOSTON WEB DESIGN — BOSTON, MA**
Client: **NEW ENGLAND COFFEE**
WWW.NEWENGLANDCOFFEE.COM

Creative Firm: **CMT — NEW YORK, NY**
Creative Team: **MARTIN CLAYTON, DONNA PRIESMEYER, LORI REEVES,
MARSHALL WOKSA, CALVIN GILBERT, JASON HILL**
Client: **CMT / CMT.COM**
WWW.CMT.COM/MUSIC/EVENTS/CMA_MUSIC_FESTIVAL/2006

Creative Firm: **SPIDERTEL, INC. — OVERLAND PARK, KS**
Creative Team: **JOE LIEBERMAN**
Client: **DRI DUCK TRADERS**
WWW.DRIDUCKTRADERS.COM

Creative Firm: **JPL PRODUCTIONS — HARRISBURG, PA**
Creative Team: **SHANE HOFFA, KATY BASTAS,**
JIM ROBBINS, JIM MITCHELL, CAROL HUNT
Client: **CAMPUS DOOR**
WWW.INTERNETSTUDENTLOANS.COM/GAME

Creative Firm: **JPL PRODUCTIONS — HARRISBURG, PA**
Creative Team: **BRANDON CRAIG, CHELSIE MARKEL,**
JIM ROBBINS, JAMY KUNJAPPU, SERENA FEDOR
Client: **JERR-DAN CORPORATION**
JERRDAN.COM/INDEX.ASP

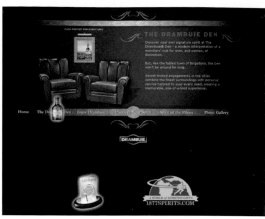

Creative Firm: **MALONEY & FOX — NEW YORK, NY**
Creative Team: **BRIAN MALONEY, MARGIE FOX, DUVAL HOPKINS,**
GILES HANSON, DAVID ORCHARD
Client: **DRAMBUIE**
WWW.SIGNATURESPIRIT.COM

Creative Firm: **CJ DESIGN — SANTA CRUZ, CA**
Creative Team: **CHRIS MARK, JOHN BENEDETTI, QUAN DO**
Client: **AIKANE**
AIKANE.ILUMINADA.COM/

Creative Firm: **SINGULARITY DESIGN, INC. — PHILADELPHIA, PA**
Creative Team: **OWEN LINTON, JOSHUA COHEN**
Client: **CBSW CORPORATION**
WWW.SUBWAYCEDARBROOK.COM

Creative Firm: **30SIXTY ADVERTISING+DESIGN, INC. — LOS ANGELES, CA**
Creative Team: **HENRY VIZCARRA, DAVID FUSCELLARO, KASEY CHATILA, MARISA GHIGLIERI**
Client: **PARAMOUNT HOME ENTERTAINMENT**
WWW.TOMMYBOYONDVD.COM

Creative Firm: **HITCHCOCK FLEMING & ASSOCIATES INC. — AKRON, OH**
Creative Team: **NICK BETRO, STEVE LAMB, ERIC HARTLINE**
Client: **GOODYEAR TIRE & RUBBER COMPANY**
WWW.DUNLOPTIRES.COM

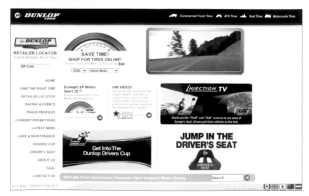

Creative Firm: **KIMBO DESIGN — VANCOUVER, BC, CANADA**
Creative Team: **KIM PICKETT, BUDIANTO NASRUN**
Client: **PEPITAS - MEXICAN SPANISH RESTAURANT**
WWW.PEPITASONBURRARD.COM

Creative Firm: **MCCANN ERICKSON, NEW YORK — NEW YORK, NY**
Creative Team: **SHARON EHRLICH, DANNY RODRIGUEZ,**
JOYCE KING THOMAS, KATHY LOVE, AARON STEWART, MIKE BORIS
Client: **WENDY'S**
HTTPS://WENDYSSUBMISSION1.WGEXCHANGE.COM

Creative Firm: **SINGULARITY DESIGN, INC. — PHILADELPHIA, PA**
Creative Team: **JOSHUA COHEN, CHRIS COUNTER,**
JEFF GREENHOUSE
Client: **CARLISLE WIDE PLANK FLOORS**
WWW.WIDEPLANKFLOORING.COM/

Creative Firm: **FIVE VISUAL COMMUNICATION & DESIGN — WEST CHESTER, OH**
Creative Team: **RONDI TSCHOPP**
Client: **THE VILLAGE SPA SALON**
WWW.THEVILLAGESPASALON.COM

Creative Firm: **CMT — NEW YORK, NY**
Client: **MARTIN CLAYTON, DONNA PRIESMEYER, KIM SORENSEN, MARSHALL WOKSA,**
STEPHANIE PENDERGRASS, CALVIN GILBERT
Client: **CMT / MISS AMERICA ORGANIZATION**
WWW.CMT.COM/SHOWS/EVENTS/MISS_AMERICA/2006/

Creative Firm: **JPL PRODUCTIONS — HARRISBURG, PA**
Creative Team: **CHELSIE MARKEL, PEGGY BRUCK, MICHAEL WETZEL,**
DAVE ROBERTSON, DAN THOMPSON
Client: **HARSCO CORPORATION**
WWW.HARSCO.COM

Creative Firm: **LISKA + ASSOCIATES — CHICAGO, IL**
Creative Team: **STEVE LISKA, MEGHAN MCCLAIN**
Client: **SCHATZ DEVELOPMENT**
WWW.600NORTHFAIRBANKS.COM

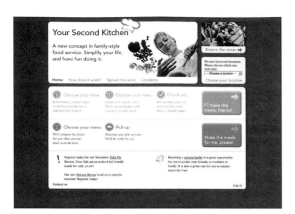

Creative Firm: **BBK STUDIO — GRAND RAPIDS, MI**
Creative Team: **KEVIN BUDELMANN, ALISON POPP, MARIE-CLAIRE CAMP**
Client: **YOUR SECOND KITCHEN**
WWW.YOURSECONDKITCHEN.COM

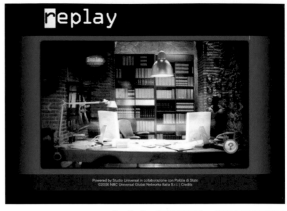

Creative Firm: **FLUILINK SRL — ROME, LAZIO, ITALY**
Creative Team: **GIULIO GIORGETTI, SARA QUINTORIO,
ALFREDO CELAIA, FABIO PALLOTTA**
WWW.STUDIOUNIVERSAL.IT/REPLAY

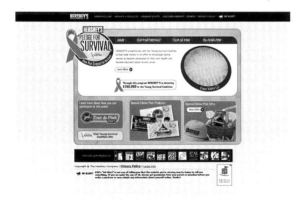

Creative Firm: **KIKU OBATA & COMPANY — ST. LOUIS, MO**
Creative Team: **TROY GUZMAN, TERESA NORTON-YOUNG, STEADY RAIN**
Client: **JAZZ CRUISES, LLC**
WWW.DAVEKOZCRUISE.COM

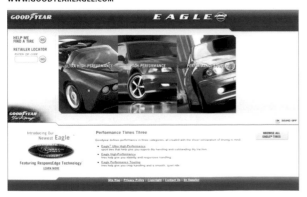

Creative Firm: **JPL PRODUCTIONS — HARRISBURG, PA**
Creative Team: **KATY BASTAS, CHELSIE MARKEL, ALISON FETTERMAN**
Client: **THE HERSHEY COMPANY**
WWW.HERSHEYS.COM/PLEDGE

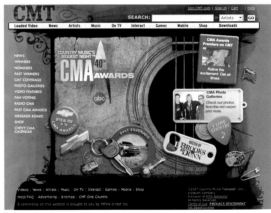

Creative Firm: **CMT — NEW YORK, NY**
Creative Team: **MARTIN CLAYTON, DONNA PRIESMEYER,
LORI REEVES SR. PRODUCER, MARSHALL WOKSA,
CALVIN GILBERT, JASON HILL**
Client: **CMT / CMT.COM**
WWW.CMT.COM/MUSIC/EVENTS/CMA/2005

Creative Firm: **HITCHCOCK FLEMING & ASSOCIATES INC. — AKRON, OH**
Creative Team: **NICK BETRO, JAMES KIEL, STEVE LAMB, ERIC HARTLINE,
MARCK COLLINS**
Client: **GOODYEAR TIRE & RUBBER COMPANY**
WWW.GOODYEAREAGLE.COM

Creative Firm: **ZERO GRAVITY DESIGN GROUP**
Client: **WOLFFER ESTATE VINEYARD & STABLES**
WWW.WOLFFERESTATESTALES.COM

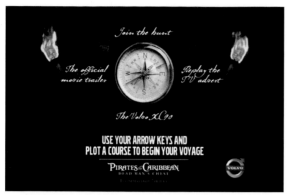

Creative Firm: **BURROWS — BRENTWOOD, ESSEX, UNITED KINGDOM**
Creative Team: **ROYDON HEARNE, DARRYL SMITH,**
AARON HULSIZER, LUCY WELDON
Client: **VOLVO CARS UK**

Creative Firm: **BURROWS — BRENTWOOD, ESSEX, UNITED KINGDOM**
Creative Team: **ROYDON HEARNE, ED SMITH, JON JUKES,**
AARON HULSIZER, LUCY WELDON
Client: **VOLVO CARS UK**
WWW.VOLVOCARCAMPAIGNS.CO.UK/GOLFCLUB/

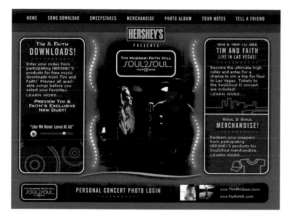

Creative Firm: **JPL PRODUCTIONS — HARRISBURG, PA**
Creative Team: **CHRIS BUCHHOLZ, CHELSIE MARKEL, MATTHEW BYERS,**
JAMY KUNJAPPU, JIM ROBBINS, SERENA FEDOR
Client: **THE HERSHEY COMPANY**
WWW.HERSHEYS.COM/TIMANDFAITH/HOME.ASPX

Creative Firm: **GODBE COMMUNICATIONS — HALF MOON BAY, CA**
Client: **FERRET COMPANY**
WWW.FERRETCOMPANY.COM

Creative Firm: **BBK STUDIO — GRAND RAPIDS, MI**
Creative Team: **GEOFF MARK, RYAN LEE**
Client: **HERMAN MILLER**
WWW.HERMANMILLER.COM/VIVOEXPERIENCE

Creative Firm: **MCCANN ERICKSON, NEW YORK — NEW YORK, NY**
Creative Team: **CRAIG MARKUS, SHALOM AUSLANDER,**
JOYCE KING THOMAS, JONATHAN SHIPMAN, SIMON BLAKE
Client: **LEVI'S**
HTTPS://LEVISSUBMISSION.WGEXCHANGE.COM

Creative Firm: **KELLER CRESCENT — EVANSVILLE, IN**
Creative Team: **CARSON CATLIN, LYNNE MLADY, RANDALL ROHN**
Client: **HEAVEN HILL**
WWW.KELLERCRESCENT.COM/PAMA

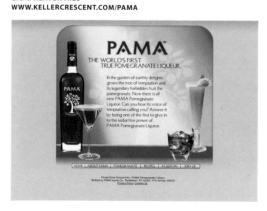

Creative Firm: **ISLAND OASIS — WALPOLE, MA**
Creative Team: **PETE BUHLER**
Client: **ISLAND OASIS**
WWW.ISLANDOASIS.COM

Creative Firm: **ZERO GRAVITY DESIGN GROUP — SMITHTOWN, NY**
Creative Team: **ZERO GRAVITY DESIGN GROUP**
Client: **MICROCOMPUTER CONSULTING GROUP**
WWW.MCGNET.COM

Creative Firm: **HUGHES HUNTER, INC.**
— THOUSAND OAKS, CA
Creative Team: **JIM HUGHES, BRUCE POLKES,**
LIZ FIELDS, TIM SCHMIDT, STEPHANIE SCHMIDT
Client: **TOYOTA MOTOR SALES USA**

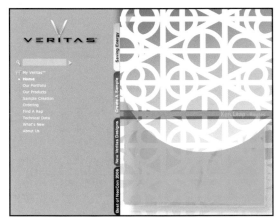

Creative Firm: **HITCHCOCK FLEMING & ASSOCIATES INC. — AKRON, OH**
Creative Team: **NICK BETRO, RENE MCCANN, KIM BRUNS**
Client: **VERITAS**
WWW.VERITASIDEAS.COM

Creative Firm: **ZERO GRAVITY DESIGN GROUP — SMITHTOWN, NY**
Creative Team: **ZERO GRAVITY DESIGN GROUP**
Client: **DIGITAL WATERWORX**
WWW.WATERWORX.COM

Creative Firm: **BBK STUDIO — GRAND RAPIDS, MI**
Creative Team: **GEOFF MARK, KEVIN BUDELMANN,**
MARIE-CLAIRE CAMP, JOHN WINKELMAN, CHUCK SHOTWELL
Client: **CUMBERLAND FURNITURE**
WWW.CUMBERLANDFURNITURE.COM

Creative Firm: **HORNALL ANDERSON DESIGN WORKS — SEATTLE, WA**
Creative Team: **HILLARY RADBILL, DAYMON BRUCK, DON KENOYER,**
ALAN DRAPER, ROEL NAVA
Client: **BLRB ARCHITECTS**
WWW.BLRB.COM

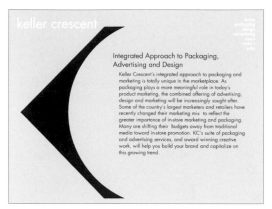

Creative Firm: **KELLER CRESCENT — EVANSVILLE, IN**
Creative Team: **CARSON CATLIN, RANDY ROHN, RANDALL ROHN**
Client: **KELLER CRESCENT**
WWW.KELLERCRESCENT.COM/

Creative Firm: **NEVER BORING DESIGN ASSOCIATES — MODESTO, CA**
Creative Team: **DAVID BORING, SHAWNA BAYERS**
Client: **RESTAURANT 15-0-FIVE**
WWW.RESTAURANT1505.COM

Creative Firm: **ACTIVE MEDIA GROUP — BAYAMON, PR**
Creative Team: **VERONIQUE DESCOMBES, GONZALO ARANIBAR, MARINA RIVON**
Client: **ACTIVE MEDIA GROUP**
WWW.ACTIVEMEDIAPR.COM

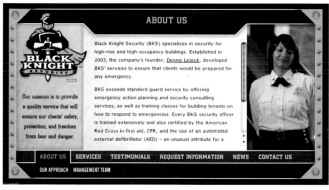

Creative Firm: **FITTING GROUP — PITTSBURGH, PA**
Creative Team: **ANDREW ELLIS, JEFF FITTING, TRAVIS NORRIS, AMY CHIAVERINI, BECKY THURNER**
Client: **BLACK KNIGHT SECURITY**
WWW.BLACKKNIGHTSECURITY.COM

Creative Firm: **SNAP CREATIVE — ST. CHARLES, MO**
Creative Team: **ANGELA NEAL, SARAH E.G. WATERS**
Client: **ENVIRONMENTAL MANAGEMENT ALTERNATIVES**
WWW.EMA-ENV.COM

Creative Firm: **HUGHES HUNTER, INC. — THOUSAND OAKS, CA**
Creative Team: **JIM HUGHES, BRUCE POLKES, LIZ FIELDS, CALLIE MILLER, TIM SCHMIDT, STEPHANIE SCHMIDT**
Client: **LEXUS**
WWW.LEXUS.COM/CPODEMYSTIFY/

Creative Firm: **OCTAVO DESIGNS — FREDERICK, MD**
Creative Team: **SUE HOUGH, MARK BURRIER**
Client: **PLATINUM PR**
WWW.PLATINUMPUBLICRELATIONS.COM

Creative Firm: **NICKTOONS — NEW YORK, NY**
Creative Team: **CHRISTINA VANN, ALLISON TUOHY, TAMI HEATON**
Client: **NICKTOONS NETWORK**
WWW.NICKTOONSNETWORK.COM

Creative Firm: **LEVINE & ASSOCIATES — WASHINGTON, DC**
Creative Team: **GREG SITZMANN, MONICA SNELLINGS**
Client: **LEVINE & ASSOCIATES**
WWW.LEVINEDC.COM

Creative Firm: **30SIXTY ADVERTISING+DESIGN, INC. — LOS ANGELES, CA**
Creative Team: **HENRY VIZCARRA, PÄR LARSSON, KASEY CHATILA, SCOTT HENSEL**
Client: **30SIXTY ADVERTISING+DESIGN, INC.**
WWW.30SIXTYDESIGN.COM

Creative Firm: **CONNIE HWANG DESIGN — GAINESVILLE, FL**
Creative Team: **CONNIE HWANG, KAI RADER, CELESTE ROBERGE**
Client: **CELESTE ROBERGE**
WWW.CELESTEROBERGE.COM

Creative Firm: **BRANDOCTOR — ZAGREB, CROATIA (HRVATSKA)**
Creative Team: **MOE MINKARA, SINISA SUDAR, ANJA BAUER MINKARA, MAJA BENCIC, HELENA ROSANDIC, DARIJE JURAJ**
Client: **BRANDOCTOR**
WWW.BRANDOCTOR.COM

Creative Firm: **DESIGN 446 — MANASQUAN, NJ**
Creative Team: **BRIAN STERN**
Client: **DESIGN 446**
WWW.DESIGN446.COM

Creative Firm: **CRABTREE & COMPANY — FALLS CHURCH, VA**
Creative Team: **SUSAN ANGRISANI, ROD VERA**
Client: **WAVE**
WWW.WAVE.ORG

Creative Firm: **LF BANKS + ASSOCIATES — PHILADELPHIA, PA**
Creative Team: **LORI BANKS, CARRIE PAUL**
Client: **LF BANKS + ASSOCIATES**
WWW.LFBANKS.COM

Creative Firm: **NANCY NEWBERRY PHOTOGRAPHY AND
DAS PLANKTON — DALLAS, TX**
Creative Team: **NANCY NEWBERRY, ANNIKA HAMAN**
Client. **NANCY NEWBERRY PHOTOGRAPHY**
WWW.NANCYNEWBERRY.COM

Creative Firm: **HUGHES HUNTER, INC. — THOUSAND OAKS, CA**
Creative Team: **JIM HUGHES, BRUCE POLKES, LIZ FIELDS, TIM SCHMIDT,
STEPHANIE SCHMIDT**
Client: **ACURA**

Creative Firm: **COMEDY CENTRAL — NEW YORK, NY**
Creative Team: **KAREN LA CHIANA, JULIE ANN PIETRANGELO,
JARRETT BRILLIANT, JESSE WILLMON, BETH LEWAND, PAUL BEDDOE-STEPHENS**
Client: **COMEDY CENTRAL**
WWW.COMEDYCENTRAL.COM/SHOWS/ROAST_ANDERSON/INDEX.JHTML

Creative Firm: **OCTAVO DESIGNS — FREDERICK, MD**
Creative Team: **SUE HOUGH, MARK BURRIER**
Client: **OCTAVO DESIGNS**
WWW.8VODESIGNS.COM

Creative Firm: **ZERO GRAVITY DESIGN GROUP — SMITHTOWN, NY**
Client: **ZERO GRAVITY DESIGN GROUP**
WWW.ZEROGNY.COM

Creative Firm: **FIVESTONE — BUFORD, GA**
Creative Team: **JASON LOCY, PATRICIO JUAREZ**
Client: **EWALD-SIGAMONEY PRODUCTIONS**
WWW.EWALDSIGAMONEY.COM

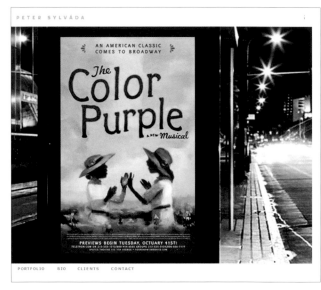

Creative Firm: **KIMBO DESIGN / FRESH STRATEGY — VANCOUVER, BC, CANADA**
Creative Team: **KIM PICKETT, BUDIANTO NASRUN, MARINA PERCY,**
SARAH KIEHNE, JENNIFER MAH
Client: **MINDSET MEDIA**
WWW.UGANDARISING.COM

Creative Firm: **RED CANOE — DEER LODGE, TN**
Creative Team: **DEB KOCH, CAROLINE KAVANAGH, PETER SYLVADA**
Client: **PETER SYLVADA**
WWW.PETERSYLVADA.COM

Creative Firm: **GRAFIK MARKETING COMMUNICATIONS — ALEXANDRIA, VA**
Creative Team: **JAMES SMITH, DAVID COLLINS, GREGG GLAVIANO, FABIO SILVA,**
JUDY KIRPICH
WWW.GRAFIK.COM

Creative Firm: **ZUNDA GROUP LLC — SOUTH NORWALK, CT**
Creative Team: **CHARLES ZUNDA, ROBERT R. THOMAS, JOHN GEOGHEGAN**
Client: **ZUNDA GROUP LLC**
WWW.ZUNDAGROUP.COM/

Creative Firm: **LEVERAGE MARKETING GROUP — NEWTOWN, CT**
Creative Team: **DAVID GOODWICK, MIKE NOVIA, TOM MARKS, BECKY KOROL**
Client: **LEVERAGE MARKETING GROUP**
WWW.LEVERAGE-MARKETING.COM

Creative Firm: **CONNIE HWANG DESIGN — GAINESVILLE, FL**
Creative Team: **CONNIE HWANG, NEAL HORSTMEYER, ARNOLD MESCHES**
Client: **ARNOLD MESCHES**
WWW.ARNOLDMESCHES.COM

Creative Firm: **ROBINLANDA.COM — NEW YORK, NY**
Creative Team: **MICHAEL SICKINGER, NEIL ADELANTE, ROBIN LANDA**
Client: **ROBIN LANDA**
WWW.ROBINLANDA.COM

Creative Firm: **THE LUDLOW GROUP — VIRGINIA BEACH, VA**
Creative Team: **NICK GLENN, MARCK WEISS, PAUL BELOTE, LEONARD ZANGS, JOSH HARRELL**
Client: **THE LUDLOW GROUP**
WWW.THELUDLOWGROUP.COM

Creative Firm: **ZERO GRAVITY DESIGN GROUP — SMITHTOWN, NY**
Creative Team: **ZERO GRAVITY DESIGN GROUP**
Client: **MARVIN A. WILLIAMS PHOTOGRAPHY**
WWW.MARVINAWILLIAMS.COM

389

Creative Firm: **OCTAVO DESIGNS — FREDERICK, MD**
Creative Team: **SUE HOUGH, MARK BURRIER, BETTINA STRAUSS**
Client: **BEST FOTO LLC**
WWW.BEST—FOTO.COM

Creative Firm: **FITTING GROUP — PITTSBURGH, PA**
Creative Team: **TRAVIS NORRIS, ANDREW ELLIS, C. SCOTT GILBERT**
WWW.FITTINGGROUP.COM/AD-O-MATIC

Creative Firm: **Q — WIESBADEN, GERMANY**
Creative Team: **MARCEL KUMMERER, LAURENZ NIELBOCK**
Client: **ALEXANDRA VOSDING**
WWW.ALEXANDRA-VOSDING.DE

Creative Firm: **RED CANOE — DEER LODGE, TN**
Creative Team: **DEB KOCH, CAROLINE KAVANAGH, DAVID VOGELEER, JAMIE BERGER, STEVE ROMANENGHI**
Client: **POTTERING AROUND**
WWW.POTTERINGAROUND.COM

Creative Firm: **ZYGO COMMUNICATIONS — WYNCOTE, PA**
Creative Team: **SCOTT LASEROW, ROE LASEROW**
Client: **SCOTT & ROE LASEROW**
WWW.REMROX.COM

Category Name: **ART & ILLUSTRATION**
Student Name: **YULIA KOLONIA**
School Name: **STEPHEN F AUSTIN STATE UNIVERSITY**

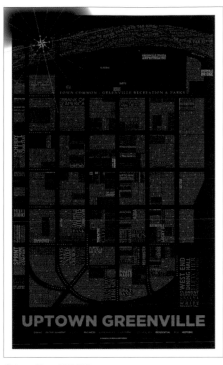

Category Name: **POSTERS**
Student Name: **COURTNEY ANN BARR**
School Name: **EAST CAROLINA UNIVERSITY OF ART AND DESIGN**
Other Creatives: **GUNNAR SWANSON**

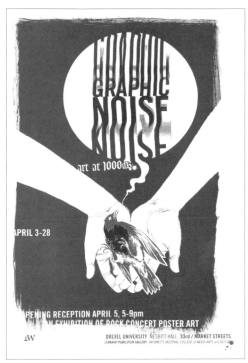

Category Name: **POSTERS**
Student Name: **DON HARING, JR.**
School Name: **DREXEL UNIVERSITY GRAPHIC DESIGN PROGRAM**

Category Name: **WEBSITE DESIGN**
Student Name: **JEANNE KOMP**
WWW.TYPEHYPE.NET

Category Name: **DIMENSIONAL PROMO**
Student Name: **SHANNON EARY**
School Name: **ART INSTITUTE OF CALIFORNIA-SAN DIEGO**
Client: **DISNEY DVD**

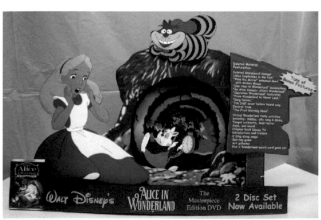

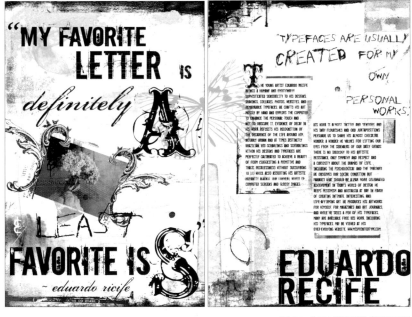

Category Name: **POSTERS, CAMPAIGN**
Student Name: **CHRISTINE MEAHAN**
School Name: **ENDICOTT COLLEGE**

Category Name: **LOGOS & TRADEMARKS**
Student Name: **JEANNE KOMP**

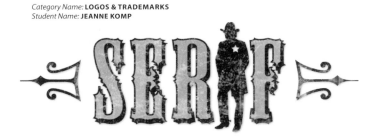

Category Name: **LETTERHEADS**
Student Name: **LESLIE HANSON**
School Name: **SUSQUEHANNA UNIVERSITY**

Category Name: POSTERS
Student Name: **MARCELLA ZUCZEK, MARK WILLIE**
School Name: **DREXEL UNIVERSITY GRAPHIC DESIGN PROGRAM**

Category Name: LOGOS & TRADEMARKS
Student Name: TREVOR HARKEMA
School Name: IOWA STATE UNIVERSITY
Client: CLUB KB DJ SERVICES

Category Name: **POSTERS**
Student Name: **LESLIE HANSON**
School Name: **SUSQUEHANNA UNIVERSITY**

Category Name: SIGNS
Student Name: IN-SIL HAN
School Name: PRATT INSTITUTE

Category Name: POSTERS
Student Name: DANIEL JACOB
School Name: MIAMI AD SCHOOL/ESPM
Client: WILATI
Other Creatives: DANIEL SCHEINER

Category Name: POSTERS
Student Name: ZVONIMIR MINTAS
School Name: UNIVERSITY OF ZAGREB
Other Creatives: ANDREA SRECKOVIC

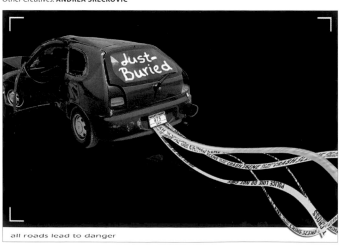

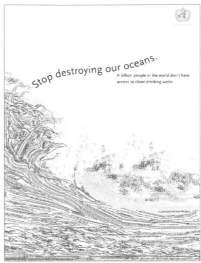

Category Name: **POSTERS**
Student Name: **DANIEL JACOB**
School Name: **MIAMI AD SCHOOL/ESPM**
Client: **L'OREAL**
Other Creatives: **ALEXANDRE AMARAL, DANIEL SASSO**

Category Name: **POSTERS, CAMPAIGN**
Student Name: **YOO-KYUNG HAN**
School Name: **OTIS COLLEGE OF ART AND DESIGN**
Client: **WORLD HEAL TH ORGANIZATION**

Category Name: **POSTERS, CAMPAIGN**
Student Name: **IN-SIL HAN**
School Name: **PRATT INSTITUTE**

Category Name: **POSTERS**
Student Name: **GINA LAMANNA,MARK WILLIE**
School Name: **DREXEL UNIVERSITY GRAPHIC DESIGN PROGRAM**

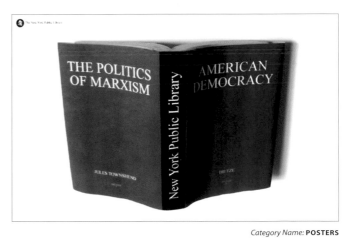

Category Name: **LOGOS & TRADEMARKS**
Student Name: **IN-SIL HAN**
School Name: **PRATT INSTITUTE**

Category Name: **POSTERS**
Student Name: **IN-SIL HAN**
School Name: **PRATT INSTITUTE**

Category Name: **BOOK DESIGN, INTERIOR**
Student Name: **KELLY LARBES**
School Name: **OHIO UNIVERSITY**

STUDENT CATEGORY

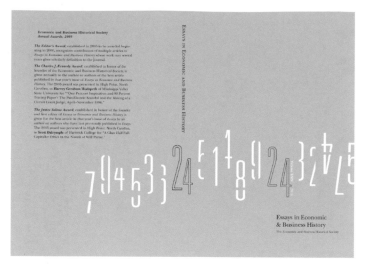

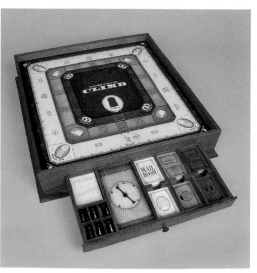

Category Name: **BOOK DESIGN, JACKETS**
Student Name: **SHELBY SPEARS**
School Name: **AUBURN UNIVERSITY**
Client: **DAVID O. WHITTEN**
Other Creatives: **KELLY BRYANT, DAVID WHITTEN**

Category Name: **LETTERHEADS**
Student Name: **LESLIE HANSON**
School Name: **SUSQUEHANNA UNIVERSITY**

Category Name: **POSTERS, CAMPAIGN**
Student Name: **DANIEL JACOB**
School Name: **MIAMI AD SCHOOL/ESPM**
Client: **GATORADE**
Other Creatives: **ALEXANDRE AMARAL, PEDRO BORTOLINI**

Category Name: **RADIO**
Entry Title: **NATURAL**
Student Name: **DANIEL JACOB**
School Name: **MIAMI AD SCHOOL/ESPM**
Client: **TWEEZERMAN TWEEZERS**
Other Creatives: **DANE ROBERTS, MIKE LAZARUS,**
AMY JARRARD

Category Name: **BROCHURES, CONSUMER PRODUCTS**
Student Name: **DIANA LOMONACO**
School Name: **ROGER WILLIAMS UNIVERSITY**

Category Name: **MAGAZINE AD, CONSUMER, SINGLE**
Student Name: **DANE ROBERTS**
School Name: **MIAMI AD SCHOOL**
Client: **COTTON GROWERS OF AMERICA**
Other Creatives: **JASON TEBBE, JENNIFER JOHNSON**

Category Name: **PROMOTIONAL PACKAGING**
Student Name: **GAVIN COOPER**

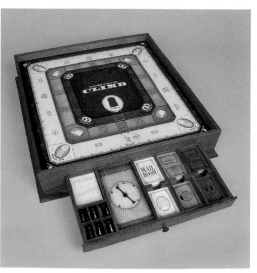